PUBLIC LIBRARY

San Anselmo, California

This book i
A fine of
book is 1

6 3,133

SEP
NOV 2

MAY

OCT

0

Art of the Huichol Indians

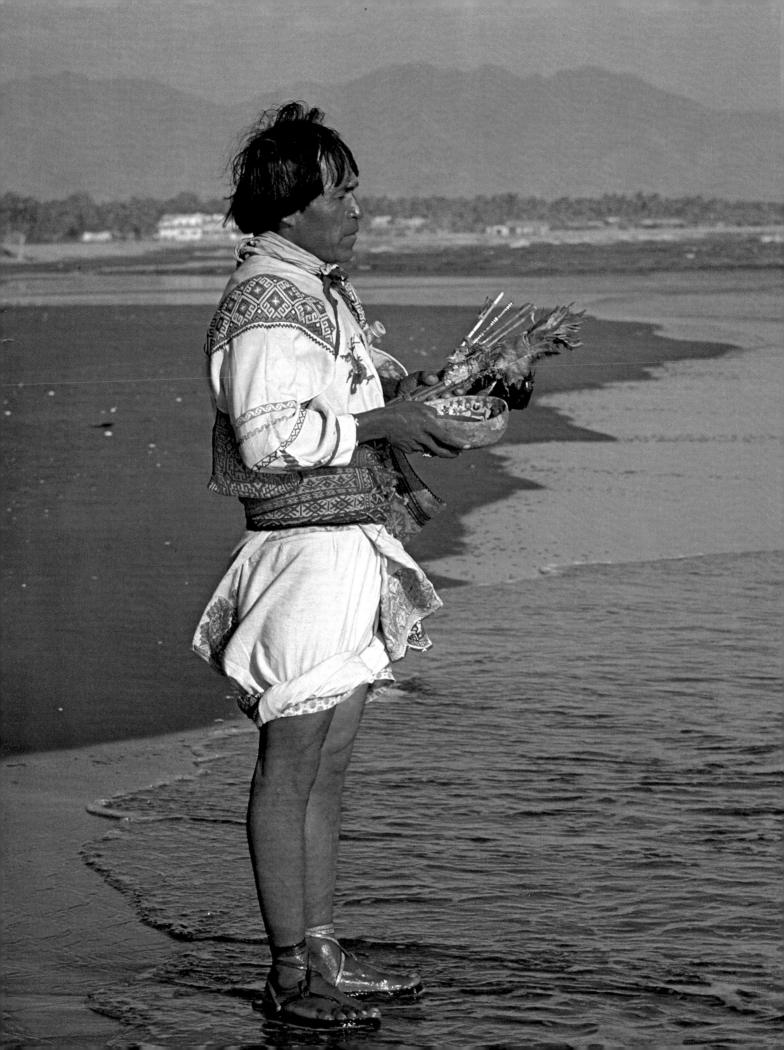

Art of the Huichol Indians

With contributions by
Lowell John Bean and Sylvia Brakke Vane
Prem Das
Susan Eger
Peter T. Furst
Arnold J. Mandell
Barbara G. Myerhoff
Kal Muller
Phil C. Weigand

Introduced and Edited by Kathleen Berrin
Preface by Thomas K. Seligman

The Fine Arts Museums of San Francisco/Harry N. Abrams, Inc., Publishers, New York

Cover illustration:

HOW DATURA PERSON WAS DEFEATED (detail)
by Guadalupe, widow of Ramón Medina Silva, after yarn
painting by Ramón. #74.21.19. The Fine Arts Museums of
San Francisco. Gift of Peter F. Young

Frontispiece:

Shaman praying to Tatei Aramara. Photo: Kal Muller

Introduction illustration, p. 10
Ceremonial paraphernalia next to a *ririkuri* or small shrine.
Photo: Kal Muller

Published in conjunction with an exhibition of Huichol Indian art
organized by The Fine Arts Museums of San Francisco and exhibited at:

M. H. de Young Memorial Museum, San Francisco
November 1978–March 1979

Field Museum of Natural History, Chicago
May 1979–August 1979

The American Museum of Natural History, New York
November 1979–February 1980

Editor: Jean Steinberg
Designer: Gilda Kuhlman

Library of Congress Cataloging in Publication Data

Main entry under title:

Art of the Huichol Indians.

 Bibliography:
 1. Huichol Indians—Art—Addresses, essays,
lectures. 2. Huichol Indians—Addresses, essays,
lectures. 3. Indians of Mexico—Art—Addresses,
essays, lectures. I. II. Berrin,
Kathleen. III. Fine Arts Museums of San Francisco.
F1221.H9A77 1978 970'.004'97 78-3144
ISBN 0-8109-0685-6 (H.C.)
ISBN 0-8109-2160-X (pb.)
ISBN 0-88401-032-5 (Museum pb.)

Library of Congress Catalogue Card Number: 78-3144

Printed and bound in Japan

Contents

63,133

Foreword

The Huichols are an increasingly known, little understood cultural group who live today much as they have in the past but who are beginning to feel the pressures of our modern world more acutely. Though they are perhaps best known for their vivid, colorful yarn paintings, they have traditionally produced a wealth of religious objects and ceremonial costumes for use within their own culture, a wide sampling of which is presented here.

This publication and the exhibition which accompanies it borrow from old and documented collections around the country to provide a comprehensive view of Huichol art from the late nineteenth century to the present day. After an initial showing in San Francisco, the exhibition will appear in Chicago and New York. This publication is both a historic record of the exhibition and a contribution to art historical and anthropological scholarship.

I want to thank The American Museum of Natural History, The Museum of New Mexico, The Museum of Cultural History, and the various private individuals who have generously allowed us to include parts of their collections in this exhibition and book. I am most grateful to the National Endowment for the Arts and The Museum Society of The Fine Arts Museums of San Francisco for support of the exhibition and publication.

IAN MCKIBBIN WHITE
Director of Museums

6

Preface

The Fine Arts Museums of San Francisco became involved with the art of the Huichol Indians several years ago as the result of my meeting a local private collector and dealer of modern Huichol yarn paintings. Having seen examples of yarn paintings before, I was aware of their vitality and power but knew very little about their makers. Urged on by what little I knew of this culture, I began an investigation of the Huichols which led to numerous public and private collections and to written accounts of Huichol culture ranging from popular magazine articles to the most scholarly anthropological texts.

A central characteristic I observed among these writings was a conflict that seemed to border on competition. Beginning with Robert Mowry Zingg's publication of his field work in 1938, for example, there is evidence of both subtle and sharp disagreement with his predecessor, Carl Lumholtz, the pioneering Norwegian ethnographer who worked among the Huichols in the late 1890s. While one would expect a certain amount of disagreement between scholars, Lumholtz and Zingg express very different opinions about the meaning of specific objects, symbols, and even religious beliefs. And while Zingg always writes of Lumholtz in the most respectful terms, a subtle kind of one-upmanship weaves itself throughout his volume.

Today, disagreements continue as strongly as they did forty years ago, but with the important added dimensions that they are much less subtle and that there are now many more people working with or on the Huichols. The once inhospitable area of the Sierra Madre of north-central Mexico which the Huichols now occupy is penetrated by roads, airstrips, radios—and non-Huichols—all competing variously for space, attention, or dominance, and all with very different purposes or motivations. Varied groups or individuals are trying to bring the Huichols within the political and economic sphere of the central government of Mexico, or make Christians of them, or educate them in Western ways. Yet others are trying to uncover who they are and where they came from, some with the desire of helping the Huichols "preserve" their traditions, while others are more interested in the commercialization of Huichol arts and crafts. Many of these motivations are at least in partial conflict with one another, and the Huichols seem to be caught in the middle.

All of these forces and factors produce the inevitable result that the Huichols are changing, perhaps far more rapidly than they would if left to themselves. But what of the information that is derived from the work being conducted among them?

The most disturbing aspect of the inevitable disagreement is that there seems to be an attempt on the part of some outsiders to portray a single or "correct" version of Huichol life. This is apparent in more than the tone of academic writing—there seems to be an effort on the part of some outsiders to control information and interpretations of information about the Huichols. Of course, this leads to false and biased versions of what isn't even a completely shared reality among all Huichols. And the situation becomes complicated by the fact that an important part of the Huichol world view and sacred practices involves verbal reversals of "reality" (see especially Myerhoff, this volume).

Aware of these conflicts, and the frequent lack of cooperation among the outside observers of the Huichols, we sought in the development of this volume and the accompanying exhibition to provide a forum for several different points of view and interpretations. To some extent we capitalized on the tradition of disagreement by encouraging authors to air their latest theories and ideas rather than rehash the old. Some of our contributors have done extensive fieldwork among the Huichols and others have not, but all open up new and important vistas for a broader understanding.

This volume does not reflect the full range of individuals doing work of value with the Huichols, nor is it intended to present a final statement about them. To the contrary, we hope it will open up new areas of inquiry and initiate a new cooperation among those who work with this fascinating group. The authors whose work is present here have certainly worked in that spirit, and for that we are exceedingly grateful.

THOMAS K. SELIGMAN
Curator in Charge
Department of Africa, Oceania and The Americas

Editor's Note:

For the sake of brevity and convenience to the general reader, short title and page references to cited sources have been incorporated into the texts of the essays. More detailed bibliographical data on these cited works appear in the Selected Bibliography at the end of this volume.

Spellings of Huichol names and terms differ widely in the literature, probably because of regional differences in pronunciation. For purposes of consistency within this volume, we have eliminated all diacritical marks and standardized all spellings. We have tried, whenever possible, to follow the spellings of Joseph E. Grimes, the most authoritative source on Huichol linguistics.

Art of the Huichol Indians

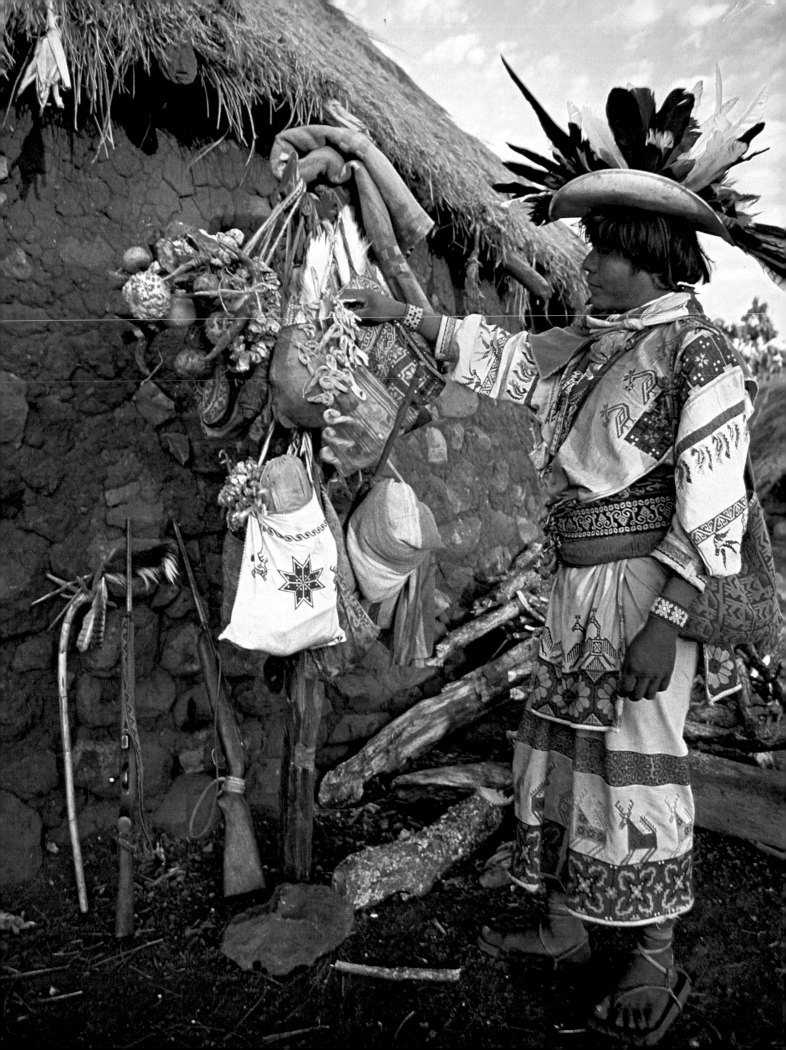

Introduction

Writers about culture necessarily speak from a subjective point of view. What they see is largely defined by what they are, as well as by the field situation they are a part of, the scholarship they are heir to, and the particular rhythms of contemporary thought in their own culture. The following remarks are offered as preparation for the diverse points of view you will encounter in this volume, and by way of introduction to the basic problems or conflicts mentioned in the Preface. They are personal observations I have made as editor of this volume and as an outsider to Huichol studies looking in.

This volume is not a unified body of essays offering unequivocal answers to questions about the Huichols. It does not presume to know "the facts" to analyze the Huichols quantitatively or "contain" them in neat, intellectually satisfying packets by presenting them as a quaint, romantically simple people who live today much as they did in the past. The truth, if there is a truth, is that the Huichol Indians of Jalisco and Nayarit (Mexico) are a tremendously complex group who have been partially studied by outsiders but whose culture still remains a mystery, enigmatic and refractory to analysis.

Because of the inevitable dissension and polarization in almost any field, we knew from the start that this volume might be a collection of sometimes antithetical views. And we also knew that there would be gaps. Yet we encouraged and even welcomed this situation as having the makings for a dynamic publication, one which would provoke questioning by scholars and nonspecialists alike. The reader will decide whether or not this has been accomplished.

What are some of the problems or questions that complicate the study of the Huichols?

First, there is that deceptively simple question: Who are the Huichols? There are roughly ten to fourteen thousand of them living both in the cities and in the Sierra, indigenous or traditional Huichols as well as citified or Westernized Huichols, those who live in *ranchos* in the Sierra and those who have made the break, who have left their communities to live in Tepic or Guadalajara, caught between the old and the new, the known and the unknown.

Who are the *real* Huichols? Perhaps they might be called seminomadic rather than self-contained, for they frequently travel and their most central religious rite, the peyote pilgrimage, annually takes them out of the Sierra into the desert of Wirikuta (see map). The Huichols have traditionally lived in a scattered settlement pattern, each community isolated and localized, yet not without many contacts among them.

What are their origins? Again we have no definitive answer. Many scholars believe that the Huichols are relatively new to their Sierra home, that their settled agricultural way of life is also relatively new, that their origins lie in the North and that they moved South as nomadic hunters and gatherers, learning agriculture from settled peoples along the way. Others believe that clues to the Huichol past are embedded in the archaeological records of the area they now occupy, that they have lived in their present home for a very long time. Cultural connections, if one looks at bits and pieces or sometimes even larger fragments, have been noted with groups in the Southwestern part of the United States, the Aztecs, or other pre-Columbian cultures. These often startling cultural resemblances usually raise many more questions than they answer, and the puzzle remains unsolved.

What is the Huichol belief system? Almost everyone agrees that they are a deeply religious people, that religion pervades every aspect of their life. Though we are beginning to understand the depth and complexity of their most central rite, the peyote pilgrimage, we do not fully understand the many other important ceremonies in the Huichol cycle, either as self-contained entities or as interrelated units. To complicate matters even further, the Huichols have a multitude of deities—or perhaps one should say a number of deities with a multitude of aspects or equivalences.

Huichol religion is broad, encompassing, and intensely

personal. Probably no two Huichols would relate sacred histories in exactly the same way. And no one has yet cleared up the maze of names of deities in the literature or successfully correlated spellings, attributes, or iconographical identifications.

And the final, perhaps most emotion-charged question of all: What is happening to the Huichols today? What *should* be happening to the Huichols today—demise of the culture, or development, and to what end?

Of course, the answers are splintered along many lines. Broadly speaking, there are really two groups: those who believe the Huichols should be "helped" and those who believe they should be left alone, the latter a rather theoretical position with but few real adherents.

What kind of help the Huichols need and the amount they should get is the crux of the issue which makes tempers flare. "Saving" the Huichols, a cause defended by some with almost religious fervor, may or may not be a worthwhile or even attainable goal. How do we help the Huichols without influencing them or changing them? Growth is essential to any culture, and it necessarily involves change. Fragile yet resilient, like the peyote, delicate yet tough, the Huichols apparently have managed to withstand the pressures of outside contacts. On the other hand, maybe their future *is* tenuous. Or perhaps the total demise of their culture exists only in the minds of their beholders.

A word about peyote, that strange substance that makes "straight" Americans squirm and hip Americans smile— that integral part of Huichol life, sacred yet as natural as eating or breathing. How can we deal with our own society's exceedingly ambivalent attitude about "drugs" and still try to understand the beauty of the peyote experience in strictly academic or religious terms without unduly romanticizing it or making it the "instant answer"?

Back to basics. Innocence regained. The pure religious experience. Going native. Part of the Huichol appeal to us today lies in their feeling of the "rightness" or certainty of their beliefs. Contrast this to our own questioning and fragmented society. We want to know *their* answers, for

perhaps those answers can partially be ours. So some people make that pilgrimage to Huichol country, performing their own Westernized version of a journey to one's origins. More often than not they are disappointed.

Carl Lumholtz and Robert Mowry Zingg, the two pioneering ethnographers of Huichol life and culture, made a lot of mistakes. There are very real problems in the differences in their reporting. Following in their footsteps, later students of Huichol culture made their own mistakes, duplicated or replicated those of others, and the cumulative snarl is difficult to untangle. Some of the problems stem from the fact that traditional fieldwork methods do not always work with the Huichols. Much of this is a function of the tremendous complexity of the Huichol world view where all things are sacred and changeable; yet human beings need to identify and compartmentalize. In doing so, however, they may oversimplify and base their thoughts on a series of false premises. Still other problems arise from a lack of communication among people in the field; and some of these may derive from the very human problem of ego-conflict.

A number of myths complicate the problem even further. First is the notion that it is possible to learn to *know* a culture within a relatively short span of time, seal it in a test tube and observe its structure and function as a self-sufficient entity. Next, a corollary to this, comes the myth of the pristine culture, untouched or uncontaminated by Western influences—an (arguably) ideal state that exists only in our minds. Third is the myth of simple or "primitive" culture, much easier to understand than our complex technological society which is fragmented and diverse by comparison. And finally, we have the myth (alluded to earlier) of "helping" the Huichols or keeping them "pure." So many well-meaning individuals and groups do indeed want to help the Huichols, whether they be the government, the anthropologists, the entrepreneurs who encourage contemporary craft production for the tourist trade, even institutions like ours, which hope to shed some light on the situation in the name of scholarship.

The other part of the problem, and one that is more

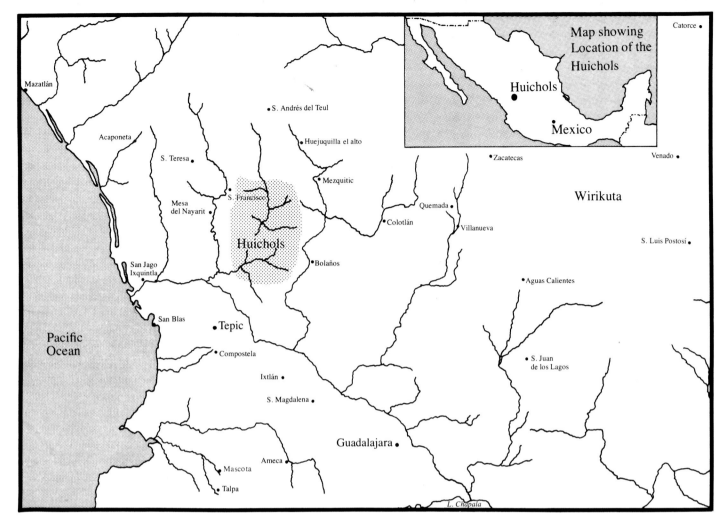

Location of the Huichol, after a map in *Symbolism of the Huichol Indians* by Carl Lumholtz.

difficult to describe or understand, is the indigenous resort to or cultural acceptability of what ethnographers have called "the lie." It may not really be a lie, of course, but simply another kind of truth.

More than one contributor to this volume has told me a Huichol will say whatever he or she thinks you want to hear. Telling people what one thinks they want to hear is not at all uncommon. Playing scholar against scholar, Indian against scholar, Indian against Indian is nothing new either. But with the Huichol the problem is more far-reaching than this, for the indigenous use of "the lie" can be a defense against outsiders, a magic language or secret code, an aspect of ritual (as in the ritual reversal or twist which is a Huichol method of approaching the sacred). It can also be a way of winning approval or goods, or a manifestation of the Huichol sense of humor.

The eight original essays in this book have been placed in complementary opposition to one another under four topics:

I. Huichol Sacred Art
II. The Religious Experience
III. Acculturation and Economics
IV. Shamanism

While they do not have to be read consecutively, we believe this approach to be a sensible one, particularly for someone without much prior knowledge about the Huichols. We do recommend that, regardless of where you start, you read the essay pairs together, for they either highlight, explain more fully, enhance, or contradict each other.

We start with the Huichol art because that is the impetus for this volume and because the essays by Furst and Eger provide background material that will help readers begin to understand the meaning of "being Huichol." Furst's essay begins with a review of the work of the early ethnographers, moves into a description of the late Ramón Medina Silva (the shaman-artist who worked with Furst and Myerhoff), and finishes with a discussion of yarn paintings and major types of Huichol sacred art. Eger's

essay delves into the complementary roles women undertake "to complete themselves" in the Huichol religious hierarchy by aspiring to artistic excellence in the creation of elaborate embroideries.

The essays of Myerhoff and Mandell, paired under the heading "The Religious Experience," view the peyote pilgrimage and experience from two seemingly incompatible vantage points: the cultural and the chemical. Myerhoff's highly distilled, almost spiritual essay discusses the operation of a hallucinogen in a totally sacred context, while Mandell's "prose fracture" about chemicals and god should be read quickly, breathlessly, and probably more than once. Myerhoff and Mandell have worked together before; their contributions are like the opposing ends of a spectrum looking at "the core religious experience" achieved through the use of drugs. While hallucinogenic glimpses of the sacred do, of course, have great bearing on the art, their two contributions remind us that aesthetic aspects of Huichol life are not necessarily limited to objects *we* call art, but can extend to individual experiences or performances.

Of all the essay pairs in this volume, perhaps those of Muller and Weigand ("Acculturation and Economics") differ most radically. Muller's thesis that the impact of Western goods and ideas on Huichol life has thus far been negligible and that there is little these self-reliant people could not give up easily if they had to stands in sharp contrast to Weigand's heavily acculturated picture of strict political and economic structures based on Mexican or Spanish prototypes.

The Bean/Vane and Prem Das essays in the "Shamanism" section present two different approaches to understanding the art production of a group so deeply rooted in the shamanic tradition. Bean/Vane provide a broad overview of shamanism in a worldwide context, while the contribution by Prem Das fills in their broad framework with details of the Huichol case. He relates his own experience of becoming an apprentice-shaman in the belief that one must literally become part of Huichol culture to understand it.

And finally, we close the circle by bringing you the art: the catalogue of objects drawn from several major collections in the United States. The ordering of objects is divided roughly into sacred or votive offerings and clothing, and within those categories, by object type and development in time.

One more note about yarn paintings: Not many of them are illustrated here, and there is a reason for that. First, they are not really sacred art objects in themselves, though they do illustrate sacred narratives or histories. The objects to which we have given priority in this volume are those most traditionally based or central to the Huichols themselves, a selection of which has never been published comprehensively or made available to the public on a large scale.

Not all Huichols make yarn paintings. They are generally made by those living in the cities, where materials are readily acquired and the market exists. Yarn paintings represent a major means, and one perhaps not too compromising, by which the Huichols have managed to cope with the Western world.

So we did not arrange this book in neat compartments to be ingested successively. What you will find here, we believe, are eight challenging, essays by nine authors, each of whom I deeply respect and immensely enjoyed working with.

When we first envisioned this volume we viewed it as a way to begin to get at the truth of Huichol culture. Now we realize that part of our premise was false; there is not one truth but many. And grasping any of these truths lies in recognizing the richness and diversity of Huichol culture, not as a homogeneous unit, but as a changing, ever-varied, and multifaceted product of a fascinating and enigmatic group.

I would first like to thank the nine authors who pro-

duced these candid, refreshing, and thought-provoking pieces. Our consultants—Michael Harner, Arnold Mandell, and Barbara Myerhoff—brought exceptional energy, both individually and collectively, to the sessions that shaped the project. They worked together with a spirit of cooperation that was deeply appreciated. Special personal thanks go to Susan Eger and Peter T. Furst, both of whom graciously and tirelessly answered my innumerable questions. I would also like to mention Peter Collings, for his intensity and fervor, and Prem Das, for his quiet yet profound insights that indirectly influenced my work on this book; but most important was the support offered me throughout the project by my husband, Al Berrin.

Stacy Schaefer dropped fortuitously into my life to help with research, ideas, and suggestions that contributed much to the character of this publication. The talents of Jim Medley, our Museum photographer, are evident in the beautiful work he produced for publication; he was ably assisted by Nina Hubbs and Ellen Werner. Gail Lar-rick brought her own interest in the Huichols to the project as she assisted us with the content editing, and Jetty Lynch and Ursula Egli typed long hours helping prepare the manuscripts for the publisher. I am grateful to all for their work, and I have especially appreciated Edward T. Engle, Jr. and Ann Heath Karlstrom, successive publications managers for The Fine Arts Museums, whose combined sense (and sense of humor) guided this book steadily into production.

I would like to thank Jean Steinberg in New York, who brought her remarkable skills to the final editing of all the manuscripts, and we have all appreciated the interest and support of Robert Morton, Margaret Kaplan, and Leta Bostelman of Harry N. Abrams, Inc.

Finally, special tribute goes to my catalyst-colleague Tom Seligman, without whose imagination, foresight, and encouragement this volume would never have come into being.

KATHLEEN BERRIN
Department of Africa, Oceania, and The Americas

EMBROIDERY SAMPLE
Collected by Susan Eger in San Andrés (1976–77)

Red deer materializes out of lattice-work background of peyote flowers and projectile forms which resemble offerings left in the fields to the fertility deity. Cross-stitched.

Huichol Sacred Art

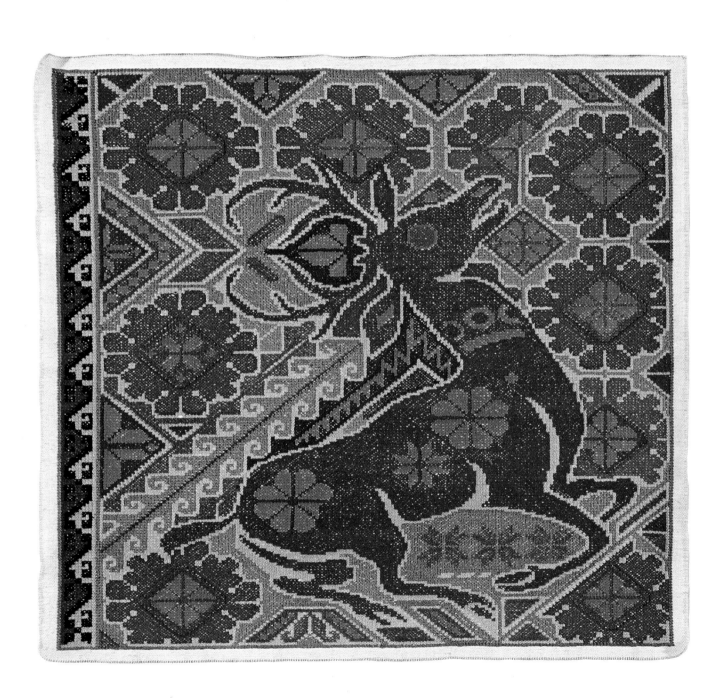

The Art of "Being Huichol"
Peter T. Furst

"All sacred things are symbols to primitive man, and the Huichols have literally no end of them. Religion to them is a personal matter, not an institution, and therefore their life is religious—from the cradle to the grave wrapped up in symbolism."

Carl Lumholtz's words from his classic, *Symbolism of the Huichol Indians*, remain appropriate as an introduction to the sacred art of the Huichols and its decorative derivatives. These words are as true now as they were when Lumholtz wrote them.

Lumholtz made three expeditions to Mexico for the American Museum of Natural History between 1890 and 1898. In 1898 he returned for another visit to check some of his earlier data and to fill out his great collection of Huichol symbolic and decorative art for the American Museum—the first in the world.

Shortcomings are apparent in Lumholtz's work, as they are in all anthropological fieldwork. Particularly in his studies of Huichol decorative art as distinct from sacred symbolism, he was too ready to apply individual interpretations to the culture as a whole. He paid too little attention to cultural diversity within the broader framework of what the shaman-artist Ramón Medina Silva (c. 1926–71) called "being Huichol." From the vantage point of modern ethnographic theory and field methods, one might wish for greater attention to the sociocultural context of the symbolic and decorative arts of a people who must be counted among the most artistically creative of native American peoples.

Nevertheless, three-quarters of a century after Lumholtz's work was completed, one cannot help but continue to be impressed by his scholarship, his sharp eye and ear for the significant detail, his courage, perseverance, humanity, and respect for the talents, traditions, and world view of the Huichols and other native Americans among whom he spent much of the last decade of the nineteenth century. The modern student, from Robert Mowry Zingg in the 1930s to those of us who came to Huichol ethnography only in the 1960s and 1970s, has Lumholtz's work from

which to proceed; Lumholtz, being first, had nothing but his own respectful curiosity.

Zingg's important ethnographic study of Huichol intellectual culture, *The Huichols: Primitive Artists*, remains virtually unknown to the modern student, because the ship carrying the first edition from the German printer to the United States was lost at sea; only a handful of advance copies survive. Zingg certainly did not underrate his debt to Lumholtz. He writes that Lumholtz first inspired him to concentrate his own fieldwork on the arts—music, dance, drama, oral tradition, and philosophy—and especially on the sacred plastic arts, the subject of one of Lumholtz's two museum monographs.

In relation to the art assembled in these pages, Zingg's observations on his own immediate and later reactions to Huichol symbolism are particularly interesting. Initially, when he first opened Lumholtz's monographs and before he had been in the field, Huichol sacred art appeared to him so mystical, complex, and even bizarre as to be totally incomprehensible; after twelve months with the Huichols he came to realize that it had internal consistency and even stability over time and that this art "is outstanding in the primitive realm for the functional correlations it exhibits with other departments of the culture."

Zingg was also fortunate to have met the German ethnologist Konrad Theodor Preuss, a towering figure in the study of native American religions. In the course of an extended stay with the Indians of the Sierra Madre Occidental in 1906 and 1907, Preuss had spent nine months with the Huichols, learning the language and recording some seventy lengthy sacred texts in longhand. He also compiled a large collection of sacred art which was subsequently divided between the ethnographic museums of Hamburg and Berlin. Fortunately, most of Berlin's Huichol holdings survived World War II, but those of Hamburg were destroyed.

Preuss' work in western Mexico was to have resulted in a series of four monographs, but only the first of these, his important study of the religion of the Cora Indians, was

actually published, in 1912. He also wrote some shorter articles on Huichol religious songs and myths, but publication of the major work on Huichol sacred texts never came to pass, for both copies of the completed manuscript were lost in World War II bombing raids.

The extent of this loss to Huichol literature may be measured by the high quality of Preuss' Cora study and the three volumes of Nahua texts, published in 1968–76 in the original Nahua and in German translation by the German Ibero-American Institute in Berlin. This work has been of particular interest to me. In it, I found sacred texts that, though from a culture with which the Huichols evidently have not had recent contact, are virtually indistinguishable in content, and sometimes even in language, from some Huichol narrations by Ramón. Among these is one of the most important of all Huichol origin traditions—the story of the first appearance of maize, principal subsistence staple for both populations, the origins of which Ramón narrated and illustrated with particular emotion.

Looking back to the work of Lumholtz, Preuss, Zingg, Léon Diguet, a French scholar and early collector of Huichol art, and other pioneer fieldworkers, and to the more recent anthropological literature on the Huichols, one must note an imbalance in favor of religion, ritual, myth, and the sacred and decorative arts, at the apparent expense of what *we* might see as a society's more mundane concerns. The imbalance arises not because economics, technology, sociopolitical organization, acculturation, and the like are unimportant or uninteresting, but rather, because, as Lumholtz observed, religion in one manifestation or another permeates all of life for the traditional Huichol, including economics, social relations, and even technology.

To fail to recognize this religious-magical universe in which the traditional Huichol moves, or to try to divide Huichol life arbitrarily into sacred and mundane domains, is to miss the whole point of Huichol culture. Huichol religion and ritual have been the focus of much of our interest because of this indivisibility of "ordinary" life and religion, and because among all the indigenous religious systems of Mesoamerica, that of the Huichols is unique in its successful resistance to all but the most minor modifications from European sources. Huichol belief and ritual and the oral or plastic arts have been better studied than other aspects of the culture because they are what Huichols do best—that which they themselves invest with their greatest emotion and artistic creativity.

Among native Americans only the Pueblo Indians can be said to rival the Huichols in the sacred arts and the intense religiosity of their lives. Most Huichol adults of both sexes are directly involved in the production or performance of some form of sacred art at many points in their lives—making *tsikuri*, or yarn crosses (mistakenly called "god's eyes"), for children, or prayer arrows aimed at the gods; helping build a large *tukipa* ("house of all" or temple) for the community, or a smaller *shiriki* (Lumholtz's "god house") on the family *rancho* as an earthly dwelling for the gods or an ancestor who has returned as guardian of the kin group in the form of a rock crystal; decorating a votive gourd with beads or yarn for one of the divine Mothers of the earth, water, or maize; or dancing or reciting the sacred song cycles in one of the many dramas of the annual ceremonial round. Almost every Huichol woman is skilled in the arts of weaving and embroidery, and many men and women excel at stringing tiny colored beads into beautiful earrings, bracelets, and necklaces whose motifs derive from the communal inventory of sacred symbolism.

For the Huichol, art is prayer and direct communication with and participation in the sacred realm. It is meant to assure the good and beautiful life: health and fertility of crops, animals, and people; prosperity of the individual, the kin group, and the larger society. Art, then, is functional as well as beautiful, as is nowhere more apparent than on the peyote pilgrimage; every *peyotero* works for weeks to prepare his or her own prayer objects, ceremonial arrows, and decorated votive gourds, or even a miniature

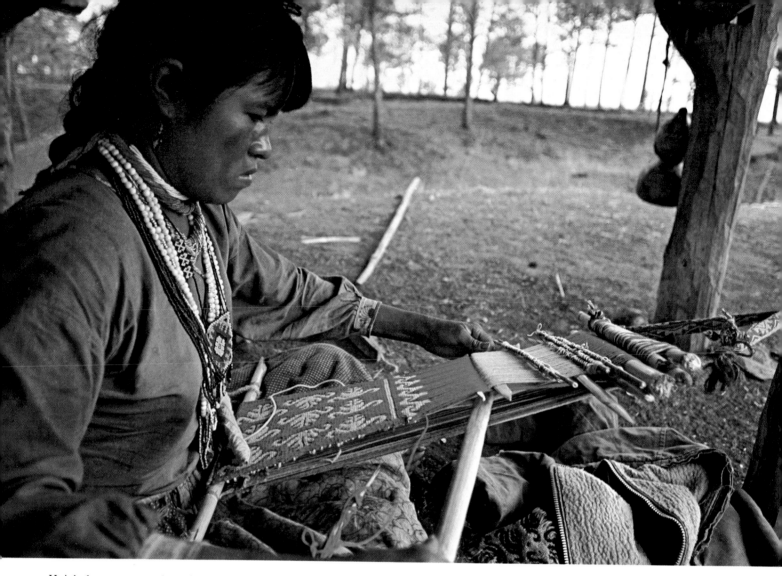

Huichol woman weaving with a backstrap loom. Photo: Kal Muller

version of the large, folk-art yarn paintings that in this context come full cycle from the sacred to the commercial and back again into the realm of the sacred. To the Westerner accustomed to the separation and even alienation of the artist and his or her work from the larger society, such full participation of so many people in the rendering of collective symbols that make up the sacred arts is a new experience.

Religion and the arts—the two are inextricably intertwined—can be properly understood only in their social context. For example, the ceremony called *Tatei Neirra* (Dance of Our Mother), which Lumholtz saw essentially as a celebration of the first fruits of subsistence agriculture, serves very important functions in the enculturation of Huichol children into the meaning of "being Huichol," and gains substantially in sociocultural significance and beauty if those functions are understood. And, as Barbara Myerhoff has astutely and sensitively shown in her book *The Peyote Hunt*, the Huichol peyote pilgrimage—itself a

work of sacred art in its most profound sense—functions within a larger social, religious, and symbolic context as a particularly effective means of social and psychological integration.

Cultural Diversity and "Being Huichol"

Because of the phenomenon of diversity within what we call "Huichol culture," we may usefully clarify the meaning of "being Huichol." The trained outsider cannot help but perceive that Huichol culture has many faces, that it is characterized by some heterogeneity, and that its different subsystems, no less than the different parts of the Huichol country, have become differentially acculturated, or have responded differently to the outside world. Even within the same *comunidad* or residential kin group, "being Huichol" obviously has different implications for the specialist in the traditional religious system—the *mara'-*

20

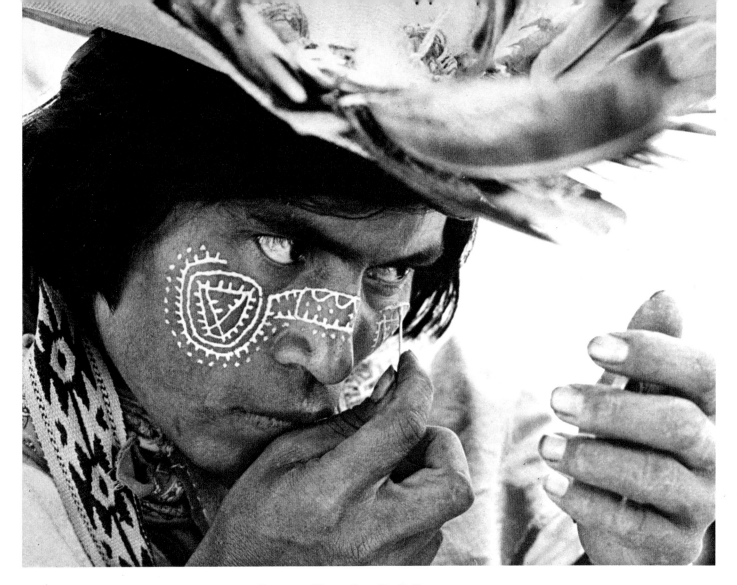

Lazaro Cardenas painting face with ground yellow root. Photo: Peter R. Collings

akame, or shaman—than for the passive participant or for one who has become somewhat alienated from the native culture and its values while outwardly continuing to adhere to some of its forms.

The danger exists that the investigator will become so engrossed in what may be local or individual, rather than generalized, culture phenomena that he takes them as typical for Huichol society as a whole. The observer's personal orientation, training, focus, methodology, and, especially, the personalities and motivations of his or her informants—all bear on the interpretation of the cultural reality and help shape the ultimate product of field research.

Not surprisingly, then, we find, at one extreme, impressions of a culture utterly mystical and spritual, as though each of its members participated equally in the rich symbolic world and mystique of the shaman. At the other extreme, the same society may emerge as little more than Mexican peasants in colorful dress, with a religion more

Catholic than aboriginal, but, in any event, not important enough to their own lives or sufficiently distinctive to deserve more than passing mention, and social, economic, and political institutions little different from those of the surrounding mestizo world.

Both extremes contain some truth. But each refers to only part of the cultural whole. In my own first published impressions of Huichol culture, for example, I took the intensely religious interpretation of Huichol culture of my informants to be a reasonably accurate reflection of how Huichols thought about the world and themselves. In fact, theirs was the idealized culture of the religious specialist. I also thought that the key to the remarkable cohesion and integrity of Huichol religion and ritual was relative isolation from the outside world through much of the time since the Spanish Conquest, and especially in the first two centuries before the end of organized resistance by the Cora in 1722. In fact, ethnohistorical documentation suggests at least sporadic interaction between the ancestral Huichols

and the colonial Spanish and other Indians on the fringes of the western frontier from the 1530s on, though never on the same intensive and sustained scale as that between Indians and Europeans elsewhere in Mexico.

We cannot realistically view the culture as a whole—or even any of its parts, including world view, religion, ritual, and symbolic arts—as "pure," in the sense that it represents the cultural condition at the time of first European contact. However, more than any other sizable, indigenous, Middle American population, the Huichols have successfully resisted the transformation of their religion, ritual, and symbolism into a mixture of Indian and Christian elements or aboriginal system with a folk-Catholic overlay.

This does not mean that the Church has made no lasting impression since the first missionaries appeared among the Huichols in the seventeenth century. A number of Christian observances have been incorporated, with major modifications, into the culture, but not, at least in the tradition-minded *comunidades*, at the expense of indigenous ceremonials that, if not purely pre-Hispanic, at least bear a strongly pre-Conquest flavor. Ceremonies of Christian origin, such as those of Holy Week, have added to rather than replaced the great body of traditional rituals. Christian deities and saints, often acknowledged and included in shamanic recitations and ritual drama even outside celebrations of Catholic origin, have not displaced but only augmented the indigenous pantheon.

We must also acknowledge that however "traditional" or non-Christian it may appear to be, the subsystem that comprises world view, religion, sacred traditions, and ritual is also a product of history, recent as well as ancient. It reflects not only actual pre-Conquest survivals but also their successive reformulation and reinterpretation. One would expect these to have occurred at different times and in different places—and with different degrees of intensity—both before and after the Conquest.

We know little about the pre-Conquest ancestry of the Huichols, but it must have included different groups, some with similar, others with distinctive cultural traditions.

The signposts point in different directions—the northern deserts, the Pacific coast, the frontiers of central Mexican civilization. The anthropologists Ralph Beals and Elsie Clews Parsons many years ago noted the similarity between Huichol and Pueblo ritual paraphernalia; to these we might add sacred architecture, for the circular Huichol temple appears strikingly like the great *kivas* of the American Southwest. Nor can we ignore the peyote pilgrimage, which annually takes small groups of devout Huichols on a three-hundred-mile trek along a route on which pueblos, hills, crossroads, springs, rock formations, cactus groves, and many other landmarks are known to the pilgrims by traditional Huichol names, regardless of their modern designations. The whole flavor of these pilgrimages is both magical and mythohistorical, with the strong suggestion that they are compressed reenactments of an ancient migration.

After the conquest of the Aztecs and other indigenous civilizations of Mexico, the Huichols came in contact not only with Spaniards, mestizos, and slaves of African origin, but with Tlaxcalans and other Indians transplanted to the frontier of their expanding empire by the Spanish. Thus, Huichol culture has been subject to considerable change, and it will continue to change. But it will probably survive, as Ramón hoped it would. However many Huichols will be taught to read and write, both in their own language and in Spanish, most young Huichols will continue to be enculturated as Indians, not as members of a larger society—at least in the foreseeable future. Like Ramón, they will assimilate what "being Huichol" means through active participation in a traditional world view and ceremonialism that are, by common agreement, accepted as uniquely Huichol, however heterogeneous the sources may appear to the outsider.

The Shaman as Artist

Ramón Medina was the grandson of a famous *mara'akame* and the brother of one of the few women shamans of some

prestige outside her own community. I first met Ramón in 1965 through his yarn paintings. Almost from the start, he seemed to embody much of what has been written about the shaman as consummate artist of his or her society.

In an essay in *Artscanada*, I discussed the origins, continuities, and characteristics of shamanism and the shaman as artist at greater length. Some observations from that article are pertinent to the personality of Ramón, in whose work, as in that of some other Huichol artists, widespread, typically shamanic symbolism of great antiquity survives to an astonishing degree. One symbolic form which appears is skeletonization, that is, the depiction of selected individuals or phenomena—shamans, sacred animals and plants, deities—in a kind of x-ray style. This convention of shamanic art goes back to the Upper Paleolithic and is also found in the recent sacred art of such widely separated peoples as those of the Pacific Northwest Coast, the Arctic, and aboriginal Australia. Once, as I watched Ramón lay out a large and complex wool yarn panel that depicted a shaman with his drum, I asked him why his shaman was skeletonized, with ribs, pelvis, and leg bones showing. Was he dead? "No," said Ramón, "that is so that you can recognize him as a shaman." And why is it done this way? "Because that is how it was established in the time of the ancestors." Not a very satisfactory answer, but not untypical. Skeletonization in shamanic or sacred art derives in large measure from the widespread belief that the bones are the seat of life, and that rebirth proceeds as much from one's bones as the life of a tree springs from the hard seed—universally called "bone" in Mesoamerica—contained within the flesh of a fruit. These concepts of the bone soul and rebirth from one's skeletal parts are characteristics of shamanic ideology the world over, as the historian of religion Mircea Eliade has amply documented.

Ramón also fits the norm of the shaman as artist in another way. Like many shamans the world over, he was a man of many gifts. Even after he could rightfully call himself a shaman and, more to the point, was recognized as such by other Indians, his drive for artistic self-expres-

sion could not accommodate itself to the economic and social limitations imposed by a primitive subsistence agriculture.

A superb reciter and singer of the sacred myths and songs, he was as skilled in the native reed flute as in the two stringed instruments of European origin—the violin and the guitar—that have become indispensable to Huichol ceremonial life. But he was also master of a more traditional stringed instrument, the musical bow, called the "bow drum" by the Huichols—the short Huichol hunting bow transformed into an instrument by tapping the bowstring with a wooden-tipped arrow and using the mouth as a sound chamber. The rhythmic sound of the bow, surprisingly pleasing to the ear, is considered to be sacred and to exert magical power on the natural and supernatural environment. On the peyote hunt, the bow drum is first played to alert the supernaturals residing in the sacred mountains of Wirikuta to the coming of the *peyoteros* and then to "transfix" the deer (the peyote in its animal manifestation) so that the shaman's arrows may reach their target.

The Huichols have also adapted from the Cora a more complex form of the musical bow: A shallow hole is dug in the earth and covered with a large gourd bowl; this hole serves as resonator for the bow, whose back is glued to the bowl or held down with one foot by the seated player, who beats the bowstring with two wood-tipped hunting arrows. This instrument, also called a bow drum, is more like a drum in that it serves only as rhythmic accompaniment to sacred songs and chants.

Ramón recorded both forms of the bow drum for us, as well as the rhythmic beat of the three-legged upright log drum which, though similar to the vertical drum the Aztecs called *huehuetl*, is known to the Huichols as *tepu*. The Huichol *tepu* is a vertical log drum with a deerskin head (see Plate 48). A great deal of shamanic mythology and symbolism is connected with the *tepu*, as with the bow drum. Only the *mara'akame* is supposed to play it, because Tatewari, the Great Mara'akame, made the first drum, taught its use and meaning to the divine ancestors, and

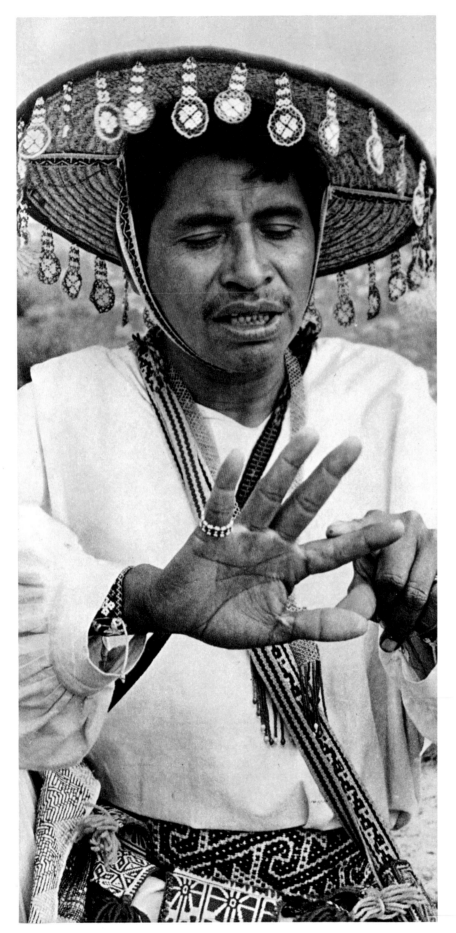

Shamans are frequently good actors, and Ramón was among the best. When the mood struck him he would act out the different characters and events of a story as he does in these pictures, taken as he played the parts of the two mythological archenemies, the sorcerer Kieri, also called "Tree of the Wind" (either *Datura* or the related solanaceous *Solandra*), who deceived the people into eating his hallucinogenic leaves, sap, and fruits, and Kauyumarie, the divine culture hero and Deer Person, the ally of the peyote cactus. In the end Kauyumarie wins the contest, killing Kieri with the fifth of five arrows. But Kieri is not really dead; he transforms himself into his plant form and flies away to live amid the high crags of the Sierra Madre.

"He was evil, this Kieri, evil. From the day he was a baby he was a deceiver, evil..."

"He danced before the people and deceived them, telling them he was good to eat. But he was not good, he made them crazy, so that they thought they could fly. But they could not fly..."

"You see, he was evil, evil. And Kauyumarie was watching him, seeing how evil he was. 'Ah,' he said, 'that Kieri is evil.'"

"Seeing how evil he was, Kauyumarie told the Sun god, 'I will learn all I can about this Kieri, this evil Tree of the Wind...'"

"And Kieri saw Kauyumarie, and whoosh, came an arrow and hit him in the right side. 'Ah,' he said, 'I am dying. You have hit me with your arrow.' But Kieri did not die. ...Another arrow, another, a fourth..."

"Whoosh, came another arrow, the fifth. And Kieri was hit in the left side, there, where the heart is."

"Pow. Kieri died, he fell dying."

"Dying, he spewed out sickness. Kieri transformed himself into the Tree of the Wind, his arms, his body, everything. He became the Tree of the Wind, living there on the rocks."

Photos: Peter T. Furst

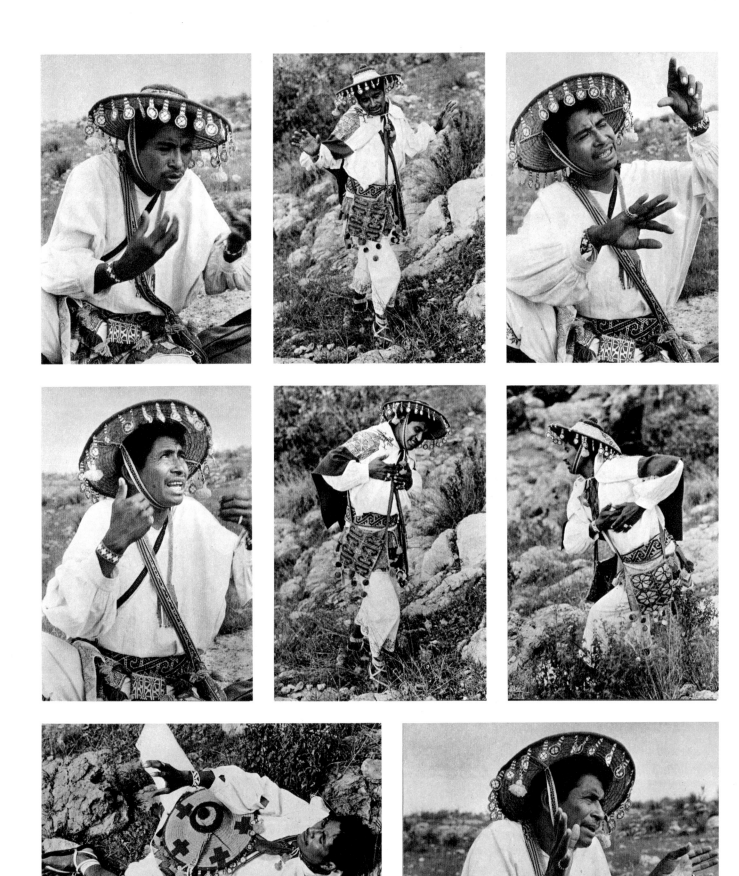

with its beat cured the sick children of the ancient Huichols.

Huichol drums do not conform in shape or overt iconography to those of Siberian or Arctic shamans, but they are certainly connected with the "breakthrough in plane." The drum's principal role is in the "Dance of Our Mother (the Drum)," when the shaman pounds it incessantly so that its vibrations may waft the children, as transformed birds, and their leader, the *mara'akame*, into the celestial sphere. *Mara'akame* and bird-children, guarded by the antlered Kauyumari as spirit guide, fly to distant Wirikuta, place of the divine Deer-Peyote, the very center of the world, to meet their divine Mother, the great maternal goddess of fertility and the sacred life-giving earth. This sacred drama, so crucial to the enculturation of children into "being Huichol," seems not to have changed substantially in form or content from its pre-Hispanic antecedents.

Like many charismatic shamans, Ramón was a consummate actor who enjoyed assuming the characters of the mythic past in dramatic performance. One of the first and longest myths he recorded for us in Huichol and Spanish involved a protracted combat between the antlered culture hero Kauyumari and the sorcerer Kieri. Kieri was either the personified *Datura inoxia* or the related *Solandra* (the narrative did not make clear which was meant). Both these plants are hallucinogenic, and both are propitiated with offerings such as prayer arrows, but actual use of the plant is considered by Huichols to be incompatible with the sacred peyote.

In the course of narrating the dramatic events of the myth, which take Kieri from birth as an "evil, ugly baby" through his career as a "false *mara'akame*" who misleads the people to his end in a hail of arrows from the bow of Kauyumari (who employs peyote to protect himself against the dangerous intoxicating exudations of his adversary), Ramón one afternoon took us to a steep hillside. Here he surprised us by acting out not only the principal parts of the two adversaries, but also the roles of men and women lured into intoxicating themselves with *Datura* (or *Solandra*), and even the peripheral role of a fox as messenger of death in the final act of the drama. The performance was unforgettable, particularly when Ramón pantomimed the death of Kieri in human form and his subsequent metamorphosis—for there is no death as we understand it, only transformation—into his botanical manifestation.

Finally, Ramón was the real innovator in the art of the yarn painting, transforming it, after only slight initial prodding from us, from haphazard assemblage of authentically Huichol, but functionally unconnected, sacred and decorative symbols (he called these purely decorative works *adornos*) into a story-telling device, a kind of picture-writing from which a sacred tradition might be recognized and recited.

He began this work some weeks after I had commissioned him to produce several very large and some smaller yarn paintings for the UCLA ethnic arts collection—the beginning of a long working relationship of mutual trust that was to last until his death, in 1971. We had already recorded a number of oral traditions in Huichol and his own Spanish translation when I asked him if he might not wish to try his remarkable skill as decorative yarn painter at depicting the events in the recorded myths—perhaps even in a whole series of paintings to go with a single story. He appeared to like the idea. Two days later the first of his original story-telling yarn paintings was born, one of four that translated the oral drama of Kauyumari and Kieri into two-dimensional form. The first depicted only the solanaceous plant; the second, the plant in both botanical form and its human manifestation as the sorcerer Kieri, shown in the act of bewitching a woman into thinking that Kieri, as "tree of the wind," was good to eat ("like tortillas," said Ramón in his narration, "like fat tamales, sacred tamales with deer meat"); the third, the antlered Kauyumari in his first attack on Kieri; and the last, the death and transformation of the sorcerer, who, even as he falls with five (the magical number) of Kauyu-

mari's arrows in his chest, spews forth streamers of colored sparks symbolizing illness and misfortune. The series came full circle, for at death, Ramón said, Kieri retransformed himself into "tree of the wind," as depicted in the first painting. "So you must pay me for five, not four," he said, only half in jest, for he was ever the resourceful entrepreneur. Since his customary price for an original two-by-two-foot yarn painting was rarely more than fifteen dollars, even the humorous overcharge would have been a bargain.

The Kieri series was soon followed by others. Over the next several years Ramón rarely recorded a sacred tradition or description of some inner vision for us which he did not also illustrate with one or more yarn paintings. Like many other artists, in response to growing demand, Ramón soon began to turn out variations as well as more-or-less faithful copies of the works of which he was particularly proud.

Today, looking back across the wealth of Huichol art in these pages and a dozen eventful years to that singular moment in 1966 when Ramón told us that we would never understand the meaning of "being Huichol" until we had gone on a peyote hunt, one realizes anew what a remarkable man he was, and how great the loss when he died—much too young—just before the coming of the rains in the summer of 1971.

Other artists—some as skilled as he, and one or two better craftsmen—have since achieved fame and, as such things are measured in the minimal world of Huichol economics, even modest fortune. But Ramón was the pioneer. He recognized before anyone else the potential of the yarn painting as a story-telling device, a means of recording and sharing in two-dimensional form his inner vision of events that to us are "myths" but to him were the real history of the people. Mythology, as we understand and use the term, would have been a meaningless concept to Ramón. When he recorded the sacred origin traditions of maize, of peyote, of deer, of the sun and the fire, he called them, in Spanish, *nuestra verdad, nuestra historia* (our truth, our history). What really happened—historical dramas with all their supernatural players—came alive when reenacted in the rituals of the crowded ceremonial calendar and in the symbolic arts in which Ramón excelled.

If Ramón sometimes straddled with less than equanimity the two contradictory worlds in which he moved—his own magical Indian universe and the modern one, with its material temptations and opportunities—he was nonetheless deeply committed to "being Huichol" and remaining Huichol. If he occasionally acted out his paradoxical existence (and, by extension, the paradoxical existence of all native Americans) in alcoholic conviviality, he was nonetheless convinced of the validity, uniqueness, and beauty of the traditional lifeway and the Indian world view.

The Yarn Painting in Relation to Sacred Art

Although we speak readily of an artist's "inspiration," we do not usually think of that word in its original meaning of infusing the being with spirit, the vital, animating force. In this sense, Ramón seemed to feel himself inspired whenever he began a yarn painting relating a sacred story or mystical event. I watched him many times before he embarked on a new work of art; never did he do so without some gesture, some mood, some sign of acknowledgment of his debt to the supernaturals for their aid in the design and its successful completion.

The sun—more correctly, the solar deity addressed by the ritual kin term Tayaupa—Our Father—played a special role in yarn painting, because sunshine was required to soften the beeswax to the proper consistency. On the other hand, Father Sun could not be too hot, or the wax would melt. So Ramón preferred working before noon, when the sun was warm enough to keep the wax soft but not so hot that wax would seep into the design and ruin the wool. One could say that these considerations

Ramón at work on his Guadalajara *rancho*, 1966.

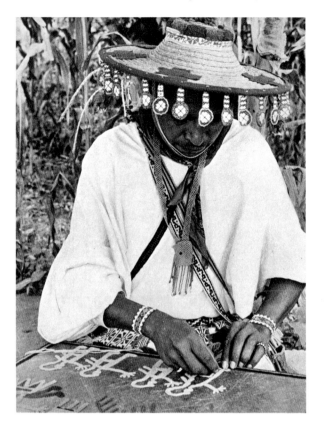

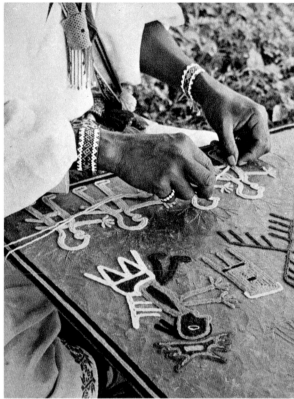

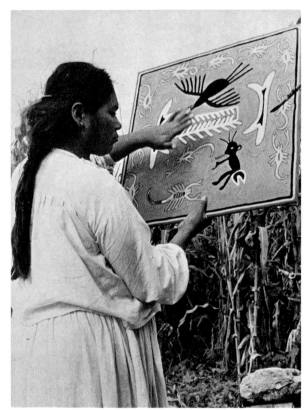

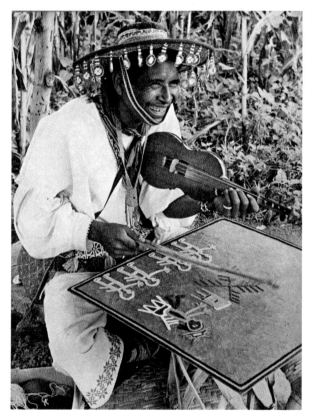

Top: Ramón preparing the base by spreading an even coat of beeswax mixed with some resin on the rough side of a composition board. The design was then scratched in with a screwdriver, after which he laid in all the figures and other details with double strands of colored wool.

Bottom left: Lupe, Ramón's wife, assisting him in filling in the background.

Bottom right: Feeling in need of relaxation or inspiration, he takes up his little homemade violin which he plays expertly.

Photos: Peter T. Furst

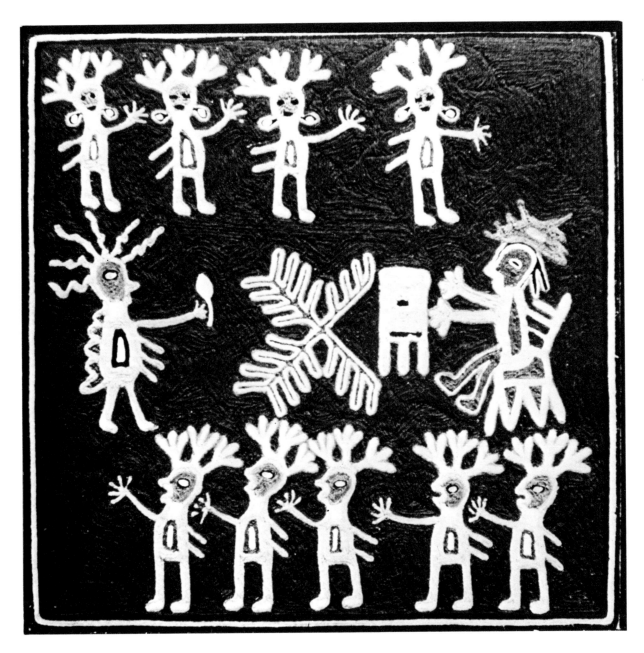

The completed yarn painting depicts Tatei Neirra, Ceremony of Our Mother (the Drum), in which the children are enculturated into the sacred peyote tradition and taught the sacred geography of the peyote pilgrimage and its destination. Opposite the shaman, his helper, playing his sacred rattle while the shaman pounds the drum. At top, little girls (identified by their ear ornaments), at bottom, little boys. Only children up to the age of five participate directly in this ritual. Photo: Peter T. Furst

were eminently sensible and practical, requiring no invocation of a mystical dimension. But Ramón was Huichol, and as such he had no need to compartmentalize the practical and the mystical. Solar power, wax, wool yarn, the sacred story, singing or dancing to bring inspiration to the work, a *copa* of tequila, perhaps, or a shared thermos of sweetened black coffee, the working relationship of patron to artist or anthropologist to informant-friend,

even the exchange of cash for the final design—all were interdependent, as much sacred as mundane.

Clearly not sacred was the fiberboard which Huichol yarn painters quickly learned to prefer to plywood because it did not warp. At times Ramón insisted on plywood, because something in the design was too sacred to be applied to a manufactured product. Plywood was also a product of industry but, at least, came from trees, which,

like people and animals, have souls. The machete, too, has a soul, because metal grows in the earth. But who knew what fiberboard might come from?

When I first met them, Ramón and his wife, Lupe, were living on the outskirts of Guadalajara, off the highway to Zacatecas, on unused land which they had unceremoniously appropriated (and from which they were eventually evicted). They had about an acre of arable soil, half of which they planted in maize and beans in the old manner, with the digging stick. Their shelter was the traditional one-room, windowless Indian house, constructed of whatever materials were at hand. At one end was a *niwetari*, a kind of altar of bamboo poles, where Ramón kept his ritual paraphernalia and a supply of peyote. His bow and a deerskin quiver full of arrows hung suspended from deer antlers—symbol of Kauyumari—and several other deer antlers, thread crosses, and ceremonial arrows were distributed over the four walls and stuck under the pitched roof.

Off to one side was a lean-to with an open, Indian hearth, and between house and kitchen shelter was a ramada of four poles supporting a grass- and palm-thatch roof, where Ramón customarily worked on his yarn paintings. In a small garden grew tomatoes, chili peppers, onions, and spices. All in all, their home was a traditional Huichol *rancho* transplanted from the Sierra to the city.

The little urban *rancho* was almost always host to other Huichols on their way to and from the Sierra; some would remain for a night, sleeping in the open by the fire, wrapped in thin, ragged blankets. Others might stay a week, until suddenly one morning they would rise and, as is Indian custom, simply announce their departure with some such words as "I go now," and walk off toward the distant Sierra, carrying baskets filled with the city's products suspended from tumplines across their forehead, or sacks of seed corn, or, perhaps, bolts of white *manta* cloth for use by their wives or sale to others. One day four Huichols arrived with bags of peyote and yarn crosses and other art for sale. Ramón found them customers in the city and prepared for an impromptu ceremony, complete with the traditional deer-meat soup, venison tamales, and a big jug of *nawa*, the fermented maize drink indispensable to Huichol ritual.

These "urban Indians," mostly skilled artists and artisans and their families for whom tourist demand provides some modest security, are an important feature not only of Huichol culture but of other regional Indian groups with marketable crafts. They are not a new phenomenon, the consequence solely of modern acculturation or new economic relationships. They were as much a feature of city life in ancient Teotihuacán (c. 100 B.C.–A.D. 700), the great city-state whose influence extended over much of Mesoamerica during the Classic period, as in Tenochtitlán, the Aztec capital, a millennium later.

The Sacred Nearika

The consumption of Huichol art by tourists, serious collectors, and museums has risen precipitously in the last dozen years. Thread crosses, in particular, have become so popular that even Maya Indians in Chiapas are making them for sale to tourists. But of all the products of Huichol taste and skill, none has more captivated the imagination of the art world than the "yarn paintings," especially Ramón Medina's, which, particularly since his death, have inspired a veritable flood of copies.

In recent years the yarn painting—i.e., a mosaic of colored yarn on a beeswax base, akin in technique, if not material, to the feather mosaics of the ancient Mixtecs—has come to be known as *nearika* (var. *nealika, nierika*). *Nearika* is a Huichol term applied to many kinds of ritual art, with or without figural representations, which embody within their overall function as communication with the gods a whole range of different meanings and associations. *Nearika* can be understood to mean likeness, face, aspect, image, representation, emblem, or, simply, picture. Lumholtz (1900) gave it the additional meaning of "front shield," to differentiate it from the *nama*, which he called "back shield," because in the mythology of the birth of the Sun

God, the Divine Mothers, then still in their animal form, wore such magical devices on their backs as protection against the unaccustomed heat of the sun. In its broadest sense, *nearika* would seem to fit the modern folk-art painting, so long as it is understood that, however sacred the sources of some of its subject matter, it is derived from, but in no sense identical in function to, several kinds of traditional sacred art of which the true *nearika* is only one. Not just the actual *nearika* but even the engraved or painted circular stone seats of the gods in the *tukipa* are to be counted among the sacred prototypes of the modern folk art. So may the ubiquitous decorated votive gourds, which are almost as common among the three-dimensional prayers of the Huichols as the arrow, and which are differentiated from the ordinary *hikara*, or drinking and eating gourd, by the ritual term *shukuri*.

As Lumholtz discovered, almost any object that symbolizes or represents the supernaturals in any of their forms can be a sacred *nearika*: masks; ancient rock carvings; the round, polygonal, or rectangular shields of interwoven splints and yarn, of which some types are virtually indistinguishable from Pueblo "squash-blossom" or "spider-web" (Spider Grandmother) designs; bamboo hoops covered with a network of yarn or strung with a single strand from one side to the other (representing the full and new moon, respectively); miniature deer snares or lassos; wooden boards or shields covered with wax figures or with string, colored crewel, or tiny trade beads; triangles of thin, painted splints suspended from a thread; full-size or diminutive hunting bows decorated with beeswax and glass beads or yarn; embroideries on cotton cloth (*manta*); crosses of beeswax decorated with coils of tiny trade beads; store-bought mirrors, by themselves or incorporated into sacred art (as, for example, symbol of the cosmic opening or the emergence hole of the gods, akin to the Pueblo *sipapu*), and so forth. Votive gourds decorated with beeswax representations of the supernaturals, with or without the addition of colored yarn or beads, likewise can function as *nearika*. The *nearika* need not hold a recognizable representation of a deity or his or her

associated symbols: Lumholtz illustrates a completely undecorated gourdlike object that hung, smoke-blackened, under the roof of the *tuki* at Santa Catarina. That object, too, turned out to be a *nearika*, and a very sacred one at that—the *nearika* of the heart of Grandfather Fire, Tatewari.

Nearika may be fashioned of any materials, in any shape or size, and for any of the many supernaturals in the crowded pantheon. One has the impression that more *nearika* are addressed as prayers or petitions to the sun than to any other deity, perhaps because the Sun God is thought to be somewhat arbitrary and capricious, capable of sending illness not only as punishment for some ritual lapse—any of the gods may do so—but for no apparent reason. Like the other supernaturals, and like shamans in their negative role of sorcerer, the Sun God sends illness by means of the arrow of sickness (the ceremonial arrow in its negative manifestation). Arrows, too, can function as *nearika* of the supernatural whose markings and colors they bear.

Nearika, then, come in many guises, but the most striking—and closest to the yarn painting as story-telling art—is the woven shield type which Lumholtz called "front shield" (see Plates 27 and 28).

Lumholtz has provided a useful technical description in his discussion of these ceremonial objects, which are generally flat but sometimes give the effect of a Japanese umbrella. In a general way, he writes, whether completely circular in appearance or polygonal, the ceremonial "shields" are made in accord with one principle, by interweaving radiating thin bamboo splints with cotton cord or variously colored crewel or yarn into a disk on which the god of the *nearika* and the animals, plants, and other beings with whom he or she is associated in the mythology are depicted, as naturalistically as the technique of interweaving will allow or in geometric abstraction. The larger the diameter of the disk, the more figures it will accommodate; some of the largest, which may reach more than half a meter, can be very crowded, indeed. The Pueblo-like "squash-blossom" or "spider-web" types of *nearika* are

made by a different technique, the end result being concentric circles of yarn in contrasting colors woven from the inside out over radiating bamboo splints, somewhat like the familiar rhomboid yarn cross, but with many more sides (from as few as six to as many as twenty-two). This type of *nearika* lacks figural representations, but its meanings are probably no less apparent than the others to the full participant in the Huichol culture. Both this Pueblo type and the shields may have a circular opening in the center, with or without an inset of carved plant material or a mirror, symbolic of the cosmic opening (in the earth or the sky, respectively, or both) or a window on the world. Through this opening, shamans and gods pass from one plane of the universe to another.

The *nama* type of *nearika* is always four-sided and usually, but not always, rectangular rather than square. One kind of *nama*, most often square, lacks figural designs, consisting, rather, of two layers of bamboo splints facing in opposite directions and tied together with bark fiber or cotton twine of alternating colors. The twines are so interwoven with the splints that the pattern on one side differs from that on the other. This type of *nama* merges conceptually with the *itari*, or "bed," of the deity to whom it belongs (see Plates 1 and 2).

The second and, for us, more interesting kind of *nama* is essentially a rectangular version of the circular or polygonal shields described above (see Plate 32). *Namas* of this type are filled with more-or-less naturalistic or abstract designs, very tightly interwoven with the splints, representing the gods and their associated symbols, or a supernatural in several different manifestations or transformations—for example, a divine Mother both as serpent and woman, or the deer as antlered stag and peyote plant. Sometimes the same deity may be seen in three or four different guises—as man or woman (or both), mammal, serpent, bird, cloud, plant, and so on.

As a rule the *nama*, like other kinds of *nearika*, is suspended from an arrow in the *tukipa* or some other sacred place (see Plate 36), the purpose being to "activate" the supernatural in behalf of the petitioner by depicting him

or her in as beautiful a manner as possible. The *nearika*, or likeness, of a being is shown to be as capable of action as that being itself. As Ramón explained it, "They are the same." One's *nearika* has the same soul, the same life force, as oneself. A god's *nearika*, be it mask, statue, painting, or even some identifying insignia or characteristic by itself, is that god.

Nama with representations of "fierce animals" can also serve as spirit traps or soul barriers; they can keep the soul of someone recently deceased from returning to his or her *rancho* to bother the living. The land of the dead lies to the west, and magical *nama*, or a special kind of thread cross called "jaguar," are placed on paths that lead in that direction. Huichols do miss their relatives, but the souls are supposed to participate in the rituals of the living only at the proper place and time. At other times they must stay in their proper abode, the underworld counterpart of the Huichol *rancho*, complete with fiestas, peyote, *nawa*, and a rich harvest, enjoying the chthonic equivalent of the good life that is the aspiration of all Huichols and the ultimate purpose of their artistic endeavor.

All *nearika* thus far discussed are made of perishable materials and, depending on their location, are destined eventually to disintegrate. One kind of "likeness," or *nearika*, of the gods is more or less indestructible—their stone "seats," called *tepari* (*tepali*), and the related perforated disk of the Sun Father that is placed as a kind of gable stone beneath the roof of the *tuki* or smaller *shiriki* (see Plates 6 and 7).

An integral component of Huichol sacred architecture, these "seats" are flat, round disks of varying size and thickness—the largest I saw measured some seventy centimeters in diameter. They are carved, like some of the three-dimensional images of the gods, from a soft volcanic stone or white tufa. They are often, though not always, decorated with abstract lines or figural representations of the god to whom they belong and with whom they are so completely identified that they actually become one with him or her. In his sacred cavity under the fireplace in the *tuki*, one always finds a *tepari* of Tatewari; another one is

often found over a second square or round cavity some distance from the hearth. The first excavation is the fire god's home deep beneath the earth; the second is the sacred emergence hole, the cosmic opening through which the divine ancestors, the Huichol gods, enter the *tuki* when summoned to council by the *mara'akame*, and through which they leave to return to their customary abodes. I have never seen a *tuki* without this sacred cavity, which is akin in appearance, mythic origin, and mystical function to the *sipapu*, the sacred emergence place of the mythological ancestors and the gods in archaeological and present-day *kivas* in the American Southwest. Like the gable-stone *nearika* of the sun, some *teparis* also have such a cosmic opening, or else a sacred hole is indicated by a carved or painted circle.

Several large and small *teparis* are usually found in the *tukipa*, some with, others without carved idols of Huichol deities. *Teparis* are also placed in some of the many niches below the roof line, and they are common also in caves and other sacred places. When not in use as seats of gods, they can be seen leaning up against the *niwetari* on the west side of the building, opposite the doorway, or against the low adobe and stone bench that, like the benches in the Great Kivas of Chaco Canyon, New Mexico, completely encircle the interior of the *tukipa*. I have also seen them lying near the pair of massive tree trunks that support the thatched, high-pitched roof.

Huichol houses today are mostly rectangular, but in the time of Lumholtz they were mostly round, constructed— as they still are—mainly of loose stones or wattle and daub, with sloping grass-thatched roofs. As sacred architecture, the circular *tukipas*, like the circular Great Kivas of Chaco Canyon with which they share many features, are really the former domestic architecture writ large— since the *tukipa* is the house of the gods (or the deified ancestors), who would not feel at home in unfamiliar surroundings.

But whichever version of the Huichol origin mythology one chooses, the *tuki* is obviously much more than just a larger, sacred version of the Huichol dwelling of former times. It is, in fact, the universe in microcosm—not just the house writ large, but the very Huichol world itself writ small. As the mythology tells us, the prototype of the circular *tuki* is the primordial council house of the gods, which Tatewari instructed the people to build after the transformation by fire of one of their number into the sun and the sun's subsequent birth from the earth. Because the young sun had traveled far and faced many obstacles in his journey from west to east through the underworld, he was weak and, instead of rising to his proper height, fell back upon the earth, bringing the sky down with him. Tatewari raised the heavens by placing four giant trees in the four corners of the world—one to support the sky in the west, another in the east, a third in the south, and a fourth in the north. That done, he ordered the people to carve a large stone disk and make a shaman's chair exactly like his own, so that the Sun God might travel from east to west across the sky without tiring and again threatening the earth with a cosmic conflagration.

That done, Tatewari instructed the people to build the first *tukipa*, so that the gods might hold council in their proper house. He walked in a circle to mark off the walls and ordered four trees to be cut and set in the four corners as supports for the roof. In the center of the *tukipa* he dug a hole on which he placed a *tepari* with an opening in the middle, and next to it the people, under his direction, constructed a rectangular hearth, beneath which he made a place for himself. When the gods assembled in council, the people carved for each his own *tepari*, which was also his *nearika*, his likeness. The "Little Old One," Great-grandmother Nakawe, the old earth goddess who is sometimes conceived as both male and female, likewise was given her *tepari*, her seat of stone. And because the trees of the sacred directions were also gods, Tatewari gave them each a *tepari* of their own. In explaining this tradition, Ramón insisted that a fifth tree—"the tree that reaches from the earth to the sky"—had been placed in the center of the first *tukipa*. But that tree could be seen only by the shaman, he said, because it was the hole through the *tepari* in the center of the *tukipa* and the

center of the world. Here Ramón spoke the universal language of shamanism, describing the world axis as cosmic opening through which gods and shamans travel from one plane to another.

The extraordinary significance of the *tepari* as sacred art, as the stone seat of the gods and as their *nearika*, their likeness and manifestation, cannot be stressed enough. Zingg is quite right when he insists that the so-called god disk, like the god's idol, "is the most sacred thing of all their rich paraphernalia, and is actually so treated."

With Aztec, Hopi, and many native American tongues of the southwestern United States and Mesoamerica, Huichol, Cora, and neighboring languages of the Sierra Madre Occidental belong to the far-flung Uto-Nahuan (Uto-Aztecan) family. In an earlier day of Huichol ethnography, the extrapolation from similarity of language to similarity of culture and symbolism was fashionable. In some ways the Huichols and their Cora neighbors emerge from the literature almost like "little Aztecs," their complex symbolic systems primitive relics of those of Central Mexico. They are not. But the rich symbolic worlds of these West Mexican peoples do contain important elements—sacred art and architecture, myths, ritual behaviors—for which analogies can be found not on'y in pre-Conquest Mexico but in the American Southwest as well.

Whatever else might be said or conjectured about Huichol ancestry, biological or ideological, it clearly lay astride the diffusion routes of peoples, ideas, trade goods, and raw materials of ritual and practical importance between the American Southwest, northwest and north-central Mexico, and the core areas of pre-Hispanic Mesoamerican civilization, and played some part in that diffusion. Conventional wisdom generally assumes a kind of one-way street from civilized central Mexico to the western frontiers and northward into the Southwest. But cultural diffusion proceeds in both directions, and it always involves more than material goods or technology. The traders who carried scarlet macaws and parrots from tropical Mexico to the Gila as early as the first century A.D. surely brought back more than turquoise: they transmitted ideas. One thing is certain: the peyote-centered component of Huichol religious ideology and ritual cannot have had its ultimate origins anywhere *but* the north, not only because the Huichols make their pilgrimages to the north, but because the sacred hallucinogenic cactus— focus of such intense emotion and so much sacred and decorative art—has no aboriginal or modern distribution other than the north-central desert, from San Luis Potosí to the valley of the Rio Grande.

Whatever its sources or external connections, however profound the transformations along its outer edges, Huichol culture is a precious legacy, worthy of respect and preservation. It is doubly precious because it is resilient enough to accommodate change without surrendering its vital center or even its external forms, and because it remains so unmistakenly—even flagrantly—native American in a larger world that becomes increasingly more uniform with each passing day.

Huichol Women's Art
Susan Eger, in collaboration with Peter R. Collings

Since 1975, I have had the unique opportunity of residing and working among the Huichol Indians of the Sierra Madre Occidental in Mexico. As research director for the Foundation for the Indians of the Sierra, an organization dedicated to channeling medical supplies and other aid to threatened indigenous populations, and as a researcher in Latin American studies at the University of California at Los Angeles, my work has been both scholarly and philanthropic. This paper is based upon the perceptions I have gained through experiences and personal friendships during this period.

Because for the most part I have been staying in and concentrating on only one of five Huichol localities, my observations will apply only to the Huichols who reside in the area in which I work. While on one level the Huichols are a homogenous tribe, there are regional differences, and what may be true of Huichols in one part of their vast homeland may be disputed or elaborated upon by those from other localities. Unless researchers are prepared to spend a great deal of time living among the Huichols, the ethnographic literature will remain superficial, fragmented and incomplete.

I hope that what I have come to learn about the Huichols in the short time I have lived, worked, traveled, and shared the pains and pleasures of their everyday existence with them will contribute to an understanding of this fascinating culture.

The Huichols: General Background

While no one knows exactly where the Huichols originated (they themselves say that they are the lineal descendants of the dog and the survivors of the "great flood" from which only one man and woman escaped), theories abound. The language of the Huichols, which is in the Nahuatl family, suggests a relationship to the Aztecs and their Toltec predecessors, as do some of the origin myths, such as that of the origin of the sun. Other evidence suggests that they came from coastal Nayarit, migrated inward, and severed relations with the tribes of which they were once a part. Perhaps they were nomadic, gypsy-like traders who later banded with refugees of the Conquest, all eking out an existence in any way they could after being forced to flee to their mountain refuge. No theory has been conclusively proved, but one thing is certain: the Huichols retain an amazing number of beliefs and practices prototypical of ancient Mesoamericans.

Even if we are still unable to' say precisely who the Huichols are, we can see them as a window into the past, a group whose culture reflects much of the knowledge lost to us today. Fragmented as it may be, what remains is both viable and applicable.

The isolation of the Huichols has been the source of their strength, stability, and survival. Because they have known stability and comparative peace over long periods, they have had time to explore their own minds and the natural world around them while building upon the discoveries of their predecessors. Like all cultures, they have experienced a general collective expansion of consciousness as they have become more and more attuned to the life, meaning, and order of the stable universe in which they live.

Their accumulated wisdom and the ways in which they have kept it alive and functioning in their culture can best be understood by examining their religion and art. To the Huichols, religion is not a part of life, it is life. Their art is a direct extension of their religion and it traditionally is made not from the standpoint of simple decoration or economic necessity but to give material representation to the most profound concepts of their religion. Traditional Huichol art, whether it be the striking costumes, the meticulously executed beadwork, the personal adornments, or the ceremonial objects, is beautiful not only from the aesthetic standpoint but from the psychological as well. Every stitch sewn onto a traditional Huichol item is symbolic of an entire belief system; the stitches are like aged seeds of thought that still flower to this day and bear fruit,

expressing, recording, and passing on to future generations the important religious concepts represented in these art forms.

Huichol art, then, can furnish insight into who and what the Huichols are, particularly as it relates to the common reservoirs of knowledge about the Huichol physical and metaphysical world. I shall not focus upon art objects but rather upon the creative forces, the motivation, which go into the production of traditional art, always keeping in mind that the art cannot be separated from the religion.

Huichol nonformal education from childhood on aims to release the creative impulse of individuals, and Huichol culture "conditions" its people, especially the women, to achieve mastery over their art forms, to develop a capacity to envision and create designs and color combinations. This conditioning might also be called enculturation, i.e., the process by which individuals achieve competency in their culture. The Huichols use their artwork as a means of coding and channeling sacred knowledge, insuring the continuity and survival of the legacy left to them by their pre-Columbian ancestors. Looking at the art thus we may come to understand just what knowledge is encoded in traditional Huichol symbols and how truly unique the Huichols are for possessing this knowledge.

If, based on superficial observation, one were to characterize the Huichol people, one might come up with words such as colorful, dignified, religious, intelligent, observant, subtle, curious, dedicated, industrious, resourceful, cautious, modest, conservative, skeptical, tolerant, patient, loving, attentive to children, playful, well-mannered, humorous, wise, fair, inventive, balanced, enduring, strong, shy. The Huichols are aloof yet down-to-earth. They exist on many levels, and learning to understand them can be very difficult. A hidden aspect seems to linger behind almost everything they do.

The various factors which influence Huichol upbringing and thought combine to create the content of the culture and daily lives of the people. An understanding of these levels of influence, or variables, will help toward an understanding of the framework of Huichol character and culture.

The first level is basic sustenance, to which all Huichols must direct themselves. Their survival depends on the success of their maize crop, used to make tortillas, their staple food. All Huichols are farmers; all put endless hours of strenuous labor into the planting, weeding, harvesting, and storing of their precious crops. The pace of their lives is contingent upon the agricultural cycle, which delineates their duties and obligations throughout the year. Survival, sustenance, keeping in balance with their environment, propagation of their people, and self-protection are necessities of life of which the Huichols must always be aware.

A second level of influence, invisible to us but very real to the Huichols, is the "other world," the realm of metaphysical existence, very demanding and potentially very dangerous if its demands are ignored. The metaphysical, supernatural, mystical realm generates the major part of Huichol behavior and belief and equips the Huichols with the character traits they need to survive in both worlds.

Because they are so pervasive, these traits can also be seen as a third level of Huichol existence. For example, their ever-present sense of purpose is demonstrated in an urgency they have about them, an intense direction that makes one feel as if they always have something very important to do. The Huichols definitely see the purpose in their lives, which enables them to reap the best rewards of the worlds in which they live.

A fourth level is seemingly boundless energy. They are motivated, energized, and able to accomplish physical feats demanding tremendous will power and endurance. Thus, they toil in their fields of work endless hours in the scorching sun to take offerings to sacred landmarks.

The fifth level that dominates Huichol consciousness is their intense awareness of and strong belief in the forces of life. The Huichols are astute readers of the book of nature. Though they are not scientists, their belief enables them to channel the forces of nature and put them to use.

The sixth level on which the Huichols can be said to

exist concerns goal orientation, charting and carrying out a course, learning the checks and balances of life, acquiring self-discipline in the pursuit of a higher aim. This pursuit of knowledge requires the observance of religious vows.

Finally, the seventh level of influence pervading Huichol thought is the achievement of completion and its inherent rewards. Achieving completion means reaching a position of esteem in both the physical and metaphysical worlds. Huichols can reach different levels of completion; as they see it, it is always possible to become "more complete," for the path of life always holds something better in store. Completion is something divine, and one can complete oneself from childhood to old age, in death and beyond. Completing oneself is identical with being Huichol.

Huichol religion is the common thread that runs through all of these levels, that provides the framework for the expression of these traits as an answer to all Huichol needs. It is an outgrowth of the necessity for survival in both the physical and metaphysical worlds. It insures that the rains needed for the crops will be controlled by the shamans, that the people will be protected from the dangers of the physical and supernatural worlds, that the sick can be healed, that many babies will be born, and that the culture will survive and be passed on. While taking care of all of the necessities of life, Huichol religion allows the other levels of the Huichol character to surface.

The High Priesthood in Huichol Culture

The pre-Columbian tradition of the priesthood is an important key to an understanding of the Huichols, because the most important aspects of the religion will also be the most pertinent aspects of the Huichol culture, the moving principle behind all that they do, the core of their existence.

The education and training of high priests—the *mara'-akame*, or shaman, who will insure the survival of the religion and hence of the Huichols—is the fulcrum of their culture. The knowledge transmitted is the very lifeblood

of Huichol existence, for the Huichols believe that were it not for the *mara'akame* they would not exist, they would be finished. This knowledge, safeguarded and passed down through the centuries, is of the highest esoteric nature. It describes not only how the physical world can be dominated by people to serve them in their pursuits but, even more importantly, how the metaphysical world can be tapped as a reservoir of strength and power. The Huichols see themselves as guardians and caretakers of this knowledge; they feel it is the reason for their being. They work meticulously and with dedication to preserve this knowledge and pass it down through the generations.

Thus, Huichol culture in an abstract way can be thought of as a kind of school for high priests, since its entire belief system and way of life is directed toward providing motivation for becoming a *mara'akame*, instilling the self-discipline required, providing memory training, and making the individual worthy of this exalted profession. Priesthood training and the profession itself require very specific tools, and the initiate cannot complete the path without them. The knowledge does not simply come down from the elders; rather, each person must learn it anew through the use of the tools of Huichol religion, the most important of which is peyote. And though the initiates gain the knowledge themselves, the culture provides them with teachers, guideposts, and reinforcements.

Peyote, a hallucinogenic spineless, mandala-shaped cactus growing in the desert in north-central Mexico, far from the Huichol homeland, leads all the initiates on their path to knowledge, to completion. Only through the use of peyote, the Huichols believe, can one become attuned to receive the knowledge, which one will in time transmit through the course of the priestly profession. It is the catalyst that takes the Huichols out of the realm of ordinary people and hurls them into the sphere of specialists— "technicians of the sacred," keepers of the knowledge. Peyote alone does not create this transformation; rather, the very nature of Huichol life works in every way to reinforce the mental framework needed for the initiates to

experience the expected visions. Huichol culture and religion create the atmosphere that allows the individual to tune into the peyote and attain the state of consciousness that will allow him or her to see and hear all that is required. The peyote enables the initiate to perform; the culture sets the stage by providing the mechanisms that reinforce, or "program," the initiate's peyote hallucinations. This programming allows the initiates to attune themselves to the "peyote knowledge," or, as the Huichols say, it attunes them to the *eeyahlree neeahrhi'tuahlri*—the heart of god which is lent to them while in the peyote state, the source of the *mara'akame*'s power. Since a large part of Huichol art takes its inspiration directly from the peyote visions, much of this discussion applies as much to the artisan as to the priest.

Peyote is omnipresent in the culture, hovering over most Huichol activities and occupations. In the ceremonies, it is used to help participants stay alert for three days and two nights, the time span of most ceremonies. The men use it to communicate with the gods, ancestors, and nature spirits who dwell in sacred caves, mountain tops, bodies of water, the sky, the underworld, and elsewhere throughout the Huichol cosmological realm, which extends from the Pacific Ocean in coastal Nayarit to the peyote desert in the east, to Guadalajara and Mexico City to the south and Durango in the north. Peyote is used by the musicians who play indigenous music on their handmade violins and guitars, and by all those who stay up to pray and dance throughout the ceremonies. It is used for controlling the rain, for curing, for blessing the people, for locating the deer and planning the sacred deer hunts, in the election of Huichol governing officials, and in many other ways. The women are given peyote for ceremonial purposes (when there is enough to go around) and also to enable them to work all night to prepare the food to be left as offerings to the gods and exchanged among the people at the end of the ceremonies.

Peyote is also used to ease the burden of strenuous labor, during the endless hours of walking to ceremonies or to visit the many sacred places and shrines throughout the Huichol homeland. Peyote plays a paramount role in the sacred deer hunts. It is used by the *mara'akame* to divine the presence of the deer, to set the date of the hunt, to predict who will make the kill, and to communicate with the spirit of the deer.

The annual pilgrimage to the sacred land of the Huichols, the peyote desert in San Luis Potosí, occupies an important place in the religion as well as in the agricultural and ceremonial cycles. The pilgrimage is much more than merely an annual religious event. No matter what the time of year, reference may be made to the journey and to the gods and spirits inhabiting this most sacred of all Huichol landmarks. Throughout the year, the ceremonies work to emphasize that those who make the strenuous journey are engaging in the most worthwhile of all Huichol activities. Indeed, the most prestigious and esteemed members of the culture are those who have partaken in the trip. Those who have been on a number of pilgrimages become the most exalted members of the culture; indeed, those old Huichols who have gone as many as twenty or thirty times are looked upon almost as living gods.

Peyote Visions, Shamanic Initiation, and Art

So much cultural activity revolves around the peyote and its annual pursuit that few aspects of Huichol life do not relate to it either overtly or subtly. The artwork, too, reflects the omnipresence of peyote. Peyote representations are the most numerous and varied of Huichol art (e.g., the *toto* flower motif), not only because of the symbolic significance of peyote, but because its symmetrical, mandala-like form lends itself to artistic elaboration, especially when envisioned in the hallucinatory state.

The following excerpts from a taped interview between me and a Huichol friend of mine who made some of the drawings reproduced here, a twenty-four-year-old man well on his way to acquiring his shamanic powers, should help clarify just how peyote teaches the Huichols what is

Top: Pen and ink drawing of *nearika* belonging to the Sun.
Center: Tatewari *nearika* belonging to the Fire deity.
Bottom: Hikuri *nearika* belonging to the peyote.

required of them during their initiatory period. Huichols are often given—or, as they say, "lent"—designs that pertain to specific gods or spirits and have definite functions that the initiate must carry out once they have been received.

My friend called these designs *nearika*, a word that has multiple meanings among the Huichols, all of which pertain to symbolic, sacred art *or* to a person's or god's face or aura. My Huichol friend answered my questions:

Q: You have made me a variety of drawings here which are very interesting. Can you tell me about them, please?

A: Yes. I saw these under the influence of peyote; the first time I went to the peyote desert these were my thoughts. Like this one [see illustration top], which is the *nearika* of the sun, who resides in Taupa.

Q: And how did it look?

A: It was very colorful and was moving, like it was wind, moving all about.

Q: And how many peyotes did you eat in order to see this?

A: Twenty-two. I began to eat them in the morning and began to hear many things, but it wasn't until the late afternoon that I began to see the designs.

Q: What kinds of things did you hear?

A: Only what the peyote was telling me. They were like songs.

Q: Who spoke to you?

A: Surely it was the peyote, surely it was god who spoke to me.

Q: Did you see a person or animal?

A: Yes. It was a deer who spoke to me and told me these things. He said that he was going to teach me to be a *mara'akame*, to cure, and that he was going to teach me all of the *nearika* that he had, to see which ones I like, and that he was also going to lend me the other things I need [the bracelets, the sandals, and the face painting, all invisible] so that I might be able to com-

plete myself in six or ten years. He told me that if it appeals to me, if I can endure, he would show me all of his *nearika* and teach me what each of them meant.

Q: And this is one that he taught you?

A: Yes, the deer taught me this when I was in *peyotado*. It is the *nearika* of the sun, and the deer taught me how to make it because the sun wants me to take it to him, in Taupa. I will make this *nearika* and take it there, just as he explained to me. He told me that the other people don't know how to make it well, and for this they must come to the peyote desert in order that all of the gods that are there can explain what they want, can teach the people how to make the things, so that the people can know. Here is another *nearika* [see illustration center] that the god of fire [Tatewari] taught me when I was under the influence of peyote, to see which one I like. Not all of us see the same things, all of the *nearika* we see are different, we don't all see alike. This is the one given to me by Tatewari, and it was a mountain lion, the one who lives there with him, who gave me this.

Q: How do you know whose *nearika* it is?

A: With the peyote, each one says, "This is my *nearika*." Whether it be the sun, the fire, the deer, the mother of the corn, they all say who it belongs to. The peyote also has a *nearika*, several of them [see illustration bottom]. The peyote *nearika* are very colorful and pass by often, many of them, and there is no explanation to them like the rest of them. They just go passing by, passing by, all moving, getting bigger and smaller all of the time. Many animals and beautiful snakes also appear and pass by, without any explanation.

Q: You said that you ate twenty-two peyotes, but if you ate less would you still see all of these things?

A: Yes, if you want to see things and if god gives you permission, you will still see things, if you eat as little as five big ones. A very strong person who has taken a lot of peyote still will need about twelve in order that his heart may begin to see things.

Q: When you were given many *nearika* to choose from, did you still remember all of them afterwards?

A: Yes. I remember all of them very well from that time and have completed what I was told to do with the ones I chose.

Clearly, peyote is the bridge between worldly and supernatural knowledge, and the Huichols think very highly of the knowledge they receive in the peyote state. Most important, they remember it and can retrieve it for future use. This fact is of particular interest with regard to art production, especially as it concerns the color combinations and geometric designs so suggestive of hallucinatory imagery. The ability to recall exact details of this dreamlike state is of extreme importance in the preparation of the *mara'-akame* and requires strong, well-trained minds. In Huichol nonformal education every attention is paid to orienting the children toward the future use and appreciation of peyote.

Learning the Huichol Culture: Children, Peyote, Ceremonies

Probably every Huichol child whose parents follow the traditional way of life receives its initial dose of peyote through breast feeding; thus, Huichol nonformal education begins in infancy. Nursing mothers are required to partake of peyote if they or their husbands are active members of the community, participating in the civil-religious hierarchy. Not uncommonly, newborn babies are taken on the pilgrimage, to the ceremonies, and to the sacred Huichol landmarks, especially if the parents wish to start their children onto the "Huichol way" early in life, rather than wait for the children themselves to take the initiative. When a child, regardless of age, is exposed to the traditional religion, he or she also becomes acquainted with peyote.

Numerous ceremonies, whether on the family, *rancho*, or community level, celebrate infants and children. Family

The first designs taught to children. The eight-pointed stars and repetitive peyote or *toto* flowers in these typical examples of children's embroidery are made by girls around the age of seven.

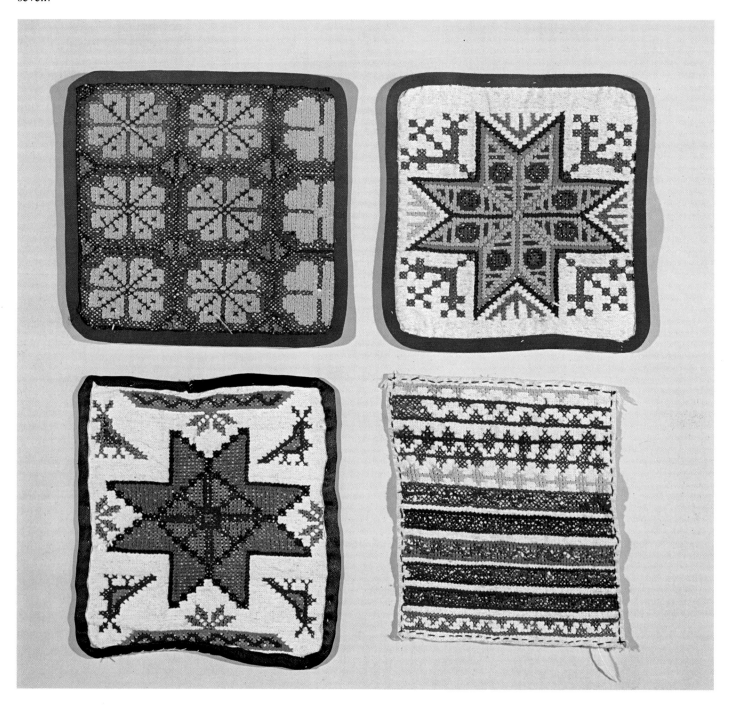

ceremonies may include baptisms, wherein a Huichol *mara'akame* dreams the child's name, anoints him or her, and performs various rituals and blessings welcoming the child into this world. *Rancho* ceremonies are performed to heal sick members of the extended families or to insure good crops, or when a *rancho* member sacrifices an animal to insure protection for himself and the family homestead in the process of completion.

During these ceremonies children and babies are loved and coddled and receive much special attention from the shamans, who bless them and sprinkle them with sacred water from sacred Huichol landmarks. Community rituals include ceremonies for planting, rain-making and rain-stopping, elaborate rites preceding and following the peyote pilgrimage, the installation of new civil-religious officials (held both annually and every five years), and the celebration of the first fruits (called the ceremony of the drum, it centers on the children). All are important means of imbuing even the very young with a strong awareness of their culture.

Parents are obligated to bring their children to the ceremonies, particularly the drum ceremony, to insure their protection against the supernatural forces and animals which threaten the life of every Huichol child. Adults who have civil-religious obligations (called *cargos* in Spanish) may attend as many as twenty ceremonies a year, accompanied by some or all of their children.

These ceremonies are not just informal gatherings of people; rather, they are like dramas where the behavior of the major participants is specifically assigned to the role, or *cargo*, they occupy in the religion. These ceremonies are formal, ritualized reenactments of Huichol history and religion. The behavior thus becomes an acting out of Huichol oral tradition—particularly on the peyote pilgrimage, where participants actually assume the identities of the Huichol pantheon for the duration of the journey, which may take as long as two months. The other ceremonies, although not so strict, are also designed according to a master plan, based in antiquity, which specifically delineates the roles and duties of the various participants. Like living codices, the Huichols transmit their sacred knowledge in this way, acting it out in a form intelligible only to other Huichols.

After five to ten years, the male child will begin to recognize the various roles and their corresponding duties, and the ceremonies will begin to make sense. He sees his father making offerings and prayer arrows and performing his ritual duties, and he sees his mother making beautiful beaded gourd bowls to be left as offerings, and preparing the soup and all the other ceremonial foods for the gods. After a while, when he begins to understand what is going on and what is expected of him, he, too, will be given small tasks and roles, such as dancing in ceremonies or participating in a deer hunt or peyote pilgrimage.

Through their observance of and participation in the ceremonies, children come to understand the sacredness of peyote and learn to esteem it at a very young age. Most children, although given peyote to taste and to play with when they become curious about it, do not actually consume it in doses large enough to produce visions until at least eight years of age. But because of the frequency with which the children attend the ceremonies and watch the performance of ceremonial duties, by the time they actually do partake of peyote, they are sufficiently clued in to be able not only to experience prototypical, expected visions but to interpret them with some degree of accuracy and to remember their significance. As soon as they are given responsibilities in the religion, they begin teaching their younger siblings. Children can begin their training toward the priesthood at the young age of ten and, if they stick to it, be fully initiated *mara'akame* by the age of twenty.

Huichol ceremonial life is of undeniable importance to the education of the child into the peyote tradition and to his eventual candidacy for priesthood. From the time the child is forming in the womb to long after death, when survivors seek communication with the person through rock crystals believed to house the soul, a Huichol's existence is surrounded by constant reminders of the impor-

tance of the high knowledge which must be acquired, applied to daily life, and passed on to future generations. Providing the incentive and stimulation for becoming a *mara'akame* and pursuing the peyote customs not only insures that a large number of Huichols will enter into this exalted profession, but guarantees that the "tools of their trade," the peyote, will always be available to them in their quest for this very special knowledge.

Shamanic Initiation

Because of the intensive exposure to the metaphysical aspects of life that occurs within the Huichol culture on such an organized, positive, reinforcing level, more than two-thirds of Huichol males over the age of eighteen are either fully initiated, or well on their way to becoming, *mara'akame*.

Among the women, the number is much smaller; female shamans are rare. Women do not ordinarily train to become *cantadoras* (singing shamans), although some do cure in their own families and *ranchos* and can perform many of the complex, special rituals. These women are most often married to *mara'akame*.

But the intensive ceremonial life and orientation toward attaining a state of higher knowledge that induce men to pursue the shamanic path also strongly influence what women do with their lives. Thus, while women generally do not become *mara'akame*, they can take a path toward completion, and this has to do with their artwork.

In the taped interview which I quoted earlier, my friend also describes some of the duties and obligations of the initiate and the attitude with which he must approach this long and difficult process. We can see the strong reliance the initiates place on the peyote for obtaining their direction and knowledge. Part of the shamanic paraphernalia that the initiate will start to accumulate as soon as he begins his training and will use throughout his life in his profession is also described when my friend speaks of the *tlackwahchee*—the oblong basket holding all of the power objects.

The *tlackwahchee* is what is used by the *mara'akame* for his power to be able to communicate with the spirits and gods. There are many things inside: his *muvieris* [feathered wands, with each individual wand sporting a pair of feathers from specific birds that have specific powers]; his *nearika* [in this case meaning a circular disk with five holes, each hole representing a different direction and place on the Huichol cosmological map]; a mirror, also called *nearika*, which is used to see where the gods are and also bad people who want to rob him of his power; tails of various snakes and reptiles which he uses for his power; arrows to guard over him and his *tlackwahchee*; spines from the *haikutzee*, the big round cactus that grows in the desert, which are used to give him courage with all the gods he meets there; and many many more things that he will use when he goes to visit the gods and presents them with his *tlackwahchee*.

As soon as the person knows that he wants to be a *mara'akame*, even if he dreams this as a child, he will begin to make his *tlackwachee* and to fill it with these objects. He will gather *muvieris* from all the places of the gods, bring them from all the different places, and put them inside, all the time thinking about how much he would like to know how to cure. He also makes his own *muvieris* to leave at those places, and takes another from there and puts it in his *tlackwachee*. In one place that he might like more than others, if there is a mirror there, he will take this mirror for himself to guard him against bad people. He will also look for an eagle, which he will kill and use in his *tlackwachee*, and all sorts of things he will seek out and find.

Afterwards, he'll go to the shaman and say, "I want to become a shaman, a healer. Is it possible that I may become this? Is it possible that the gods will give me courage, the spirit that I need in my heart?" "Go ahead," says the *mara'akame*, "but first you must do this. You must fast for five days, so that you can go with a god, and at that time he will lend you the spirit, he will put

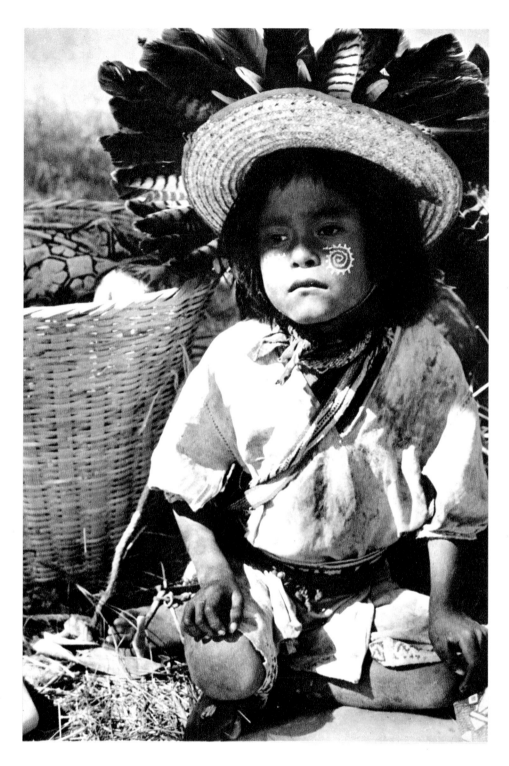

Huichol child.
Photo: Peter R. Collings

it there, but you must go back every year for five years and do the same thing, every year. The next time that you go there you will say, "I want to be a *mara'akame*, I wish to have the *nearika*, will you give me permission?"

But you must do this for five years, every year, and after five years you still don't have the knowledge that you seek. Because of this people often make the mistake of giving up after five years, because they say, "Five years have passed and I still know nothing. I'm not going to be able to sing, to cure. I know nothing, not

even a little bit. Maybe it would be better if I quit. I'm going to go after a girl now, that girl who is walking close here, I'm going to make love to her." But if he does that, he will betray himself and lose it all. He does not realize that it is only in the beginning of the sixth year that he will be able to cure, to see in his dream what the person who is sick has, and how to cure him. But this comes only after the sixth year and onward, six, seven, eight, nine, ten years after he has started. This is how they learn to become *mara'akame*, and

while learning they don't know anything until the sixth year after they've begun.

But with the peyote, it is quicker to learn. If I go to the peyote every year, every year for four or five years, with my only thoughts those of becoming a *mara'akame*, thinking only of this, at night dreaming only of this, then I may learn sooner. But you have to want this in the same way you might want a woman, thinking, "Oh, how I want this woman, if she were only mine, how I love her" You must want to become a *mara'akame* in the same way, but of course during this time you may have no woman at all, except if you are married, and at times you may not even have your wife.

But you must not think of anything else other than becoming a *mara'akame*, nothing else. And if you do this, then god will see you, look at you, hear you, and he knows all. He will test you to see if you can bear so many years dedicating yourself only to this, give you tests to see if you pass. He will tell you that every year you go to the peyote desert, from the time that you leave to the time you return you may not eat salt, for five years you must do this.

When you go to the peyote desert, thinking only of becoming a *mara'akame*, you will eat the peyote and speak to the deer [the deity who is the intermediary between the Huichols and their gods] and say, "I come here to learn how to be a *mara'akame*, I think only of this. I don't know anything, but what do you know? They say that you are god, the heart of god [meaning the peyote], and that you know everything. I come here, maybe it is because I am a bad person, maybe I talk too much, maybe I do not work too well, but you know who I am, you know what I am because Tatewari has seen my heart and he has purified me to come here and speak to you. I cannot hide anything from you. I am only a poor man, but I come so that you may teach me something."

Speak to the peyote with your heart, with your thoughts. And the peyote sees your heart and then you can eat as much as you want, with total confidence you eat it, without fear you eat five, ten, fifteen, twenty, it doesn't matter. And you sit there thinking, what will I see, how will it be? But in a little while you lose all of your thoughts, and then in a little while you begin to see and hear beautiful things, moving, beautiful things, *nearika*, and you don't move, you just sit there watching, like you are at the movies. And if you have luck, you will hear things, and receive things that are invisible to others, but that god has given you to pursue your path.

Thus we see that the training is rigorous, demanding self-control, humility, dedication, and personal sacrifice, in addition to concentration, memory training, and strength of will. The accumulation of shamanic paraphernalia of the *tlackwahchee* requires years and years of traveling about the Huichol homeland, and a good deal of luck, to locate the numerous power objects in the mountainous and precipitous terrain. This is one of the main reasons that women rarely become shamans; it is just too difficult a task for a women with children. However, even if women seldom attain the status of singing shamans, they do become curers. The objects in their *tlackwahchees* are different from those of the men; they include a variety of beaded gourd bowls which serve as a woman's main source of power. A woman's training is much the same as the man's, particularly when it comes to leaving offerings and visiting the various gods and spirits. Women must also acquire animal and natural objects during their training, and, like the men, they must establish rapport with the peyote, which they consume in equal or possibly slightly smaller quantities. Women must also partake in the ceremonial exchanges of alcohol and *tesquino* (the maize beer made for the ceremonies) as part of their *cargos*.

Women's Religious Paths

Another reason for the rarity of women shamans is the very clearly demarcated division of labor between the sexes which specifically delineates the areas pertaining to

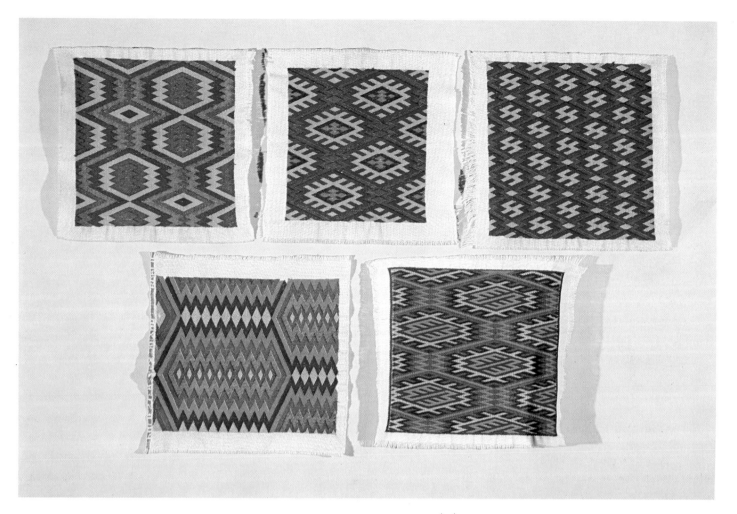

Embroidery employing the running stitch to create geometric and lattice-work patterns, inspired by the artist's dreams and hallucinations. The women who have "completed themselves" in the Huichol religion seem to have the most success in creating these patterns.

each sex. Religious acts such as ceremonies, prayers, chants, the sacred deer hunt, rain-making, temple reconstruction, music, dancing, and the peyote pilgrimage fall more within the realm of men, although women can and do participate. Home-based operations—especially food preparation—and all the connected labor—for both the home and ceremonies fall into the woman's realm. The division of labor outside of ceremonial life is much less clearly defined, with men and women frequently helping each other out in the fields and in economic activities, but the complementary roles of women and men in religious life cannot function independently of one another.

The duties and obligations of the shamanic quest are so intense that the effort must be a joint undertaking of husband and wife. Thus, if a man is married, obligations will automatically be placed on his wife. For example, when a man is given a *cargo* in the temple in recognition of his striving upward toward completion, his wife is also given a *cargo*, or at least a multitude of obligations, which she must perform with complete dedication. While the men lead the ceremonies, the women stay in the background, preparing the food to be consumed or left as offerings during the three days. They participate in the prayers, blessings, and other male-dominated activities only at intervals. When a man finally does complete himself, the woman shares his glory, because she helped him to attain it, and she is appreciated and esteemed.

But the religious path of the Huichol woman offers more

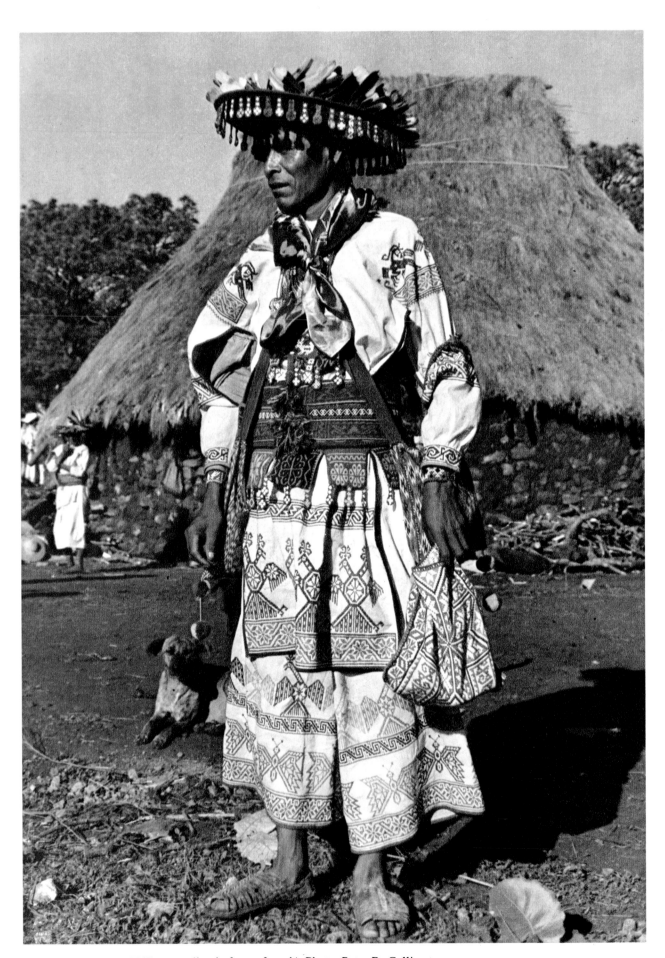

Antonio de la Cruz Philipe standing in front of a *tuki*. Photo: Peter R. Collings

than standing in her husband's shadow. If she desires, as a great many women do, she can set out to excel at various crafts, to become an expert at emrboidery work, weaving, and beadwork—a master artist. This is believed to be the destiny of every "good woman," as she will learn to bring the powers of the supernatural into her artwork and life.

Women are highly esteemed in the culture, and a good deal of respect is paid to them, particularly those who have completed themselves. "Good women" are not at all hard to find among the Huichols. They lead well-rounded lives and try to do whatever they do well. They live contentedly in their modest surroundings and find much fulfillment in their lives. Their religion gives them a strong sense of purpose and provides them with the motivation to persevere and excel in what they do. Hence, they excel in the arts, because they produce art not only for the sake of art and economics, but for the sake of preserving their collective cultural knowledge, thereby completing their destinies as Huichol women. And although a Huichol woman's artwork is a skill which she employs for the economic survival of her family, it is also much more. It is the vehicle through which she can follow her religion, one of the most important activities she can engage in on behalf of herself and her people. To the Huichols, religion is survival; to the Huichol woman, artwork is a means of practicing her religion. Therefore, though a Huichol woman may love the gentle little forms of nature and the beautiful designs she creates, she does so not just because they look pretty and are marketable, but because they are extensions of herself and her people which need to be created in order for her to survive.

Why do some women know so very much more than others? While my guess would have been that it is simply because some people are more gifted than others, a Huichol might disagree. The reason one sister may be so much better than another or a daughter may do better work than her mother is that some women work to complete themselves and others do not. The woman who sets out on this course, a course that strongly parallels the path of initiate

shamans, is believed to derive her artistic creativity and inspiration from a "divine" source, which, as in the case of the men, actually "lends" her this power. A woman must undertake this path with complete dedication, just as the men commit themselves to their paths. The most dedicated women do not sell any of their work from the time they begin until they have attained completion—a period of from five to ten years.

Lumholtz (1900) made reference to the fact that women, like men, leave offerings for a variety of reasons. He seems to overlook the fact that these offerings are not always left at random, when the women wish to make special prayers, but as requirements on the women's paths to completion.

My male Huichol informant elaborated upon these offerings and the path that women must follow in order to become divinely inspired in their handiwork:

Q: What kinds of offerings do women leave, and why?
A: They use an arrow, with a little piece of cloth on it that has a small man or woman stitched onto it. When the women are just beginning to learn how to embroider, they use these for good luck. . . . Like my wife, who right now is sitting here idle because she is sleepy and doesn't feel like working. When they are like this they take these offerings and leave them, and then afterwards they work really well, they aren't tired or lazy, and love to work. Then they begin to work really well.
Q: And if a young girl wishes to learn how to embroider, how to weave, or to do the beadwork, at what age will she begin to leave the offerings in order to learn well?
A: At ten years she will begin to take arrows with a small piece of embroidery attached to various places, wherever she might happen to visit. Then after five or ten years she will finish, and at this time she will be able to sell her things, but not before. If she does not complete herself and sells her artwork, she will lose the knowledge she has in her heart, and when she

tries to make something, she will no longer know how to do it well. There is also the danger of her going blind if she begins and does not complete herself.

Q: And is there a place that is only for women, where only women go to leave these offerings?

A: No, all the places are for both men and women, but there are some places where women can specifically go to leave offerings, along with their husbands, that will be more beneficial than others.

Q: If the woman wishes to complete herself and become a good artist, does she have to complete herself in the same way that a man does when he desires to become a *mara'akame*?

A: Yes. She has to take her offerings to the various places the same way the men do, but, even more than just leaving the offerings, she must also be faithful to her husband. That's why most women don't begin to do this until after they are married, even though they could begin from ten years old onward. If she begins this path as a single person, she must remain single until she completes this path, otherwise she will lose all that she worked for. Once she gets married she usually begins, because the two of them have to be completing their individual paths together, without other men and women, for five to ten years. If they change husbands or wives, or if one makes a mistake, then their work is valueless, they get sick, they die, or the gods make them pay every year with their animals, which they must sacrifice as a fine.

Q: You have told me before that when a man is learning to become a shaman, he must sacrifice a bull or a sheep every other year, or when the *mara'akame* tells him to in the course of his apprenticeship. Is this also true of the woman who wishes to do her embroidery well?

A: Any person who is trying to complete himself must sacrifice an animal, so that the blood can be used to anoint the offerings which will be taken to the sacred places. When the husband kills a bull, the wife too will anoint her gourd bowls and candles, which she will leave as offerings. The husband kills the animal when the *mara'akame* tells him to, and the husband and wife do this together, make the ceremony together. Later on, after the wife completes herself, if she is earning a lot of money selling her work, she will be asked to give a calf or bull for the ceremonies. But the women and men complete themselves together, they are equal.

Thus, a woman who wishes to complete herself enters into a joint venture with her husband; together they prepare their offerings and deposit them in the sacred places. When the wife must stay home with the children, or if they do not have enough money to allow both of them to go to the peyote desert, the man will leave his wife's offerings for her. The woman also provides the man with any help she can in his path to completion, but becomes even more important to him—especially in the economic sense—after both have completed.

This joint venture of men and women is visible at the site where offerings are left. Those left by women to obtain luck in their crafts are put alongside the men's in special places the gods inhabit or visit. Clearly, the Huichol religion is very well structured to accommodate both men and women in their individual quests, while at the same time solidifying and balancing the relationship between husband and wife so that each can contribute to and grow within it. The individuals take the initiative in their self-completion, each working hard, coming to terms, and developing rapport with the gods and forces of the universe, and making personal sacrifices in their aspirations toward a higher aim. Each person must do the work for him or herself, yet at the same time, each is also doing it for the other.

Thus, in this mutual learning and growing process, there is a constant interaction between husband and wife which is very important when it comes to the esoteric knowledge each is exposed to in the course of fulfilling what is required of them. While the husband is becoming attuned to

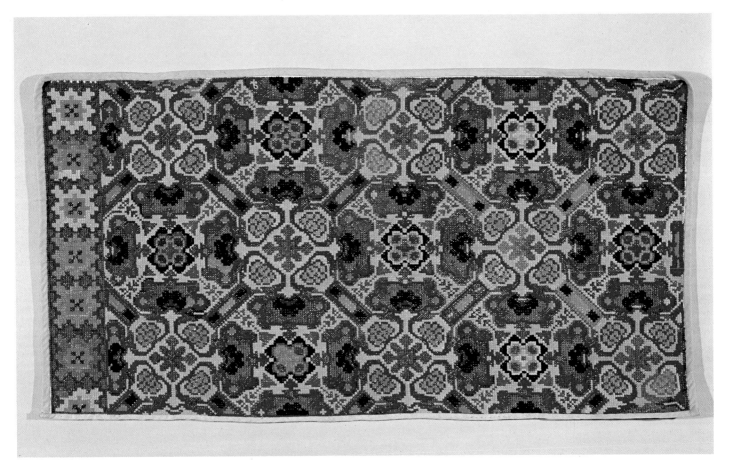

The cross-stitch, the most common stitch in Huichol embroidery, is here employed to depict a vision the artist "saw with her heart."

the secrets of the physical and metaphysical worlds, his wife is his confidant, his witness. She, too, is required to learn certain things, and she does this in the same way as her husband, through the use of peyote, often ingesting it with him, as required by the ceremonies. The knowledge each receives in the course of completion comes from the same source.

Religious Knowledge Encoded in Art

The fact that the knowledge a woman receives in the course of her initiation is on a par with that received by initiate shamans is of paramount importance in considering the significance of her designs. Women who have completed themselves on this path will use their art forms as outlets for their esoteric knowledge. Even if a woman's

knowledge is lacking in some areas which pertain only to the men, and is in some ways incomplete, the knowledge she acquires through her personal communication with the deities that pertain to her, and the realms of knowledge which open up to her as she witnesses and interacts with her husband on his quest, are sufficient to increase and enhance her design inventory and her knowledge of the symbolism.

When a woman embarks on her path toward completion, she aspires not only to become skilled in the execution of the crafts, but more important, also to attain the knowledge that goes hand in hand with these crafts.

For example, in the course of their initiation, male shamanic aspirants must acquire precise knowledge of the animals and plants in their environment and of their physical and supernatural uses and powers. In order to derive the maximum amount of power in their future shamanic professions, the initiates must form alliances with countless

birds and animals to gain their powers long enough to become familiar with their magical and mystical qualities. Specific animals have specific powers. Thus, the feathers of certain birds are of utmost importance in bewitching and healing, as are certain serpents and reptiles.

The initiates acquire the powers of these animals by locating them and, in the case of birds, eating the heart and keeping the tail feathers, or in the case of snakes and reptiles, cutting off the tail and sucking the blood from it, setting the animal free. The alliance between the initiates and the animals must not be broken for five years, or until the initiate has encountered this animal and performed the ritual five times. If the alliance is broken before that time, the animal will cause serious harm to the initiate and his family. Once these snakes and reptiles are allied, however, the initiates will possess the full powers of these animals forever. Even poisonous snakes can be picked up and held once the alliance is made, or so my informants tell me.

Like male shamanic initiates, the woman who completes herself knows so much more than other women when it comes to the interpretation of the designs because her "training" requires her to. While the woman's knowledge is generally not nearly as extensive as the man's in regard to the Huichol belief system and cosmology, the woman who has completed herself can be considered a specialist whose knowledge about her world and her handiwork is drawn from the same reservoir of shamanic knowledge and power. At the same time that a Huichol woman completes herself and becomes a master in the arts, she becomes, like her male counterparts, a "keeper of the knowledge." She automatically assumes the role of guardian and interpreter of the designs, and she is obligated to pass them on to future generations.

Through the process of her initiation to and continued ingestions of peyote, the completed woman also develops the ability to "dream" her designs and remember them. Striking color combinations and hallucinatory geometric forms are typical examples of these dream creations. Variations on traditional designs, with enhanced feeling for form, composition, and highly saturated colors also typify

the work of the women possessing these divinely inspired talents.

The women who complete themselves are, however, not the only ones skilled in the crafts and capable of producing beautiful things. The great majority of Huichol women and men are excellent artists. It is not unusual to see men embroidering or doing beadwork, and most women are skilled in all of the handicrafts. But the difference between those women who have taken it upon themselves to solicit divine guidance and power in the creation of their art and those who learn by watching others is a whole level of existence. The difference becomes particularly obvious in regard to the symbolism, which ordinary women who have not completed themselves are fairly oblivious to.

Huichol symbolism is so complex in nature that it is almost impossible to understand it without formal training. Analogy and syllogism characterize innumerable aspects of the Huichol belief system and daily lives. Huichols also find analogies in the colors they see and use in their daily lives. Colors can be symbolic of everything from the five directions to the sexes of individuals to the character traits of the deities or of individuals. I was told that when shamans are under the influence of peyote, they can actually "see" the essential color of a person.

Such x-ray vision allows shamans to see which children, based on the colors they radiate, might be the most likely prospect for the shamanic profession. Shamans are also able to use this color vision to look into the souls of other shamans to see whether they take their powers from the positive or negative forces of the universe. A shaman whose colors are white, red, and green is said to have the gift of life and to be inspired by positive, purifying, healing influences. Shamans whose colors are blue and black are more inclined to work in the negative aspects of the profession, bewitching and causing harm to others.

Indeed Huichol religion and daily life are so filled with analogy and syllogism that it is very difficult to understand the Huichols and penetrate beyond the superficial levels of their culture. It is as if they have two different languages—one which everyone shares in and understands, the other,

a language of mind, based completely on analogies and fully intelligible only to the initiate.

The language of analogy carries the most important knowledge; it is the esoteric language containing the "secret formula" for the *mara'akame*'s knowledge and power. Being a symbolic language, important aspects of it are found in the art, which gives material expression to these mental concepts. Thus the completed women become like scribes, encoding these concepts into their designs. Many of those who create the artwork are totally unaware of the hidden meanings behind the traditional forms, just as they might be unaware of the dual meanings of common words or phrases. But the women who have completed themselves have participated actively in the ceremonies; they have watched their husbands and assisted them in carrying out their initiatory roles. These women are familiar and have communicated with the deities and visited the landmarks which figure in the Huichol cosmology. They have educated themselves about the supernatural powers of the plants and animals in their environment and have developed their mental powers through the use of peyote, from which they have received insight. They have strived for, sacrificed for, and completed their destined role. They have attained the highest level of cultural knowledge available to women.

These women understand the symbolic language because they understand the knowledge. But they do not express this knowledge through the ritual acting out of religious concepts in the ceremonies or use it in the same way as the men. Rather, they express it through their own creativity in their artwork, which serves as a means of recording and transmitting privileged information that might otherwise be lost. Huichol men and women thus depend heavily on one another for the realization of what they consider to be the prime purpose of their lives: insuring the survival and continuation of their lifeblood—their collective sacred knowledge—and, in so doing, justifying their own existence.

EMBROIDERY SAMPLE
Collected by Susan Eger in San Andrés (1976–77)

The eagle *(welika)* is a common Huichol design most often depicted frontally with outstretched wings and one or more heads. This example is unusual because it is done in the running stitch, a stitch most often employed for geometric patterns. Example showing the tremendous variety and elaboration on traditional design forms.

The Religious Experience

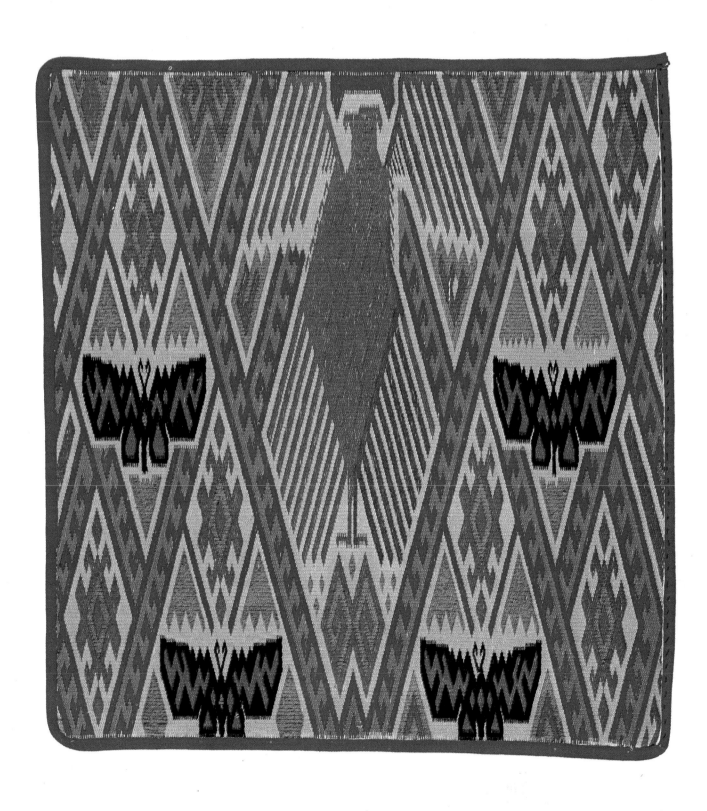

Peyote and the Mystic Vision
Barbara G. Myerhoff

The Peyote Hunt[1]

The Huichol Indians realize the climax of their religious
life in Wirikuta, a high desert plateau several hundred
miles from their mountain homeland, conceived of as
their sacred land of origin.[2] Wirikuta may well represent a
historical as well as mythical site of Huichol beginnings.
In Wirikuta, the First People, quasi-deified ancient ances-
tors, once dwelled in harmony and freedom as nomadic
hunters. According to their legends, they were driven out,
into mortality, into a life of sedentary agriculture in the
Sierra Madre Occidental. Every year, small groups of
Huichols, men and women, young and old, are led by a
shaman-priest, the *mara'akame*, in a return to Wirikuta to
hunt peyote (*Lophophora williamsii*; Huichol, *hikuri*), a
hallucinogenic cactus growing in the high central plateau
of northern Mexico between the Sierra Madre Oriental
and Sierra Madre Occidental. Although peyote hunts

1. A shorter version of this paper was prepared for and presented
 to a conference on Cross-Cultural Perspectives on Cannabis,
 convened in Chicago, August, 1973, during the IXth International
 Congress of the International Union of Anthropological and
 Ethnological Sciences, coordinated by Dr. Vera Rubin. It
 appeared in the volume issuing from that conference, *Cannabis
 and Culture* (ed. Vera Rubin; The Hague: Mouton, 1975).
 Grateful acknowledgment is made to the publisher for permis-
 sion to use it in this context.
2. Field work on which this article is based was conducted during
 1965 and 1966, and was partially funded by a Ford International
 and Comparative Studies Grant administered through Pro-
 fessor Johannes Wilbert of the University of California at Los
 Angeles, Latin American Center. My colleague Professor Peter
 T. Furst worked with me in Mexico and collaborated in sub-
 sequent interpretations of the data. Many of the Huichol texts
 were translated by Professors Joseph E. Grimes and Barbara
 Grimes. I acknowledge gratefully this assistance, and especially
 that of the late Ramón Medina Silva, Huichol *mara'akame*, his
 wife, Guadalupe, and the Huichols who shared so much of their
 time, their knowledge, and their lives. Ramón led the peyote
 hunt in which Furst and I participated in 1966; to my knowl-
 edge this was the first time anthropologists had an opportunity
 for firsthand observation of this event.

differ, depending on a variety of factors, such as the com-
position of the hunt party, *mara'akame* leadership, and
the like, it is nonetheless a very stable event.

To reenter this sacred land these pilgrims, or *peyoteros*,
must be transformed into the deities. The complex cluster
of ceremonies and rituals which prepares them for this
return includes a rite wherein the *mara'akame* dreams
their names and the names of the Ancient Ones and thus
determines their godly identities. The peyote-hunt pil-
grimage is a return to paradise, for Wirikuta is the place
where, as they say, "All is one, it is a unity, it is ourselves."
There they "find their lives" and dwell in primordial unity
until the *mara'akame* leads them back to ordinary time and
life. The climax of the pilgrimage is the hunting of peyote.

For the Huichols, peyote as a sacred symbol is insepa-
rable from deer and maize. Together, deer, maize, and
peyote account for the totality of Huichol life and history.
The deer is associated with the Huichols' idealized his-
torical past as nomadic hunters; the maize stands for the
life of the present—mundane, sedentary, good and
beautiful, utilitarian, difficult, and demanding; and peyote
evokes the timeless, private, purposeless, aesthetic dimen-
sion of the spiritual life, mediating between former and
present realities and providing a sense of being one people,
despite dramatic changes in their recent history, society
and culture.

The actual pilgrimage lasts several weeks. Each step
along the way is highly ritualized, and in retracing the
steps of the Ancient Ones, the pilgrims perform numerous
actions attributed to the First People at specific locations,
reenacting the feelings and attitudes as well as the behavior
of the deities. They rejoice, grieve, celebrate, and mourn
appropriately as the journey progresses. They do so as a
profoundly integrated community. For the hunt to suc-
ceed, they must pledge their entire loyalty and affection to
each other and to their *mara'akame*. Unless they are in
complete accord, their venture will fail and they will not
find the peyote. The journey is a very dangerous under-

taking. The pilgrims may lose their souls, conceptualized as fuzzy threads (*kupuri*) that connect each *peyotero* to the deity who gave him or her life. If the *mara'akame* is to protect them from the danger of soul loss, the pilgrims must unconditionally give their hearts to him and to the others. Such trust and intensity of affection cannot be sustained in the everyday world, and once the peyote hunt has ended, it is dissolved. The unity and its disbandment are symbolized by a ritual in which each pilgrim makes a knot in a cord which the *mara'akame* keeps during the journey. When the pilgrimage has been completed, the cord is unknotted and the unity terminated. In a statement of great sociological acumen, Ramón Medina Silva said, "It is true that I receive my power from Tatewari, our Grandfather Fire, but I could not use it without the complete trust of my peyote comrades."

As deities, the pilgrims endure many privations. They forgo or minimize physiological needs: sleep, sexual relations, excretion, eating, and drinking are actually or ritually foresworn during this period, for these are activities of humans, not gods. In becoming gods, the pilgrims are cleansed of their mortality, symbolized by sexual relations. Ritually they confess to all illicit adventures; even children must participate, and the *mara'akame* as well. After this confession, they are reborn and renamed, and the godly character so received is maintained throughout the pilgrimage.

Sometime before reaching the sacred land, everything is equated with its opposite and reversed. The known world is backward and upside down: the old man becomes the little child; that which is sad and ugly is spoken of as beautiful and gay; one thanks another by saying "You are welcome"; one greets a friend by turning one's back and bidding him or her good-bye. The sun is the moon, the moon the sun. It is said:

> When the world ends, it will be like when the names of things are changed, during the peyote hunt. All will be different, the opposite of what it is now. Now there are two eyes in the heavens, *Dios Sol* and *Dios Fuego*. Then, the moon will open his eye and become brighter. The sun will become dimmer. There will be no more difference. No more man and woman. No child and no adult. All will change places. Even the *mara'akame* will no longer be separate. That is why there is always a *nunutsi* [Huichol, little baby] when we go to Wirikuta. Because the old man, the tiny baby, they are the same.

These oppositions, like the godly identities and like the hunt of the peyote, are not merely stated; they are acted out. For example, an old man, now having become a *nunutsi*—a little baby—does not gather firewood in Wirikuta, for such work is not fitting for an infant.

Primeros, those making their first peyote pilgrimage, have their eyes covered on arriving at the periphery of Wirikuta so as not to be blinded by the glory and brilliant light of the sacred land. Their blindfolds may be safely removed only after proper preparation, which involves a kind of baptism with sacred water by the *mara'akame* and a description of what they may expect to see when their eyes are bared to the sight of Wirikuta.

Once arrived, the party camps and begins to search for the peyote, which is tracked by following its deer tracks. When the tracks are sighted, the *mara'akame* stalks the peyote-deer, and cautiously, silently drawing near, slays it with bow and arrow. Blood gushes upward from it in the form of an arc of rays. (Blinding light, flashing colors, and the general intensification of visual imagery are, of course, constants in psychedelic experiences, and indeed the presence of the divine is most commonly signified by dazzling luminosity.) With his sacred plumes, the *mara'akame* gently strokes the rays back into the body. The *peyoteros* weep with joy at having attained their goal and with grief at having slain their brother; his "bones," the roots of the peyote plant, will be cut away and saved, to be buried in the brush so that he may be reborn. The peyote is removed

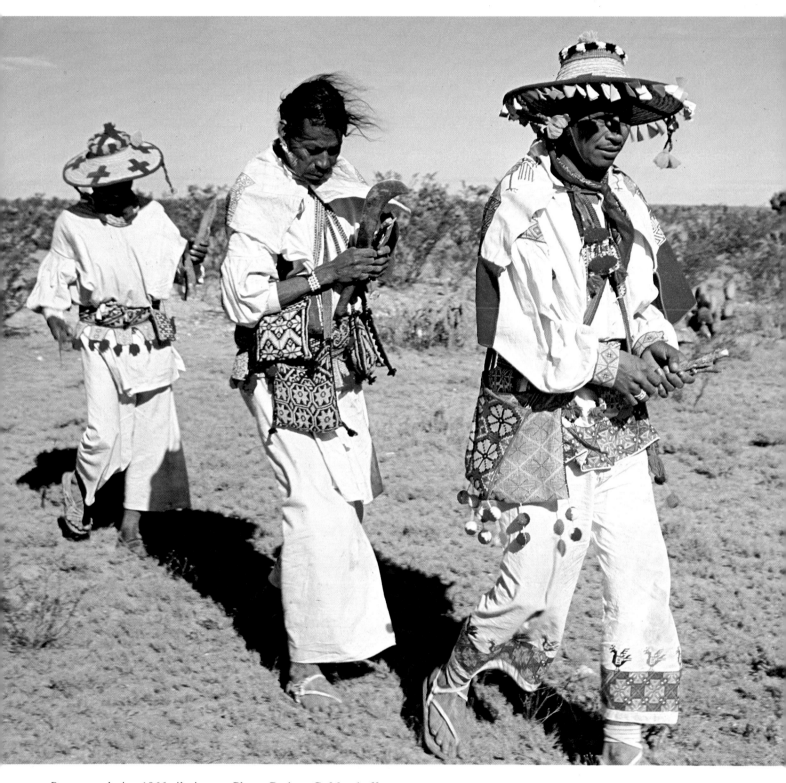

Peyoteros during 1966 pilgrimage. Photo: Barbara G. Myerhoff

from the earth, and the resultant cavity surrounded with offerings. The cactus is then sliced by the *mara'akame*, who gives a segment to each of the peyote companions. Then, a pilgrim acting as the *mara'akame*'s assistant in turn administers a segment of the peyote to the leader.

This moment marks the fulfillment of the highest goal in Huichol religious life. Unity has been achieved on every level; social distinctions have been obliterated: male and female, old and young, have been treated and have behaved as though they were alike. The otherwise profound distinctions between the *mara'akame* and the followers are deliberately eradicated when the former becomes one of them by receiving the peyote from their hands. The separation of the natural and the supernatural order has been overcome, for the *peyoteros* are the deities. The plant and animal realms have likewise merged, for the deer and the peyote are one. And the past and present are fused in the equation of deer-maize with the peyote. All paradoxes, separations, and contradictions have been transcended. Opposites have become identical. Time itself has been obliterated, for Wirikuta is not only the world as it existed before Creation, but it is also the world that will reappear at the end of Time, after this epoch has ended. Ramón stated this explicitly in saying, "One day all will be as you have seen it there in Wirikuta. The First People will come back. The fields will be pure and crystalline. . . . One day the world will end and that beauty will be here again." The past and future are the same, and the present is but a human interlude, atypical and transitory, a mere deviation from the enduring reality represented by Wirikuta. This moment of unity is a foretaste of paradise and eternity.

The rest of the day is spent in gathering more peyote, to be eaten later. On the evening following the ritual slaying and token consumption of the first peyote, the pilgrims seat themselves before the fire surrounded by their companions and eat several segments of their best peyote. This generally quiet affair is the first release they have had from the earlier intense camaraderie and demanding conformity to ritual. Each one is now alone in his or her inner world, for it is not the custom, as the Huichols say, to talk of one's visions. Ramón explained:

> One eats peyote and sees many things, remembers many things. One remembers everything which one has seen and heard. But one must not talk about it. You keep it in your heart. Only one's self knows it. It is a perfect thing. A personal thing, a very private thing. It is like a secret because others have not heard the same thing, others have not seen the same thing. That is why it is not a good thing to tell it to others.

All that is said is that ordinary people see beautiful lights, lovely vivid shooting colors, little animals, and peculiar creatures. These visions have no purpose, no message: they are themselves.

The year before the peyote hunt in which I participated, before I understood the need for secrecy, Ramón had given me some peyote and watched over me while I had my vision. Afterwards, I attempted to elicit from Ramón an explanation or interpretation of what I had seen. It took me some time to understand his reluctance as he attempted tactfully to steer me away from questions about its meaning to observations about its beauty. We continued in this fashion for a while, until at last he said, "It means itself— no more!" Each experience is personal, and only the vaguest references are made to this part of the ceremony. The visions are always good. If one has followed the *mara'akame* and done all with a pure heart, the experience can only be happy, even joyous. Neither nausea nor terror is experienced, with one exception: When peyote is eaten by one who has not properly prepared himself, not truly confessed, or not gathered "good peyote" under the direction of a *mara'akame*, conventional bad visions are said to occur.

Only the *mara'akame* has routinized visions. They are concerned with lessons and messages from Tatewari. He or she sees Tatewari in the fire and communicates directly with him. Thus the *mara'akame* brings back information

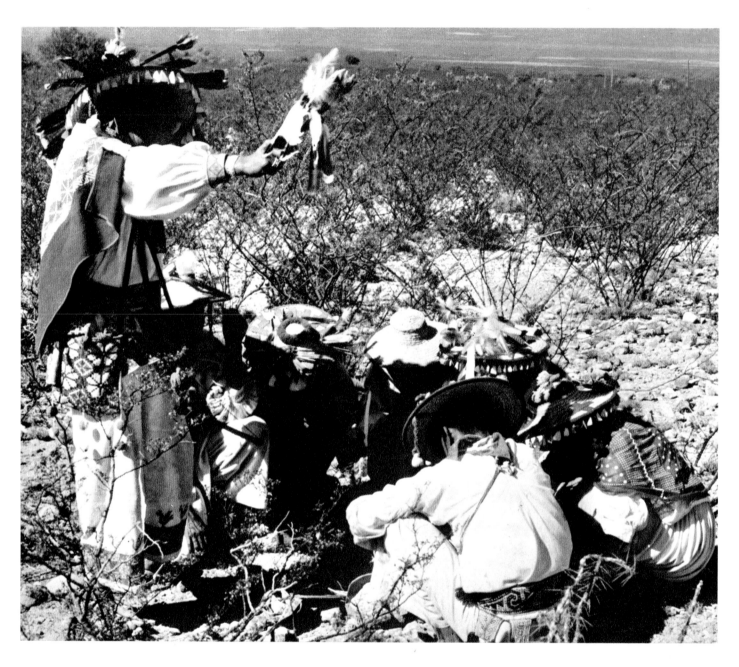

Peyoteros venerate the first peyote. Photo: Barbara G. Myerhoff

from other worlds, information of value and meaning to the people. In classical shamanic fashion, the Huichol *mara'akame* undertakes a magic flight to help the people understand the regions of the unknown. But ordinary pilgrims need not be concerned with such cares; for them peyote brings only extravagant, purposeless beauty and release into the realm of pure aesthetic and spiritual delight. The peyote experience constitutes that part of a person's life which is private, beautiful, and unique. As such, it constitutes that part of religion which has nothing to do with shared sentiments, morals, ethics, or dogma. It is within the religious experience but separate from it. In

some philosophical systems such experiences are considered the most elevated and most intensely spiritual known to humankind, providing liberation from structure within a structure, allowing for a voyage into subjectivity, into the unknowable, within a fixed framework.

Peyote may be viewed as the Huichol provision for that dimension of religious experience which can never be routinized and made altogether public—that sense of awe and wonder, the *mysterium tremendum et fascinans*, without which religion is mere ritual and form. It provides the ecstatic and enormous moment when the soul departs, flies upward, and loses itself in the other reality. The dark-

ness explodes into dancing colors. The Huichol pilgrims have nothing to fear; knowing that their flight will not last, they can fling themselves into it with impunity. They are protected by the wealth of Huichol tradition, ritual, symbol, and mythology, and by the certain knowledge that the *mara'akame* is guarding them, that they are pure in their hearts. They are at one with their comrades. The religious culture of peyote can be thought of as a strong resilient net that allows for ever higher ascent and greater and greater freedom.

What does the *peyotero* actually see? The *mara'akame* described an ordinary vision and his own contrasting didactic vision of Tatewari:

> And then, when one takes peyote, one looks upward and what does one see? One sees darkness. Only darkness. It is very dark, very black. And one feels drunk with the peyote. And when one looks up again it is total darkness except for a little bit of light, a tiny bit of light, brilliant yellow. It comes there, a brilliant yellow. And one looks into the fire. One sits there, looking into the fire which is Tatewari. One sees the fire in colors, very many colors, five colors, different colors. The flames divide—it is all brilliant, very brilliant and very beautiful. The beauty is very great, very great. The flames come up, they shoot up, and each flame divides into those colors and each is multicolored—blue, green, yellow, all those colors. The yellow appears on the tip of the flames as the flame shoots upward. And on the tips you can see little sparks in many colors coming out. And the smoke which rises from the fire, it also looks more and more yellow, more and more brilliant.
>
> Then one sees the fire, very bright, one sees the offerings there, many arrows with feathers, and they are full of color, shimmering, shimmering. That is what one sees.
>
> But the *mara'akame*, what does he see? He sees Tatewari, if he is chief of those who go to hunt the peyote. And he sees the Sun. *He* sees the *mara'akame* venerating the fire and he hears those prayers, like music. He hears praying and singing.

> All this is necessary to understand, to comprehend, to have one's life. This we must do so that we can see what Tatewari lets go from his heart for us. One goes understanding all that which Tatewari has given one. That is when we understand all that, when we find life over there.

Wirikuta is no less magnificent than the pilgrims had been led to expect in the stories they had heard all their lives. Yet after gathering sufficient peyote to take home and plant in house gardens and for use throughout the year, they leave Wirikuta precipitously. It is said, "It is dangerous to remain." Not a moment of lingering is permitted, and the pilgrims literally run away, following the *mara'akame* beyond the boundaries of the sacred area as speedily as their bundles and baskets of peyote permit. They leave behind their offerings, their deity names, the reversals, their intense companionship, and all physical traces and reminders of Wirikuta. Cactus spines, bits of earth, dust, matchsticks, cigarette stubs, pieces of food—everything that was part of or was consumed or used in Wirikuta—is discarded and scraped and shaken into the fire. The things of the everyday world and the things of the sacred are kept rigidly apart.

Returning to ordinary reality, the pilgrims are left grief-stricken, exhausted, and exhilarated by the experience. An enormous undertaking has been accomplished. They have traveled to paradise, dwelled there as deities for a moment, and returned to mortal life. In their lifetime they achieved the most complete intention of religion: the experience of total meaning and coherence in the universe. If, as Bertrand Russell has suggested, a minimal definition of religion consists of the relatively modest assertion that God is not mad, the maximum definition of religion might be said to be the insight and knowledge of utter harmony and meaning, the participation in the alleged coherence of the cosmos. The distinction between appearance and reality is not merely blurred; the two are the same. It is impossible to put it any better than the Huichols' own

description of the peyote hunt and the pilgrimage: "It is one, it is a unity, it is ourselves." Through the *mara'akame* and peyote, the pilgrim has found his or her place in the divine scheme of things: the *peyotero* is of the divine and the divine is in the *peyotero*.

The Structure of the Mystic Vision as Revealed in Wirikuta

Scholars and writers generally agree on the nature of the mystical experience, whether the phenomenon is called transcendence, peak experience, poetic vision, ecstasy, or mysticism; whether it is described in religious or secular terms; whether it is induced by drugs, occurs spontaneously, or is facilitated by techniques that produce bodily changes—altered respiration, fasting, special diets, flagellation, sensory deprivation, rhythmic behaviors such as drumming, chanting, dancing, and physical exercise. Several writers, among them Dobkin de Rios, Walter Pahnke, Alan Watts (1971), Bernard Aronson, and Humphrey Osmond, intrigued by the obvious relationship between religion and psychedelic drugs, have suggested typologies for common constituents of the mystical and the psychedelic experience. I have drawn upon these schemes selectively in analyzing the Huichol peyote hunt as an excellent example of the mystical experience elaborated into a world view.

The most significant theme in the peyote hunt is the achievement of total unification on every level. This sense of unity is the most important characteristic of the mystical experience according to Pahnke, who distinguishes between internal and external unity. Internal unity refers to the loss of the ego or self without the loss of consciousness and to the fading of the sense of the multiplicity of sensory impressions. External unity consists of the disappearance of the barriers between self and object.

Mircea Eliade, in *The Myth of the External Return*, terms this most fundamental experience of unity "the pan-human yearning for paradise." Paradise is the archetype for the primordial bliss which preceded Creation. The feeling accompanying this condition is variously characterized as beatitude, peacefulness, bliss, blessedness, a sense of melting, and an oceanic flowing into the totality. Images of flowing and blending are a common part of mystic experiences, according to Marghanita Laski's *Ecstasy*, a content analysis of ecstatic imagery. Many explanations have been offered for this yearning toward paradise. Freudian interpretations conceptualize it as a desire to return to the womb or as the wish never to have been separated from prenatal dependence. Jungians see it as a form of incest, a reluctance to individuate and take on the demands of adulthood, for after Creation the human being must be born, die, suffer, feel pain and confusion. The human being works, struggles, is vulnerable and ultimately alone; in short, he or she is mortal. The dangers of attempting to reenter Eden are couched in many idioms. The Huichols say that one's soul may be lost in Wirikuta, that the *kupuri* may be severed. It may be called the loss of ego, rationality, volition, or sanity. The awareness of danger and transience is regularly cited as part of the mystic vision, most dramatically portrayed in the *peyoteros*' flight from Wirikuta—an explicit recognition that ecstasy cannot be a permanent way of life.

Also regularly mentioned are feelings of brotherly love and camaraderie more intense than everyday feelings of friendship and affection. Victor Turner (1969) has suggested that these feelings may be called *communitas*; Martin Buber referred to them as *Zwischenmenschlichkeit*, the I-Thou intimacy that knows no boundaries, when people stand alongside one another, naked, shorn of the guidelines and expectations of role and persona, a seamless, skinless continuity which is the most intense kind of community conceivable. Watts, in *The Joyous Cosmology*, calls the feelings between those who together undertake the mystical voyage "a love which is distinctly eucharistic, an acceptance of each other's natures from the heights to depths" (51). Among the Huichols this acceptance is concep-

The hunt for peyote in Wirikuta. Yarn painting by Ramón Medina Silva.
The Museum for Cultural History, University of California at Los Angeles

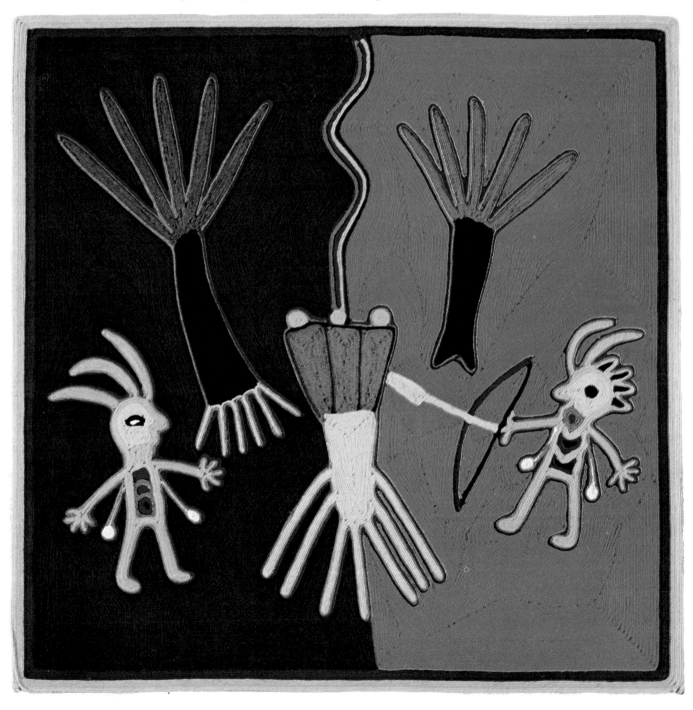

tualized, symbolized, and ritualized. The knotted cord binds the *peyoteros* together, but the bonds cannot and should not be carried back to everyday life. Just as the things of the sacred land and the home are separated by leaving behind that which belongs to Wirikuta, so are the human connections undone after the peyote hunt. The *mara'akame* aids the Huichols in relinquishing ecstasy and shows them that they must leave it behind for another year. *Communitas*, like internal and external unity, is also an experience of wholeness, a form of flowing together, the all is One manifested in social relationships.

Transcendence of time and space is cited by Pahnke and others as a universal constituent of the mystical experience. Space does not appear to be treated with special significance by *peyoteros*, except that the usual spatial categories clearly do not obtain. The entrance to Wirikuta through crashing rocks is known as the Vagina. Transit through these portals is perilous, and shamans must typically pass through such dangerous doorways in the course of their magical flights. Clearly, Wirikuta is not in everyday space.

More significant is the notion of time during the peyote hunt. Mythic time prevails. The single moment contains all that was and will yet be, history is obliterated and the present elongated to imply the beginning and the end of the world. The seamless flow into which the peyote pilgrim slips is eternity, a stable feature in mystical visions.

Also significant is the manner in which individuals dwell, behave, and recognize themselves in the sacred realm. Knowledge of this is provided by the ritualization of reversals on the peyote hunt, which serves several distinct purposes. To know how to act in paradise is not a simple matter; being designated a god is one thing, acting like one is more difficult. How does one remain in character for an entire day or evening or even weeks? How does one treat one's fellow deities? Surely not by following ordinary norms. The upside-down quality of life in Wirikuta serves as a kind of mnemonics, providing a basic metaphor by which the pilgrims can coordinate their behaviors and attitudes and understand exactly what is transpiring. If the sacred realm is just the opposite of the real world, one can picture it in detail and relate to it very concretely and precisely, but not just any metaphor will serve. The recourse to the reversals is a way of stating that despite appearances, all indeed is One. Not only are differences and multiplicities of form illusory, but things which appear to be the very opposite of each other are shown to be identical, to be completely interdependent, to be part of each other. Subject-object, left-right, male-female, old-young, figure-ground, saint-sinner, police-criminal—all these are definable only in terms of each other. Paradoxes are resolved in this experience; formulations that tax the rational mind to its limits are managed comfortably and lucidly. The deer, peyote, and maize are one. A logic prevails, though not the Aristotelian logic which holds that A cannot be B. Eliade (1962) has called this the *coincidentia oppositorum* and regards it as the eschatological image par excellence. Indeed, it occurs in countless societies, in folklore, and in the worlds of dream and imagination, always suggesting the mystery of totality.

Ineffability is consistently cited as part of this vision. The experience is essentially nonverbal. In spite of attempts to relate or write about the mystical experience, mystics insist either that words fail to describe it adequately or that the experience is beyond words. "Perhaps," Pahnke suggests, "the reason is an embarrassment with language because of the paradoxical nature of the essential phenomenon." Another interpretation for the ineffable nature of the mystic vision may be added to that of paradoxicality. As poets have always known, in order to evoke an intense emotional response, effective symbols must be ambiguous to a degree. This notion has been called the multireferential feature of symbols by Turner. The broad spectrum of references embraced by symbols permits one to find in them particulars sufficiently personal to elicit a subjective response. A detailed discussion of individual ecstatic experiences would make it clear to

those within a mystical community that each person's vision is distinctive. It is more important for each person to have an intense and private experience and at the same time a sense of sharing it with others. Specific language would diminish the sense of *communitas* among the Huichol pilgrims; this is implied in these words of the *mara'akame*: "It is like a secret, because others have not heard the same thing, seen the same thing."

Finally, one of the recurring explanations of the power of drugs is their ability to loosen cognitive social categories. Conceptualizations are socially provided and given in language. One of the sources of wonder and ecstasy in the mystic experience is the direct perception of the world, without the intervention and precedence of language and interpretation. The mystic experience is nonverbal precisely because it takes one back behind the word, or more accurately, before the word, to the stunning immediacy of sense data. The Huichols are surely correct when they say that to talk about one's visions is not good.

Peyote Outside of Wirikuta

To discuss peyote only in connection with Wirikuta would be misleading, for it is also part of ordinary Huichol life, and is used on many occasions. One of the most significant features of peyote use among the Huichol is its integration within the society and culture. This notion is especially relevant from the perspective of contemporary American youth culture, in which drug use by comparison is haphazard and promiscuous; with few exceptions, psychedelic drugs, although possibly producing similar visions, are not integrated into a system of meaning which may be regarded as a world view.

Among the Huichols, peyote itself is called "very delicate" and generally regarded as sacred. But to be sacred it has to have been gathered in the proper fashion, that is, under the leadership of a *mara'akame* in Wirikuta. Peyote purchased in Mexican markets is not sacred, according to Ramón, who comments: "That other peyote, that which

one buys, it did not reveal itself in the Huichol manner. One did not hunt it properly, one did not make offerings to it over there [in Wirikuta]. That is why it is not good for us." In order to be sure that they always have a supply of peyote from Wirikuta, the Huichols bring some back from the peyote hunt to plant in their gardens.

The references to "that other peyote," the one that can be purchased, is explained by Huichol ethnobotanical classification, which specifies the existence of two kinds of peyote, "good and bad." (Peter Furst, in *Flesh of the Gods*, identified bad peyote as *Arioscarpus retusus*, a member of the same cactus subgroup as *Lophophoro williamsii*.) They are very similar in appearance, and only someone experienced, usually a *mara'akame*, can be certain of collecting the good kind. One may accidentally purchase the bad kind, called *tsuwiri*. The results of eating *tsuwiri* are indeed terrible: "If one eats one of those, one goes mad, one goes running into the *barrancas*, one sees scorpions, serpents, dangerous animals. One is unable to walk, one falls, one often kills oneself in those *barrancas*, falling off the rocks"—effects are similar to those attributed to *Datura*. The hallucinations described due to eating *tsuwiri* are conventional; a common one is the experience of encountering a huge agave cactus in the desert, thinking it is a woman, and making love to it.

Eating *tsuwiri* may occur not only as a result of mistaking it for peyote; it may be a supernatural sanction, punishment for going to Wirikuta without prior confession. "It is said that if one comes there not having spoken of one's life, if one comes not having been cleansed of everything, then this false *hikuri* will discover it. It is going to bring out that which is evil in one, that which frightens one. It knows all one's bad thoughts." Not only will the *tsuwiri* read one's thoughts, but those who have not confessed honestly or completely will probably behave oddly. The pilgrim who knows that he has lied to his companions will eat his peyote in secret "because he does not have good thoughts, he knows he has not spoken honestly with his companions." When such a person hunts for peyote, he

Yarn painting by Ramón Medina Silva of Barbara Myerhoff receiving
the name of a deity on the 1966 pilgrimage. Collection of Barbara G.
Myerhoff

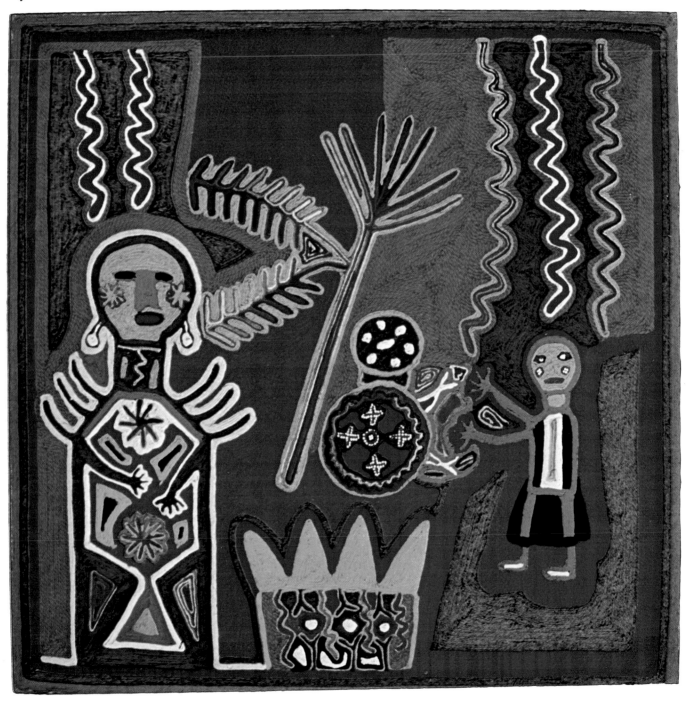

Yarn painting by Guadalupe, Ramón's widow, of Peter Furst receiving
the name of a deity before the 1966 pilgrimage. The Fine Arts Museums
of San Francisco. Gift of Peter F. Young

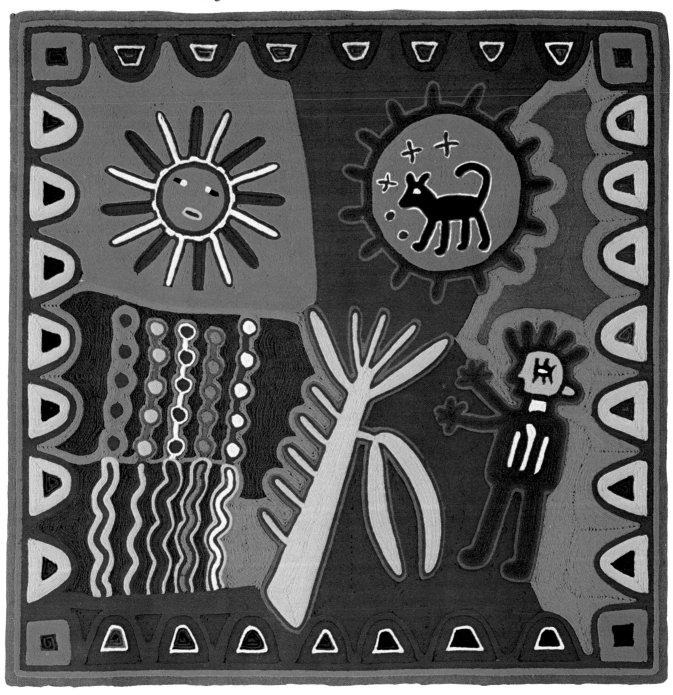

will find the *tsuwiri*, which "only has the appearance of peyote," and when he returns to his companions after his harrowing visions, the *mara'akame* knows at once what has occurred. The man must confess, and then he will be cleansed by the *mara'akame*.

Peyote, like maize, can "read one's thoughts" and punish one for being false or evil. The peyote rewards or punishes a person according to his or her inner state and moral standing. The sanction is immediate, just, and certain, a most effective regulator of behavior in a small, well-integrated society.

Peyote is eaten or drunk ritually only during dry-season ceremonies, but may be eaten casually at any time of the year. It is used medicinally in a multitude of situations—to relieve pain, as a poultice applied to wounds. It may also be taken for energy, endurance, or courage. In fact, it is a panacea. The quantity taken ritually is usually insufficient to obtain visions and must in this context be regarded as having the specific symbolic purpose of achieving communion with the deities.

Peyote-eating for the purpose of experiencing a vision thus constitutes but one relatively narrow part of a larger set of purposes. It is nonetheless quite an important part, though more for the *mara'akame* than for ordinary folk. When peyote is eaten for visions, nonritually, it is taken in a relaxed and convivial atmosphere, much in the manner of the Westerner's use of liquor. Concerning one's first experiences with peyote early in life, Ramón had this to say:

> The first time one puts the peyote into one's mouth, one feels it going down into the stomach. It feels very cold, like ice. And the inside of one's mouth becomes dry, very dry. And then it becomes wet, very wet. One has much saliva then. And then a while later, one feels as if one were fainting. And one begins to yawn, to feel very tired. And after a while one feels very light. One feels sleepy, but one must not go to sleep. One must stay awake to have the visions.

In at least one context peyote may be used in prophecy. If a very young child, upon being given a small amount of peyote, finds it pleasant-tasting, this may be construed as a sign that he or she would make a good *mara'akame*. The interpretation of the taste of peyote is itself an interesting matter; the Huichols insist that peyote is "sweet." "Chew it well," they tell each other, "it is sweet, like tortillas." This may be a reversal brought back from Wirikuta; clearly, though no one vomits after eating peyote, neither is it savored. Huichols eating it look like anyone else with a mouthful of peyote: they grimace, sucking in their cheeks and moving their eyebrows up and down in a most uncharacteristic manner—a reaction to the shockingly sour taste of the cactus.

Cleaning the peyote is not an elaborate process: the roots are usually cut off and the dust and earth brushed away. The little tufts of hair on the top, called *tsinurawe* (the eyebrows of the peyote), are especially delicate and are always eaten. Different peyotes are said to differ in flavor, texture, and color, and one of the pleasurable pastimes in Wirikuta is comparing peyotes and their aesthetic attributes. The most highly valued are those with five segments, five being the Huichol sacred number. These five-segment peyotes are often strung together as a necklace and may be used to adorn the antlers of Tatewari. Peyote is often referred to affectionately as "*ti peyote*" (our peyote) and even spoken to in baby talk. Often its attributes are likened to stages in the growth of maize. "It is new, it is soft like the ripening maize, how fine, how lovely."

Before being consumed, the first peyote eaten in Wirikuta is touched to the forehead, eyes, breast, voice box, and cheeks. The gesture is not repeated after this first ceremonial eating. Peyote brought out of Wirikuta is carefully packed into baskets in concentric circles from the bottom up to prevent its being jostled en route, for, as is said, it is delicate and the trip is long.

Peyote may be eaten fresh or it may be dried and ground and drunk. It may be taken along on trips and given as a

gift to a host, to eat or plant. It is sometimes traded for various items with other Indians, especially the Cora and Tarahumara, who regard Huichol peyote as very desirable. It is always in demand and must be available throughout the year, since all major religious ceremonies require the presence of peyote, maize, and deer meat or blood. The ceremonies form an interlocking cycle. The peyote hunt is preceded by the drum-and-calabash ceremony and followed by the deer hunt; substitutes for deer meat and blood are acceptable, but nothing can take the place of properly gathered peyote.

Peyote is no less important as an artistic motif. As Carl Lumholtz (1900) has shown, peyote is a theme with numerous variations in embroidery and weaving, a key source of inspiration.

The Huichol World View

The Huichol world view in several important features represents a cultural inflection of what appears to be a highly regular human production: the mystic vision. If dreams and myths are structured, as Freud and Lévi-Strauss have persuasively demonstrated, it should come as no surprise to find that one of the most private, subtle, ineffable, mysterious, and elusive human experiences—the mystic vision—is also structured. Still, it is easier by far to deal with cultural regularities in matters of an instrumental nature, pertaining to subsistence and survival, environmental requirements, and similar events where utility and efficiency dictate a fixed number of possible alternatives. In the realms of the imagination, metaphysics, the arts, religion, areas which are not identifiably rational undertakings, we expect variation rather than uniformity. Our explanatory concepts are taxed when we find specific similarities in very different cultural settings where history and diffusion cannot be evoked. We may then fall back on old concepts—memory traces, collective unconscious, instinct, racial memories, and the like—or on the as yet incomplete formulations about universal characteristics of the human mind and human nature. Most anthropologists have had to content themselves with mere descriptions of social processes, falling short of earlier hopes for the discovery of genuinely lawful regularities. Nowadays, only the intrepid take up problems of psychic unity and common human experience, though these issues, if hazardous, are among the most important and interesting.

From this perspective, recent studies on the relationship between hallucinogenic drugs and religion may be regarded as a significant development in the attempt to enlarge our understanding of universals in human social phenomena. Osmund, Schultes, and Wasson have demonstrated that the origins and history of religion are inseparable from the use of psychedelic plants. More recently, Aaronson and Osmund, Pahnke, Watts (1971), and Dobkin de Rios have developed typologies which draw our attention to the highly regular factors in psychedelic drug experiences. Watts, Pahnke, and R. P. Marsh have been concerned specifically with isolating the effects of a drug experience which appear to be the same as those associated with the mystical vision—the "Fourth Way," as it is called in the *Mandukya Upanishad*, the way that is neither waking dreaming nor dreaming sleep, but "pure unitary consciousness, wherein awareness of the world and of multiplicity is completely obliterated. . . . It is One without a second."

The Huichols offer a fine example of this experience; more than that, they provide a case in which the mystic vision is extended and elaborated into a world view, much of which can be explained by reference to their use of peyote. That hallucinogenic drugs produce regular experiences is now an established fact: what interests us is how these Indians use those experiences. To say that peyote is the direct cause of the Huichol world view would be an oversimplification. Peyote use produces the raw material which is built into a system of thought, a *Weltanschauung*. The individual peyote eater's expectations precede and profoundly influence perceptions and interpretations of

personal visions. But these expectations are not random; they are shaped by the regularly recurring results of eating peyote. Thus do culture and individual interlock.

Peyote is the touchstone for the Huichol world view. In the basic psychedelic experience we find the source of much of their version of the ideal—in human relations, in the relationship of men and women to the natural world, in the understanding of human history and ultimate destiny.

The Huichol world view may be understood as a combination of several layers of belief: the mystic vision, classical shamanism, and a hunting ideology. Many features typically associated with the last of these include the continuity between man and animal; the belief that the animal (deer-peyote) is reborn from its bones; the deer as the *mara'akame*'s familiar spirit; the shamanic flight through dangerous passages to the other world; the shaman's access to direct knowledge of the supernatural realm, and so forth.

Perhaps in the present context the most significant lesson of the Huichol use of peyote is a fuller understanding of a hallucinogenic drug in a sacred context. Peyote produces certain biochemical changes to some degree uniform in their effects. What is done with these effects, what meanings they are given, and how they are integrated and elaborated into a context of significance, coherence, and beauty, is the concern of anthropologists. Simply stated, we see peyote used as a means. Clearly, its effects per se are valued, but they are a relatively small part of the entire picture. To discuss Huichol peyote use in terms of "kicks," "highs," "escapes," and all the other terms used to describe the goals of individualistic drug-taking outside of an integrated cultural setting would be a profanation. Peyote is woven into every dimension of Huichol life. It is venerated for its gifts of beauty and pleasure. But this projection is Durkheimian; with it we see with the Huichols venerating their own customs and traditions, the sense and pattern of a way of life which uses this little plant, this part of its natural environment, so wisely and so well.

The Neurochemistry of Religious Insight and Ecstasy
Arnold J. Mandell

Amphetamine is the same as up:

Happy moving, restless, telling loudly, intricately, how it works. Sure ground under thoughts, biting nails in impatient ambition. Publish and get widely talked about. No hunger for anything but waves of success. I take four women; one each night screams for mercy and I hang them in the sun to dry. Quick, my thoughts might be lost. I know about brain and religion. Culture, personality, and brain chemistry are the same, separated by the fences of each academic specialist. The anthropologist, the comparative religionist, the art historian, I stand above them all with the power of knowing in the vial in my hand. A shaman, a sauna, starvation and pain, thunder, bright colors, and the Huichol deer-maize-peyote complex are all chemicals in my brain.

Reserpine is the same as down:

Dawn is gray, my eyes open on another one. Once energetic in morning surge to make the world a better place, living now is guilty self-discipline, lethargic, heavy, dull. She doesn't love me but has so many years in. The last time my penis was long and soft. My ideas, sudden lights popping, are now endless ticker tape tapping the little ups and downs of the market meaning of life. Death arrived without announcement, graying pink flesh into rock. Feelingless.

Peyote was something else:

The sun was blinding, eyes naked baby skin searing, the light riding optic nerves to ash brain. Open, seeing, without the inner litany of insulting words, walking small among tall tree trunks, a prehistoric horse at the feet of these giants holding up the sun. The ground underfoot, dry, cracked earth, was tender and alive. I minced in cautious awe for its breathing crust, a new swell of joy in the chest, tearfully grateful for this reprieve from death. Full, excited, rushing, yet careful not to disturb this world that I knew now knew better.

Death died here, old pines lying in decay, the children rose from rotting bark, their young needles a fresher green than they would be. These Jewish eyes, paranoid genetically, aware of every nuance to survive, were blind to this beautiful world. The out-of-doors had been an afternoon at the paved zoo with peanuts, my father asking me and me asking my sons to list the breeds of monkey in Latin. A root was a row of long, rectangular cells under the microscope, I competed hard to get into medical school. Death was there, white, cold bodies on gray metal dissecting tables, later black-red blood vomited with a despairing groan. Life, the few times I saw it, sparkled in large blue eyes, the mother, her young shaved legs strapped into stirrups, seeing the balls of her new male peeking out from his buttocks as he was held upside down by the doctor. I'm a psychiatrist now and my time is spent arranging old furniture, naming the same pieces week after week and getting old from more of the same moving in tighter circles which finally choked. In silent desperation I grabbed the frozen package of bitter gray-greenish pieces of peyote cactus and drove to the woods. Shortly everything shimmered soft bright and new, my body a warm glow of knowing love, each rock living, trees wise, birds funny, an ant world enough for hours, I cried seeing God who nearly died.

Louis Lewin, for whom the peyote cactus was named (*Anhalonium lewinii*) was a Jewish pharmacologist-physician of brilliance and vision living in Berlin during the time of Freud and suffering similarly from the anti-Semitic bias of the German academy. He never held a professorial position but worked and wrote as did Freud in his private laboratory. His classic book, *Phantastica: Narcotic and Stimulating Drugs*, is a summary of his life's work with central-nervous-system drugs. It is tempting to think that in this time of the new psychiatry with a frame of reference of brain biology, this book may come to be as important for an understanding of man as did *The Interpretation of Dreams*. *Phantastica* is a fusion of organic chemistry, plant biology, and intimate accounts of human experimentation with the various drugs. It is remarkable for the easy manner of relating brain events to their cultural reflections in work habits, morality, art, music, and religion. His mind knew

Mature peyote plants from same root stock being lifted from the ground. Photo: Peter T. Furst

not of the boundaries between brain chemistry and the artifacts of human behavior. A charismatic lecturer, linguist, sculptor, and prolific writer, he identified mescaline as peyote's major message in 1888 and described its many perceptual effects: bright colors, the movement of visual edges, intricate geometric pattern configurations of objects, shadows without objects, sensitivity to sound, and the physiological phenomena of nausea, cardiac slowing, sweating, and the characteristic occipital headache. More important, he saw the drug's effects on personality, on outlook, on spirit.

Whereas opiate narcotics "gradually detach the soul from terrestrial sensations leading gently to the threshold of death," and cocaine "attaches to delight" with arrogant fixity, peyote, wrote Lewin, transports its user

> to a new world of sensibility and intelligence . . . is a vegetable incarnation of divinity . . . leads to the appearance of a purely internal life which excites astonishment . . . produces modifications of the spiritual life which are peculiar in that they are felt as gladness of soul . . . and the most important fact in the whole mechanism of the cerebral cortex is the modification of the mental state, the modification of psychological life into a hitherto unknown spiritual experience . . . leading out of a state of apathy into superior spheres of perception [97–107 *passim*].

The peyote's capacity to facilitate the experience of the

metaphysical was seen by Havelock Ellis as early as 1898. He both took the cactus and administered it to friends. The experience, he wrote in an article in the *Contemporary Review*, vindicated the "majesty of its [his mind's] impersonal nature . . . it had reigned for a while . . . as an autocrat, without ministers and their officiousness." This account of a detached yet acutely aware brain state, the ideal of Buddhism and Tao, was brought to this turn-of-the-century Western physician-scientist by a cactus, and without previous philosophical entrainment. Weir Mitchell, in an address before the American Neurological Society in 1896, described the perceptual splendor following the ingestion of peyote and noted "a certain sense of the things about me as having a more positive existence than usual . . . an elated sense of superiority, a mood like a climate not to be reasoned with." A friend to whom he had given an extract described the effortless flow of his being "free from aspiration . . . going on by virtue of my own momentum." These early observers describe a loss of hunger, thirst, fatigue, and sexual desire, as well as a heightened sensitivity in human affairs. Egoless energy, a feeling of divine completeness, and spiritual insights, features often lost amid early pharmacological reports of the sensory distortions and beautifications, may be the plant's most significant message both to man and about man.

These observations of peyote's induction of spiritual events suggest drug effects rather than the influence of expectation and setting, because they were made outside the cultural context of modern hallucinogen psychopharmacology, which has been contaminated by the westward migration of Eastern religions as well as the coming and going of the street drug-use movement in America with its attendant recruitment of relevant explanatory spiritual documents such as *The Tibetan Book of the Dead*. As Barbara Myerhoff suggests, there is an isomorphism between the world view of the Huichols and the peyote drug effect on the human brain. This may be an example of cultural history that can be characterized, a world view conveyed, by using a brain chemical agent. We can know the group feeling of the panzer divisions of Hitler's army, taking large daily doses of amphetamine—paranoid, sadistic, and high-spirited rage. We can make our brain receptive to Jack Kerouac's prose in *The Subterraneans* with the marijuana he was on when he wrote it—dreamy, sensually turgid, mystical. The Smithsonian's future museum for anthropological artifacts useful in showing what culture was like back then may well look like a pharmacy.

Modern brain biology has taken the potentiality for cultural representation in brain chemical terms even further than a circumstance of drug and cultural resonance, as is the case with the Huichols' use of peyote. Recent discoveries have suggested that most known drugs or their analogues *are already in the brain*. That is, the brain has its own amphetamines (dopamine), sedative tranquilizers (serotonin), opiates (polypeptide encephalins and endorphines), cocaine (norepinephrine), and even hallucinogens (dimethyltryptamine). Brain states and world views will be characterized as profiles of expression of a symphony of chemical voices; drugs, like environments, will elicit coherent expressions of personality and culture. The penetration of classical anthropology as the study of culture as an abstraction, rules of it emerging independently of rules of people, by psychoanalytic and other forms of personality psychology in the late 1940s and early 1950s, will happen again as a new biological psychology of the brain encodes many of the old perceptions in the new language system (alcohol's courage and cowardice; emotional detachment from familial figures in optimistic autonomy of the tricyclic-antidepressant drug type; dissociated sexual activity of the Quaalude type), whether the chemicals involved are endogenously or exogenously supplied. Football and war are amphetamine, and transcendental meditation does not work if the otherwise normal subject has a relative deficiency of the brain's tranquilizer, serotonin.

The sequence of neurobiological events that serves as the focus of this paper has frequently been called "ineffable." William James adds a "noetic" quality (immediate knowing without discursive or analytic thought), transiency, and an

involuntary, will-less feeling. In *The Varieties of Religious Experience*, James called it a mystical experience. Saint Paul called it "the peace that passeth understanding"; Thomas Merton, the "transcendental unconscious"; Maslow, "peak experience"; Gurdjieff, "objective consciousness"; the Quakers, "inner light"; Jung, "individuation"; Emerson, "Oversoul"; Lao Tse, "the absolute Tao"; Zen Buddhism, "satori"; yogis, "samadhi"; Saint John of the Cross, "living flame"; *The Tibetan Book of the Dead*, "luminosity"; Saint Teresa, "ecstasy"; Blake, "divine intuition"; Buddha, "awake"; Brother Lawrence, "unclouded vision"; Jacob Boehme, "light, which is the heart of God"; Phil Judaeus, "joyful with exceeding gravity"; Plotinus, "divine spirit"; Colin Wilson, "intensity experience"; Eliade, "shamanic ecstasy"; Arthur Clarke, "overmind"; Arthur Deikman, "deautomatization"; a Harvard undergraduate on LSD, "moment of truth"; Julian Silverman (about an aspect of the acute schizophrenic reaction), "the oceanic fusion of higher and lower referential processes"; Walter Pahnke, "unity"; Wasson (about mushrooms), "the dawning of a new world"; Myerhoff, "mystic vision"; Tennyson, "the loss of personality seeming no extinction but the only true life"; Hinduism, "that"; and Ramón the Huichol, "Our life." Are these all the same? The Eastern comparative religionist Alan Watts, after his second LSD experience, answered, "embarrassingly" so. Like sexual orgasm, however, full of many of the same ineffable qualities and similarly associated with long-lasting metaphysical feelings like "being in love," manifestations of the same nervous-system reflex are often variously embellished by personality and culture. One can get into quite an argument about the similarities and differences of orgasms even though the neuromuscular aspects have been quantified. The religious experience lacks even these subtle signs.

One must differentiate between the human event of which we speak, the core religious experience, and what James has called the system of practices of the institutionalized followers. Weston La Barre distinguishes between religious practitioners who are visionaries, omniscient prophets, omnipotent shamans, and those who are the priests, "nonecstatic journeyman officiants of routinized established cults." The activity of the second group (what James called the practice of the "well" religions) falls easily within the frame of reference of cult diffusion, the sociology of ideas and institutions. Things are and will be fine if every item on the list is attended so. Secure in the inner knowing of one's orderly conduct and right thoughts, the priest and his followers feel safe. In contrast, the phenomena of the visionaries, the experiencers and promulgators of the core religious experience (the practice of what James called "sick" religion), usually grow out of severe melancholy, deprivation, pain, and desperation, involve altered states of consciousness and the infectious influence deriving from the effect and personal charisma of the experiencer on a group of followers.

Defining religious activity as that group of functions related to the construction and maintenance of a world view, and moving toward a physical understanding of the phenomena originally conceived of as metaphysical, such division of labor must not be seen as unique to the "religious" religions. Thomas Kuhn, in *The Structure of Scientific Revolutions*, suggests such dualism in the practice of the scientific religions as well: the practitioners of the paradigm—an increasingly unproductive but established belief system in an area of scientific thought—and the scientists who make anomalous discoveries and generate new theory leading to new field energy in a crisis of belief. These two roles help circumscribe the area of analysis; that is, we are not talking about established religious practice and its role in culture, but rather of the dynamics of the innovative moment. Social analysts have tried to reach from the phenomenology of the core religious experience to the moment of creative insight in the institutionalized religions of the sciences and the humanities, and we shall make the case that such times of inspired deviation may be partial expressions of the same brain mechanism and serve the same biologically adaptive

purpose. The appearance or emergence of the "explorer mutant" during a time of cult or paradigmatic crisis may well be an upper brain expression of a species survival reflex, reenergizing with hope and new possibilities at a time when tribal demoralization threatens all with resignation to death. Fatigue, hunger, depression, and anomie disappear as the group now in loving cooperation makes a renewed effort to survive, driven by the brain's religious reflex and its attendant metaphysical ideation.

Ramón, Furst and Myerhoff's Huichol medicine man, played both roles, shaman-visionary and priest-practitioner, and his followers shared regularly (through the sufferance of mescaline and other alkaloids in the peyote cactus) in the inspired moment. Each man was to some extent his own shaman, although both anthropologists note that Ramón's flock saw his peyote experience as having more significant metaphysical import than their own. Such an unusual and regular fusion of the energy of discovery and renewal (the experience of mescaline) with the confirmation of the established world view through the practice of established ritual may account for both the vigor and tenacity of the Huichol religion and its unique resistance to the assault of Christianity for over four hundred years. Above all modern Mexican Indians, the Huichols have been described as poised, dignified, and chauvinistic without being defensive. One might speculate that they have benefited from *both* (a) the regular experience of the divine religious moment and its aftereffects without the disruptions of cult crisis that such experiences have usually meant to the established order and (b) the structure and comfort of the practice of established religious ritual (first-fruits teaching of children; the peyote hunt; the spring rain ceremonies) without the insidious creeping focus on issues of individual power that arise in circumstances in which discovery and innovation no longer inspire and congeal the group. It may be that the Huichols, combining drug experience and ritual, have given us an ideal model to follow in what may be anticipated as an era of brain-chemical religions. Their art—manic-full, bright, strong, and clear in embroidery and yarn paintings—conveys the feeling of unapologetic belief in their symbols, the truths of their existence still alive in this era of Mexican Indian alcoholism, poverty, obsequious fear, and despair.

Walter Pahnke gathered widely the accounts of the core religious experience and listed nine phenomena which make up the syndrome. These include (1) A feeling of unification in both internal and external affairs; that is, previously disparate or conflictual material is now *felt* to be all of a piece. The word *felt* should be noted because it may not mean a new organization of cognitive material (though it may) but rather the same perceptions with a new feeling tone. Such detachment of feeling from symbolic activity is seen commonly in the experience of *déjà vu*, or in the influence of mood on perception: Is the glass half empty or half full? (2) Changes in one's perception of time and space. Time becomes a continuous ribbon without demarcations, so that what was, is, and will be are all the same. The deer, representative of the Huichol origins as hunters, and the maize, representative of the Huichols' partial conversion to agriculture, are fused with the peyote as symbols of simultaneous past, future, and present. (3) Deeply felt positive mood: things are or are becoming as good as they can be. (4) A sense of sacredness, specialness, respect, awe. (5) What James called the noetic quality; outside of logical thought, the realization and knowing about the truths of one's outside and inside worlds. A nonanalytic grasp that feels authoritative. (6) Logical incongruities that reveal the essential sameness of the polarities. The perception of another level of organization that encompasses and unifies over the authority of old divisions. (7) Ineffableness, because perhaps in the initial perceptual experience of an event—the creation of "newness" is a prominent feature of the action of mescaline—no ready vocabulary of analytic thoughts is waiting in the brain to grind up the new and stuff it into old drawers. (8) Transiency, a prominent issue for James and perhaps, along with "newness" and "persistency," the most useful properties for the neurobiological analysis. (9) Long-term

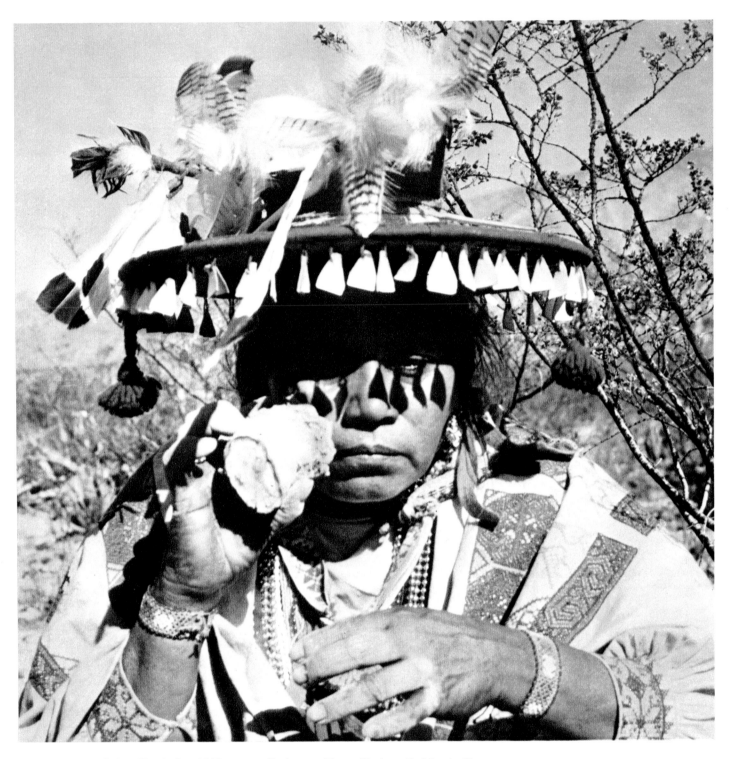

Guadalupe, Ramón's wife, during 1966 peyote pilgrimage. Photo: Barbara G. Myerhoff

or persisting changes in attitude and behavior toward the self, others, and the memory of the spiritual event. Myerhoff relates the goal and practice of the rites of the peyote hunt and its consummation to a singular property, unity, which with minimal semantic gyration can certainly be made to include the other eight categories.

In my review of the accounts of this moment, their circumstances including such diversity as the extension of effort risking death in long-distance running, epilepsy, acute schizophrenic episodes, and shamanic ecstasy, as well as the multiple drug- and non–drug-related religious experiences in the above list, I am left with the clinical impression of a pervasive stereotypy, sameness, in the human experience—what the modern physician would readily label a syndrome. Across thousands of miles and thousands of years, across myriad etiological circumstances, it all reads

the same. Given the ineffable quality of the event as well as its complexity, the amazing aspect of such a review is this sameness in the accounts. Such universality mandates the search for a common element, and that undeniably is man's brain. A mechanism must be built into the human brain that produces this response, given the conditions for its evocation. The fact that drugs whose effects on brain mechanisms can be investigated by means of experiments on animals are among its inducers allows the exploration of the neurochemistry and neurophysiology of the core religious experience, and, because such an experience expresses itself in personality and cultural terms, we can use such a bridge to speak of the neurochemistry of a religious world view.

The most useful pharmacological approach to identifying a biological event is the dose-response curve. The hypothesis that one is observing a biological dimension in response to a drug effect is bolstered by experiments in which graded amounts of drug are administered and a proportional change in the purported response is expected. A continuum of biological organization is thus identified. The larger the dose of digitalis, the slower the heartbeat. There appears to be a dimension of religious experience that varies systematically with the dose of the evocative agent. Popular Tao, made of magic, ritual, sorcery, and necromancy, has little or none of it. Esoteric Tao, the practice of the very few, represents the "full-dose" state in which one's life is sitting with a blank mind doing arduous exercises and meditation, deprived of the human intercourse thought to buffet destructively with desire, revulsion, grief, joy, delight, and annoyance. A few achieve pure consciousness from which rises a joyful unity, the Absolute Tao. The third Tao is philosophical, the "half-dose" state, teaching a life of creative quietude, a harmony of opposites, Wu Wei as involuntary and easy action coming from a relaxed consciousness and leading to serene and graceful living. Speaking from another data base, from experiences with psychedelic drugs and psychiatric patients, Roland Fischer proposes that "normality,

creativity, mystical states, and schizophrenia, though seemingly disparate, actually lie along a continuum." With increasing brain activation along the dimension of his theoretical construct, the organization of self and objects tied to sensate experience gradually dissolves in a fusion of subject and object in "pure cerebral time-space," leading to the ultimate "oceanic" experience. Creative states are seen to lie halfway, the mind not tied to the fixity of learned connections and yet still able to differentiate between objects well enough to make innovative rearrangement.

The cannabinoids, weak hallucinogens unable to produce full psychedelic effects except in enormous doses, create phenomena suggestive of a change in cerebral dominance and electroencephalogrammic slowing of the sort associated with meditation and trance states. Thus we may view this "half-dose" realm in the way we look at the similarities in descriptions of the religious and neuropharmacological events of the "peak experience," demonstrating similarity of phenomena independent of causative techniques and aiding further in describing the neurobiological matrix of this dimension of human existence. A recently synthesized group of hallucinogens with a broad range of middle doses has allowed the exploration of this middle zone. (In contrast, LSD is in the middle-dose range at 50 to 75 micrograms, and at a full dose at 150 micrograms, a dose-range factor of two; the new compounds have a dose-range factor of 100.) Because of these finer gradations of potency, human response can be titrated, depending of course upon the individual threshold, in gradual transition from meditative calm with imaginative alertness through mystical wondering and new insights to the full white peak, overwhelming in grandeur, soulshaking in impact, cosmic in implication.

This unique continuum of brain arousal, first calming (though alert) and then activating, appears in the behavior of animals when a particular brain hormone level is increased. There are two known neurohormonal systems that activate behavior, but with very different characteristics. When the catecholamines dopamine or norepinephrine are

infused into the brains of rats, the animals first become hyperactive, exploring their environment with zeal, and then locked into repetitive behavior. In humans, amphetamine, the drug representation of brain dopamine, first creates alert searching, but finally anger, circular, fixed, delusional thoughts, unresponsive to new information. Warlike and paranoid, the dopamine world view at its peak is the righteous killings of Ireland, Korea, Israel, Vietnam, the Sino-Russian border, and the Ku Klux Klan. This energizing "up" of rage and war, latent in the brain and contagious in activation from fathers, big brothers, and television, is *not* the same as the gradient of energy of the religious circuit. The latter dimension is more like that seen during the infusion of another brain hormone, serotonin, which in small doses reduces spontaneous activity though the animal remains alert. He stares into space, waiting. With further amounts he becomes active but assumes unusual postures, sometimes seeming to deal with imagined environmental events. As human beings descend through the states of surgical anesthesia before unresponsiveness, they go through first a phase of relaxation and light sleep and then one of brain arousal characterized by intense visual imagery, activation of emotional memories, and highly significant cognitive events. Nitrous oxide and light chloroform were noted to be evocative of this mystical religious experience by James in 1902. It is tempting to speculate that the brain's religious circuit involves the serotonin dimension of arousal. There is a great deal of evidence suggesting that the hallucinogens express themselves through the serotonin system and that the serotonin system may regulate the inhibitory influences of habituation (the gradual disappearance of the experience of "new"), the other side of the continuum from what observers of the religious and psychedelic drug scenes have called a renewal. It was Myerhoff's insight that the symbolism and feeling of the peyote hunt among the Huichols bespoke a return to the beginning, a revivification. The process of inhibiting the perceptual response to repeated stimulation (habituation), tied to the function of the serotonin system by the hallucinogenic drug action which alters both, can also serve as a link to schizophrenia (the phenomenology of which has been seen as an aspect of the expression of the religious circuit) in that the failure to habituate to repeated startling stimuli has been found to be a characteristic of children genetically prone to (later-developing) schizophrenia. Though it is a very complex issue, it would not be outrageous to suggest that the sensitivity, awareness, unanchored cognitive processes and strange experiences of the borderline patient may be a "half-dose" representation of the expression of the core religious experience; the psychotic break, the "full dose"—the difference between divine revelation and schizophrenic disorganization—being a matter of semantics, degree of ego integrative capacity, and/or the cultural context of the event.

Serotonin, a quieting brain hormone that comes from tryptophan, an amino acid component of the protein of the diet, is secreted by cells that help to control excitement. The brain, needing to keep its informational freeways open, has gating systems that arrange it so we get used to things quickly. We stop noticing as we put the old away wrapped in pat explanation. We live protected from information by boredom. Signals of pleasure and pain coming in to light up a sign at the same time trigger serotonin cells to get there first, like a law-enforcement contingent sent to keep local excitement from becoming riotous. They dampen the reception accorded the same signal next time. Finally, we who live by ocean beauty and sleep beside a soft sensual sag in upturned breasts stop noticing. Studying this mechanism, we learn that meaning, a feeling of significance, illuminating like a bright beacon, flits to another place or sleeps as time disappears in the lethargy of another *yet again*. Philip Roth, our professor of desire, despairs of needing the risk of jumps across a tall new set of ovaries to get excited. It's hard to do with a friend. The male rat mounts the female until ejaculation and isn't interested again until a new female rat is brought into the cage. Changing partners constantly, he will fornicate to exhaustion. This organized and protective boredom is called

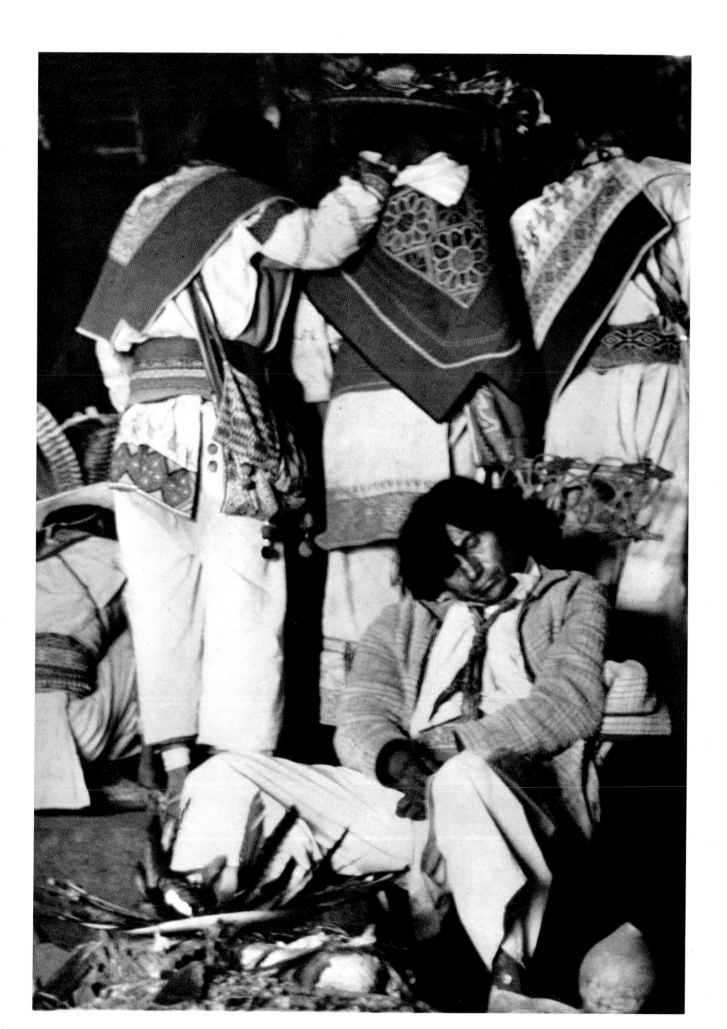

habituation by the psychologists, virtue by the British, torture by the French, and myth by the Italians. The Russians have called the brain's response to a new stimulus the orienting response, and it signals paying attention. As boredom sets in, the response disappears. Hallucinogens of the sort found in peyote have the unique property of retarding the onset and development of habituation by inhibiting the brain's serotonin system, allowing the brain to respond to old stimuli as if they were new—over and over without waning excitation, analytic organization, or cynical dismissal. In her *Peyote Hunt*, Myerhoff described the essence of the Huichol peyote-hunt cycle of ritual search and chemical consumption as a "return" to the naïveté of childhood, the freshness of not knowing, giving the pleasure of seeing again. The brain-chemistry studies of the action of mescaline, the active principle in the peyote cactus, can be seen as confirming that hypothesis. When the *mara'akame* directs his pilgrims to "chew it well . . . so that you will see your life" it is to see the old life anew. And God.

Another sequence of links between religious experience and the function of the brain's serotonin system relates to the maneuvers and circumstances found useful in the induction of the state without drugs. William James's classical review of the mystical experiences in literature has found that pain, fatigue, hunger, and, prominently, melancholy were substrates for the core religious experience. Expressed in neurophysiological language, one might say that these experiences lower the threshold for the expression of the religious reflex. The deprivations of the Huichol peyote hunt—reduced food, water, salt, sexual activity—and the grave, sad tearfulness as part of the ritual before reaching Wirikuta, as well as the sleep deprivation and fatigue of the entire ordeal, can be argued to potentiate the action of the peyote on physiological grounds by their "teasing" of the brain's serotonin system toward lowering the threshold for the expression of religious feelings. Serotonin synthesis is promoted by pain, hunger, prolonged physical activity, sleep deprivation, sexuality, sensory isolation, and depression. Saint John's "long night" of metaphysical searching

and depressive pain may well be a necessary part of the induction of the core religious experience in some brains.

Recent research has shown that the brain has many ways of adjusting to external influences and that environmental circumstances that produce chemical changes stop doing so with repeated exposure. This is not the neurophysiological organization that produces the habituation to sensory stimuli described above, but rather a more fundamental characteristic of brain cells called "adaptive regulation." The brain thus protects itself from the runaway influence of a system, in this case the serotonin inhibitory system. These mechanisms are seen in such drug-abuse syndromes as "tolerance"; the same dose of the drug ceases to work. Without going into the myriad mechanisms involved, suffice it to say that for the serotonin system, continued activation apparently produces increases in serotonin synthesis until a point is reached when its synthesis is markedly reduced. What begins as an activation of a system, carried further results in its arrest. It is the thesis of this essay that the core religious experience occurs at this time of sudden serotonin-system arrest, either because of its overstimulation by multiple "normal" phenomena like pain, hunger, fatigue, temperature extremes, and ruminative depressive thoughts (brain activity leading finally to reduced serotonin synthesis through the mechanisms of adaptive regulation) or because of the shutdown of this system with hallucinogenic drugs which have been shown uniquely to stop serotonin-cell discharges suddenly. The subjective correlates of this experience are a "release," a sudden reversal of the chemical changes of habituation and the re-emergence of fresh experience, the disinhibition of complex sensory responses previously gated by serotonin, allowing their inner reception and convergence into new combinations, a sudden "relief" from the background pain of living, a reinfusion of energy and hope, and the metaphysical wondering that such miracles stimulate. James called this experience, coming out of the substrate of sickness, the religion of the twice born.

The persistence of these feelings for weeks or months

after the event can also be understood within the framework of adaptive regulation. Whereas acute effects of drugs may last only hours, the brain mechanisms triggered to counteract their effects last much longer. Changes in these brain mechanisms have been known to last months after a single administration of a drug. The tricyclic antidepressant drugs take three to six weeks to work; it appears that the antidepressant effect is achieved by the brain's own compensatory mechanisms, for the depressive phenomenon is temporarily worsened by the drug. The longer-lasting effects of drugs have become increasingly important to those interested in understanding the wider cultural influence of psychopharmacological agents. Whereas the time of drug taking and drug effect is demarcated by ritual and awareness—a cocktail party last night, the amphetamine taken as part of a diet this morning—the longer-lasting expressions of brain mechanisms that follow are lost in a welter of personality and cultural interpretation. The anxious tentativeness, vulnerability to criticism, and brain-chemistry guilt of alcohol withdrawal, lasting hours or days, are seen as oral dependence, socially derived superego concerns based on cultural attitudes toward alcohol, or a characterological fearfulness of the alcoholic. The depressive mood and obesity of the chronic amphetamine taker is characteristic of the amphetamine withdrawal state as well as, or instead of, a diagnostic syndrome. Cultures tend to reflect the brain chemistry of the long-lasting withdrawal states of their dominant drugs. The minor tranquilizers like Librium and Valium, taken for comfort and courage, generate long-lasting withdrawal states of depressively fearful conformity deriving from their effects on the brain. One gets more enslaved to a system that promotes fearful dependence when the manner of coping with it is a drug that brings temporary comfort but follows with days and weeks of vulnerability to criticism growing out of already anxious feelings.

The expression of the religious neural circuit, whether coming from the adaptive changes following long periods of psychological and physiological bombardment or triggered by hallucinogenic drugs, is followed by long periods of euphoric and peaceful positivity, what Myerhoff has called the Huichol worldview, the structure of a mystic vision. It is perhaps ironic that the neurochemical-cultural metaphysic that was so resistant to change when attacked for four hundred years by Spanish Catholicism may be finally falling in a battle between the withdrawal states of peyote and the withdrawal states of alcohol, world views which are mutually exclusive, antithetical serotonin brain states. Serotonin synthesis, reduced by peyote, is increased by alcohol withdrawal—poised, proud, and undefensive, versus obsequious, guilty, and afraid. It has been pointed out by Furst, Myerhoff, and Norman and Guillermo that the increased money supply the Huichol people derived from their arts and crafts, particularly their yarn paintings, has led to the availability of cheaper, commercially prepared alcoholic beverages with a much higher alcohol content than their native maize beer and rare maize liquor.

Ramón, the wise and kind medicine man who was an informant for Myerhoff and Furst, was killed on June 23, 1971, in a drunken quarrel and shooting. I simply could not imagine that happening after reading their material about him and his life. It was as though his head had been invaded by a force not manifested anywhere else in their ethnographies. We must entertain the possibility that the Huichol culture will die from the brain changes induced by the same agent turning their metaphysically complete peyote world of peaceful joy into the anxious emptiness, need, and pain-engendered rage of alcoholism.

EMBROIDERY SAMPLE
Collected by Susan Eger in San Andrés (1976–77)

Sample of pattern referring to four sacred directions and showing the incredible variety and combination of design elements and colors.

Acculturation and Economics

Huichol Art and Acculturation
Kal Muller

The San Andrés Cohamiata

The Huichol Indians described here are those from the district of San Andrés Cohamiata. They have preserved their aboriginal culture to a remarkable degree, and their metaphysics and life style have remained largely unchanged. Their society is egalitarian and free of class distinctions. Shaman and governor, rich and poor, lead fundamentally similar lives based on subsistence agriculture. The Huichol culture has not reached any degree of specialization as we know it. The tribe is conservative in many aspects, having preserved in its religion elements of its preagricultural past. Both the population dispersion pattern and much of the basic mythology seem to indicate that the Huichols were once a hunting and gathering people who settled down to an agricultural way of life rather recently.

Adaptability, combined with a tenacious attachment to their traditional way of life, is an essential characteristic of the Huichols, both in the material and the spiritual realms. Pressure by Franciscan missionaries in the mid-eighteenth century, backed by Spanish military power, led to the adoption—and later assimilation—of some of the outward forms of Roman Catholicism. When outside political structures demanded dealings with a recognizable and responsive body of officials, the present system of district civil officers arose. The need for material goods introduced through cultural contact has been satisfied with cash obtained through work on coastal plantations, through the sale of cattle, and, above all, through the sale of artwork. The changes their society has undergone have until now been superficial, leaving its underlying dynamics relatively intact. As new pressures present much stronger challenges than those of the past, only time will tell if the Huichol culture will survive essentially in its present form.

According to myths and the historical piecing done so far by Phil Weigand, Barbara Myerhoff and other scholars, the two possible routes of migration which brought the Huichols to the Sierra both started from the north and passed along either the eastern side of the Sierra Madre Occidental or the western side, down the Pacific coast. The Huichols probably learned agriculture through contact with other more technologically advanced groups prior to being pushed into the inhospitable canyons of the Sierra by stronger tribes. Their cultural survival to the present is due in large part to this rugged, poorly accessible terrain lacking easily worked fertile land and natural resources. The main stages of the unrecorded history of the tribe probably survive in the sacred peyote-deer-corn trinity, with peyote and deer associated with the hunting-gathering stage, and corn symbolizing the more recent agricultural pursuits.

Settlement patterns tend to be scattered by extended family groups, with several huts and grain storage structures at close proximity for the various related families. The distances between these small agglomerations, called *ranchos*, range from several hundred yards to a half day's walk. The *ranchos* tend to be largely autonomous with regard to food production and many rituals. A myth states that the gods ordered the Huichols to live far enough apart so that the women would not quarrel, but in practical terms it is more convenient to live near where the corn, beans, and squash are planted. With little land suitable for agriculture, these fields tend to be scattered. The dispersion of settlements could also be a carry-over from the hunting stage, when only small groups could hope to survive from an occasional kill.

The essential ceremonies of the year—the planting and harvest rituals and those associated with the peyote pilgrimage—are held in centrally located *tuki*. These ceremonies are led by a *tsauririka*, or singing shaman, who is assisted by various temple officers, all chosen for five-year terms. Almost every Huichol male will hold several of the official positions during his lifetime. All these rituals, each preceded by a deer hunt, demonstrate the combination of hunting and settled ideologies inherent in the Huichols' character.

Outside Influences on Organization and Religion

Traditionally, social and political organization stopped at the *tuki* level. The integration of new values, accepted under threat of force and molded by the Huichols to fit in with their traditions, has left the essential underlying cultural attitudes intact.

Under pressure from the Spanish colonial administration the Huichol territory was divided into three districts. Two other districts were subsequently formed from parts of the original three. Every year, through the dreams and consensus of the *kawitero*, or elders, a governor and other officials are selected for the districts. The new leaders must present themselves to the seat of the appropriate Mexican *municipio* (county) for ratification in their posts, a purely formal gesture. The principal official, the governor, has the native title of *tatoani* (the one who speaks). The policemen-messengers attached to each principal civil official are called *topilli*. The titles of the other principal officials—*alcalde, alguacil, capitán*—come straight out of Spanish colonial administration, as does the title *comisario* given to those who represent subdivisions of the district, usually corresponding to the various *tuki* areas. These officials, along with the council of elders, deal with problems arising from contacts with the outside, community matters such as reroofing of the church, and punishment for offenses such as theft and adultery.

Various rituals loosely based on early contacts with Catholicism are performed in the district center. These include *Semana Sancta*, or Easter Week, and *Las Pachitas*, an eclectic ceremony combining *carnaval*, Ash Wednesday, the honoring of saints, the Mexican festival of Flag Day, and elements of a fertility ceremony. These two rituals are now completely integrated into the lives of the Indians, who identify to some extent with the others of their district. Although both ceremonies are necessary from a religious and social point of view, the *tuki*-based rituals retain their paramount importance.

The district-wide political structure and Christian-based rituals have been so thoroughly integrated into Huichol patterns as to be almost indistinguishable from indigenous elements, except for the use of Catholic statues and Spanish titles.

From the Conquest to the 1950s

Huichol history since the sixteenth century has been influenced to a large extent by developments in the rest of Mexico. Formal contacts between the Spaniards and Huichols did not start until the eighteenth century, although some ideas and material culture had been introduced earlier. For the first two hundred years after the Conquest, the Spaniards showed little organized interest in the Huichols' rugged territory. We cannot assume, however, that the Huichols were completely isolated during this period, or even before the Conquest. Trading undoubtedly took place with more advanced groups on the Pacific side of the Sierra as well as with other groups. With trade, some religious ideas might have been assimilated, although nothing in present-day Huichol rituals suggests anything as elaborate as those of the more advanced groups in central and southern Mexico.

During the centuries following the advent of the Spaniards and the fall of Tenochtitlán, the Aztec capital, the Huichols were introduced to metal implements and domestic animals—sheep, horses, mules, and cattle—through sporadic contacts with Spaniards—mestizos—and other tribes in close relation with the foreigners. (Though mestizos are in fact persons of mixed Spanish and Indian blood, the Huichols refer to all Mexicans living in the Sierras as mestizos, and the term is here used in their sense.) The Huichols today make pilgrimages to take offerings to deities who live outside the Sierra Madre as well as to gather peyote. Presumably, these pilgrimages date back hundreds of years and may have led to contacts with the Spaniards.

Huichols had contact with and probably participated in

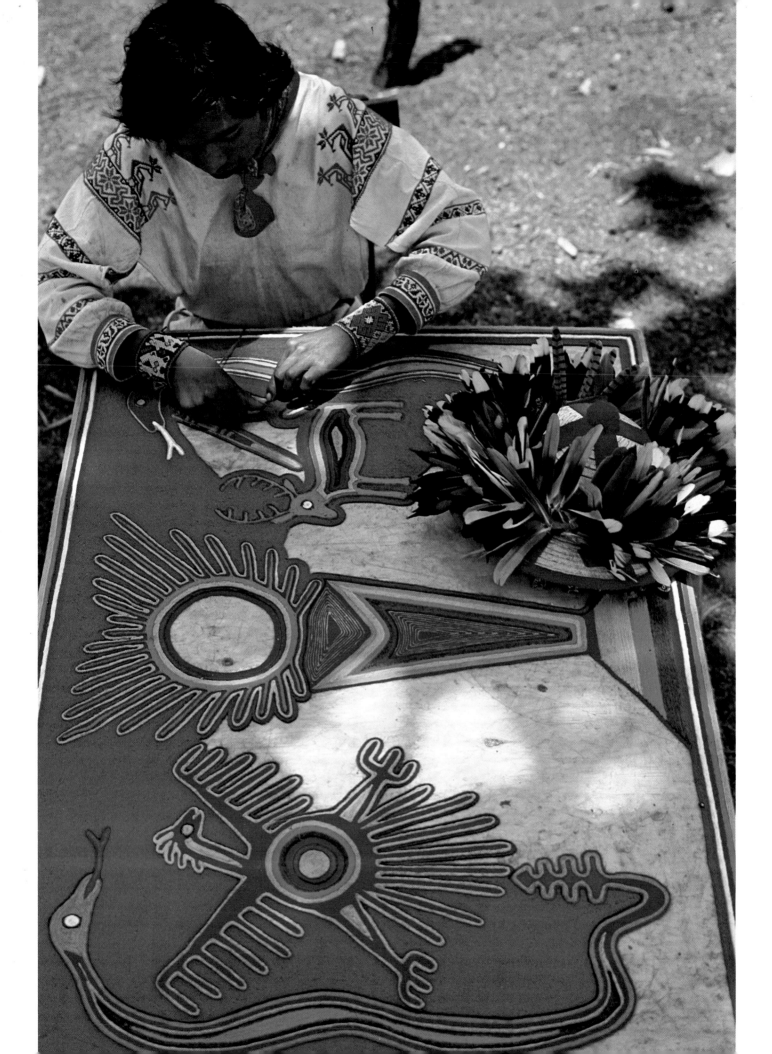

Huichol artist at work on large yarn painting representing the birth of the sun. Photo: Kal Muller

raids against the Spanish, possibly led by refugees from other tribes subjugated by the conquistadores. The neighboring Coras were conquered at the beginning of the eighteenth century because they had refused to allow missionaries to enter their homeland. Few records remain regarding the Huichols, but missionary activity in their section of the Sierras presumably began in earnest shortly after the conquest of the Coras. Little money was then available to the missions, due partly to the emphasis on other regions and to corruption within the Catholic Church, whereby funds earmarked for missionary work often ended up elsewhere.

The contacts with missionaries in the eighteenth and nineteenth centuries, however sporadic, left a definite mark on the Huichol religion. A stone church built in San Andrés, probably in the latter part of the nineteenth century, is the focal point of present-day Christian-based ceremonies. The Indians make no attempt to re-create their version of mass; rather, the church is simply considered a holy place where, for example, necklaces made of dried tortillas or *pinole* (corn dough mixed with honey) are consecrated and then placed on fruit trees to increase their productivity. During Easter Week the two statues of Christ on the cross are bathed and "put to sleep" in the church. On Holy Saturday, when they "awake," bulls are killed in the church and their blood diverted into a special opening in the floor.

Elements of Catholic mythology were also introduced by the missionaries. These historical legends have become so assimilated that they are difficult to recognize. For example, Joseph is said to have obtained Mary by winning a Huichol violin-playing contest; Mary to have conceived Jesus from a flower she put in her skirt when she was sweeping a *tuki* (a popular pre-Columbian method of conceiving a deity); and Christ allegedly was crucified by bad Mexicans. The saints are credited with putting a stop to the persecution of the Jews in Mexico (probably a confusion with Egypt) and with having introduced cattle into the Sierras.

Other remnants of missionary influence include the *matachín* dancers—originally trained by missionaries as substitutes for "pagan" dancers—who perform in various district ceremonies. Baptism is still performed, just like various indigenous rituals in which holy water is also sprinkled on the top of the head where the *kupuri*, or soul, is said to dwell. Statues of Christ and various saints have been accepted into the Huichol pantheon, albeit as minor deities. A *mayordomo* is in charge of each statue. Offerings, including peyote, are made to the saints and to the two statues of Christ. All the various statues of the saints and Christs are said to be able to speak the Huichol language to the shamans.

During the first half of the twentieth century, contacts with the outside became increasingly frequent. Missionary activity ceased almost completely, but tensions over land ownership began to be felt. After the revolution of 1910–17, the hacienda of San Juan Capistrano was converted into an *ejido*. Land in the *ejidos*, which were created after the revolution, is divided among the original recipients and cannot be sold. Some of its marginal lands, considered by the Huichols to be in their territory, were settled by mestizos. Indeed, territorial jurisdictions remain a major problem, with land-hungry mestizos trying to obtain Huichol lands for both agriculture and grazing. Only recently have the Indians in the district realized that they have to organize themselves to try to contain mestizo encroachments. Current Mexican law is more sympathetic toward *ejidos* than to the traditional communal land ownership of the Huichols. The problem is compounded by the fact that the Indians' land is underpopulated. Legal difficulties and bureaucracy stand in the way of secure boundaries.

INFLUENCES OF THE INI, THE PLAN HUICOT,
AND RENEWED MISSIONARY EFFORTS

During the last two decades, Mexico has begun to pay greater attention to marginal areas such as those in the Sierras. The government has introduced better means of communications, schools, medical services, and, especially,

87

modern agricultural methods. These programs have had a varied measure of success. Popular hostility against the Catholic Church has decreased, and missionary activity among the Huichols has been resumed.

Starting in the 1950s, contacts began to accelerate, due primarily to the construction of aircraft landing strips by the Catholic Church. Although the Church was refused permission to establish itself at the district center of San Andrés—indeed, priests are not allowed to conduct any kind of service at its church—two missions are maintained in the district: at Santa Clara, a little over one hour's walk from San Andrés, and at Huestita, on the opposite side of a huge canyon. Each mission has a well-organized school where the children are also fed and given some clothing. So far, the missionaries' efforts have had little impact; scarcely any Huichol adults show up for mass. But the reassimilation of the children into the indigenous culture after time spent at the mission can produce psychological crises, as in the case of a young man, the son and grandson of shamans, who, on returning home for a ritual, vociferously denounced "pagan" practices. After a series of other traumas, he is now reintegrated into Huichol culture. However, missionaries are persistent and may slowly be able to achieve results.

The external changes brought about by the Mexican government started in 1960, when the Instituto Nacional Indigenista, or National Indian Institute (INI), started a Cora-Huichol center which is now located in Tepic, the capital of the state of Nayarit. In 1964, a landing strip was built at San Andrés to accommodate both official and commercial flights. The INI also started a medical program, an experimental agricultural station, and a school in San Andrés.

In 1970, the foundation was laid for the Plan HUICOT (an acronym of Huichol, Cora, and Tepehuane, the three Indian groups living in this region of the Sierras) to coordinate the efforts of various government agencies. A special interest of then-President Luís Echeverría, it insured funding for plans designed to bring the Huichols into the na-

tional orbit. The INI programs were expanded and new programs started with mixed results and acceptance. As of early 1978, however, Plan HUICOT was disbanded.

The Public Works Department has recently completed a dirt road linking San Andrés to the existing Zacatecas–San Juan–Peyotán road. At present, no funds are allocated for its upkeep, and at the end of the rainy season the road may well be impassable. When it is working, a transmitter-receiver radio makes communication with the outside world possible twice a day. The agricultural station has seen to the adaption of new strains of corn to the Sierras, the introduction of better strains of cattle to cross-breed with the Huichols' stock, and inoculation programs for the animals. With a monumental lack of foresight, the Department of Agriculture built a large slaughterhouse, failing to take into account the year-round water shortage, transportation logistics, and the limited cattle. The facilities now serve as sleeping quarters and storage area for the carpentry shop making beehives for distribution throughout the Sierras. The choice of the shop's location leaves much to be desired, as all the wood has to be flown in and the beehives flown out. The Hydrological Resources Department has sunk a well with pump, storage tank, and faucet in the central plaza, and outlets to the carpentry shop and the agricultural station. But often the pump does not work. The Federal Electrical Commission has installed a generator next to the carpentry shop and has run power lines some five hundred yards to San Andrés, but the system breaks down frequently and at times lacks diesel fuel, which has to be flown in. Most of the time, electrical use is limited to the carpentry shop and to the Mexican workers at night. The health program often lacks medicines due to scant finances and problems of logistics. The school functions with forty to fifty students and Huichol teachers who have had six years of primary schooling and one or two years of teachers' training. Little has been done to adapt the curriculum to the context of the Sierras.

The agricultural program has had the most visible effect. Traditionally, the Huichol family farms one or more small

plots on the slopes of steep canyons using the slash-and-burn method of preparing the soil and a digging stick, or *coa*, to make a hole into which corn, bean, and squash seeds are dropped. The soil is poor, and yields of corn meager.

After some experimentation, the Department of Agriculture decided to try to put into use some of the flat mesa areas of the district. Tractors, barbed wire, fertilizer, and hybrid seed corn were flown in. Credit was made available to those Huichols who wanted to participate in the program. By 1975, some twenty-six heads of families had joined.

On the surface the program seems excellent, but some problems are apparent. Agriculture and religion are closely linked in the Huichol mind, and the modern methods do not fit into their metaphysics. The requisite psychological foundation had not been laid. Some of the participants were criticized by their peers for discarding traditional agriculture. Those who also planted in the canyons were faced with a residency problem, since growing corn requires constant care. Unable to dwell in two places at the same time, they opted to live near the canyon fields, neglecting those on the mesa. The government, acting in good faith, had taken a paternalistic attitude whereby almost everything was done for the Huichols, and little if any initiative on their part was required. The excellent results and the little work it took prompted some Huichols to leave their *coamil*—a plot of land worked with a *coa*—unprepared the next year. However, due to administrative and logistical problems, the seed corn did not arrive on time, and no corn was sown on the mesa. The Indians are liable for the expenses of the preparation of the land and are now faced with a serious shortage of corn.

Increased government efforts in the Sierras have resulted in continuous contact, which, if kept up, could mean some profound changes for the Huichols. However, results so far have been somewhat spotty, and lack of government finances has curtailed some programs. The net effect could well mean greater self-reliance as the Huichols realize that they cannot count on the government to carry through all the started programs.

THE INTRODUCTION OF MATERIAL ELEMENTS INTO HUICHOL CULTURE

The many contacts with the dominant Mexican culture have resulted in the introduction of a fairly large number of material goods, almost all of which could easily be dispensed with. The Indian families are self-sufficient in foodstuffs and building materials. Recent contacts with various classes of outsiders—mestizos, Mexican government workers, tourists—have exposed the Huichols to different values and many material goods, but so far no basic changes are apparent in their way of life.

The omnipresent short, curved machete is the one item from the outside which is almost indispensable. A Huichol male uses his machete to clear his fields, cut firewood, dig up peyote, fashion a small violin, and for a thousand other purposes. Almost every *rancho* also has an ax for cutting the larger trees and splitting logs for firewood.

Many men own .22 rifles, but their use in hunting is restricted by the cost and unavailability of cartridges. Nevertheless, since the introduction of these rifles in the late 1940s and early 1950s, the deer population of the Huichol territory has been almost completely wiped out. Traditionally the Indians hunted with nets, trapping the deer and asking its forgiveness before killing it. The Indians believe that they see a deer because the gods have sent the animal and that they cannot kill it unless the deer wants to die. This attitude, combined with the efficiency of the rifle, has forced the Huichols to do their traditional hunting (when killing a deer is essential for a ritual) either on the periphery of their territory or in mestizo-controlled lands.

The women's most useful imported tool is the metal corn grinder. After the corn has been boiled with lime, it is first passed through this grinder and then reground on a stone metate, often also store-bought. Only a few of the Indians in the district make their own clay pots and grid-

dles; most purchase them or trade for them with Indians of another district. Matches are widely used, although new fires are most frequently started from embers. Most *ranchos* are self-sufficient in the staple foods, but buy salt, sugar, and occasional luxury items such as tinned fish and sweet biscuits.

Less essential but nevertheless common items from the outside incorporated into Huichol life include rope halters and saddles for horses, mules, and donkeys. Most of the raw material used for making clothing—cloth, thread, needles, and colored wool—is store-bought. Although the purchased *manta* cloth (a coarse cotton) is used in all clothing, the techniques of weaving and braiding cactus fibers are still in daily use and could be adapted for clothing. Suitcases are used for storage, to keep the rats from chewing up the clothing. The use of cotton blankets is also widespread. Store-bought huaraches, made of leather and pieces of tires, are commonly worn by both men and women at festivals, although at the *ranchos* many women go barefoot.

Radios have become increasingly popular in recent years in spite of their high cost. Mexican music has become quite popular, as has a regular weekly program in the Huichol language. A few of the Indians own record players which they bring to festivals and play for anyone able to pay to listen to one of their scratchy records. Some tape recorders have also appeared, and they are used most frequently to tape the chanting of the *tsaururika* and the owner's own violin and guitar music.

Contacts with Outsiders

A great deal of material and some ideological acculturation has resulted from contact with the mestizo population of the Sierras. Many mestizos eke out a living in the same harsh environment and tend to have similar material problems as the Huichols. Although little socialization takes place between Huichol and mestizo, there is a great deal of contact during the district-wide festivals at San Andrés.

Groups of mestizos show up for the fiestas, hawking their wares. Mestizo cattle buyers sometimes also make an appearance, but their visits are not restricted to these occasions. In some cases, Huichols have loaned plots of land to poor mestizos who work them for a half share of the harvest.

Tourists are also turning up with increased frequency in San Andrés throughout the year, but especially during Easter Week, the only fixed-date festival in the Huichol calendar. Many of these tend to be young, attracted by the exotic, peyote-based rituals. Those who come craving acceptance are doomed to disappointment. The Huichols are not particularly friendly, do not want to be photographed, and seldom give out peyote. Most tourists stay a few days in the vicinity of San Andrés, buy or trade for a few items such as necklaces, woven bags, or some embroidered items, and then leave.

Some *tewari* (foreigners, outsiders) who have lived in San Andrés for long periods of time have had more influence on the Huichols than have the casual tourists. Those who have stayed more than one year include two doctors, workers at the carpentry shop and the agricultural station, social workers, a nurse with over five years' residence, and three non-Mexicans. The non-Mexican *tewari* have brought in raw materials for the arts and crafts, purchased artwork in relatively large quantities, and tended to pay higher prices for better-made articles. One has also started an extensive fruit-tree-planting program. In general they have also shown a continued and deep interest in the Huichols' traditions.

As the outside world has intruded into their homeland, and they have remained substantially independent in the spiritual sphere, the Huichols have become somewhat materialistic. Their material needs, still not very deeply rooted, can be satisfied either by working for wages or through the sale of arts and crafts. Because few wage-earning opportunities exist in the Sierras, many of the men leave for a few months every year to perform agricultural work on the Pacific side of the mountains. During this

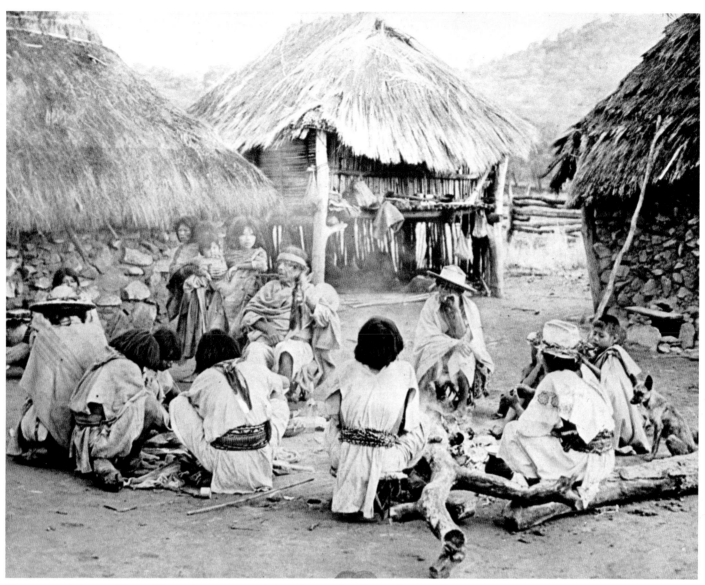

Ceremony of the parching of the maize on a *mara'akame's rancho*. Photo: Peter T. Furst

time they are subject to many acculturation pressures, with regard both to external appearance and ideas, but upon returning home, they will resume their native dress and religion.

Traditional Huichol Religion

One finds many older Mesoamerican elements in the Huichol religion. The personification of nature, the offerings to the deities, and the peyote-connected rituals go back many centuries, as do rituals connected with the crops.

The religion of the Huichols is basically pantheistic. The forces of nature are personified and labeled in kinship terms. Thus we have, among others, Tayau, Father Sun; Tatewari, Grandfather Fire; Tatei Matinieri, Rapawilleme, and Aramara, the Rain Mothers; Kauyumari, Brother Deer; Nakawe, Grandmother Growth; and Tatei Urianaka, Mother Earth. This view of the supernatural bears some resemblance to the view existing in Mexico before the rituals became extremely elaborate and served not so much as forms of worship but as political tools used by the upper classes. Various aspects of Huichol metaphysics and rituals were certainly introduced through contact with other peoples, but the religion has been kept essentially as a means of manipulating those forces of nature which can give the people good health, abundant crops, and success in the deer hunt.

Deities are propitiated and controlled through offerings taken to their residences in or outside the mountains. The

most important pilgrimages outside the Huichol homeland are to San Blas, Nayarit, the home of Tatei Aramara; to Lake Chapala, Jalisco, home of Tatei Rapawilleme; and to the desert near Real de Catorce, San Luis Potosí, the location of Wirikuta, the land of peyote.

Peyote is an integral part of the Huichol religious experience. A small dose (one to four heads) inhibits hunger, thirst, fatigue, and sexual desire. Larger doses (five or more) produce hallucinations and afford a means of communication with the deities. The shamans often take peyote to enable them to chant over long periods of time during rituals. They also eat peyote to try to find out which deity sent a particular sickness and what must be done to alleviate the condition.

Peyote does not grow in the Sierras and must be obtained from the desert, some three hundred fifty miles from the Huichols' territory. The principal temple officers from each *tuki* participate in a yearly pilgrimage to bring back the sacred cactus. Individuals who wish to fulfill a vow or were directed to do so by a shaman also join in the peyote pilgrimage; they take along ritual offerings which symbolically express their desires and intents.

Some join the peyote pilgrimage to find out whether they should become shamans. The father of a Huichol friend of mine, a middle-aged shaman, told me that he had gone to Wirikuta as a young man and had eaten thirty-five peyote buttons in one sitting. Two unknown old men appeared at his side, just like the assistants of the *tsauririka*. One told him to look into the fire, where he saw a typewriter, writing by itself. The other told him to pull the sheets out of the typewriter and read what was on them. He did, even though he cannot read. The sheets kept coming out of the typewriter all night, and he kept "reading" and chanting what he saw. The next day the other pilgrims told him that during the whole night he had performed as a *tsauririka*, singing in a complicated ritual, and that surely the gods wanted him to become a shaman.

Of all Huichol rituals, the peyote pilgrimage exposes the Huichols to the most acculturative influences by bringing groups of them into contact with the outside world. The Huichols have accepted some changes in the ritual as both convenient and inevitable. They use available means of transportation when possible and purchase some of the required offerings along the way. During colonial times, the pilgrims had to be careful not to get caught and put to forced labor in the mines. They still must be careful of drug-conscious Mexican officials who will sometimes confiscate the peyote unless a bribe is paid. If they lack the required cash, they have to assume a deferential manner in order to be able to continue their return trip with their peyote. Interestingly, on a recent pilgrimage confiscated peyote was returned by a military official when the Indians threatened to summon a lawyer.

The peyote pilgrimage is not as arduous as in the past, when it took some twenty days of walking each way. Now, after three or four days' walk from the *tuki*, buses and trucks are taken to Wirikuta. But the use of these conveyances presents some problems. They do not take the traditional route past sacred places where offerings should be deposited. When the road does go by a sacred spot, the buses do not stop, and the offerings to the deities have to be thrown out of the window.

Although the trip is no longer as arduous as in the old days, cash is required to cover the cost of transportation as well as the purchase of some items (chocolate, ribbons, candles) to go with the offerings. Little money is spent on food, thanks to stringent dietary restrictions. The staple fare consists of dried tortillas brought from home, perhaps supplemented by some oranges and sweet biscuits. The major expense is transportation. The money for the pilgrimage is either saved up while working on the coast, raised through the sale of artwork (sometimes during the pilgrimage itself), or borrowed from a friend or relative. "Bothersome" outside observers are allowed to go along on a pilgrimage if they provide some or all of the transportation or help with the expenses.

The peyote pilgrimage and related essential ceremonies in the Huichols' religion have attracted the attention of

outsiders almost exclusively. But we must not lose sight of the equally important agricultural rituals connected with planting, harvesting, and rain. Many gods must be propitiated to obtain what is most important: good health and abundant crops.

RELIGIOUS PARAPHERNALIA

In order to win the favor of the deities, several different types of offerings are left at various sacred sites. Fasts, sexual abstinence, and the promise to perform a ceremony sometimes accompany the gifts to the gods.

Uru, or ceremonial arrows, are the most common offerings. By analogy with the flight of birds, they represent a message to the deities. These arrows are also used in sorcery as well as in curing. The essential part of the arrow consists of a bamboo shaft into which a long piece of hardwood is inserted. The rear shaft is decorated with painted bands, often of different colors for the different deities. Feathers of birds belonging to the particular god to whom the arrow is to be given are attached to the rear shaft along with symbolic objects, often woven or embroidered on pieces of manta, asking for some particular favor—generally good health, rain, and material benefits. These arrows, which are some nine to twelve inches in length, are not to be confused with the *muvieri*, or shaman's arrow, used in curing and other ritual purposes. The *muvieri* always have eagle or hawk feathers attached to the rear shaft, as these birds fly higher than any other.

Rukuri, or votive bowls, are fashioned from the bottom section of gourds, often of the same type as those used to hold drinking water. Beeswax is applied to the inside to hold various symbolic objects, including grains of corn, tufts of cotton, coins, and beads arranged in designs to represent, for example, deer and human figures. The bowls vary in diameter from two to six inches. Figures fashioned out of beeswax are often stuck to the inside of the bowl. The number of beads stuck into these figures depends on the wealth of the individual and on the importance of the offering. The vow to hold a ceremony is sometimes symbolically represented in the bowl.

Tsikuri, or "gods' eyes," consist of a framework of two sticks tied together to form a cross—probably representing the gods of the four cardinal directions—and colored yarn wound to form one but sometimes more diamond-shaped figures. The offering symbolically asks the particular deity to "keep an eye" on the individual. These *tsikuri* are most prominent in the harvest festival, during which the children are taken on a pretended peyote pilgrimage by the songs of the officiating *tsauririka*. The songs introduce the children to the various deities who live along the road to Wirikuta so that these gods will recognize the children and keep them from harm. Every child is supposed to participate in this ceremony for five years. The number of yarn diamonds on his or her *tsikuri* represents the number of times the child was taken on the pretended pilgrimage.

Nearika, or stylized front shields, are round or polygonal weavings, some two to eight inches in diameter, with pieces of bamboo or sticks to hold the colored yarn. The symbolic designs ask for favors from the deities to whom they are offered. According to Lumholtz, the shield as a whole symbolized "the face or aspect of a god and is usually attached to a prayer arrow. In a larger sense, a *nearika* may be defined as an instrument for seeing the invisible and for conjuring up the sacred ancestors."

Upari, or stools, and *uwemi*, or large easy chairs, are miniature models of these objects used by the Huichols. The *upari*, a low stool, is in frequent use in the home; the *uwemi*, basically an *upari* with sides and a back, provides a comfortable seat for the *tsauririka* during the many hours he spends in ritual chanting. The material for both is similar: a bamboo framework with some wood and bark held together with ixtle string (made from the fiber of a species of cactus) and a vegetal glue mixed with burned grass. The seat is made of bark supporting interwoven strips of bamboo, edged with a circular bundle of century plant leaves. The sides and back of the *uwemi* are made of sticks and thin strips of bamboo in rounded shapes. The

miniature *upari* and *uwemi* given to the gods have prayer arrows and other offerings attached to the back or placed on the seats.

Aside from offerings fashioned to please the gods, a great deal of paraphernalia is associated with the rituals. A violinist and a guitarist participate in all ceremonies. Their instruments, which look almost like toys or miniatures, are played as an accompaniment to ritual dances both inside and outside the *tuki* and often during the peyote pilgrimage. They are also played outside the ceremonial context. A man might play a violin on his way to clear a field, or he might relax in the evening with a friend, each playing one of the instruments. Both the violin and the guitar are fashioned from wood with the curved machete.

During the harvest festival, an oak drum with deerskin covering is beaten, so that the children who are taken on a pretended trip to the land of peyote can keep track of the shaman leading them and not get lost. Deer, eagles, and other motifs are sometimes incised in the sides of the drum.

Teapari, or round disks of solidified volcanic ash inscribed with symbolic motifs of the deities, are found in all the *tuki*. The same type of stone is used for small crude carvings of some gods, usually Tatewari or Nakawe. One can occasionally see these carvings in a *tuki* or some sacred spot.

The motifs in adornments, weavings, and embroidery can also be considered as religious paraphernalia. The colorful outfits worn by the men are made of coarse, store-bought, cotton *manta* cloth sewn into loose-fitting pants and a type of shirt reaching to mid-thigh in the front and just below the buttocks in the back. The shirts are open on both sides as well as along each sleeve, fitting snugly only at the wrists A wide, long, woolen belt cinches the shirt around the waist. Often, one or more shorter and narrower belts are tied on top of the woolen one. The wide-brimmed hat is made from plaited soyate, a type of tough grass. The hats are often decorated with different feathers and sometimes beads or other fanciful adornments. Woven or embroidered shoulder bags of various sizes are often worn. Many of the men have a plain outfit for everyday use and another highly colorful and decorated one for rituals.

Beadwork necklaces and bracelets are often worn on ceremonial occasions.

The women who do the embroidery and weaving for the men seldom wear any of their finery. For themselves, they make blouses and long, wide skirts from store-bought colorful printed cloth. Two large handkerchiefs are sewn together to cover the hair and are sometimes used to cover the chest and back. Occasionally a woman will make an embroidered blouse for herself or a young daughter, but almost all of her efforts are directed to showing off her husband or sons during festivals.

One of the main preoccupations of the Huichols is rain to make the life-sustaining corn grow. Beadwork, embroidery, and weaving often depict flowers. Since flowers bloom only during the brief rainy season, they probably represent prayers by association. Snakes and the many double water-gourd designs most likely serve a similar purpose. Curiously, the corn plant itself is seldom represented, and beans and squash are not dominant patterns. Perhaps the Huichols have to ask their gods for favors indirectly.

Various animals are sacred to different deities and could represent adoration as well. The most common animal motif on clothing is the deer, probably representing elder brother Kauyumari, who, among his other functions, acts as an intermediary between the shamans and the various deities. The blood of the deer is also necessary to anoint certain offerings. The double-headed eagle is another common animal motif. The eagle is undoubtedly of great religious importance, as its feathers are essential for various shamanistic purposes. However, the design might have been influenced by the Hapsburg double-headed eagle, probably introduced during colonial times by contact with tribes having closer relations with the Spaniards. Another introduced motif could be that of the flower, stylized in many forms. The basic form is perhaps a fifteenth-century Hispano-Moorish design. Curved steel, formerly used in conjunction with flint to start fires, is a definite example of the incorporation of an introduced object into Huichol motifs. No one to my knowledge now uses these objects—matches are much more convenient—but the motif remains

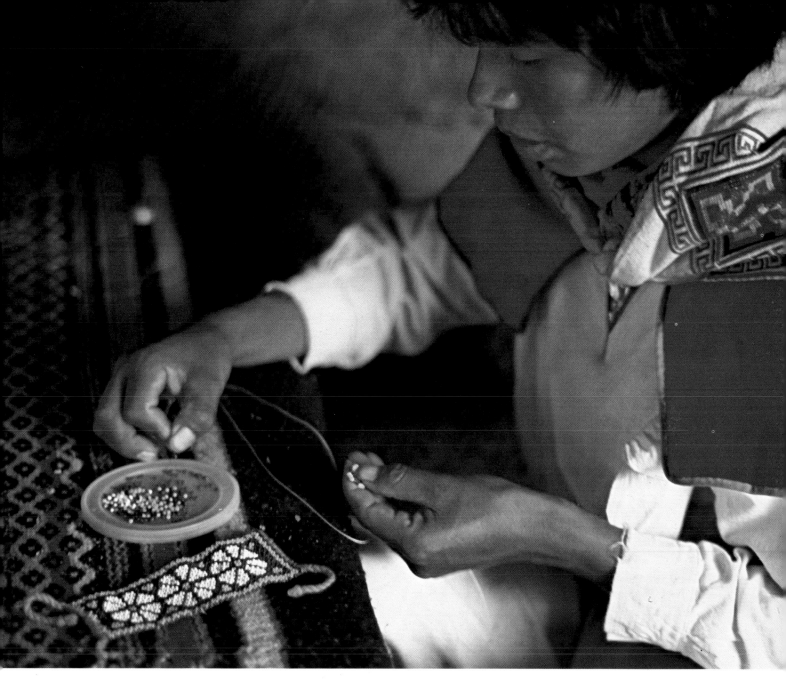

Huichol craftsman making bead waistband. Photo: Peter R. Collings

important in embroidery and weaving. Horses are another popular design, but both the animal and its motif in embroidery (I have never seen it in weaving or beadwork) seem to have been introduced, whereas in the case of the steel only the item itself came from the outside.

Religious paraphernalia is an integral part of the Huichols' lives. A great deal of time is spent in fashioning the various items, as well as the clothing and decorations which have a symbolic religious value. The Huichols live in close contact with their gods, and an almost constant effort is required to satisfy the deities.

Crafts Made for Sale

Since the Huichols are now partially on a money economy, it was natural that, as their art drew the attention of outsiders, they should eventually sell some of these items. With increased outside contact, new materials have been adopted both for religious articles and sale items.

Huichol art made for sale has had to conform to a certain degree to what buyers are willing to purchase. As the Huichols' need for cash increased they prepared those items which they thought would sell. When some of them

95

moved to towns, they began to work full-time making objects for sale which were completely divorced from a religious context and modified to conform to the market. Finally, enterprising Mexicans have copied Huichol artworks and are selling them as the genuine article.

Some objects of Huichol art are almost never sold. The *teapari* and stone deities are too crudely carved to appeal to outsiders, and they are also too heavy to be taken along. The Huichols would not sell secred items in actual use in a temple, but, were markets available, they could make copies or find old ones no longer in use. The ceremonial arrows do not appeal to prospective buyers, although an occasional one is sold.

The most common objects made for sale are woven bags, *tsikuris*, bead wristbands, and necklaces. The cost of beads varies with quality, size, place of purchase, and volume. The best beads come from Czechoslovakia and Japan, with less expensive varieties widely available. Both men and women work with beads. The time required for beadwork varies with the item and the skill of the maker. A wristband may be completed in one or two hours, whereas a large beaded bag can take over a week. Sometimes these and other items are sold at a loss under duress —when a Huichol runs out of cash in town or wants to buy more alcohol during a ritual in the Sierras.

The best woven shoulder bags are made of white-and-black wool spun by the Indians from the fleece of their sheep. Since sales prices are low in relation to the work involved, most bags are made from store-bought colored yarn. The yarn is not expensive—but the weaving is time-consuming.

When a woman makes something for a man, it is difficult for him to sell the item without her concurrence. During a ritual I once asked a young man if he would sell me his woven bag. We agreed on a price, and I bought the bag. A little while later I saw him fighting with his wife, throwing her to the ground, and beating her with his fists. She fought back, shouting curses at him. I was told that she was angry because she had not agreed to the sale of the bag. An hour or so later the young man returned my money and I gave back the bag.

The Huichol item one sees most often for sale is the *tsikuri* commonly known as *ojo de dios* (gods' eye). They are quickly made with a minimum of investment, and a profit can be realized at almost any sale price. Basing them on the religious *tsikuri* of one to five diamond-shaped yarn windings, the Indians and their Mexican imitators have produced contraptions sometimes reaching six feet or more in height, with dozens of diamond windings.

Embroidered clothes and shoulder bags are sold both to visitors and stores. Sales prices often depend on the amount of embroidery rather than on quality. The Huichols have not succeeded in modifying the basic cut of their clothes to suit outside tastes. Had they done so, they would be able to sell much more of their embroidery. Voluminous ladies' skirts and shapeless blouses, and men's baggy trousers and long-tailed shirts do not appeal to fashion-conscious visitors. The clothing is purchased for wall decorations. Although most designs are traditional, it is not unusual to see flowers, peacocks, horses, automobiles, and even airplanes copied from embroidery magazines.

Occasionally one sees an offering in a sacred spot consisting of a round, flat piece of wood covered with beeswax, with colored threads pressed into the wax to form designs. These offerings have "degenerated" into the large rectangular or square yarn paintings seen frequently in stores and varying greatly in quality. The inspiration for the yarn paintings often comes from Huichol mythology as interpreted by the individual maker. Most of the paintings are turned out on a mass-production basis by urban Huichols or those who come to live in cities for extended periods of time. The necessary plywood base is not available in the Sierras and is too difficult to transport.

The *rukuri* have also undergone a radical transformation to make them suitable for sale. The bowls used for offerings are simple and small. Those destined for sale tend to be larger, with the inside covered with wax so that it can be completely lined with beads arranged in various patterns. The commercial bowls do not have offerings such as grains of corn or coins stuck to the inside. Some of the votive bowls, as well as tobacco gourds made for sale, are

covered with wax both inside and out. Colored yarns are then pressed into the beeswax in various designs.

All the artwork produced in the Sierras is done on the *ranchos* when nothing more pressing needs to be accomplished. Each piece is made by a single person. No assembly-line production has yet developed. Children learn to fashion the objects by watching adults and are helped when necessary as they begin to make the items themselves. Sometimes less care is taken in making items for sale, but generally the process is little different from the traditional process used in creating religious art.

For a time, the Plan HUICOT provided some low-priced materials for artwork and bought some of the products for the Casa de Artesanías, an official government outlet for crafts. This support has been discontinued due to lack of finances. While the program functioned, it encouraged low-quality production, as the same low price was paid for similar items. Revival of the system, but with a knowledgeable buyer who could financially reward quality work, would go a long way both toward giving the Huichols a secure source of income and toward raising the quality of their salable artwork. Given sufficiently high incentives, they can produce absolute masterpieces.

Neither the fact that new materials are used in the fashioning of artwork nor the modifications of the objects themselves has had much overt effect on the religious life and culture of the Indians of the San Andrés Cohamiata district. The items they make for sale might not be as well constructed as the objects they fashion for themselves, but this differentiation has not altered their life style. Other factors could portend more dramatic changes.

Conclusion and Future Possibilities

I have described many contacts between the Huichol culture and the outside world. The resulting influences and assimilation have been largely restricted to the material sphere, although all but a few introduced material objects could be given up without trauma. The scattered *ranchos*, daily activities, and agriculture remain basically unchanged. A few Christian elements have been assimilated into the system of supernatural beliefs, and bulls have been substituted for deer in some sacrifices, but all the essentials of religious belief and practice remain unchanged. Psychologically, some macho attitudes have made inroads but are not yet sufficiently significant to change the underlying peaceful character of the people. The infrastructure of traditional Huichol culture seems intact in the district of San Andrés Cohamiata.

Land problems could portend basic changes. Mestizo encroachments for grazing, timber, and general land use have presented a need for changing attitudes. In order to face this challenge, strong Huichol leaders must develop an understanding of outside institutions such as lawyers, surveyors, government bureaucracy, and land-tenure laws. These leaders need the support and cooperation of individuals who have largely maintained a *rancho*-based mentality, indifferent to what happens outside their immediate surroundings. This *crise de conscience* has become apparent, but whether it can develop fast enough to prevent further land losses is open to question. One concrete result of this attitude has been the expulsion of several mestizo families living in the San Andrés Cohamiata district, but these groups of Mexicans have had no outside backing. The taking on of powerful cattle or lumber interests supported by government officials is a far more difficult task.

At the moment chances do not seem good that San Andrés Cohamiata will become a centralized Huichol community such as Guadalupe Ocotán, where most of the children go to school and where the Indians all live grouped together, wear mestizo clothing, have neglected much of their religious traditions, and have partially accepted the Catholic Church. The Franciscan missionaries in San Andrés Cohamiata have made no significant number of converts. The incentives for settling closer to San Andrés include medical care, more productive agriculture, the possibility of employment in various government programs, and closer proximity to the school, store, and means of communication. The breakup of the scattered *rancho*-based settlement pattern would deal a very severe blow—perhaps even a fatal one—to the traditional Huichol

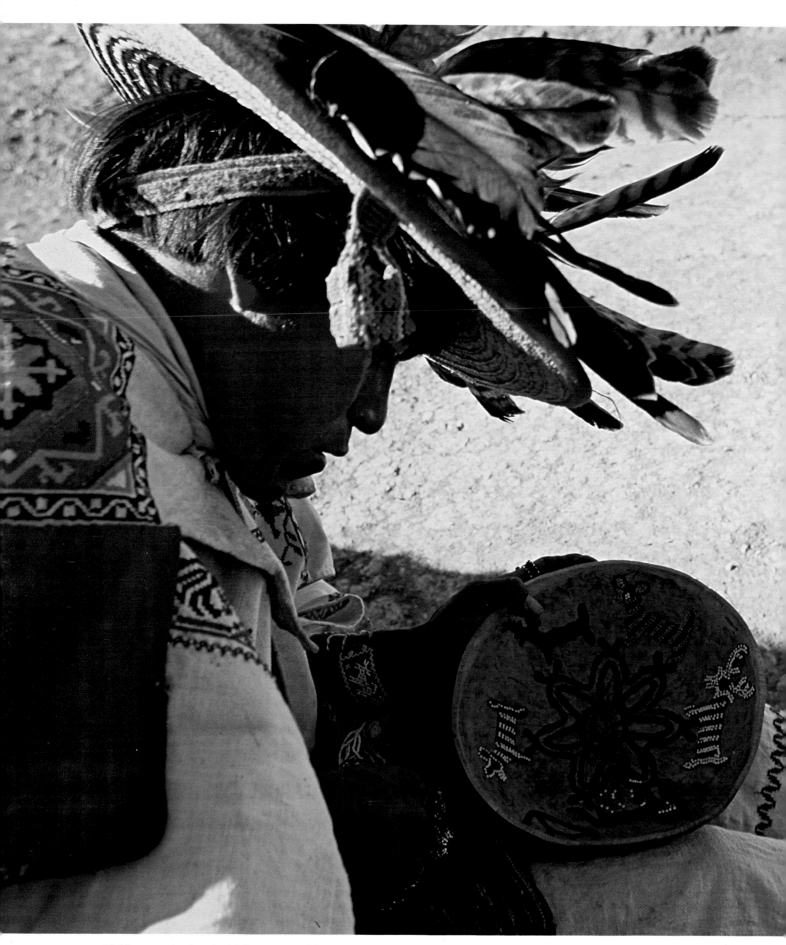

Making a votive bowl with beeswax and beads. Photo: Kal Muller

Church at San Andrés. Photo: Peter R. Collings

way of life. So far, very few individuals have moved from their *ranchos* to settle in San Andrés or in Mexican cities, although many work outside of their territory for months at a time. Working away from home can be a jarring experience, and a certain degree of conformity and adaptation is required. However, Huichols consider their culture superior to that of the Mexicans (or anyone else), and upon their return to the Sierras they resume their independent attitude as well as their colorful costumes.

The attitude and resources of the government and forces of economics are going to be key factors in the future. Although many members of the community have acquired an awareness of their problems and have resolved to cooperate, there is little they could do if the price of timber and beef rose sharply or if extensive mineral resources were discovered on their territory. The pro-Indian ideology and sympathetic attitude of some government officials could easily be swept away by economic concerns, as has been

the case in other areas. The government could, if it wanted, decide to make the Huichol boundaries respected by helping the Indians discourage encroachments.

Officials are involved in an ambiguous task. On the one hand, they would like the Indians incorporated into the mainstream of Mexican life as responsible, conscious, tax-paying citizens, easily administered through concentrated population centers. On the other hand, they recognize that to change the Huichols in this way would negate their cultural uniqueness. In order to encourage this identity, school curricula could be adapted to give more emphasis to agriculture and culture consciousness, in addition to teaching the Spanish language, which is essential in dealing with the outside world.

The government could also encourage the Indians through the regular purchase of their art, with prices pending on quality. Emphasis upon the important symbolism and religious nature inherent in this art would differentiate it from much of what is now available in Mexican crafts, giving added pride and incentive to the artists. In addition, essential cash could be earned by Huichols while remaining on the *ranchos*, so that they would not have to leave the Sierras for work.

If the Huichols of San Andrés Cohamiata are left alone, with only some well-thought-out help and encouragement from the government, their traditional culture could continue to thrive. But if economic pressures open their territory to a large influx of outsiders, they will find it difficult to maintain their way of life, which now provides us with a valuable window into pre-Columbian America.

Contemporary Social and Economic Structure
Phil C. Weigand

The Huichol Indians have been a focus for anthropological attention since the early twentieth century, when Carl Lumholtz's classic works were first published. While religion and symbolism have dominated the interests of outsiders, other basic and fascinating aspects of the Huichol culture and society have remained poorly understood.

Historical The Peyote Hunt[1]

Today's Huichols have a long history at the fringes of at least three centers of Mesoamerican civilization. Recent archaeological work in and near the Huichol *comunidades* (chartered land grants from the Spanish crown) shows a long in situ, sub-Mesoamerican development. The archaeological sequence, beginning about A.D. 200, suggests strongly that the eastern *nayarita* (one of the many terms applied to the Huichols during the early Colonial period) received Mesoamerican influences from many directions during the long period of aboriginal development in the mountains. Recent data show no archaeological break to support the popular theory that the Huichols are recent arrivals into the area.

Circular ceremonial structures which served as the models from which the *kalihueh* religious compound of the Huichols was developed have been dated by carbon 14 to the early Classic period (about A.D. 200 to A.D. 700) for the nearby upper Bolaños valley. While religious architecture seems derived from the south, many motifs seem derived from the coast. Recent·research clearly shows that by the Classic period the Huichols were tightly integrated into the larger configuration of the surrounding Mesoamerican societies (Weigand, 1976a, 1977b; Kelley).

In the period between the first contact by the Spanish in the 1520s until Spanish settlement among the Huichols in the early and mid-1700s, there were migrations by Indians seeking refuge among them. With the collapse of the independent Indian societies around the Huichols, especially the Cazcanes after the Mixton War of the 1540s (Lopez-Portillo y Weber) and the coastal groups, the refugees came in organized groups, bringing their culture.

During this period, the eastern *nayarita* were also known by a variety of names—e.g., Xurute, Vitzurita, Usilíque, Uzare, Guisól, Guisare, Visarca—indicating that the area was occupied by many groups. The traditional date set for the conquest of the *nayarita* is A.D. 1722 with the expedition of Capitán don Juan Flores de San Pedro (Reynoso), but the Huichols had no doubt been gradually pacified decades before. The Huichols found by the conquistadores were composite, varied societies made up of the fragments of neighboring native societies which had imploded into the mountains and canyons where a sub-Mesoamerican tradition already existed (Weigand, 1977b).

How does one sort out what is Huichol? One cannot, for "Huichol" historically means composite societies dedicated to resisting incorporation into the Spanish orbit. The Huichol area was and is a classic example of a *región de refugio* (cf. Aguirre Beltran). The western *nayarita*, or Chora *nayarita*, today known as Coras, underwent a very similar process of composite, responsive political and cultural formation.

Clearly, a pure and isolated Indian culture did not survive the deep social changes that transformed all of western Mesoamerica during the early Colonial period. In the mid- and late-eighteenth century, Franciscan missions introduced even more radical changes into the various Huichol groups, among them the *comunidad* political structure, which the traditional Huichol regard as the essence of their social life.

1. The research for this study was funded by grants from the National Science Foundation, Wenner-Gren Foundation, the State University of New York Research Foundation, and the Mesoamerican Co-operative Research Fund of Southern Illinois University. My particular thanks to Celia García de Weigand, Lic. Alfonso Manzanilla, Dr. Campbell Pennington, Dr. Carroll Riley, and Dr. J. Charles Kelley.

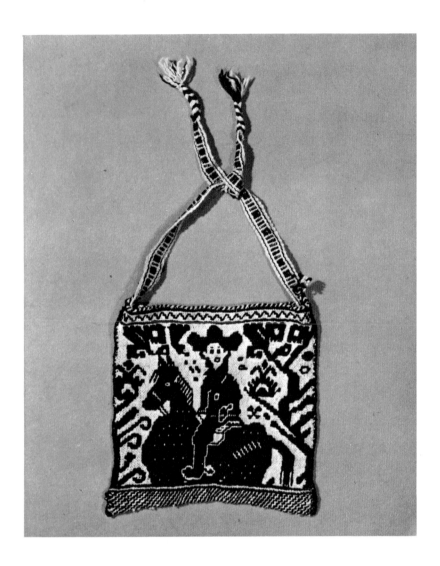

Traditional type of wool bag with representation of *tewari* (the foreigner). Collection of Anne and Peter Collings

The contemporary diversity of the Huichol districts and *comunidades* is as great as that among the Pueblo Indians of New Mexico (Weigand, 1972, 1977b). This great diversity, little appreciated by most outsiders, is especially evident in their highly personalized (and inherited) symbolism and mythology. The "homogeneity" of Huichol culture is often an artifact created by anthropologists relying upon urban informants. In the urban environments, Huichol cultures have blended, not only among themselves but with those of the equally diversified Cora, and a new composite has emerged.

Demography

Population estimates among the Huichols have been regarded as a problem of numerical accuracy, but the real problem lies in determining whom to count. The greatest difficulties arise in the counting of the urban Huichols and those who live permanently on the Nayarit coast. In addi-tion, most anthropologists confuse the Tequales (Indian neighbors of the Huichols) with the Huichols. Population counts for the rural, *comunidad* setting are accurate if one relies on the municipal census of 1975–77, the Comisión Nacional de Erradicación de Paludismo census, and the General Census of the Nation in combination. In addi-tion, the Plan HUICOT has gathered census data (HUI-COT, 1976), and several field anthropologists have made very accurate counts for smaller zones.

I believe the total number of Huichols to be between thirteen and fourteen thousand as of 1977. *Informes*, pub-lished in 1961 (Velazquez), estimates one thousand Hui-chols for all the newly founded *comunidades* in the late 1700s—the first figure to be given, and one probably far too low. A document dated 1848 estimates twenty-five hundred Huichols. Since the 1890s, estimates for the *com-unidades* have varied from four thousand to eight thousand. The lowest point—1930—reflects the diaspora after the collapse of the Cristero Revolt rather than an actual count. The wide acceptance and accessibility of modern medicine has brought a baby boom, and there has been a steady flow

Formal Governmental Structure

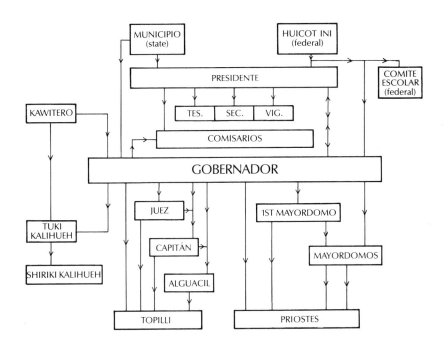

of Huichols seeking employment toward the cities and the coast.

Economic, Political, and Social Organization and Settlement Patterns

The formal political structure within the regional society in which the Huichol are located is considerably more complex and internally varied than is generally assumed. (Much of what follows is based on experiences gathered in the course of my field-work in the *comunidad* of San Sebastián in San Sebastián Teponahuastlán.) The *comunidad indígena* (Indian, chartered land unit) exists side by side with many *comunidades agrárias* (*ejidos*, or communal farms whose membership is usually mestizo, i.e. individuals of mixed Indian-European heritage), some of which are also very old. The regional society includes Coras, Tequales, Tepehuanes, Tepecanos, and Mexicaneros as Indian groups, all of which are diversified internally in culture and adaptation. While most of these are organized into either *comunidades indígenas* or *agrárias*, they are also organized directly into municipios as *pequeños propietarios* (small land owners, with individualized title to land), *peónes* (day-wage workers), *ganaderos* (cattle owners, or cowboys), *braceros* (migrant workers), *campesinos* (yeomen), and artisans, storekeepers, mule drivers, and so on.

The *vecinos* (neighboring mestizos), a culturally and socially diverse group with a firmly developed class structure, include tradesmen, merchants, cattlemen, *peónes*, *campesinos*, *braceros*, proletarians, police, politicians, and the like. They clearly hold the balance of power, both political and economic, throughout the region.

The defensive stance of the Huichols has placed enormous strains on their societies, especially as acculturation efforts in the area are now organized as never before. Banks have effectively penetrated the *comunidades* (beginning in the early 1970s) and now control their finances either directly or indirectly through the government agencies. Economic autonomy is gone under the new system of credits, interests, balance sheets, and administrators. Also gone are the patterns of encapsulated subsistence agriculture which had been at the heart of the old, self-sufficient *comunidad* structure. Economic acculturation of the *comunidades* was very gradual, beginning long ago with the adoption of cattle, commercial muslins, and other consumer goods. Cattle have since the outset integrated the Huichols in the national market economy. This integration, which brought economic acculturation, is nearly complete today.

With the patterns of economic acculturation have come new patterns of political control. The Cristero Revolt and the subsequent dispersion meant the beginning of the end for the ancient ways of *comunidad* governance. In the late 1940s, when the army finally withdrew from the *comunidades*, they were reorganized by decree into *presidencias*, whose leadership was elected under the super-

vision of government authorities. Each *comunidad* has a *presidencia*, but the older system of rule by the elders in the civil-religious hierarchy remains a strong check on these new forms of governance. With militias and government programs such as the Instituto Nacional Indigenista and Plan HUICOT, the political acculturation of the Huichols (at least in the sense of control) is nearly complete.

The Comunidades

Settlement pattern in the *comunidades* is dictated by the economic necessity for dispersion. *Rancherías* (clusters of farmsteads into districts) form the basis of the *comunidad* pattern. The farmstead can range in size from a single nuclear family living in a single compound of structures with one patio, to extended bilateral families (with agnatic, or patrilineal, emphasis) living around several attached patio compounds. The population of a farmstead can vary from four or five to as many as fifty individuals.

In favored areas within the rugged canyons that dominate the *comunidad* topography, *kalihueh* religious compounds (or ruins) are usually found. These compounds formerly defined the districts. In the past, the *kalihueh* buildings, now district property, were controlled by the oldest men of the oldest family of the district.

The districts were previously the focal point for well-integrated, bilateral lineages sharing economic tasks and ceremonial activities. They also formed the basis for *corvée* (obligatory labor) groups when called upon by the *comunidad*. The 1910 Revolution, the disastrous Cristero Revolt, and the diaspora that followed destroyed lineage unity. The *kalihueh* lost its central focus in district social organization. Complex, nonkin residential groupings, in many cases too vaguely formed to keep up the religious compound, let alone cooperate in labor functions, have replaced the bilateral lineages.

The current districts are *comisario*-oriented throughout much of the *comunidad* zone. The *comisarios* (delegates), although responsive to the traditional leadership, are responsible to the *presidencia* as the elective or appointed district leaders. With the old leadership patterns a thing of the past, and since the *rancherías* are now mostly residential groupings not tightly bound by kinship, *comisarios* have supplanted elders in many areas. The collapse of the district system has meant a thorough reorganization of Huichol society.

Just as farmsteads are clustered into districts, the districts are clustered around small pueblos. Five major pueblos exist in the three Huichol *comunidades*, though several small pueblos are found outside the *comunidad* setting. The *comunidad* pueblos are San Sebastián and Tuxpan de Bolaños in the *comunidad indígena* of San Sebastián Teponahuastlán (plus Ocota de la Sierra, which has recently acquired many aspects of a pueblo but which is not chartered as such); Santa Catarina, in Santa Catarina Cuexcomatitlán (though Pueblo Nuevo and La Colonia have many aspects of pueblos); and San Andrés and Guadalupe Ocotán in the *comunidad* of San Andrés Cohamiata (with the active Franciscan missions at both Guadalupe Ocotán and Santa Clara enjoying special status). Guadalupe Ocotán and Tuxpan de Bolaños are *anexos* (annexes) within their respective *comunidades* and thus have separate civil-religious hierarchies that many people confuse as markers of *comunidad* status. In effect, the *comunidades* hold five *gobernancias* (Colonial civil-religious hierarchies), but only three of the *gobernancias* are chartered and hence *comunidades*.

In contrast to the farmsteads, the pueblos or proto-pueblos often seem unpopulated, since they serve as meeting places and not as permanent residential centers. They are attended by a small resident core of officeholders duty-bound to stay there. Storekeepers also at times reside in the pueblos. During the fixed ceremonial periods and during trials (especially for witchcraft or adultery), cattle sales, school sessions, and the like, the pueblos come alive. Deserted during the rainy season, they are packed for Holy Week or the Change of Bastons. Having a "town house" is a convenience but not a necessity in Huichol culture. Officeholders are most often supplied housing

built or maintained at *comunidad* expense by cooperative labor groups called in by the *gobernador* (*tatuhuane*, governor) and *comisarios* for that and other tasks.

Except for state and federal agencies, neither political, economic, cultural, or social organizations bind all Huichol *comunidades* together. Indeed, the *comunidades* are often suspicious of one other, and mistrust can run high. Indeed, they have acted so independently of each other as to be working at cross-purposes.

THE FEDERAL GOVERNMENT AND THE COMUNIDAD

Overt but not well integrated into the governmental hierarchy are the various federal government agencies organized, for the most part, as programs for economic development of the *comunidades*. The Instituto Nacional Indigenista (INI) was the first such program among the Huichols, followed by Plan Lerma and Plan HUICOT. Schools, clinics, credits, stores, airstrips, veterinary services, and radio communications are some of the more important changes introduced during the past few decades. HUICOT has been particularly effective and has had an important influence of governance at the *presidencia* and *gobernador* levels. It has also backed the organization of *Comites Escolares* (School Committees) at every pueblo with a school. These committeees are presided over by Huichols who, with other officers, are the go-betweens for the schools and the community. HUICOT-trained teachers control these committees and thus play an influential, though indirect, role in the area's resource management and politics.

THE STATE AND THE COMUNIDAD

The state agencies in closest contact with the *comunidades* are represented at the levels of the *municipio* (municipality) and *canton* (grouping of *municipios* into regions managed by the state government). Politics at this level are dominated by the Partido Revolucionario Institucional (PRI) and can be characterized as paternalistic. Government of the *comunidades* at this level is complicated by the fact

that Jalisco and Nayarit cannot agree upon their mutual boundaries, a dispute that affects the Guadalupe Ocotán section of the San Andrés *comunidad*. The San Sebastián *comunidad* is divided between two *municipios*—Mezquitic and Bolaños; opportunists have tried to take advantage of this to split up the *comunidad* for their pasturage. The *municipios* are responsible for law and order within the *comunidades*, though the Huichols actually manage most of their own affairs. Only murderers, repeated witchcraft violators and cattle rustlers or the like are turned over to the *municipios* for trial. The *municipios* are also charged with collecting the *contribución* (yearly tax).

The state government supervises the *comunidades'* *presidencia* elections held every three years. The *municipio* is charged with the annual accreditation of the selection of *gobernadores*, *jueces* (judges), and other officials. In general, the presence of the state government hierarchy is neither overt nor overburdening; it is well integrated and very important.

THE PRESIDENCIA

The offices of the *presidencia* are not well defined in the Huichol *comunidades*, despite all the handbooks of rules and procedures. Since the relatively recent institution of these offices, though, several functions have fallen to the *presidencia* which the *gobernadores* and the traditional civil-religious hierarchy have not been able to handle well. The *presidencias* have come to stand for the *comunidades'* territorial integrity, especially when dealing with boundary problems with *vecino* cattlemen. Within the *presidencia*, a *jefe de vigilancia* (chief of security) is in charge of a group of Huichol *rurales* (armed police, or militia). A *secretario* handles the *comunidad's* correspondence with the *municipio* and the *vecino* renters, writes cattle passes, and so on. He is also in charge of census data and the cattle-brand registry. A *tesorero* (treasurer) is in charge of collecting the Huichols' annual *contribución*, writing receipts for other taxes for special projects, and safeguarding the *comunidad's* capital resources. At least in San Sebastián, the *comunidad's*

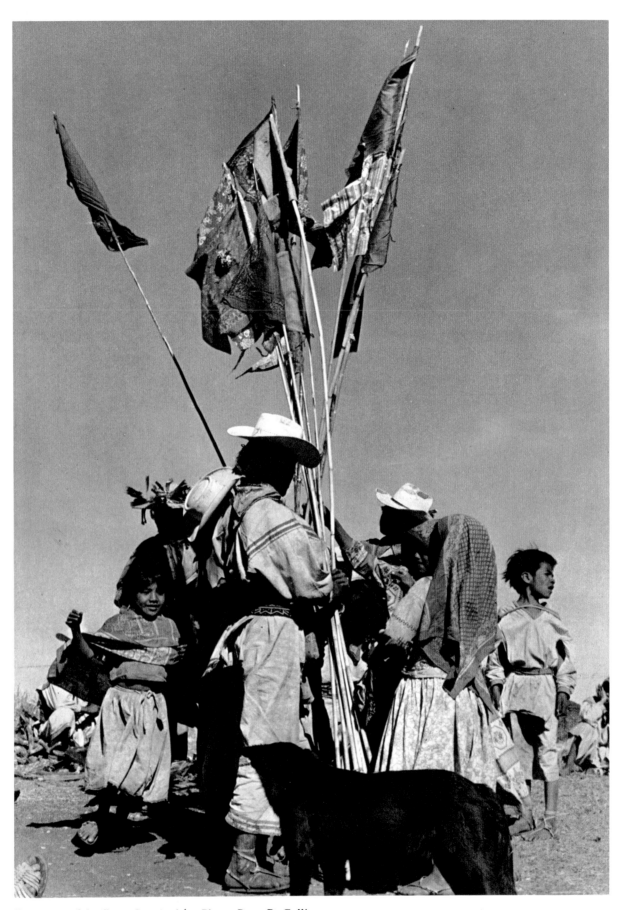

Ceremony of the flags, San Andrés. Photo: Peter R. Collings

charter is now held by the *presidencia*. While the *presidente* and his men wield a great deal of power, they are not accorded the respect given to the civil-religious hierarchy. People may tend to doff their hats when entering the presence of the *presidente*, but he is treated with a degree of jocular familiarity; he is after all only an elected official.

THE CIVIL-RELIGIOUS HIERARCHY

The Gobernador. The very essence of the traditional *comunidad* political structure is the civil-religious hierarchy that culminates in the person of the *gobernador*. He is the embodiment of the *comunidad*. The respect due him is absolute, so much so that his police, the *topilli*, do not even carry weapons. His major function within the social unit is to assure tranquillity by arbitrating disputes. In this capacity he sits, with the *juez* at his side, through endless trials concerning inheritances, theft, witchcraft, adultery, non-support, personal conflicts, land-use rights, bad debts, and so on. His presence is desirable at cattle transfers, and it sanctifies festivals at *rancherías*. He is the center of activity at all the religious festivals held in the pueblo at either the Casa Real (the civil hierarchy's office and meeting area) or the Church, where the *mayordomos* (endowment caretakers) keep their images. The *gobernador*, along with the other civil officeholders, is chosen by consensus by past officers and the *comunidad*'s *kawitero* (men who know everything). The prerequisites for office are that one be traditional, experienced in prior offices (though this qualification does not necessarily imply that age is a criterion), dedicated, dependable, respectable, well-enough off to afford the economic burdens of the office, a good speaker, a good listener, and a good judge of character. The *gobernador* and his fellow officers serve for one year, from January to January.

The best of them pray long, individualized chants to composite groups of ancestors and gods venerated within the *comunidad*. The *bastón* of authority and other appurtenances of the office are passed on to his successor. Nowadays, the offices have *suplentes* (alternates), just as

the *presidencia* does, in case the *gobernador* is incapacitated. The physical health of these leaders is of general concern, for some Huichols feel that if the officers are sick, the *comunidad* is vulnerable.

The officers rule by authority, not force. Their collective word is final, and they have the right to banish troublemakers from the *comunidad*. Banishment is a terrible fate—imagine having to spend the rest of your life among *tewari* ("them," that is, non-Huichols). Only a *gobernador* can lift a banishment imposed by a prior officer.

The Council. While the *gobernador* is the focus of the civil-religious hierarchy, he is actually the head of a council. The council is divided into two sections, one civil and the other religious. The civil staff always accompanies the *gobernador* during trials and at *comunidad* functions. Its members are ranked hieratically below the *gobernador* (high to low: *juez*, *capitán*, *alguacil*), and each shares in decision-making with the *gobernador*. Indeed, the *gobernador* never acts on an important matter without consulting these council members. Each member of this section has additional special functions. For example, applications for trials are made to the *juez*, the *alguacil* is in charge of the *topilli*, and so on. Each hierarchy has four *topilli*—one (and his wife or a young female of his family) assigned as a servant-helper to each member of this section of the council. They work for the officer and his wife (who shares in the prestige, duties, and respect of her husband's office) but are also on call for general service. The life of a *topil* is rough, hard, sustained work. *Topilli* are almost always young and are closely watched by all for further office potential, and everyone feels free to criticize a *topil*. Service as a *topil* is a period of proving oneself, of initiation into manhood.

The other section of the ruling council is much more loosely presided over by the *gobernador*. The *mayordomos* are less officials than caretakers. They are seldom consulted on decisions within the *comunidad*, unless the matter directly affects their responsibilities. They, too, are chosen by consensus by former officers and the *kawitero*, and are expected to serve at least a year.

The *mayordomo* structure within and between the *com-*

unidades is more diverse than any other aspect of Huichol governance. In general, each *mayordomo* is charged with a special *cofradía* (endowment) that belongs to and is dedicated to the image of which he is the principal caretaker. His major duties are to expand that *cofradía*, inventory it publicly, sponsor at least one annual church-oriented festival, and preserve the *cofradía*'s (and *comunidad*'s) image. Each hierarchy has a principal *mayordomo*. He holds no special authority over the others, but he is more prestigious because he is in charge of the most important image and religious symbol of the council, and hence of the *gobernancia*.

Each *mayordomo* controls a helper—a *prióste*—who, with his wife, serves like the *topilli*. The *gobernador* controls the *prióste* group in the same way he controls the *topilli*; in fact, little difference is apparent in their duties and harassed lives.

When a festival is given in a *ranchería*, an elder may request the presence of a particular image—the Virgin of Guadalupe is quite popular nowadays. The *mayordomo* of that image has to carry it to the festival site and remain until the image can be returned. When a *comunidad* festival is given in the pueblo, the appropriate *mayordomo* must act as the master of ceremonies; he must work with the *kawitero* to assure that the ceremony is properly planned and executed; he must display the *cofradía* and image in a dignified altar elaborated for the occasion; he must get the firewood for the nightly fires and cooking facilities; he must acquire the young bull for the sacrifice; he must remain sober and awake with the rest of the council. These festivals are expensive and demanding; they are also beautiful and joyous.

As esteemed as are the higher members of the council, the *kawitero* enjoy even greater prestige. These aged "men who know everything" are probably the people the conquering Spanish referred to as the *principales*. They are shown enormous respect, even by the members of the council and the officers of the *presidencia*. They are the ultimate resource in matters of selection of future officers, of ceremonial questions, of knowledge of the past. No more than five can serve at any one time. The problem nowadays is that too few sage men exist, and no one seems qualified to take over when the present generation dies.

Traditionally, the *kawitero* exerted their greatest influence at the *kalihueh* compound during the seasonal ceremonies to worship common ancestors and the nature gods. Since the *kalihueh* compounds have lost importance, the *kawitero* have gradually remade many a Casa Real into their substitutes. The *kawitero*'s authority position was so well established that it survived the collapse of the *kalihueh* structure. No decision affecting the *comunidad* is made without consulting at least one *kawitero*—even the *presidente* defers, at least outwardly.

A man becomes a *kawitero* through lifelong study of the customs, history, religion, and myths of his *comunidad*. These men with their phenomenal memories are the *comunidad*'s data bank. In addition to memorizing countless myths, legends, and ceremonies, they have also served as officers in the *comunidad*'s civil-religious hierarchy. Indeed, one cannot become a *kawitero* without first having served the *comunidad* at the top levels of that hierarchy. A *kawitero* usually also has curing skills, and some remain practicing *mara'akame* even after becoming *kawitero*. They are not, however, necessarily famed or even good curers, for their functions within Huichol society lie elsewhere. Almost all are good singers and orators, and they pass on their knowledge through these skills.

Formerly, the *kawitero*, along with the *ranchería* bilateral lineage elders, were the organizers of the *kalihueh* religious compound hierarchy. These hierarchies, chosen for five-year terms, acted as the governing body, or council, at the *ranchería* level. In that hierarchy, the most prestige was enjoyed by the individual in charge of the *tuki*, the major structure of the compound in which the altar to Tacacayuma and the fire hearth of Tatewari are located. The *tuki* is a circular structure which serves as the focus for the indoor activities of the ceremonial group. Ten other officeholders exist in the *kalihueh* hierarchy, each dedicated to a special god or goddess housed in *shiriki* (god houses). Women often hold these positions directly.

These hierarchies no longer function well, if at all, since the system of social organization upon which they depended has collapsed.

ECONOMIC ACTIVITY IN THE COMUNIDAD

Agriculture. Agriculture is the primary economic activity of almost all *comunidad* Huichols except the HUICOT personnel, the very aged, and the very young. Some Huichols now devote less time to agriculture than before, because other, more reliable income sources (for example, craft specialization and income supplements) have opened up. Some cattle owners and storekeepers can afford to buy a percentage of the maize they need and hence plant less.

Successful *mara'akame* often demand cattle in payment for curings or as fees for presiding at *rancheria* seasonal festivals. This compensation is absolutely necessary; the *mara'akame* may have to spend days at festivals when he should be working his fields. The cattle he is given does not necessarily mean wealth, since he must exchange them for maize almost immediately—generally before they reach breeding age. While many *mara'akame* are indeed quite wealthy, that wealth is derived from family herds or inheritance, or both, not from curing and singing. The few *mara'akame* who have tried to acquire wealth through their skills soon find themselves without a following and are often accused of witchcraft. The use of ceremonial knowledge to gain wealth is not regarded as proper behavior, and this attitude may in part explain the Huichols' strong anticlerical sentiments.

Most agricultural fields are slash-and-burn hillside plots planted in classic Mesoamerican fashion with the digging stick. Fields are interspersed—at every pace, two or three kernels of maize (always of the same color) and a bean or two are planted. Every third or fourth hole holds a squash seed. The corn stalks serve as poles for the beans, while the squash fan out on the ground below.

Families work the plots together in cooperative labor patterns involving friends, other relations, and neighbors. Each work or economic unit is supposed to plant five fields—one for each of the sacred colors of corn—but this practice is seldom observed; perhaps a tiny patch of one color or another is sown to fulfill the ceremonial obligation.

White and yellow corns are the most important, and they can be divided into two other important categories that have nothing to do with ceremonialism—short and long growers. The short corns mature within ninety days and are planted in the mountains, where frost is a problem. The ears are small and the stalks quite short, but yields are high. Since the mountain soil is almost virgin and the terrain offers more level areas than the middle canyon mesas, plows and plow teams are needed.

In the middle mesa country of the canyons, the soil is less productive but also less vulnerable to frosts. The Huichols prefer the corn types locally called *bofos* (high flour content) and *chinos* (dented, hard kernels), as they make the best-tasting tortillas. Harvests per family vary according to family size or the ability to attract cooperative labor groups. These groups are especially important for weeding the fields. Sowing a large area, though very hard work, presents no real problem, but cleaning it is another story.

Cleaning is time-consuming, back-breaking labor and has to be done at just the right period or the crop will be stunted and lost. Planting starts immediately after the first rains in early or mid-June. Cleaning can occupy the family for the next six weeks, interrupted only by a single festival period of several days. A family of ten dependents needs to harvest twenty *cargas* (the load of ungrained ears packed into two cloth sacks, or *costales*, a burro or pack animal can carry) to be self-sufficient in corn supply for one year.

The type of farming done by the one-family economic unit (of ten) is clearly not commercial agriculture, nor does the area have any potential for cash crops. The only feasible commercial use of this landscape is in cattle raising. HUICOT and the rural development banks are exploring the possibilities of raising improved breeds such as the

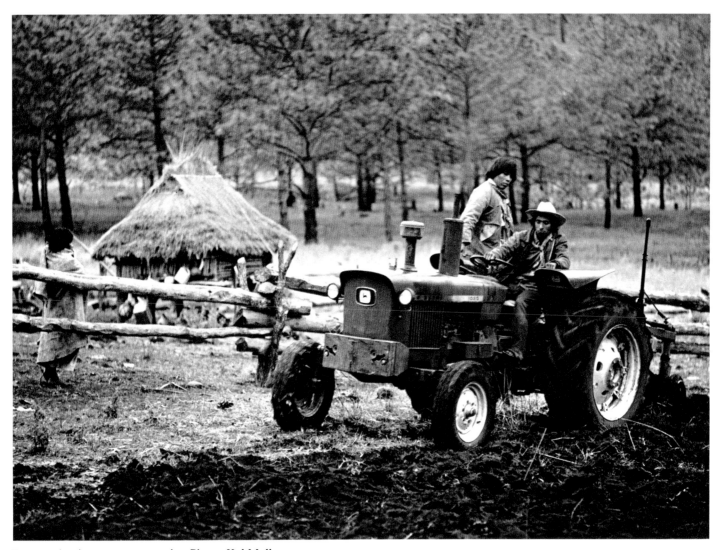

Tractor plowing next to a *rancho*. Photo: Kal Muller

modified brahma, or *cebú*, types. Improved corn-seed types have not been successful, as they have not been able to adapt to the local conditions. Huichols have shown little enthusiasm for other introduced plants, such as carrots, lettuce, radishes, and the like. The scanty use of these garden crops is less a matter of adaptation to soil than one of taste. Onions can be seen from time to time.

Other plants grown in the *comunidades* include chilies, gourds (for containers), tomatoes (two varieties), tobacco, and, very infrequently, peyote and cotton. Cotton was formerly a popular crop, but since the Huichols adopted the use of commercial cloth, planting and weaving of native cotton has become a thing of the past. Peyote plants are transplanted from the desert, since the plant does not reproduce in the canyons. No ceremonialism surrounds the transplanting of a peyote plant—mostly curiosity to

see how long it will last. Ceremonialism still accompanies the planting of cotton and gourd and tobacco seeds and the act of sowing, though the rites are no longer well remembered or even generally practiced. Ceremonialism for corn and squash is very well developed and central to the rainy-dry season dichotomy in the Huichol calendar.

Cattle Wealth. Most Huichols, especially those who appreciate and can afford cattle vaccines, still consider cattle the ideal form of investment. Many do not trust the vaccines, however, a distrust based on fact. Early vaccines often were not refrigrated; amateurs have on occasion administered the vaccines with very bad results—not only for the cattle and owners, but for the overall government programs for cattle health. Cattle wealth is still a direct indicator of social position within the *comunidad*. Since in the past such wealth could be wiped out almost overnight

by an epidemic, no classes formed. Today, however, cattle wealth can be stable, and a Huichol *peón*–Huichol *patrón* system is beginning to form. Wages for Huichol *peónes* are very low—ten to twenty pesos a day are common, depending on the type of work and the relationship to the boss. As in the past, those with wealth almost always invest it in cattle. Wealth is also directly related to family size; a wealthy family can support a larger kin group.

A wealthy man can also afford more than one wife, and he often marries a sister of his first wife. Another wife means one more worker. The new wife is given the most tedious jobs—until another wife comes along. Since most marriages are formalized by an exchange of cattle with the bride and her family, they are in effect economic bonds of common-estate management. Poor Huichols may elope, but when cattle wealth is involved, marriages are still very often arranged by parents.

The authority that cattle wealth brings is seldom ignored; while wealth is not a prerequisite for civil-religious hierarchy positions, it is often a major consideration. A man must be able to afford being a *gobernador*. Otherwise, both he and the office will suffer, ceremonies will not be carried out correctly, *cofradías* (endowments) of the office will not expand, and so on. Having wealth, office, and a large family is the peak of aspiration for a Huichol in the *comunidad* setting. With wealth, a man stands an excellent chance of being able to keep his sons in residence with him even after they have married. Each new couple is an economic asset.

Cattle are ranged communally, though there is a strong tendency to fence off access to good farm land and the best pasturage. Cattle transfers among Huichols or sales to *vecinos* are controlled by the *gobernador*; the movement of cattle is regarded as a serious concern for all the *comunidad*. All Huichols, whether rich or poor, vigilantly guard against the illegal invasion of their *comunidad*'s pastures by *vecino* cattlemen. The *vecinos* maintain that the Huichols have more land than they can use; therefore, they insist, they have a right to use it. The Huichols have compromised on this point, but want the *vecinos* to pay a yearly head tax for all the cattle so ranged. The constant push-and-pull regarding this tax on pasture rights, and other questions relating to cattle occasionally erupts into violence.

Inheritances. Wills, if they are to be honored, are made with the *gobernador* as a signing witness. Cattle are the central item in inheritance procedures, and litigation about even well-witnessed wills can go on for years. Sons inherit predominantly from their fathers and daughters from their mothers, but daughters frequently receive gifts of cattle from their fathers as well as their husbands. In the course of several generations, the women of a farmstead may gain control of the lineage's cattle. Farm plots and farmsteads, however, always go to the eldest son of the first wife if he is capable of managing them and is present to do so.

The eldest son and the eldest daughter of the first wife hold special positions within each farmstead, and kinship terminology differentiates between them and their other brothers and sisters. They are in preferred positions in inheriting the highly specialized chants, magic, and motifs from their parents—once again, the lore of the father is passed on to his son, of the mother to her daughter.

With cattle inheritance, no attempt is made to distribute the animals equally among all children. In order to preserve the prestige of the eldest son, he usually is given the controlling share. And if, in addition, he is an exceptionally strong person, he may be able to keep the farmstead intact as a single economic unit after his father's death. Most often, however, the farmstead splits up, with the youngest sons building new farms or moving in with their in-laws.

Land Tenure. Land tenure in the *comunidad* setting is communal in that individual titles to plots of land within the overall unit are not granted. But lack of title does not imply lack of very strong and inheritable use rights. Each *ranchería* has a well-defined field system, and this field system can be used only by residents of the *ranchería*, or with the witnessed permission of those residents. Since little pressure is felt concerning land, disputes about field land are uncommon. Those that do occur are arbitrated by

the *gobernador* at the pueblo in a trial setting where each side presents its case, brings in witnesses, and awaits a decision. Since all slash-and-burn fields need to be fallowed, the fact that a field is not in use is not sufficient reason to alienate it from the prior user. A pattern of nonuse must be shown, as must the applicant's need for the field. If both can be demonstrated, the field may become alienated from the prior users. *Huertas* (orchards, improved gardens) are nonalienable, even if the original user moves away and never picks the produce. They are passed from father to son, mother to daughter, as are cattle, during a normal inheritance procedure.

Use rights are also passed in inheritance. As a man ages, he turns over certain fields to his children so that they may both support him and take primary responsibility for those fields. By the time a young man matures, he has often already inherited the economic resources he will need in order to live an independent life with his own family. Theoretically, women do not inherit use rights to land; the ideal pattern of postmarital residence is patri- or neopatrilocal (with or near the son's father). In fact, however, women do have strong use rights, and they attempt to preserve them through inheritance. Alienation of these rights usually occurs within the family, and without litigation. Strong rivalry for fields seldom occurs within a particular family, because the entire family exploits the fields as members of a cooperative labor group. Only when a family splits up, due to the death of the elder, does the occasion for litigation arise. The eldest son has first rights to the contested fields as well as to those of his preinheritance. In many respects, the use-right communal system is as complicated as the private-property system.

Cattle Products, Hunting, Fishing, Gathering. Conversation and mythology are rich in references to cattle, as well as to other animals—both wild and domesticated. Cattle products are not systematically part of the day-to-day Huichol diet. Milk is usually left for the suckling calves, but some is made into cheese during the rainy season, mostly for sale to outsiders. Meat is eaten only on ceremonial occasions, when a young bull is sacrificed for a communal feast. Cattle that die of accidents or illness are also frequently eaten, though never ceremonially.

Hunting is no longer a viable economic activity. With the widespread introduction of the .22 caliber rifle, the deer population dropped to such a low that only the luckiest hunter occasionally bags one. Hunting remains a popular pastime among young men in particular, and a great deal of prestige accrues to the successful hunter. Hunting is no longer ceremonial. Eagles and hawks are rare; even squirrels are difficult to find.

Fishing, on the other hand, is still popular, though it is a seasonal activity that requires a long hike into the deepest parts of the Chapalagana canyon. The main catch is the fresh-water shrimps that abound in the dry-season pools. Poisons and dynamite are most commonly used to stun or kill the shrimps, which are dried for later consumption.

A very wide range of wild plants (tubers, berries, nuts, mushrooms, greens, and seeds) are still intensely exploited and serve as important dietary supplements to provide bulk, vitamins, and variety.

Trade. The economic system in the *comunidades* is less intensified and more generalized than in the cities. Economic activity is embedded in a large social group of relatives and neighbors, and to a large degree is not individualized and overtly profit-oriented, except among peddlers or storekeepers. However, not even the HUICOT stores are prosperous enough to allow a family to depend completely upon merchandising for a living. The most successful *comunidad* merchants are as much an adaptation to the modern consumer market as are the urban artists and craftsmen. Trading among themselves and within the general region is an old practice.

Aboriginally, the Huichols were involved in long-distance trade routes for rare and exotic items such as peyote, feathers, shells, salt, crystals, and other commodities. Today's merchants carry only today's goods; only salt is retained from the ancient trade systems. Canned beer, soda pop, fresh fruits, canned chilies, sandals, buckets, soaps, razor blades, cigarettes, antacids, sugar, wheat flour, corn flour, matches, batteries, yard goods, threads, yarns,

buttons, needles, plastic toys, school notebooks, pencils, ball-point pens, knives, nails, wire, and other items can be found piled helter-skelter in the better-stocked stores. The stores are most often located in the pueblos or the larger *rancherías*, and hours can be very irregular. Nowadays, merchandise is often brought in by airplane, especially to the HUICOT stores. The private stores generally are stocked by mule and burro trains, but, while their prices are somewhat higher than the HUICOT prices, they sell alcoholic beverages and thus have a steadier clientele.

Profits are often invested in stock, in festivals, and in cattle. Beads, which used to be an important investment, especially for display, are no longer the object of much attention. The number of stores is not fixed, and individuals enter and leave the trade easily. Capital investment in goods in the small private stores seldom exceeds a few thousand pesos.

MEANS OF SUPPLEMENTAL INCOME

Bracero *Labor in the Coastal Plantations.* Agricultural work as *braceros* is an important income supplement for many Huichols, particularly those who have neither cattle nor skill in crafts. Although many Huichols have moved to the coast, the majority visit the coast only for set work periods during the dry season, staying an average of six weeks. Working under slavelike conditions, the migrants can earn sixty to seventy pesos per day, and save about one-third if they are frugal. Those who return spend this money on food, especially maize, to survive until the next harvest. Whole families, including small children, make the trek to the coast, but sickness and death often eat up all the earnings. Children work in the plantations—mostly tobacco, cotton, and corn commercial farms—at half pay. Women work at full pay for as long as they can stand it.

Bracero work, though traditional, is not popular; only the poor and desperate repeatedly go to the coastal areas, though almost all Huichols have gone at least once to visit the shrines and be baptized in the ocean.

In the coastal plantations, Huichols from the *com-unidades* are culturally almost invisible, being interspersed among *vecinos*, mestizos, and other Indians. They live in rural shantytowns and on the fringes of the towns and cities of the coast of Nayarit. Lineages, still important in the *comunidades*, mean little in this environment. Huichols do not move as lineages but rather as families and individuals. Family life is strong, though the husband-wife bond is weak. Since the entire family makes up the work force, family breakups are quickly re-formed into new units. The environment is not promiscuous, although promiscuity and alcoholism are problems at a level not tolerated in the *comunidades*.

The neighborhood rather than the lineage forms the face-to-face society in which the Huichols integrate and work. Its composition is controlled by the *patrones* (bosses, or sponsors) who usually own the buildings and command access to jobs, credit, and better opportunities in the work-camp environment. Many Huichols have broken out of the cycle by peddling, opening small stores, or selling alcohol or other goods and services.

Acculturation is rapid for those who stay at the coast. Traditional dress is discarded immediately, though the garments are sometimes saved for visits to the mountains, or for sale in an emergency. Spanish is most often the work language and frequently the family language as well, especially in the case of mixed families. Children seldom speak Huichol after they begin playing in the streets, and youths from this environment are rarely interested in Huichol traditions. The plantation setting of the Huichols is one of poverty, rapid erosion of traditions, and exploitation.

Arts and Crafts. Within the novel environment of political and economic acculturation, one new economic adaptation for the Huichols is craft production for the tourist and museum trade. Although their crafts began to attract international attention with the collections of Carl Lumholtz and Enrique F. Mertens, only recently has production for marketing begun to be a major supplemental source of income for a large number of Huichols. Income from crafts and arts varies considerably, although

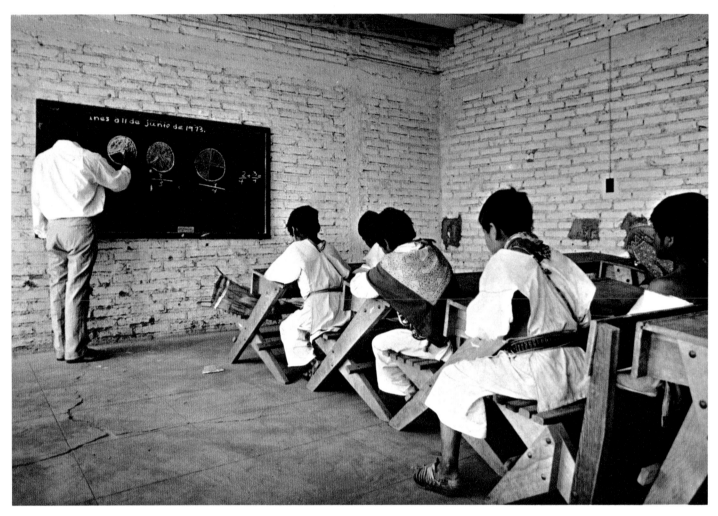

Government school. Photo: Kal Muller

almost everyone benefits at least indirectly. (One urban artist made close to five thousand dollars one year—a fortune for him, though the sum included the sale of his last cattle holding in the *comunidad*.)

Within the *comunidades* women weave for Huichol retailers for about half the market price of the items, or, quite frequently, they build up a stock and then go to the cities in the hope of selling their goods at a higher profit. Weavers and other artisans often stay in the cities for long periods and contract to other Huichols for materials, or to the mission at Zapopan or to the many stores in Tepic. The successful artisan is often tempted to stay.

In many respects, the popularity of Huichol arts and crafts has breathed new economic life into the *comunidades*. Those who stay in the cities often send money back to the *comunidad* or, on returning, invest in cattle. But more and more Huichols remain in the cities. Much of the published misinformation about Huichol symbolism and religion can be traced back to them; they sell their crafts and arts with charming legends and myths to enhance the sales appeal. The accuracy of this type of material is questionable, especially since the urban environment is a composite in which all Huichol cultural differences are blended and obscured.

Crafts of dubious quality are often produced in factory-like surroundings, with many workers—not all of them Indians, let alone Huichols—mass-producing bead-encrusted cigarette boxes, god's eyes, bead bracelets, woven bags, and even yarn paintings. Fortunately, the best artists have shunned this type of commercialism.

Several subschools of style in the art of yarn painting have sprung up in the cities. (Yarn-painting schools are an urban development. The more elaborate paintings have no place in tradition and thus are never found in the *comunidades*.) Leaders of some of these schools have become famous to a degree, and their careers as artists make a

fascinating study. Their perceptions of Huichol culture are adaptations of the traditional culture within an urban and market setting. Remarkable men have come out of this urban, artistic environment. Some of their work is incredibly dramatic, and the full richness of the various Huichol and Cora symbol systems has been blended into a fine, new art form. But a lot of junk is also created, especially in copies of existing paintings. The vast majority of the urban artists do not receive a fair price for their work. They have been exploited by government agencies, missions, retailers, and museums. Retailers, including some Huichols, have done much better. Only a small percentage of Huichols have been able to take advantage of the full-time art-and-craft environment. Most regard crafts as supplements to more traditional income sources—largely agriculture, cattle sales, and peddling.

The Urban Dwellers. In the highland cities (especially Guadalajara and Tepic, but also Mexico City and Zacatecas), adaptation takes a much different line. Along the coast, the work is primarily agricultural; the city offers industrial and manufacturing opportunities. Many urban migrants find employment in crafts manufacture, especially those crafts that reflect their traditions.

Urban Huichols also live in mixed and composite environments where different traditions of the *comunidades* are blended among Coras, Tepehuanes, Tequales, *vecinos*, and mestizos. In the city, too, lineage is unimportant, but Huichols are freer to form their own residential groups because residence and employment are less often controlled by the same person than is the case on the plantations. Family life is vital but unstable, and alcoholism is a major urban peril. Spanish is most often the language of work, but if the work is in crafts, Huichol seems to be retained longer than on the coast. Since crafts play such an important economic role among the urban Huichols, the erosion of tradition is frequently less rapid. Nevertheless, the face-to-face group is most often the *vecindad* (patio neighborhood), or work group, which is most often controlled by non-Huichols.

Urban settlement is remarkably spread out—small clusters of mixed Indians are found throughout the slums and poorer neighborhoods. No associations or religious ties hold them together. These groups are often unaware that another family has moved in just some blocks away. Among the craft workers, however, more formal groups based on livelihood are beginning to evolve. These proto-guilds have very limited goals, the most prominent being higher prices for craft products through better marketing techniques and less reliance on middlemen.

The urban Huichols also work as maintenance, factory, and postal workers, as teachers, health workers, and kitchen aides, and as maids and as beggars.

Summary

The social aspects of the Huichol Indians have been poorly understood. Their social and cultural systems are being rapidly eroded as basic economic and political acculturation proceeds. Government programs are now instrumental in bringing about many changes within the *comunidades*. However, the Huichols are responding to the new environments with imagination. The markets for their crafts have given them enough economic flexibility to retain their dynamism throughout this period of change. While many Huichols are moving out of their traditional communities to the cities and the coast of Nayarit, others are trying to work with the new systems of credits in order to remain in their homes. They are responding to new challenges and making cultural adaptations.

Whatever happens to the Huichol culture, the *comunidades* appear to be viable social units. As social groups, they will be active long after Huichol acculturation. The *comunidades* are an excellent resource for cattle raising, an economic activity in which the Huichols are beginning to specialize. Their political structure has a depth and flexibility that allows cultural change within social stability.

EMBROIDERY SAMPLE
Collected by Susan Eger in San Andrés (1976–77)

The eight-pointed star or *toto* flower is the most popular of all Huichol design elements. The popularity of the form undoubtedly is related to its association with peyote, from which the image most probably took its form.

Shamanism

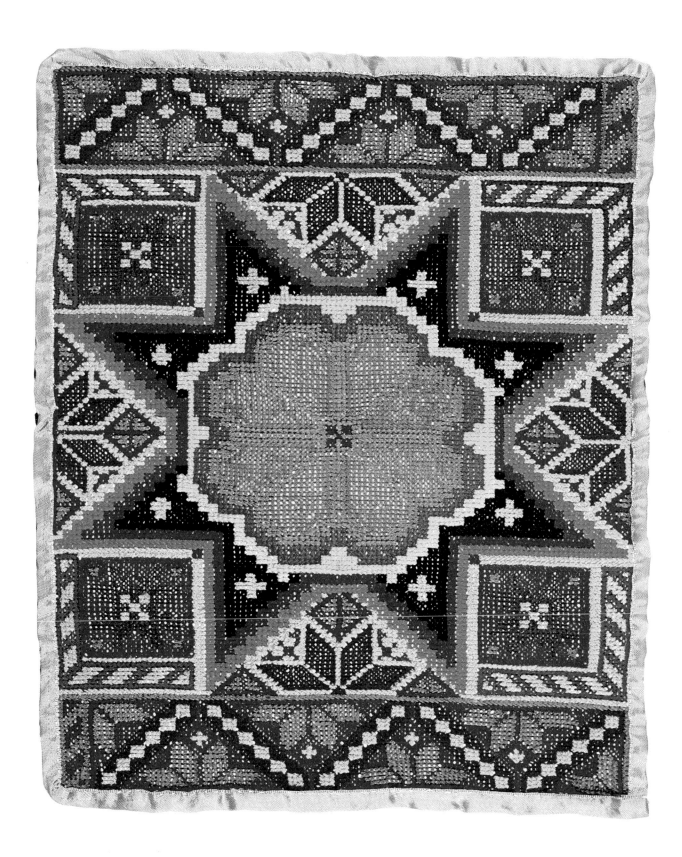

Shamanism: An Introduction
Lowell John Bean and Sylvia Brakke Vane

The particular forms of Huichol shamanism still extant should be understood as manifestations of a widespread social phenomenon rather than as something unusual or unprecedented. Because so much of Huichol art is really shamanic art, or art deriving from a strong shamanic tradition, it seems important to place it in a larger, pan-human perspective.

Even today, the shamanic tradition survives in the midst of a world where the original cultural context in which it arose and functioned is rapidly disappearing, and despite the fact that shamanism has long been misunderstood, rejected, or superficially idealized by those outside the culture.

Shamanism and shamanic art are vital links to the paleolithic past which may help illuminate the human condition and provide insights desperately needed in our complicated world.

There is no consensus among the scholars as to exactly what a shaman is. In *Shamanism*, Mircea Eliade (1964) speaks of "shamanism-technique of ecstasy," and then specifies that the ecstatic experience in which the shaman specializes is "a trance during which his soul is believed to leave his body and ascend to the sky or descend to the underworld"; that he is in control of, rather than possessed by, the demons, spirits, and ghosts of the dead with whom he is able to communicate (4–8 *passim*).

Andreas Lommel, in his work on shamanism, takes a rather different approach when he distinguishes between medicine men and shamans:

> Unlike the medicine man, the future shaman acts under an inner compulsion . . . a psychosis that is emerging for some reason or other is so strong that the only way out open to the individual attacked by it is to escape from it into shamanistic activity, that is to say essentially by means of artistic productivity, such as dancing or singing, which always involves a state of trance [9–10].

Taking a more sociological approach, Gerald Weiss, in *Hallucinogens and Shamanism*, distinguishes between the concepts of shaman and priest, suggesting that there may be a continuum of roles. The shamanic role, he points out, is associated with direct contact with the supernatural, part-time operation, and with the curing of individuals by means of rituals "characterized by possession, trance, and frenzy"; whereas the priest is a full-time specialist who has had special training and "leads group activities of a ceremonial nature" in which "routine propitiatory acts of adoration, prayer and offerings" are important (41–42).

According to Harner, on the other hand, "a shaman may be defined as a man or woman who is in direct contact with the spirit world through a trance state and has one or more spirits at his command to carry out his bidding for good or evil" (xi).

Eliade's definition is useful as a guideline, although it is considerably more restrictive than the others.

Our own definition of shamanism, which is implicit in what follows, incorporates most of the above and attempts to describe and explain this poorly understood, fascinating, and useful ancient universal role.

The Origins of Shamanism

Shamanism was first recognized by Western observers in central and northern Asia. The word "shaman" is derived from the language of the Tungus, one of the groups in which shamanism is important. It existed in its most "classic" form (that is, the form in which it was first described) in these parts of Asia and in northern North America.

The origins of shamanism are hidden in the mists of the human past, although surely the presence in earliest human groups of individuals with particular skills as healers must have gone hand in hand with the development of human culture. Disease, traumatic injury, and emotional problems had to be dealt with as surely as infantile helplessness, and those who had the power to cope with these problems must have been esteemed. It seems likely that

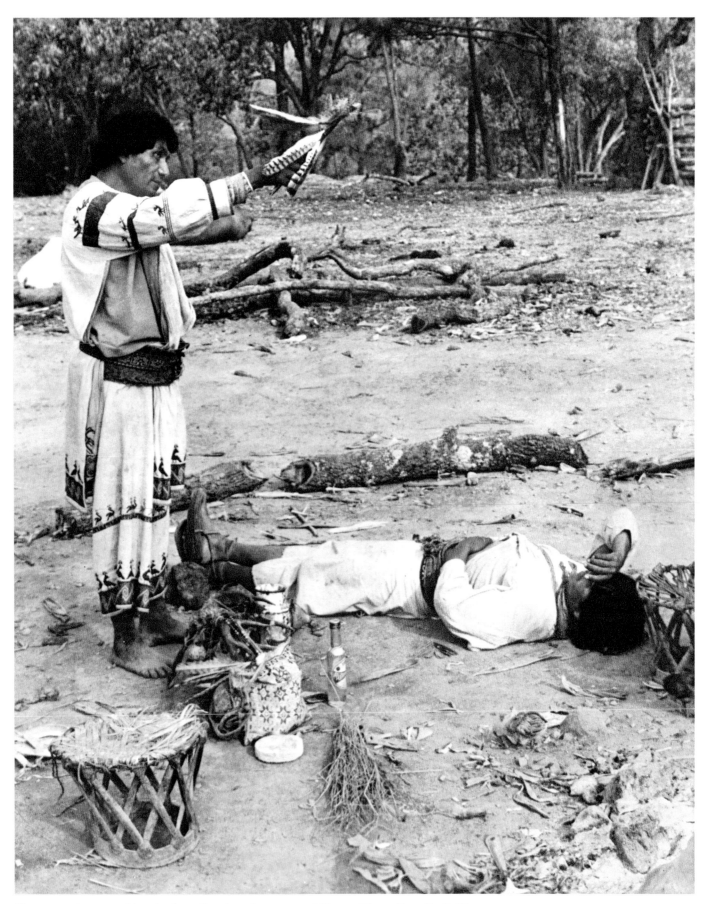

Shaman curing, searching the four directions for source of illness. Photo: Peter R. Collings

Colás, now deceased, was once a Huichol shaman in the San Andrés region. Photo: Kal Muller

persons with special healing powers were very often shamans.

We can only speculate about the techniques of the earliest healers. It is not likely that they had available to them the full panoply of skills of present-day shamans, which must be built up over many thousands of years. However, the 1960 discovery of skeletons in the Shanidar cave in Iraq, which were estimated to be about sixty thousand years old, suggests the presence of the role of curer. With these skeletons, one of which appeared to be that of an important man, were found soil samples particularly rich in eight species of flower pollen, seven of which are known to have medicinal properties. It is certain that they were

included purposefully, and we know that pollens have not been found in other graves of that period. If they were, indeed, placed in the grave because of their medicinal properties, it is reasonable to infer that this was the grave of a shaman. Beyond this, the antiquity of shamanism can be inferred from the fact that it appears to be a near-universal phenomenon, appearing in the hunting and gathering societies of all continents and underlying the religions of more complex societies. What comes as a surprise to intellectuals is that a social role with such distinctive attributes enjoyed such near universality in pre-agricultural societies. Shamanism, or something very much like it, has persisted in the small societies of all continents until the

present, even though it is not always recognized as such.

What is surprising is not the fact that there are people who can go into trance, but that knowledge acquired in a state of trance can be effectively put to work to cure the ill or to restore equilibrium in a group, and that the beginnings not only of medicine and religion, but also of art, music, dance, and literature appear to be intimately associated with revelations gained in states of trance.

On Becoming a Shaman

The shaman invariably receives a spiritual "call" which indicates that he or she may be a worthy candidate for the role, whereupon the process of becoming a shaman begins. Although this process varies from culture to culture, there seems to be a universal underlying pattern.

The shaman's role is distinct and special in each culture, although it usually overlaps other roles. The recruitment of the shaman is necessarily dramatic enough to emphasize the special quality of the role. The candidate may become ill, have vivid dreams or hallucinations, undergo a severe psychic crisis, exhibit nervousness or instability, or undertake a quest involving extraordinary physical effort, self-denial, or self-torture. Whether the role is hereditary or not, sought by or forced upon the candidate, its assumption begins with some event which calls attention to the fact that the candidate may be set apart or consecrated.

In some cultures shamans reportedly do not seek the call—it comes to them spontaneously. Usually, indications that the call may come are observed in a child at an early age by the adults in the community; and, in retrospect at least, these early indications are remembered by the shamans. A dramatic event in early puberty often indicates the propensity toward shamanism. At that time the individual may suffer some great psychic trauma or illness and effect his or her own recovery, may perform a miraculous cure, or have a significant dream. The ability to recover, to cure another, or to communicate a spiritual message may indicate a potential for future power which society can channel for its own ends. The initiation ceremonies of boys and girls may also serve as a revelation of shamanic propensity.

When the shamanic role is hereditary, it may descend in either the male or the female line in accordance with cultural tradition. There is often considerable flexibility in the rules of inheritance, so that the most promising of a shaman's descendants are "chosen," either becoming manifest through a psychic crisis or through direct inheritance of paraphernalia and formulas.

Superior skill or unusual talent, either intellectual or physical, is sometimes seen as a "sign" of shamanic potential. Thus the best hunter or the fastest runner may become the shaman of a group or be thought to have shamanic potential. There are indications in the literature that in the early stages of metallurgy the smiths who knew the secrets of metalworking were assumed to have the supernatural powers essential to shamanism, an assumption also made about alchemists among others. An escape from danger, like an escape from illness, is sometimes taken as a sign of supernatural power. Likewise, the person with unusual sexual proclivities may be a shaman, and it was not unusual in North American groups for *berdaches* (male and female homosexuals) to be shamans.

In some cultures a person may consciously seek the role by achieving an ecstatic experience. The vision quest was particularly important among many western North American groups, in which aspiring shamans underwent strict regimens of physical and psychological stress in order to achieve the desired spiritual experience. Sometimes all the elite adolescents of a group underwent an initiation into a secret society whose members had quasi-shamanic status.

The shamanic candidate may also become a member of the profession by purchase or transfer of formulas, equipage, rights, or supernatural experience from another shaman. For example, according to Harner, among the Jivaro of South America, the would-be shaman gives a gift to a practicing shaman, who administers a psychotropic drink under the influence of which a spirit helper or "dart" is transferred.

The selection process seems to occur at covert and/or overt levels. A youngster who is intelligent, alert, curious, and ambitious is seen as a potential shaman and guided toward the career. The essential requirements for becoming a shaman are the acquisition of a power source and community acceptance. The various kinds of "call" are experienced subjectively as the acquisition of a power source or sources, that is, of guardian spirits, "darts," "pains," and the like, depending on how the group expresses this idea. The would-be shaman enters into a contractual agreement with the power source or sources and undertakes to develop a working relationship with it or them. Either at the time of the call, during initiation, or in the course of training, he or she receives instructions, rules and regulations, and formulas. These responsibilities imposed by the power source must be accepted. Failure to abide by the contract may bring death, illness, or harm to those around the shaman family and community, and of course the loss of power. The contract is binding regardless of the feelings of the shaman. A prominent present-day shaman failed to practice for several years. During this time, she and her family suffered from diseases and other stresses. Another shaman advised them that the former shaman's abdication of her role was the cause of all their illnesses. The "spirit" would not accept this rejection. When the shaman returned to her traditional role, her and her family's tribulations ceased.

Shamans are set apart from the sorcerers and witches of their own and more complex societies in that theirs is a more positive and important role. Community belief and support is essential to them. Shamans may get the call or decide to seek it, but to validate it the power elites of the community, as well as supernatural beings, must pass judgment. The shamans must satisfy their future peers, who control recruitment into the powerful and secret world of the highly skilled.

Public initiatory rites usually precede the final acceptance of a shaman. The initiate is observed at some point in his or her development by other shamans and the community in public performances where power is demonstrated or affirmed. It may be a curing session, or it may be a more dramatic theatrical event involving a ritual reenactment of the would-be shaman's death and rebirth as experienced in trance. One of the functions of the initiation is the public proclamation and validation of the shaman's status. This is necessary because the shaman must ultimately have a "congregation"—a group of others who believe he or she is indeed a person of power.

The ritual death and rebirth which the initiate experiences while in a state of trance—i.e., ecstasy—is remarkably similar in a wide variety of cultures. It is intense, far more convincing than rites of passage which do not involve trance—christenings, puberty ceremonies, weddings, and funerals, of which the initiatory experience may be a prototype. The subject, in trance, may be killed by spirits or ghosts, have his or her organs removed and skeleton dismembered. The navel may be pierced by spears or arrows, and quartz crystals signifying supernatural power may be shot into the body. The dangers encountered and overcome often include dangerous journeys marked by difficult passages where the candidate is in danger of being crushed by great rocks, of falling from great heights, or of being devoured by monsters. The mastery of basic human fears—height, darkness, and space—gives the shaman the self-confidence to make decisions. His creative energy is opened up, since he is more self-assured and less afraid of being in error than an ordinary person. In effect, he is able to make a self-fulfilling prophecy of success.

Although the initiation rite of a shaman may take only a short time, the full acquisition of the shamanic role usually takes many years and is achieved only after many tests or trials, along with instruction from master shamans. Sometimes the end of an apprenticeship is marked by an elaborate public ceremony lasting for days.

Aspects of the initiatory experience are apparently repeated, at least in part, whenever the shaman goes into trance; but having learned to cope with the dangers, the full-fledged shaman is more firmly in control of the situa-

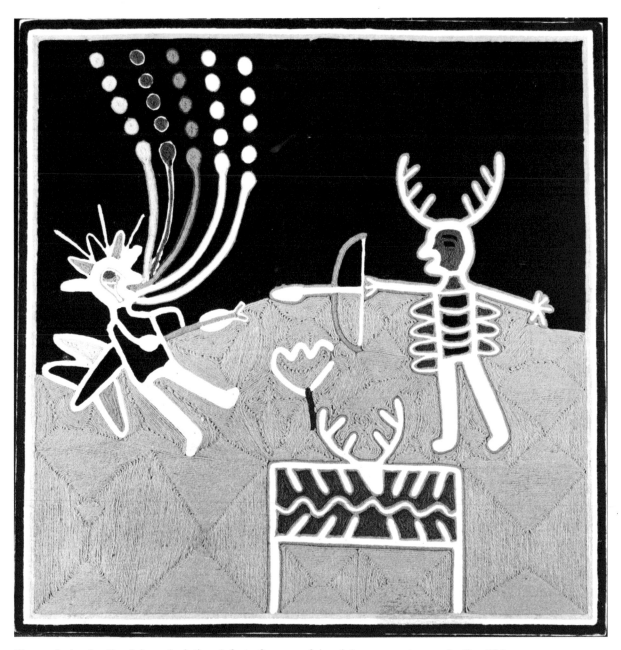

Yarn painting by Guadalupe depicting defeat of a powerful and dangerous sorcerer by Our Elder Mother Deer in the First Times. The Fine Arts Museums of San Francisco. Gift of Peter F. Young

tions he encounters than is the initiate, and is more likely to increase the intensity of them as his career goes forward.

Even though the initiation is so important for the validation of the shaman's status, it does not establish it for all time. A community may reassess its shamans, and only after a long career is a shaman likely to be unquestioningly accepted. There is often a tacit assumption that his or her power is subject to entropic processes—that it diminishes with age, unless there is evidence to the contrary. But in some groups, it is assumed that power increases with age and the acquisition of more spiritual helpers. This, also, has to be demonstrated by the individual shaman.

In addition, the shaman often finds him or herself in competition with other shamans and the target of envy. In public performances, shamans may test one another's degree or legitimacy of power. A shaman may even have his power taken away during such an event. Shamans may also evaluate each other's ethics. Power from spiritual guardians may be quixotic, and a shaman's status in the eyes of both clients and peers may vary accordingly.

Most societies believe that the shaman's power can be used for either "good" or "evil." Hence shamans are closely watched for malevolent or benevolent tendencies. An imbalance in this dualistic role can lead to a shaman's

disenfranchisement and even death. For these reasons a shaman's career must be carefully managed.

The Ecstatic Experience—Trance

Unlike experiences in "ordinary reality," the experiences of the person in trance are not likely to be perceived directly by others; yet they are, according to anthropologists who have apprenticed themselves to shamans and taken psychedelic drugs under their direction, so compellingly "real" that trance has been called a "nonordinary reality." What the tutelary shaman does is to teach the apprentice the "language" of the visionary experience, to organize it and make out of it a culturally validated "sense."

The shaman does somewhat the same thing with the people in his or her society when leading curing sessions or ceremonials, especially when this involves putting everyone in trance or trancelike states. The shaman organizes and interprets the experience. This is well illustrated by the way in which Huichol shamans conduct the peyote hunt, as discussed by Myerhoff and others. As an interesting aside to the Huichol case, some shamanic complexes have disappeared because the world view of the group and its cultural complex were such that shamans could not control the psychedelic experience for the good of the group.

The purposes of trance are several. According to typical shamanic philosophy, trance allows the shaman through magical flight to travel to other worlds, interact with supernatural beings, and discover the nature of life and the pathway to the land of the dead, so that the living may be told and reassured about the future. It permits shamans to find lost souls, catch them, and return them before their loss causes death or illness. Trance also serves as a device by which the shaman breaks through intellectual and cultural boundaries—creating new ideas, seeing "things" in different ways and in new combinations. It puts the shaman at the widening gulf between a world that is and one that may be.

Dramatically, the experience provides a psychological metaphor of immense proportions—life, death, creation, rebirth, and transformation. It provides the well-trained shaman with an intellectual dimension which can apparently multiply his or her capacity to understand the world and its problems, but it is so impressive, so striking, so dramatic, that in order to communicate its meaning—usually by means of ritual—shamans have had to improvise means of communication and thereby have given birth to various art forms. Only these can carry ineffable messages; thus the laymen of a society see and hear realities in a way that enforces societal cohesion, reinforces the symbolic representation of their world, and promotes the mental health of the community at large. This process, as Barbara Myerhoff has pointed out, is manifest in such ceremonies as the peyote hunt—individuals come together to become part of the timeless, placeless totality, to renew their world through a fusion of contrarities or paradoxes and through group sharing of individually experienced but culturally understood visions (Myerhoff 1974).

The trance experience is a natural potential of all people, but some have a greater biological and/or psychological predisposition toward achieving it. Various means, including sensory deprivation, are used to induce trance: rhythmic sound or activity as in music, dance, or meditation; electrical stimulation of the nervous system; fasting; and drugs. All these, except electrical stimulation, are known to shamans. Drugs are used in the form of plant roots, stems, leaves, flowers, or seeds. According to Schultes, the most common of these are hallucinogens belonging either to the nitrogen-containing alkaloids derived from the amino acid tryptophan, or to the nonnitrogenous dibenzopyrans, phenylpropenes, catechols, or alcohols.

In several species of mushrooms which are important in this respect the significant alkaloid is psilocybine, a powerful agent which induces both auditory and visual hallucinations as well as physiological changes. Among the flowering plants the cacti, several members of the morning glory family (Convolvulaceae), mints (Lamiaceae), legumes

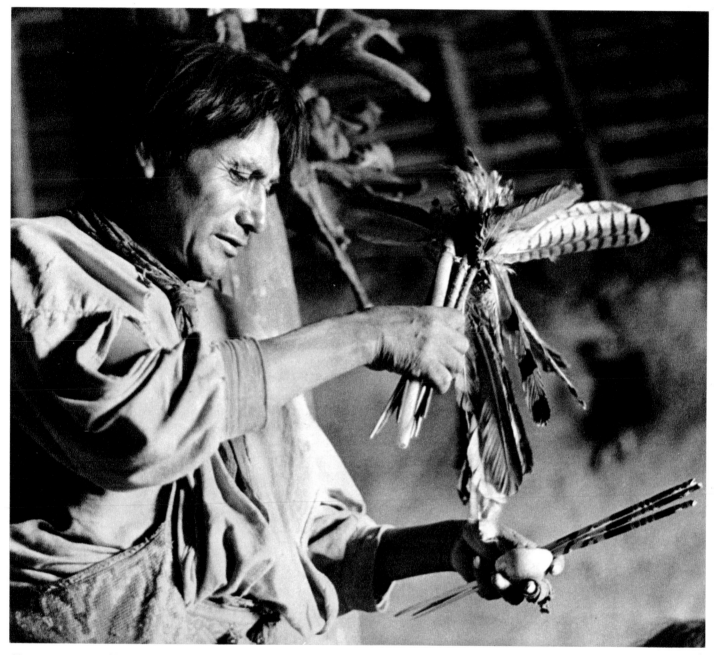

Shaman blessing offerings. Photo: Peter R. Collings

(Leguminosae), Lythraceae, Malpighiaceae, Myristicaceae, Rubiaceae, and Solanaceae include species which yield hallucinogenic substances. Peyote, *Lophophora williamsii*, is the most prominent hallucinogenic cactus.

Lophophora williamsii contains more than thirty alkaloids and alkaloid derivatives. Peyote intoxication, according to Richard Evans Schultes, begins with "a period of contentment and hypersensitivity," followed by "calm and muscular sluggishness, often accompanied by hypercerebrality and colored visions. Before visual hallucinations appear, usually within three hours after ingestion of the drug, the subject sees flashes of color across the field of vision, the depth and saturation of the colors (which always precede the visions) defying description." The visions follow in a sequence which is usually "from geometric figures to familiar scenes and faces to unfamiliar scenes and faces and in some cases objects" (Schultes, 15–16).

It is very common to use more than one plant in the preparations employed to induce trance, the mixtures varying from group to group and from shaman to shaman. The use of these psychotropic substances is often accompanied by very unpleasant side effects and even lethal danger,

since reactions tend to be idiosyncratic and since the amounts contained in each plant may vary. Of course, a skilled shaman is supposed to be able to put together a formula that will yield the desired hallucinatory effects without serious side effects.

Apparently the achievement of trance, whether by the use of drugs or otherwise, can be learned, and a shaman may be able to control the state, adjusting the various levels of the trance to circumstance and need. However, this control is denied by some shamans, who attribute the degree of intensity of the experience to the will of the spiritual guardian rather than to their own conscious efforts.

Several lines of research promise to shed some light on the biological aspects of trance and to explain why the state can be achieved by such diverse means. Both ingestion of psychotropic substances and the other roads to trance would appear to affect the functioning of the autonomic nervous system, bringing about second- or third-stage "tuning" of either the trophotropic or ergotropic system and thus altering ordinary cognitive processes.

It seems likely that skilled shamans learn to interpret the state of the autonomic nervous system by observing such signals as the dilation of the pupils, sweating, respiration, nausea and vomiting, muscle tone, and mental alertness, and use the information to adjust dosages and, in ceremonials, to alternate periods of intense activity and of rest to achieve a desired effect.

These observations do not fully explain why by these processes shamans are able to reach for and discover the deep level of knowledge they do, but it is evident that these processes of special cerebration do occur.

Social Aspects of Shamanism

The full-fledged shaman is a person of power, controlling, directing, and persuading other members of a society, and usually stands at the apex of the power hierarchy. The power is derived not only from the knowledge and wisdom acquired during apprenticeship and initiation, but also from the confidence of the society, from the legitimacy of the role.

The societies in which shamanism has flourished have usually been small, relatively self-sufficient social systems which see themselves as coping directly with their natural worlds. Like all other human beings, the members of such groups lived in a world of uncertainty, where the shape of each tomorrow could be only partially predicted; but unlike the citizens of a complex society, the members of such groups had no presidents or parliaments, no kings or chancellors standing between them and the vicissitudes of an uncertain future, to bear the responsibility, praise, or blame. In such societies the presence of a person or persons who could maintain contact with the cosmic forces of the universe directly, who could explain and make sense of both the measured order of ordinary times and the catastrophes of drought, thunder and lightning, earthquake, or flood, was of incalculable value.

More complex social systems tend to have "institutionalized" specialists who transmit information from one generation to another without explicit recourse to the supernatural. Such societies have priests and prophets, not shamans, at the overt level. But the line between shaman and prophet is tenuous, a matter of definition. The prophet usually does not enjoy the legitimacy within his society that is granted the shaman. His is a voice crying in the wilderness, not that of the legitimate curer and philosopher. Moreover, the prophet usually professes a knowledge of what would be good for his society, whereas the shaman has power, to be used for good or evil. Despite the differences, the prophet can be seen as a kind of shaman, and the study of shamanism illuminates some of the obscurities in the histories and doctrines of the great religious traditions.

Shamans are members of the inner circles of their societies, elites able to explicate the implicit aspects of their cul-

ture. They are also boundary players between their own and other cultures, since they travel not only into sacred space and time in trance, but also, as members of an international network of elites, move outside their own social groups in ordinary reality. They are often multilingual, and hence able to interact with neighboring groups; they have access to a great deal of information. They know the concepts of the past and present, can anticipate the future, and share the ideas of neighboring cultures and subcultures. They are the intellectuals of their societies and "brokers" of ideas between the sacred and profane (or secular) worlds, between the past and the future, between their own societies and others.

The social networks of the shamans are likely to include all aspects conceived of by their cultures. Since they are able to travel between worlds, whatever their number—lower, upper, and middle—they are able to communicate with all forms of life and knowledge. It is generally assumed that whatever has life has intelligence. Thus the shaman may communicate with "spiritual" beings or souls who are in sacred worlds or times and with those sacred persons who are in the ordinary world. His network includes all living things, and even seemingly inanimate things may contain life and power. A rock, for example, may be a source of residual power or the location of a spiritual being; so may animals, birds, trees, grass, flowers, wind, or water. The shaman may know the language of these. And with them as well as with persons from the various levels (ranks) of his society he communicates regularly.

In addition to contacts with other shamans and their congregations, the shaman often maintains an entourage of personal helpers. These are likely to be people trained to assist in the esoteric matters of the profession. Whether the objective is the cure of a patient or the restoration of "order" in the social "universe," the shaman's various public and private performances encompass a wide variety of dramatic presentations—singing, dancing, music, magical acts, and ritual recapitulations of cosmic creations.

These performances often require assistants who may perform purification ceremonies, protect the shaman's privacy, or care for his or her personal needs during the performance. They may gather special herbs or minerals or make special equipment. The singers, musicians, and dancers who often provide ritual accompaniment need to know the unique musical and poetic repertoire of the shaman and be able to perform correctly while the shaman is in trance or undergoing a transformation or magical flight.

These assistants may be members of a shaman's immediate family—husband or wife, child or sibling—apprentice shamans, or, as in the case of one tradition we have observed, they may be deliberately selected from different families within the community in order to provide the shaman with immediate ties to a number of families and a greater network of supporters for his or her position.

The shaman's social sphere often includes other practitioners, who may be either assistants or independent specialists. For example, diviners, who may or may not be shamans may be employed to tell a client what kind of shaman to call upon for a specific service. Herbalists may have the responsibility for herbal cures or may supervise the care of the patient in the absence of the shaman. The shaman in such an instance serves as the physician, instructing the patient and those who assist or collaborate in the patient's care in the procedures necessary for the cure. The shaman understands the skeletal structure, musculature, and so on, especially in hunting societies where butchery of game provides empirical data. This kind of practical knowledge is combined with legerdemain and skilled diagnosis, and these in turn reinforce the trust of the patient and the group. Thus, the shaman may show the conquered disease as an object which has been sucked from the patient—the object being a representation of the disease's cause or of the patient's pain—or may demand that the patient or a member of the community confess to acts which may have caused or aggravated the illness—the violation of taboos or cultural norms.

The Shaman in Today's World

Shamans and their modern counterparts can still be found in many societies. Despite the pressures upon the institutions of shamanism—missionaries, Western medicine, governmental proscription, theft or displacement of their specialties—it is alive and well throughout the world. Among American Indians, for example, there is a resurgence of shamans and their influence in contemporary political movements on both continents. Many political organizations, among them the American Indian Movement, use the wisdom and political skills of shamans. Even those shamans primarily dedicated to serving their own small communities (including Essie Parrish and Mabel McKay of the Kashia Pomo) are called upon and visited by major political leaders of the American Indian community. Mabel McKay, for example, now serves on the Native American Heritage Commission by appointment of Governor Brown. There is also now an annual conference of shamans, or people of power, from the native American community, a movement which began in 1970—a North American Indian ecumenical movement.

In various communities the shaman also serves a wider congregation. Many non-Indians come to shamans with a reputation for special mystical power and healing (part of our own *indigenismo*). The authors, in their public appearances (lectures) with shamans, have invariably found students and others suffering from psychological or physical pain turning to the shamans for help.

On the reservations where shamans live, it is common for strangers to appear at the door seeking aid. Many have a large following bridging ethnic backgrounds and classes. Their success as healers and their acceptance by non-Indians is testimony to their communities that the Indian culture has retained uniquely attractive, mystically powerful characteristics. This assuages the pain of the stigma of being exploited by a dominant culture.

Within their own ethnic sphere the shamans continue many of their traditional roles—as philosophers, as psychological advisers, as pychiatrists engaged in group therapy, as curers using traditional methods of healing for many ailments, often those which they define as "Indian" rather than "non-Indian" diseases. This interesting diagnostic dichotomy occurs among many North American Indian groups, where shamans automatically refer many ailments to non-Indian doctors. Some enlightened members of the medical profession in the dominant culture reciprocate. Where this occurs, as among the Navaho, a very valuable and creative collaboration can exist between experts of the two traditions, each learning from the other.

The shaman's role is difficult today, perhaps more difficult than in an earlier time. There is, despite the survival value of shamanism, less community support, less economic and political advantage to the individual shaman, and always the nagging doubts of people within and without the culture who, out of ignorance or perhaps fear, negate the ancient role.

Those shamans who have continued to practice their roles in recent years have been personally strong and deeply committed to their professions. But the extraordinary new support which has developed in recent years because of the American Indian Movement, the renaissance of national interest and concern for the Indian culture and community, and a new interest in non-Western religious traditions, has been a significant catalyst for shamans, who can now be placed in context by reference to characters such as Black Elk in Joseph Epes Brown's *The Sacred Pipe* and Castaneda's don Juan, familiar to readers of popular literature. They have a new cross-cultural legitimacy among literati and among Western therapists who are anxious to learn from a study of shamanism and its new methods for maintaining and restoring mental and physical health.

Initiation by a Huichol Shaman
Prem Das

Eligio Carrillos Vicente, a Huichol yarn painter, and I began an apprenticeship with don José Matsuwa in the early summer months of 1971. It was initiated by a pilgrimage we made to Wirikuta, the land of peyote cactus. Neither of us realized at that time how profoundly our lives were to be changed by following the path of a Huichol *mara'akame*.

I first met Eligio in Tepic, the capital of Nayarit, when he was beginning to make yarn paintings depicting visionary states of consciousness. Eligio, a then thirty-one-year-old Huichol Indian, had moved to Tepic from his mountain home in the Sierra Madre of Nayarit. Soft-spoken and gentle, he left his *rancho* at the age of twenty-seven and moved with his wives, Jacinta and Maria, to the city to make yarn paintings and learn about Mexican culture. His brothers and parents remained in the mountains; Eligio visits them regularly and attends family ceremonies throughout the year.

We met in the old adobe house of Guadalupe, the widow of Ramón Medina. It was there also where Eligio and I met our teacher, don José. He had come down from his remote mountain village to cure one of Guadalupe's friends. Upon his arrival he encountered Eligio and myself sitting under a ramada talking about yoga and my recent trip to India.

Don José deeply impressed me on first sight. He was the exact image of Carlos Castaneda's don Juan: eighty-six years old, extremely fit, radiating exuberance and vitality. His eyes glowed, casting a soft, yet intensely powerful gaze upon all in his orbit. That he is a small man, about five foot five, in no way detracts from his nobility.

Guadalupe, or Lupe, as she is called, introduced us and then went to prepare coffee and a lunch of beans and tortillas. Don José was presented to me as her father—not her real father, but her stepfather, the man who had raised her. Immediately I realized that Eligio already knew don José, for they had begun a conversation in Huichol and were laughing and joking—about what, I had no idea, as I had no understanding of the Uto-Aztecan dialect.

Eligio told don José about my trip to the opposite side of the planet to study the knowledge of the yogis or "shamans" of that faraway land.

"How did you get there?" the old shaman asked as he offered us a cigarette.

"I flew," I responded as I hesitantly accepted the cigarette. Smoking was against the rules of yoga, but I decided to puff one to maintain social continuity.

Don José exchanged a look with Eligio and they both broke out in laughter. At first I did not know whether it was the clumsy way I was smoking or my saying that I had flown to India that brought on the laughter.

"Where is the other side of the world?" don José asked in total seriousness. Then he added, smiling, "And how did you learn to fly?" Several other Huichols, including Lupe, had joined us, and they were all nearly hysterical watching the unfolding comedy.

I tried to tell them that the world is round and about the seas and continents on the far sides of the ocean, which in respect to us are on the opposite side of the world. I told don José about high-speed aircraft that can fly one there, and how twelve o'clock noon here is twelve o'clock midnight there. He simply shook his head and continued smoking. I knew I was in a difficult situation trying to explain this to a group of people who obviously had a different belief system, and I felt a little depressed as everyone continued to laugh.

Don José got up from his chair to look closer at the figures Eligio was "painting" with yarn into a plywood board covered with a thin layer of beeswax. Eligio stopped for a moment and began to explain that what I was saying was what the Mexican school teachers had also taught.

"I don't doubt it," don José said in a tone that implied the Mexicans were crazy.

"Why did you go to the other side of the world?" the old man asked, "And what did they teach you there?" He sat down again, and Lupe served us Nescafé with a big dish of Mexican sweet rolls.

I took a sip of coffee and wondered if I should attempt to tell him the real story or make up a simple answer to

avoid another embarrassing outbreak of laughter over my strange tales. I decided to risk the truth in the hope of eliciting a reply that might lead us into a conversation about the Huichol shaman and his path. The discussion that followed eventually led to a pilgrimage on which Eligio and I accompanied don José to learn of the life of a Huichol shaman.

Six months later a group of us were gathered around a spring called Tatei Matinieri preparing votive offerings of small prayer arrows, cookies, chocolate, and candles, which we would leave with the sacred desert spring in exchange for the purifying blessing bestowed upon those who loved this place as their great-, great-, great-grand-mother.

Don José had brought us to the sacred water hole after leading us through Jaikitenieh (Cloud Mouth Pass), a critical point of passage from the homeland Sierra Madre behind us to the divine realm we were in, called Shirikita, the Place of Our Temple.

We had been fasting for two days in preparation for drinking the life-giving water (kupuri) and being baptized by Her Holiness, Mother Earth. Don José prayed over the spring, which was surrounded by our offerings; the luminous green parrot feathers attached to our prayer arrows glittered in the light from the rising sun as they danced on their shafts in the early morning breeze. As the first rays of the sun touched the crystal-clear spring, don José directed his sacred plumes to the cardinal points: to the north, south, and west, to our radiant Father Takauyasi rising in the east, above to Tajeima, the Sky Realm, and then down into the flowing waters of life seeping from the breast of Mother Earth.

In a state of awe and reverence, we all held out candles before the spectacular view of don José praying aloud to the earth, sun, water, and the winds that blew around and through us. I looked to the flickering flame of my candle and felt as if it were my life which had to be prayed over

and protected from the great desert winds that blew in from all sides and never ceased.

It was wintertime and not much above freezing in this beautiful, remote desert spot. After don José and the four other Huichols who were with us ended their vocal and highly emotional prayer, the old shaman asked me to come over next to him at the edge of the spring. He lifted a pair of red-tailed hawk feathers attached to a short arrow (muvieri) from a small rectangular basket (takwatsi) and began to pass them over my head in a counterclockwise direction and down my whole body. Then he stopped for a moment and appeared to go into a deep trance, still holding the feathers as he looked toward the ascending sun. I looked into his eyes and had the distinct impression he was not there, as if he had left his body or had become transparent. When I looked closer, I realized tears were flowing gently down his dark cheeks. Suddenly he hurled his muvieri toward the sun, captured something with them, and then just as suddenly passed the sacred plumes to the top of my head and then down, to touch each of my cheeks with a light and gentle stroke. Following this he picked up an old gourd bowl (shrukuri), filled it with ice-cold water, and slowly poured it over my head. Shivering and surprised by the unexpected icy shower, I heard all of the Huichols break into peals of laughter. Before I could move, don José refilled the gourd bowl and insisted that I drink it quickly. More laughter ensued, and soon I too began to laugh as I saw everyone else receive the same blessing, including don José.

The next day we were riding third class on an old Mexican train headed toward the historic mining town of Real de Catorce. In the past, the two-hundred-mile peyote pilgrimage was made on foot, traveling first across the rugged Sierra Madre and then out over the seven-thou-sand-foot-high desert plateau to the sacred land of Wirikuta. Walking is no longer possible because of the many barbed-wire fences set up since the mid-1930s by Mexican cattle ranchers. Rather than hop fences and con-

Don José. Photo: Prem Das

front unfriendly cowboys, Huichols prefer to take a bus, train, or car to reach their Holy Land. Thus they can no longer visit many of the sacred points, or *kakauyari*, along the traditional path which, according to Huichol cosmology, was first traversed by the gods themselves at the time of creation.

Don José and Lupe rode together in front of the seats Eligio and I had chosen. Behind us were Domingo, Lupe's brother-in-law, and Catarino, don José's son, who is also a *mara'akame*.

Almost all the pilgrims who go to Wirikuta seek a blessing or special favor from the gods who dwell there. As I looked out the train window to the desert chaparral and distant bare hills, I decided this was a good opportunity to ask Eligio why he was going to the Holy Land, what it was that he sought.

"I want to see into the visionary world," he began quietly, "to make good yarn paintings of the gods, spirits, and powers who teach the *mara'akate* [plural of *mara'-akame*] how to heal and conduct ceremonies. Only by truly seeing them and their hidden world can I attempt to portray them in my paintings." He took a sip of fruit juice from his gourd and then continued, "I have made several small, round yarn paintings to leave with the gods in Wirikuta, and they show me receiving this special vision. Kauyumari, the deer spirit ally of the *mara'akate*, is shown in the offering carrying the visions from the gods to me. This is because he is the invisible spirit who has been the

go-between for man and the gods since the time of creation, and it is only he who can open the way for us."

The track over which the locomotive traveled gave us a bumpy ride, but we ignored it and delved deeper into the mystical dimensions of the Huichol shaman.

"When I was a little boy I was able to see in this special way, and I remember well," he said, stopping for a minute as the train conductor came by to punch our tickets. "My father once took me to a Huichol *rancho* near our home. I was sitting next to a grain bin listening to a *mara'akame* sing and I could see colorful visions of all that he was singing about. Then something bad happened. Another *mara'akame* attending the ceremony was staring intently at me, and I began to feel drunk. The visions vanished, and I have never seen in such a way since," he explained sadly.

"What do you think it was the shaman did to you?" I asked, wondering why anyone would want to bother a little boy.

"You have to understand there is jealousy between *mara'akate*. If you can see through the *nearika*, sing well, or heal, they may try to psychically cover over your ability. All *mara'akate* have power to do such things and sometimes misuse the powers in this way."

"What is a *nearika*," I asked.

Eligio looked around us, apparently to be sure no one was listening.

"It is the portal or bridge between our world and the realm of the gods. I know very little about it other than what I have heard from my grandfather who was a story-telling *mara'akame*."

He stopped for a moment and then went on, "It is said that all shamans can look through it to see whatever they wish, and that they have spirit helpers who live on the other side who act as guides and teachers. Well, what happened to me when I was a little boy at that ceremony was caused by one of these spirit agents sent by the visiting *mara'akame*. He had seen me through the *nearika* and considered me dangerous to his future work, and so

sent a power to block my inner vision."

Eligio shook his head and then added, "I would have been a shaman years ago if that had not occurred; it is really sad that so many shamans turn to sorcery."

I agreed with him and told him of the apprentice yogis who, upon attaining a high state of consciousness, receive *siddhis*, or psychic powers, and quite commonly fall to using them to manipulate the events of their daily lives.

"I guess it's the same everywhere," he said smiling. "But now an opportunity has come, a chance to see and talk with the gods directly—that is if Kauyumari's tracks ["Kauyumari's tracks" has a double meaning: peyote cacti are also believed to be sacred tracks left by the deer spirit] will lead us on a good path." He stopped talking and started to laugh.

"What is so funny?" I asked.

"Kauyumari is such a tricky character. Who knows where he will lead us? Maybe in another five years we will have come to the end of our apprenticeship only to fall into the ranks of the sorcerers as well."

In the late afternoon we got off the train at a Mexican *rancho* which consisted of fifteen or twenty adobe huts by the railroad track. This was not Real de Catorce, don José informed us, but a pueblo not far from it and much closer to our destination.

We hiked through the pueblo. About two hours later we stopped walking when don José said suddenly, "Stop, listen . . . do you hear that?" I did not hear anything but thought he might be hearing an approaching train, for we were not more than a mile from the track. I looked all around and saw nothing but the flat, majestic expanse of desert covered by light green chaparral.

"He's here," don José said, smiling and exuberant in his joy. With that, don José walked off the dirt road and proceeded slowly into the desert brush; we followed him. After going a short distance he stopped once again and said to me, "His tracks are all around us, do you see them?" I knew then he was referring to peyote (*hikuri*), so I looked carefully all over the ground around us but saw

only the brush and a few large thorn-covered cacti. The other Huichols were searching all around and obviously did not see anything either.

Don José just stood there, smiling, as we scattered about trying to find the elusive tracks. Suddenly the sharp, piercing sound of a horn broke the desert silence. Catarino, don José's son, had blown his goat horn as a signal for all of us to join him. When we reached him, we found he had placed several prayer arrows in the ground under a small, leafless bush. I looked very carefully and could see first one and then five or six more small, round cacti protruding slightly above the ground. Little white tufts of hair grew from the center of each; they were of a greenish color that blended well with the earth and brush around them.

Everyone moved in closely around the magical "deer tracks" and knelt down in reverence. As don José began to pray out loud we placed our prayer arrows and offerings of small yarn paintings, prayer bowls (*shrukuri*), chocolate, and cookies around the sacred cacti and arrows of don José and Catarino.

Once again, as at the springs of Tatei Matinieri, we lit our candles and watched don José pray with his sacred plumes to the cardinal directions. All the Huichols were praying aloud, rapidly and tearfully, for the peyote cacti (*hikuri*), to Our Mother the Earth (Tatei Urianaka), to all collective mother goddesses (*tateteima*) and the natural monuments (*kakauyari*), as well as to Kauyumari, the deer spirit. Don José purified everyone with his *muvieri* and then touched our cheeks with the plumes to bestow a special blessing extracted psychically from the tops of the peyote cacti. He then very carefully dug out the largest cactus, at least five inches in diameter, and sliced it vertically with his small machete. He took one piece and after touching my cheeks with it placed it in my mouth and said, "It's sweet, like a banana. There's so much fruit here, so many flowers. ["Flowers," or *tuturi*, also metaphorically represent peyote.] And we're the little banditos, we have come to rob the garden. Now go find and pick as many

flowers as you like and meet us back here before it gets too dark." He gave everyone a piece of peyote in the same way and directed them to follow the "tracks" and pick pretty flowers.

We wandered off, each following an individual path, until we lost sight of one another. There was little time to hunt the peyote, for Father Sun, Takauyasi, had already flown across the sky in his *uwemi* (the ceremonial chair of a leading *mara'akame*) and was beginning to set over the distant mountains.

Wirikuta is a huge desert valley ringed by mountains. We were on a gently sloping plane which, a few miles to our east, suddenly ascended to form the Real de Catorce range, where silver mines from the last century could still be seen as white spots dotting the crests. I learned later that the highest peak, called Uri Mana Katura by the Huichols, was an extinct volcano containing a crater known as Le'unashu. Huichol creation stories identify it as the birthplace of the sun, Takauyasi. This mountain is the most sacred place known to the Huichols, located at the exact center of the four cardinal directions referred to in their cosmology.

Walking slowly and already feeling heavy from the peyote I had eaten, I stopped and sat down near two barrel cacti. My attention was drawn to the setting sun and the rays that were fanning out all across the western horizon through multilayered cloud formations. I knew that my perception was being enhanced by the peyote, but still it was a view that would have taken away my breath even if I had not ingested the sacramental "flower."

When I looked down to the ground I saw peyote cacti everywhere about me, and they seemed to glow with a special luminescence of their own. The two richly embroidered Huichol peyote bags I was wearing were easily filled and held at least a hundred peyote cacti of various sizes. I ate several more, continuing to watch the luminous and constantly changing cloud formations in the awesome and penetrating silence of Wirikuta.

It was getting late, but I could not move from this spot

which had become precious to me. I felt so much peace, so at home here among the peyote "flowers," chaparral, and my two barrel cactus companions, that going anywhere else seemed an offense to the sacredness of the moment. I closed my eyes and began to think about how blessed I had been to meet the Huichol Indians and to have been brought to their Holy Land.

I began to cry as I thought of my own people, my own race, with its atomic bombs and missiles sitting ready to destroy everyone and everything at any moment. Why, I wondered, why had we become so isolated and estranged from the harmony and beauty of our wonderful planet?

I heard an answer that seemed to come from all around me, and it rose in my mind's eye like a great time-lapse vision. I saw a human being rise from the earth, stand for a moment, and then dissolve back into it. It was only a brief moment; and in that moment our whole lives passed. Then I saw a huge city rise out of the desert floor before me, exist for a second, and then vanish back into the vastness of the desert. The plants, rocks, and earth under me were saying, Yes, this is how it really is, your life, the city you live in. It was as if in my peyotized state I was able to perceive and communicate with a resonance or vibration that surrounded me. Those inner barriers which defined "me" as a separate identity from "that"— my environment—had dissolved. An overwhelming realization poured through me—that the human race and all technology formed by it are nothing other than flowers of the earth. The painful problem that had confronted me disappeared entirely, to be replaced with a vision of people and their technology as temporary forms through which Mother Earth was expressing herself. I felt a surge of happiness and ecstasy which flowed out to dance with all forms of the earth about me; I cried with joy and thanked Wirikuta, don José, and the Huichols for such a profound blessing.

When I opened my eyes again I was surprised to be able to see, for it was now dark; but a kind of moving twilight seemed to illuminate the desert. I was sure my Huichol friends were worried about me, and just as the thought crossed my mind I heard Catarino's horn sounding several hundred yards off to my left. I got up, strapped the full peyote bags over my shoulder, and as quickly as possible set off toward the sound. A special sensitivity to light which the peyote had given me allowed me to move through the desert with ease even though it was night. As I approached my companions I saw that they had already built a campfire, and everyone except Domingo was present.

I sat down between Eligio and don José, who handed me a slice of peyote, asking, "Did you see Kauyumari out there anywhere?" The others who had been bent over in deep contemplation looked up at me, smiling.

"Not in the form I had expected," I replied, grinning; and with that everyone started laughing. At that moment Domingo returned and sat down to join us around the fire.

"Kauyumari never comes in the form you expect," don José said, scratching his head. He then spoke to Catarino and Domingo in Huichol and again everyone laughed.

A few minutes later we all stood up and prayed to Tatewari, the great-grandfather fire who was burning before us. One by one we placed a piece of wood into the flames to feed the ancient fire god who was protecting us from the intense chill of the night.

Catarino picked up a cloth bundle and unfolded it to reveal a small handmade Huichol violin.

"We are going to dance," don José said cheerfully, as Domingo unfolded another bundle containing a miniature five-string Huichol guitar.

The musicians tuned their instruments and a few moments later began to play an exhilarating, joyful melody. The tones were high and penetrating and the melody delightfully simple. Eligio and don José, facing Tatewari, began to stomp on the ground in rhythm with the peyote music. As the others began to dance too, I watched closely and imitated the steps. Don José looked at me and said, "*ishra, ishra, ishra*," meaning "fine, fine, fine."

Every now and again someone would do a complete

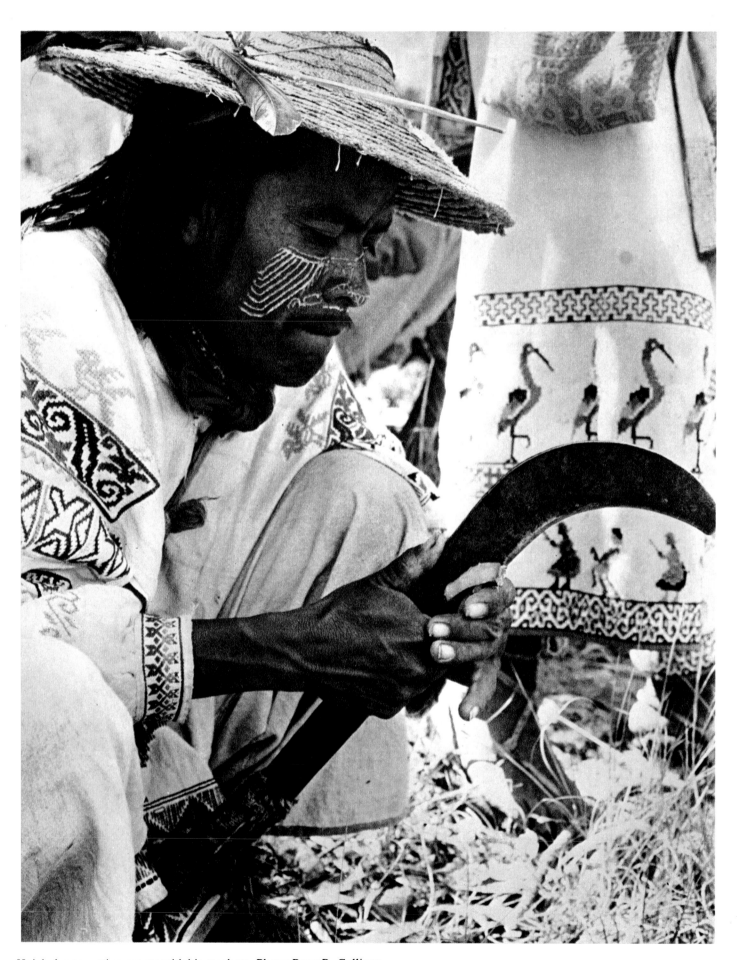

Huichol man cutting peyote with his machete. Photo: Peter R. Collings

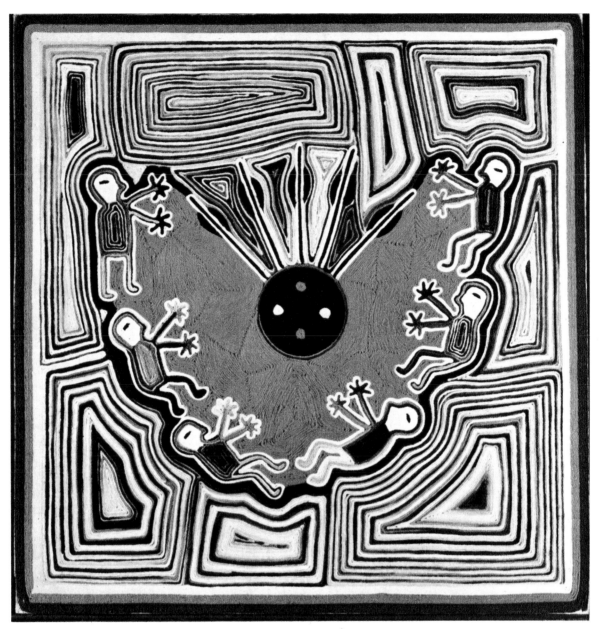

Yarn painting by Guadalupe depicting How We Contemplate *Hikuri* in Wirikuta.
The Fine Arts Museums of San Francisco. Gift of Peter F. Young

360-degree spin while still keeping time with the music. I tried it and felt as though I had not moved, but instead the whole world around was dancing and spinning past me. I was filled with a strong intuitive feeling that Wirikuta was happy we had come to dance within its divine province.

I looked at each of the dancers and saw that they were consumed in the ecstasy of a ceremonial tradition started by the gods themselves who had made the first pilgrimage here back in the time of creation.

We danced five rounds that lasted almost half an hour. By the end of the last dance everyone was sweating profusely and smiling radiantly. We again sat down in a circle around Tatewari; lively jokes and almost uncontrollable rippling laughter filled the air. Moments later the jokes and laughter subsided and we all fell into deep contemplation of Tatewari, Wirikuta, and the spiritual power inundating our souls. The whole night passed in this way,

alternately dancing and meditating, until the rays of the morning sun shone down upon us from over the mountaintops of Uri Mana Katura.

Our prayers floated up into the sky with the smoke of great-grandfather fire, a hawk circled high above, and Takauyasi ascended radiant and full of splendor to bless us with another day.

The return from the divine domain of Wirikuta was rapid and direct, for my Huichol companions had no wish to stay any longer than necessary to leave their offerings, pick the multicolored "flowers," dance through the night, and say a parting prayer.

"It's dangerous to stay too long up there," Eligio told me as we drove back from San Luis Potosí. The train had brought us back from Wirikuta to the nearest large city, where we had left my car, and even though it was already getting dark, don José insisted we drive all night to get back to the homeland Sierra Madre by the next day. I was opposed to the idea because the highways are so precarious after dark, and recommended we spend the night in a motel. No one would hear of the idea. They reminded me that the women back in the village were all praying for our safe return and that they were "feeding" Tatewari, who had been burning in the center of the *rancho* patio since the pilgrimage had begun.

Only a few miles outside of San Luis Potosí I had to pull over to check my right front wheel, which was emitting a strange, whining sound. Lupe, the only one still awake, asked why I had stopped. I checked the wheel and told her that it was oozing grease; most likely a seal had broken, and the bearings were beginning to grind. She obviously had no idea what I was talking about, so I decided to wake up don José and inform him. She spoke to him in Huichol; finally he mumbled a reply, yawned, and asked to be let out of the car. I got out with him to show him the damaged wheel. Nodding his head, still half asleep, he asked for his *takwatsi* (a small rectangular basket holding a shaman's prayer plumes and power objects); Lupe handed it to him through the window. When I saw him take out a prayer plume and in all seriousness begin to "feather off," or psychically "dust off" the tire, rim, and then the whole car, I could barely keep from bursting out laughing.

"It's O.K. now, let's go," he said, getting back into the car. I stood there bewildered, wondering how I could drive the car in this condition over two hundred miles of rough roads, over steep, dangerous mountain passes, and at night!

I thought I would at least give it a try for a few miles. I got in, turned to look at don José, only to see he had gone back to sleep, and then started up. After driving about ten miles at 30 m.p.h., I pulled over again to doublecheck the wheel. It had quit making the whining sound, but I felt sure it was still leaking grease. A quick look assured me it was not, and as I got back in, don José said, "What's wrong? Come on, let's go. Your car is fine. Now start passing those trucks again."

We drove all night and arrived in Tepic early next afternoon. After buying some candles, chocolate, and cigarettes, we headed out on an old, bumpy dirt road for some twenty-five miles, where it ended in a Mexican *rancho* community. I could not believe it! The car had made the whole trip with no problem.

After we left the car we started hiking toward the remote mountain range at the top of which sits don José's *rancho* village, La Mesita ("the little mesa"—a flat clearing on the ridge of the mountain).

The heat was intense in the long river valley through which we had to pass before ascending some five thousand feet to reach La Mesita. Don José and the others walked ahead of me, as I needed to stop periodically to cool off and catch my breath.

At one rest stop, in a dried creekbed under the shade of some high evergreen trees, I found don José smoking and waiting for me. I sat down on a flat boulder next to him and began to wipe off the sweat from my forehead.

"Good," he said smiling.

Yarn painting by Ramón Medina Silva showing Tatewari, Our Grandfather Fire.
The Fine Arts Museums of San Francisco. Gift of Peter F. Young

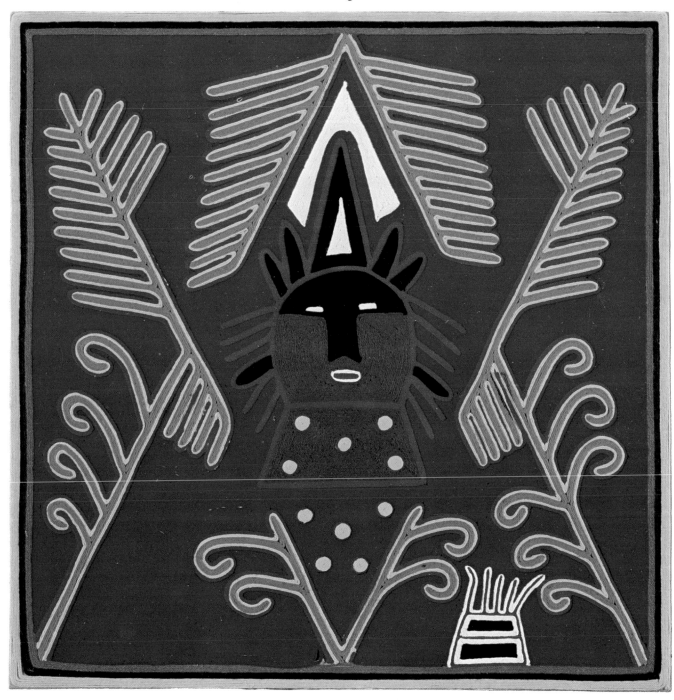

"What?" I said.

"You're sweating."

"I know; I'm burning up," I told him.

"It's the best thing, sweating, it gets all the garbage out of your body," he said as he took another puff on his cigarette. Then he took out his pack of tobacco and offered me one.

"No, thanks," I said, shaking my head, and asked him, "How can you smoke in this heat?" Then I added, "Don't you think smoking is harmful?"

He just laughed. "It's not so much a matter of what you do as what you don't do." And with that he took another puff.

"What do you mean?" I asked, lifting my sweat-soaked shirt to let the air in.

"It's easy for people to do things, such as smoke, drink coffee, and make love; but it's what they don't do that makes them sick and eventually kills them."

"What are the things they don't do?"

At that moment a pair of macaws flew into the higher branches of the tree next to us and began a lively dialogue. Don José pointed up to them and said, "We use the tail feathers of that bird to talk with the fire, Tatewari, and he teaches the *mara'akame* everything he can stand to learn. I am an old man now, and it is the fire that has given me such a long life. Tatewari told me when I began my apprenticeship many years ago to work hard every day in the heat and rays of the sun until I poured sweat. In this way, he once told me in a dream, I would always be healthy and live to an old age."

I looked at him and said, "I have never seen anyone your age so alert, agile, and active; Tatewari must be right." We both smiled.

"You would not believe how much knowledge the fire has," he said. "We can never know it all, the path is unending. I am in my nineties and am still a *nunutsi* [baby]. At first all I wanted to do was know, and they [the gods, i.e., the earth, sea, wind, fire, and sun] all taught me so much that I gave up trying to learn, and now all I want to do is sing seated in front of great-grandfather fire. This is the ultimate for me—the ceremonies, singing and dancing under the stars on my mountain top until the sun, Takauyasi, again rises to bless us with another day."

"I can't wait to see your ceremony," I said.

"All night long tomorrow night," he said with a tone and expression that indicated he wondered if I could endure it.

"Let's go," I said enthusiastically, and with that we got up and continued on the trail to catch up with the others.

As we walked, don José told me of the ancient tradition of repeating ceremonies that the gods who created the world in the first times performed to bring the sun out of the underworld. The sun was born into our world through the love generated by the gods in the ceremony they conducted. After that, he told me, they created the race of man to continue the tradition of these ceremonies, for they decided to turn themselves into all the various natural monuments seen to this day all over the earth.

Don José explained further, "Anyone who really listens to great-grandfather fire will learn how alive he is, how alive the whole earth is, and the sun. These are our great-, great-, great-grandparents, and they can teach us and help us so much. But as our ancestors, who are living and seen as everything around us, they need one thing: our love. Parents provide for their children and hope that their children will live happily and healthily. But if, after raising the children, you find that they turn on you, deny you love or affection, it really hurts. Sometimes it hurts so much you want to end it all, and that is why the great flood came long ago and killed almost everyone. The gods back at that time saw that everyone was unhappy and fighting with each other and did their ceremonies only to get drunk. It made them so sad they decided to end it all and return their children's souls to the sky realm (Tajeima), where they would be free and happy again. Only one person survived, Watecame, and later he obtained a wife. They

had children, from whom came children, and so here we are. Watecame was a good man and a great *mara'akame* who taught his people the beauty and importance of the great tradition, the ceremony; and so it was passed down from father to son until it reached us today."

"The ceremonies are hard," don José continued, "and it is something else, like working hard and sweating, that can too easily slip by and wind up as a 'not done' that should be done. It's a sacrifice—to stay awake all night, sing from your heart for hours, dance with all your life upon the earth, to fast and pray for everyone. But look at me. I am an old man and I do it, and every time I do it I exhaust myself, yet Tatewari always restores me with *kupuri* [life force]."

"You know who it was who fixed your car back in San Luis Potosí?" he asked suddenly.

"Who?" I asked, now walking carefully on the trail to avoid slipping on loose rocks.

"Tatewari, the fire," he said as he walked up the rocky trail effortlessly. I noticed he hardly paid attention to the rough trail and seemed to be guided intuitively to the safest steps.

A few minutes later we entered a clearing in the semi-tropical jungle and joined the others. It was now getting dark and we decided to spend the night there and climb to La Mesita early the next morning. Catarino had gathered firewood and was already kindling Tatewari. We all picked up a small piece of wood and placed it over the fire. All of the sticks pointed in the same direction, toward La Mesita high above us, where Tatewari was also burning

under the care of don José's wife and the other women of the village.

The next morning, before sunrise, we hiked up the mountain. That night I sat next to don José as he sang and prayed with his hawk and parrot plumes. Over eighty Huichols, most of them relatives of don José, danced and sang, repeating phrases after him. Andrea, his eldest daughter, insisted I dance as well, and she carried a small cord whip to make sure everyone danced and no one slept.

We were all given sacred "flowers" to consume at the onset in order to follow the magical deer spirit Kauyumari to the Realm of the Gods, of which don José sang—singing, then dancing, and then singing again, to the tune of the little violin and guitar.

Soon I felt the presence of the gods about us and could hear the fire singing the songs which came from the wood, the trees, and the earth, and which ascended as the smoke to the four directions and the radiant stars above. The awesome beauty of the ceremony brought tears to my eyes and I felt a profound love for don José and his family. Several times during the night, as he sang songs as ancient and powerful as the earth herself, he touched me with his soft prayer plumes. Eligio, who also received the same blessing, later informed me that this was done only at the peak moments in the ceremony. It was a direct transmission of *kupuri* from the gods themselves via don José, and like rays of the morning sun that open flowers, this blessing was to awaken us to the *nierika* within, and to the dimensions of the *mara'akame*.

Catalogue entries by Kathleen Berrin, except
numbers 18 to 26, by Peter T. Furst.

EMBROIDERY SAMPLE
Collected by Susan Eger in San Andrés (1976–77)

Samples showing various border designs used on clothing. Note scorpions, horses, birds, and plant forms.

Catalogue of Objects

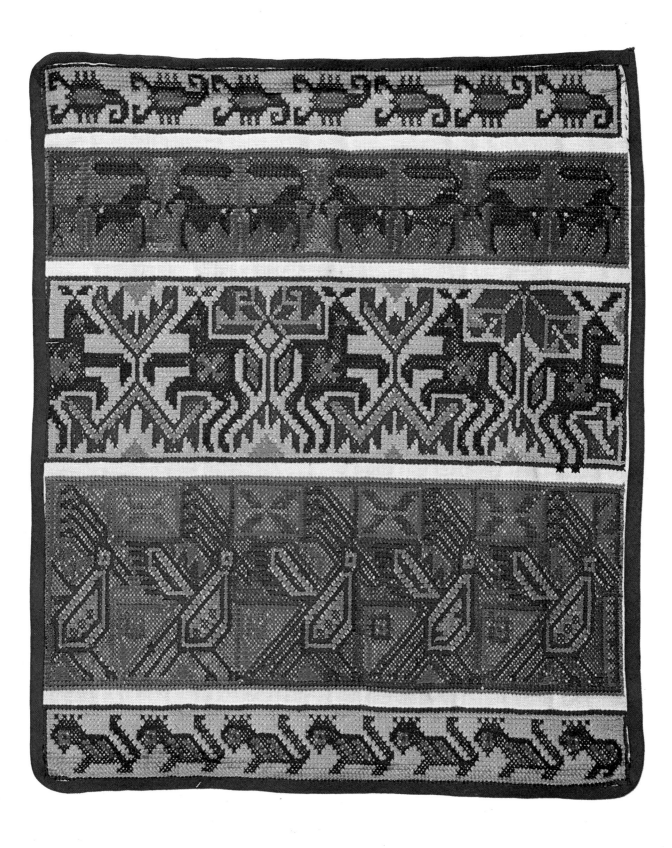

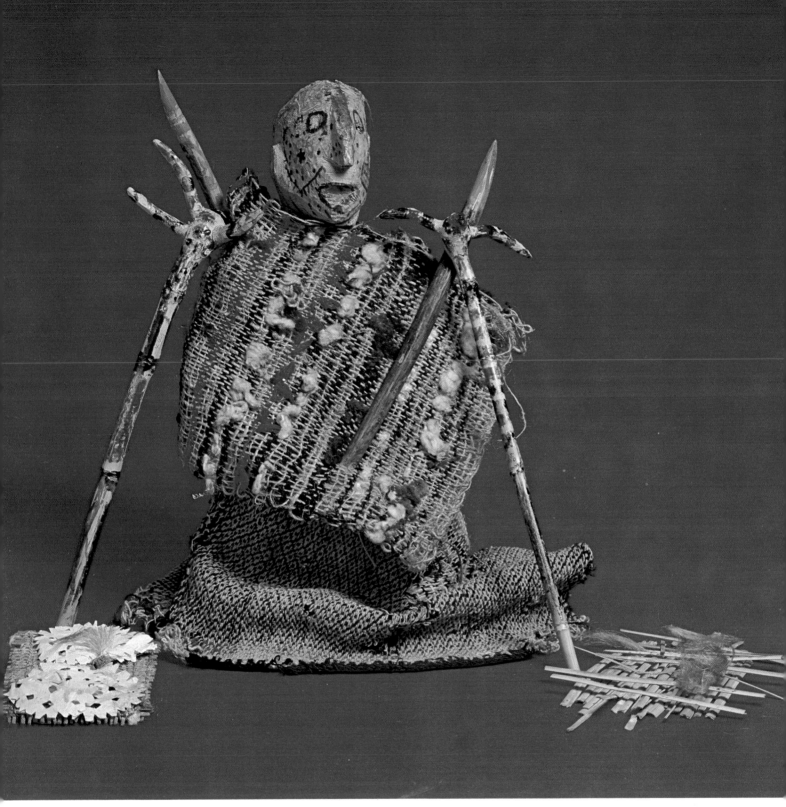

1

GRANDMOTHER GROWTH AND HER ATTRIBUTES
15 x 9″ (38 x 23 cm.). Wood, cotton, wool, paint, paper, fiber. Collected by Lumholtz in Santa Catarina (1890-98). Illustrated Lumholtz 1900:44. #65-1554, 65-1558, 65-1562. From the anthropology collections, The American Museum of Natural History, New York City

Lumholtz first saw a representation of Grandmother Growth in a cave near Santa Catarina and persuaded a shaman to reproduce this example. The original image was located near a spring in the Cave of Grandmother Growth in a spot where children bathed. Intended to pray for the health of the children who bathed there, it also served to insure that the beneficial water would never dry up.

3 & 4

FACE PAINT ON GRANDMOTHER
GROWTH (details of figure in Plate 1)
From *Symbolism of the Huichol Indians* by Carl Lumholtz, p. 44.

On the right cheek, a star-shaped "eye," said to symbolize a cross-section of corn. The face and body of the figure are covered with black, red, and yellow spots, also said to symbolize corn. On the left cheek, a picture of a back shield (see Plate 32) suspended by a string, representing a prayer for luck in making back shields.

144

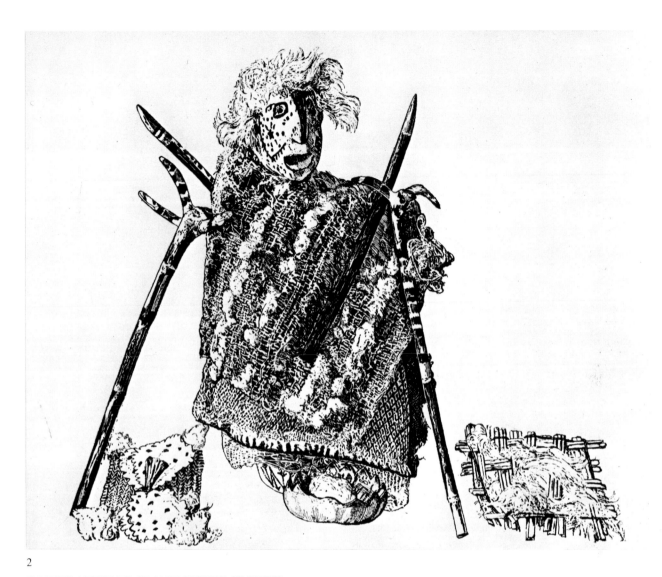

2

ILLUSTRATION OF GRANDMOTHER GROWTH
From *Symbolism of the Huichol Indians* by Carl Lumholtz, p. 44.

Shows how the figure originally looked. Lumholtz comments that it is dressed in a skirt and tunic woven in an ancient design. Her attributes consist of northern and southern beds (or resting places), north and south pronged sticks representing snakes (compare with Plate 5), and east and west bows attached to the tunic which represent water serpents.

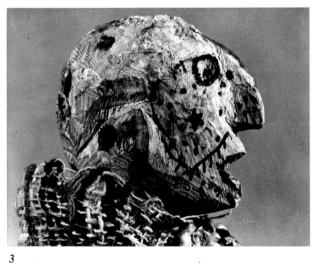

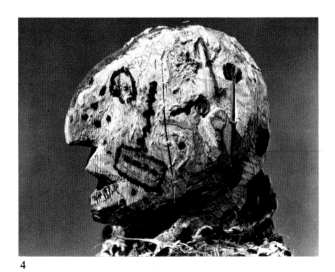

3

4

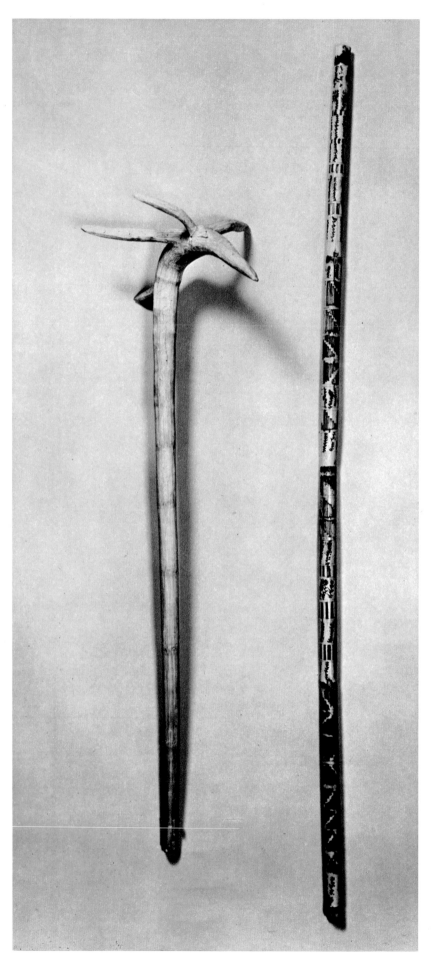

Left: STAFF OF GRANDMOTHER GROWTH
34½ x 10½" (87.6 x 26.7 cm.). Rattan root.
Collected by Zingg (1934–35). Illustrated
Dutton 1962:17. #14072/12. Collections of
the School of American Research in the
Museum of New Mexico, Santa Fe

Compare with figure of Grandmother Growth
and her accoutrements (Plate 1). Zingg iden-
tifies this object as her magic staff with which
she performs miracles. Its top prongs are
fashioned from the root of the solid bamboo
(rattan) and carried in peyote dances.

Right: PEYOTE DANCE STAFF
49¼ x ⅞" (25 x 2.2 cm.). Incised, hollow
cane, pigment. Collected by Zingg (1934–
35). Illustrated Dutton 1962:17. #14069/12.
Collections of the School of American
Research in the Museum of New Mexico,
Santa Fe

Dance staff or symbol of authority with in-
cised stepped forms and zigzags in green.

6

GOD DISK

12″ diameter x 2⅛″ (30.6 cm. diameter x 5.6 cm.). Tuff and paint. Collected by Zingg (1934–35). Illustrated Dutton 1962:29. #14066/12. Collections of the School of American Research in the Museum of New Mexico, Santa Fe

Sacred disk placed in the wall of the god house which becomes successively more sacred as it is consecrated by repeated offerings of incense and candles at the altar. According to a myth, the god disk of the Sun Father must be cut through the structure so that the Sun Father can see. Two deer and three fish are painted and incised in red and blue.

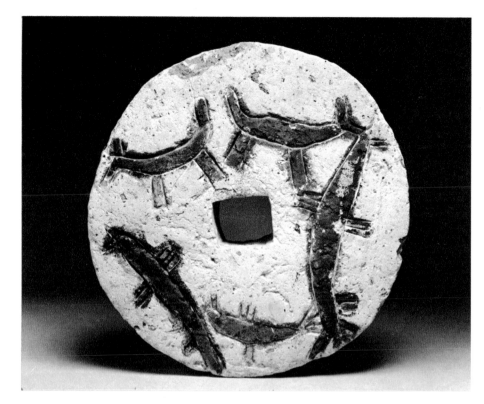

7

GOD DISK (reverse of Plate 6)

Red and blue incised wedges radiating from center.

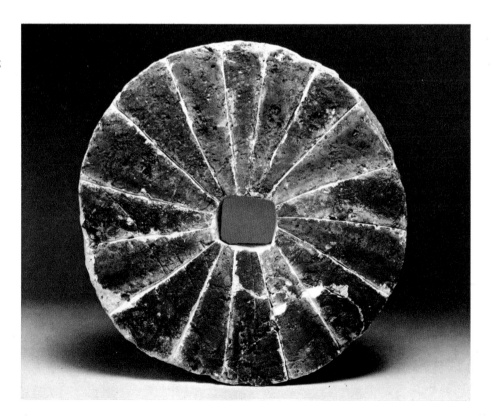

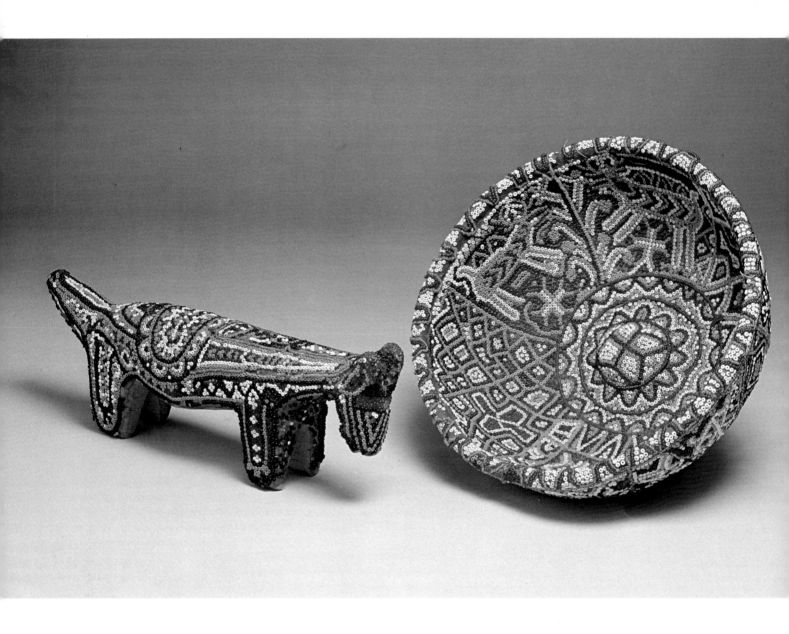

8

Left: BEADED DEER FIGURE
2½ x 11″ (6.5 x 28 cm.). Wood, beads, beeswax. Collected by Lumholtz in San Andrés (1890–98). Illustrated Lumholtz 1900:66. #65-519. From the anthropology collections, The American Museum of Natural History, New York City

Right: BEADED VOTIVE BOWL
8½″ diameter x 3⅓″ (21.5 cm. diameter x 9 cm.). Jicara gourd, beads, beeswax. Collected by Lumholtz in San Andrés (1890–98). Illustrated Lumholtz 1900:66. #65-511. From the anthropology collections, The American Museum of Natural History, New York City

Two votive objects (wooden image of a deer and a bowl belonging to Mother East Water) possibly made by the same artist, Juan Antonio Minjares.

9

BEADED VOTIVE BOWL (detail of outside of bowl in Plate 8)
Illustrated Lumholtz 1900:167

Votive bowl belonging to Mother East Water. Rectangular arrangement of
beads (at bottom of bowl) in alternating rows of blue and white is said to signify
the name of the maker's son. Note that some beads are first strung and then
pressed in wax in rows, while others are pressed in individually.

Votive bowls (as votive objects in general) are offerings to the gods so that they
will hear prayers for health, luck, and well-being.

10

Left: VOTIVE BOWL

7⅞ x 2⅜″ (20 x 6 cm.). Gourd, paint, beads, beeswax. Collected by Zingg (1934–35). #1448/12. Collections of the School of American Research in the Museum of New Mexico, Santa Fe

Votive bowl of Nakawe (Grandmother Growth) depicted in severe contest with the sun who tries to destroy the race he created. The story of their struggle is the annual struggle between the dry and wet seasons. Marginal designs may represent ancient god disks.

Center: VOTIVE BOWL

7⅜″ diameter x 2⅝″ (18.6 cm. diameter x 6.6 cm.). Gourd, beads, paint, beeswax, silver coin. Collected by Zingg (1934–35). Illus-trated Dutton 1962:24. #1461/12. Collections of the School of American Research in the Museum of New Mexico, Santa Fe

Votive bowl depicting deer hunt, man, and scorpions. Mexican silver coin in center bears an eagle (a traditional Huichol motif) and reads "50 Centavos, Estados Unidos Mexicanos, 1919."

Right: VOTIVE BOWL

7⅞″ diameter x 2¾″ (20 cm. diameter x 7 cm.). Gourd, yarn, paint, beads, silver coin, beeswax. Collected by Zingg (1934–35). #1216/12. Collections of the School of American Research in the Museum of New Mexico, Santa Fe

Gourd with painted interior and yarn overlay. Old silver coin in center also depicts an eagle and is inscribed "Carolus IIII Dei Gratia 1803."

11

Left: FLAT GOURD BOWL WITH YARN AND BEAD DECORATION

7⅞" diameter x 1¼" (20 cm. diameter x 3.1 cm.). Gourd, yarn, beads, paint. Collected by Peter T. Furst via Father Ernesto Ochóa in San Sebastian (1966). #X66-317. The Museum of Cultural History, University of California at Los Angeles

Multicolored votive bowl. Designs signifying peyote and the four cardinal, or sacred, directions.

Center: DOUBLE GOURD BOWL WITH YARN LINING

14½ x 4½" (36.8 x 11.4 cm.). Gourd, yarn, beeswax. Collected by Peter T. Furst (1966). #X66-292. The Museum of Cultural History, University of California at Los Angeles

Yarn-lined gourd bowl in orange, blue, and magenta, obtained in a shop in Tepic. Made by the Cora Indians, it is included here as a comparison with Huichol designs and motifs.

Right: PAINTED GOURD BOWL

10½" diameter x 3⅝" (26 cm. diameter x 7.9 cm.). Gourd and paint. Collected by Peter T. Furst via Father Ernesto Ochóa in San Sebastian (1966). #X66-316. The Museum of Cultural History, University of California at Los Angeles

Votive painted bowl with four stalks of corn, two deer, a woman, and cross motifs.

12

PAINTED GOURD BOWLS

Top: (left) 7½" diameter x 5" (19 cm. diameter x 12.2 cm.); *(right)* 3¾" diameter x 2" (7 cm. diameter x 5.1 cm.). *Bottom: (left)* 8½" diameter x 2½" (21.6 cm. diameter x 6.3 cm.); *(center)* 3½" diameter x 2¾" (8.7 cm. diameter x 7 cm.); *(right)* 8¼" diameter x 2¾" (20.8 cm. diameter x 7 cm.). Gourd and pigment. Collected by Zingg (1934–35). Illustrated Dutton 1962:24. #14055/12, #14018/12, #1217/12, #14060/12, #1218/12. Collections of the School of American Research in the Museum of New Mexico, Santa Fe

A selection of gourd bowls for domestic use. Exteriors and interiors painted red and green.

11

12

13

SACRED BOARDS

Left to right: 6″ diameter (15 cm. diameter); 9½″ diameter (24.1 cm. diameter); 3⅞ x 2¾″ (9.8 x 7 cm.); 4½ x 2¾″ (11.4 x 7 cm.). Wood, yarn, beeswax, mirror (#14144/12 only). Collected by Lumholtz (1890–98) #65-4503 (extreme left), and Zingg (1934–35) #14144/12, #14142/12, #14132/12. Illustrated Dutton 1962:41. #14144/12.

Four sacred boards used as votive offerings. Precursors of contemporary yarn painting in terms of technique.

14

SACRED DISK (reverse of board at left in Plate 13)

6″ diameter (15 cm. diameter). Wood, yarn, beeswax. Collected by Lumholtz (1890–98). #65-4503. From the anthropology collections, The American Museum of Natural History, New York City

Sacred disk made as offering for the gods and placed in sacred places, like caves, where the gods dwell. Lumholtz notes that every year the *hikuli* seekers (peyote pilgrims) take a disk from Santa Catarina to the country where the *hikuli* grows. One side has two deer figures on it (see Plate 13); this side is purely geometric and may represent the sun.

15

SACRED ROUND BOARD WITH MIRROR (reverse of large board in Plate 13)

9½″ diameter x ½″ (24.1 cm. diameter x 1.2 cm.). Wood, yarn, mirror, beeswax. Collected by Zingg (1934–35). Illustrated Dutton 1962:41. #14144/12. Collections of the School of American Research in the Museum of New Mexico, Santa Fe

Votive object. According to Zingg, this object, and similar ones, served as votive hangings for prayer arrows. They also served as stands or bases for votive bowls.

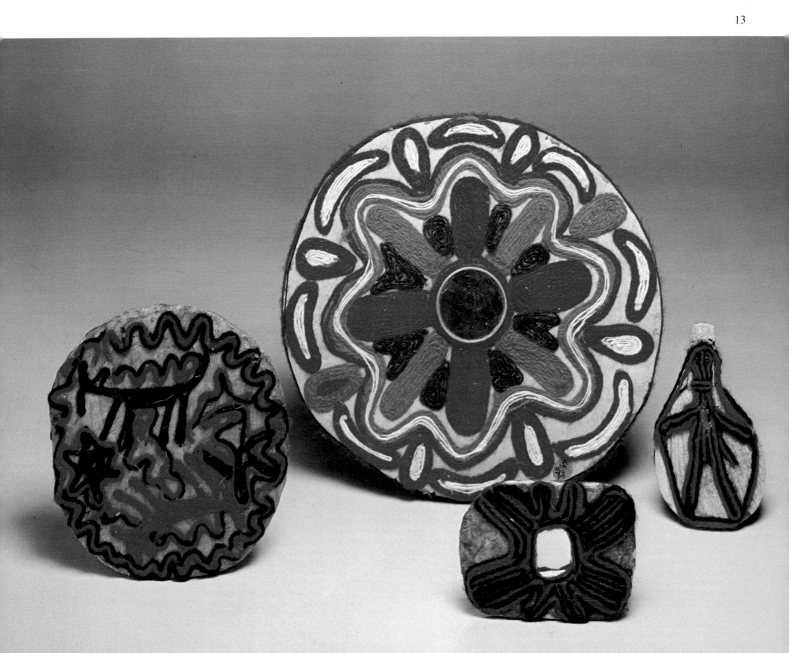

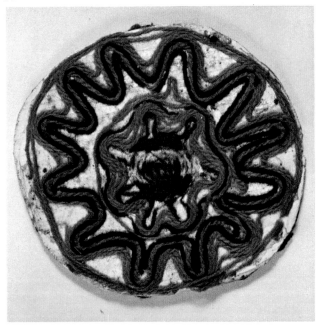 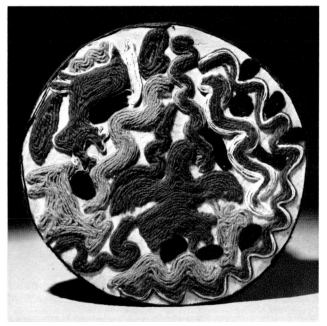

16

SACRED BOARDS (reverse of two small boards at right in Plate 13)
Left: 3⅞ x 2¾″ (9.8 x 7 cm.). *Right:* 4½ x 2¾″ (11.4 x 7 cm.). Wood, yarn, beeswax. Collected by Zingg (1934–35). #14142/12. #14132/12. Collections of the School of American Research in the Museum of New Mexico, Santa Fe

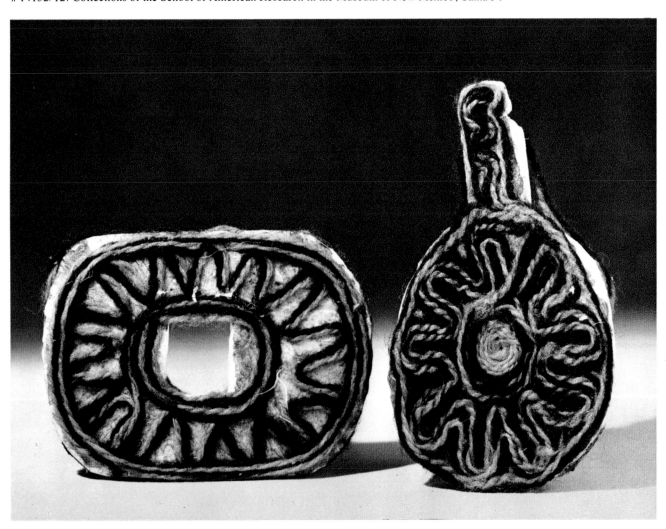

17

NEARIKA FOR THE DEIFIED SUN by Ramón Medina Silva.
24½ x 23¼″ (62.2 x 59 cm.). Yarn on plywood, beeswax. Illustrated Furst
1968–69:17. #X67-54. The Museum of Cultural History, University of
California at Los Angeles

Nearika (face, aspect, design) made in yarn-painting technique but intended for
ritual use. Sun (center) surrounded by various symbols including Watakame,
Clearer of the Fields, water serpent, maize plant with girl who guards the sacred
votive offerings, two aspects of Our Elder Brother Deer, and Our Mother Eagle
Girl.

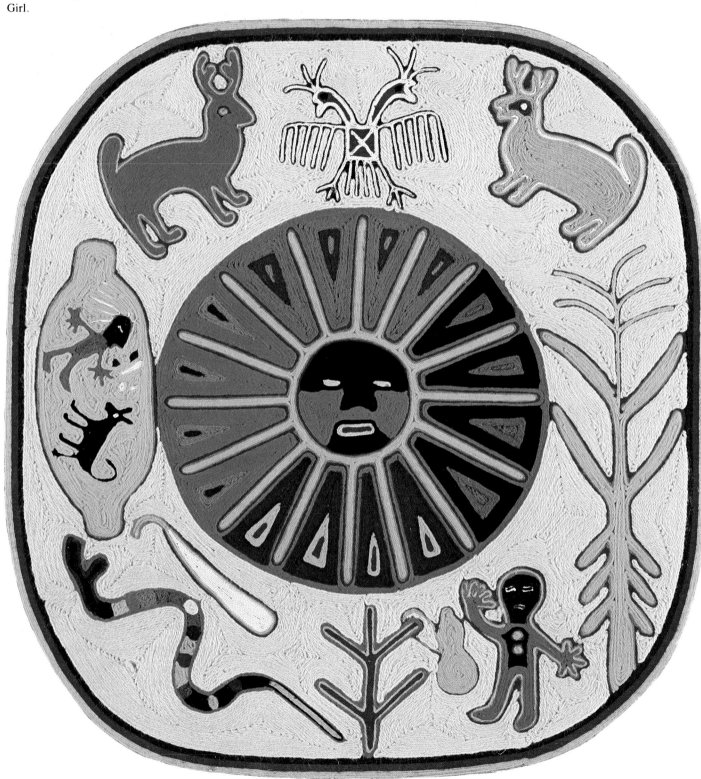

18

THE DIVINE MOTHERS by José Benítez Sánchez.
20¾ x 30¼″ (52.6 x 76.6 cm.). Yarn on plywood, beeswax. #76.26.4. The
Fine Arts Museums of San Francisco. Gift of Peter F. Young

"Our Mothers" are the female deities of the earth, maize, rain, terrestrial
water, children, and fertility in the crowded Huichol pantheon of nature deities.
The artist has here employed the so-called "x-ray style," showing internal as
well as external features. The rays emanating from the bodies of the goddesses
symbolize their sacred power; the pairs of crosses associate them with the four
directions and the sacred center of the world.

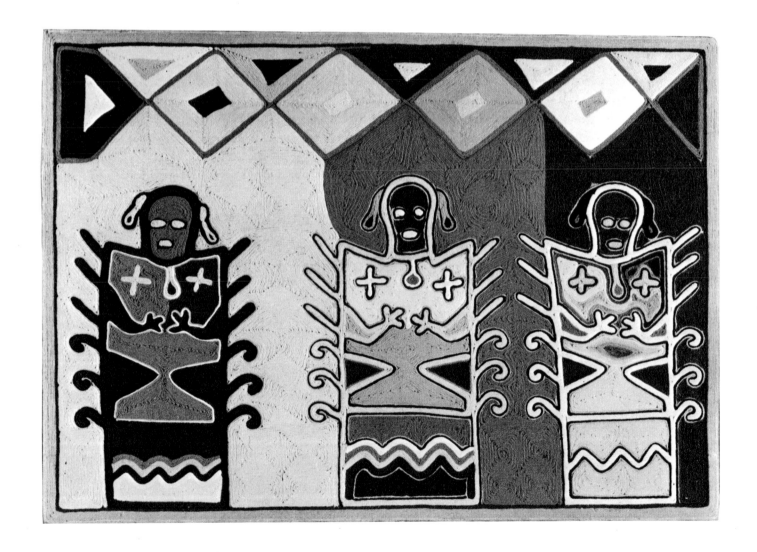

19

TATEI URIANAKA, GODDESS OF THE EARTH READY FOR PLANTING
by Cresencio Pérez Robles.
21 x 30¼″ (53.2 x 76.6 cm.). Yarn on plywood, beeswax. #76.26.5. The Fine
Arts Museums of San Francisco. Gift of Peter F. Young

The different stages of the agricultural process are closely identified with
different female deities in the symbolic world of the Huichols. The old earth
goddess is Our Great-Grandmother Nakawe, the fecund earth and maize god-
dess is Our Mother Utuanaka, the maize personified as dove is Our Mother
Kukuruku, and the earth made ready for planting by the right amount of rain and
sun is Tatei (Our Mother) Urianaka, here flanked by stylized food plants, the
sun above her and two images of the Rain Mothers of the four sacred directions
at upper left and right.

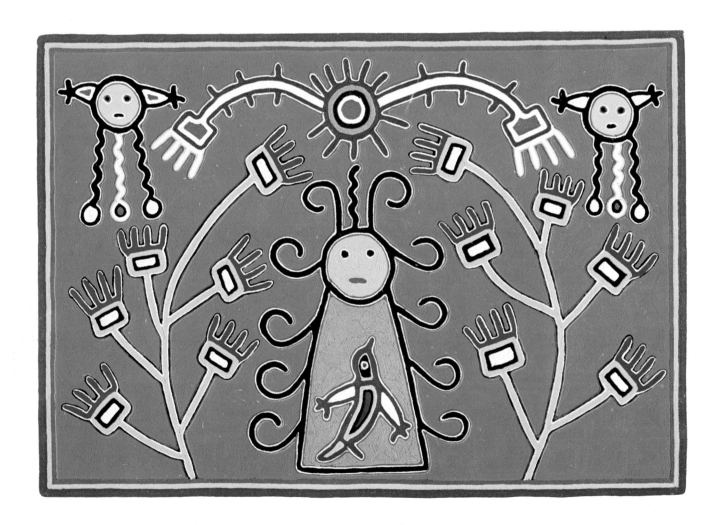

WHERE OFFERINGS ARE MADE IN THE SEA by José Benítez Sánchez.
36¼ x 42⅛″ (92 x 100.6 cm.). Yarn on plywood, beeswax. #75.30.9. The Fine
Arts Museums of San Francisco. Gift of Peter F. Young

Huichol shamans periodically travel from their homes in the Sierra Madre
Occidental to the coast to make offerings of plants, symbols of sacred animals,
and fresh water from the sacred inland springs to the goddess of the Pacific
Ocean, Our Mother Haramara. The sea lies to the west, the direction of the land
of the dead, so that these offerings also serve to honor and propitiate the
deceased. The four-directional universe is symbolized by the double starlike
symbol in the center of the yarn painting, the sacredness and power of the four
cardinal points emphasized by the rays emanating from the four points. Bottom
left, symbols of the rocks along the shore, with a sacred votive arrow stuck into
them; center, two fish flanked by sea plants, and other water plants at the top.

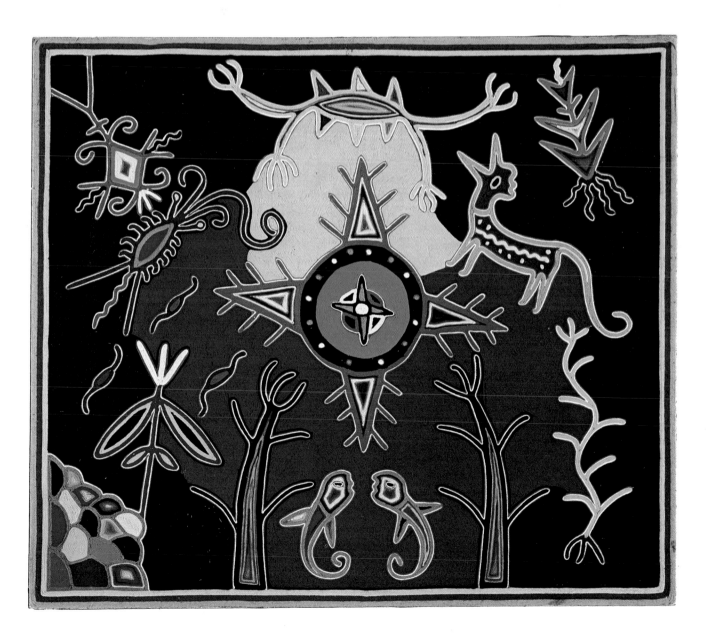

THE DANGEROUS PASSAGE by José Benítez Sánchez.
36⅛ x 42″ (90.2 x 100.6 cm.). Yarn on plywood, beeswax. #75.30.8. The Fine
Arts Museums of San Francisco. Gift of Peter F. Young

Like the souls of the Aztec dead, the Huichol soul must pass through a
dangerous passage, a kind of tunnel lined with clashing rocks (center), on its
way to its final destination in the land of the dead in the west. This difficult
passage is attended (right) by the shaman, who accompanies the soul part of the
way and who narrates its progress for the surviving relatives at an elaborate
funerary ceremony in which foodstuffs and ceremonial gifts are magically
dispatched to the Otherworld to facilitate the dead soul's travels.

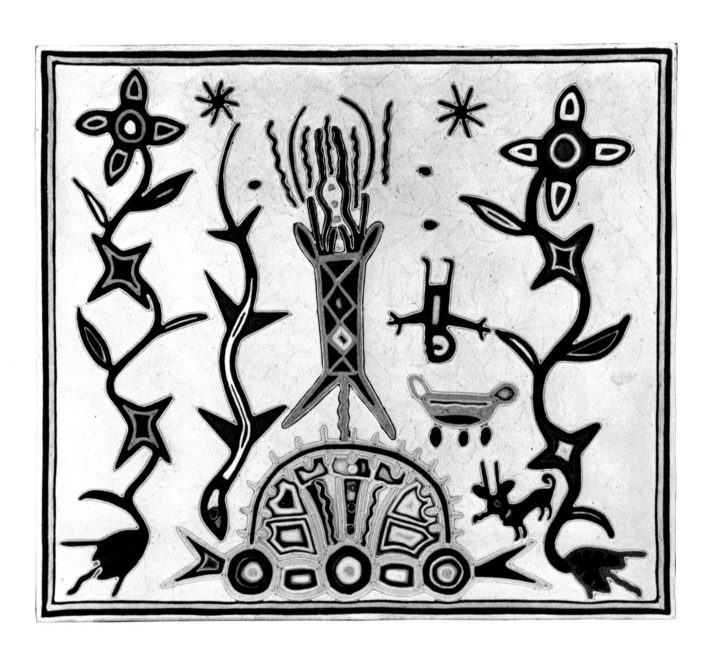

THE FIVE SACRED COLORS OF MAIZE by Guadalupe, widow of Ramón
Medina Silva, after yarn painting by Ramón.
23⅝ x 23¾" (60 x 60.2 cm.). Yarn on plywood, beeswax. #74.21.9. The Fine
Arts Museums of San Francisco. Gift of Peter F. Young

The five sacred colors of maize in the symbolic universe of the Huichols are
white, yellow, red, blue, and speckled, with blue the most sacred of all. These
five colors are personified as the young maize goddesses, who together
coalesce into the maize deity, Our Mother Kukuruku, but also manifest them-
selves as a single bundle of maize cobs in the five colors. The maize goddess
herself appears as a wild dove, after whose distinctive call she is named.

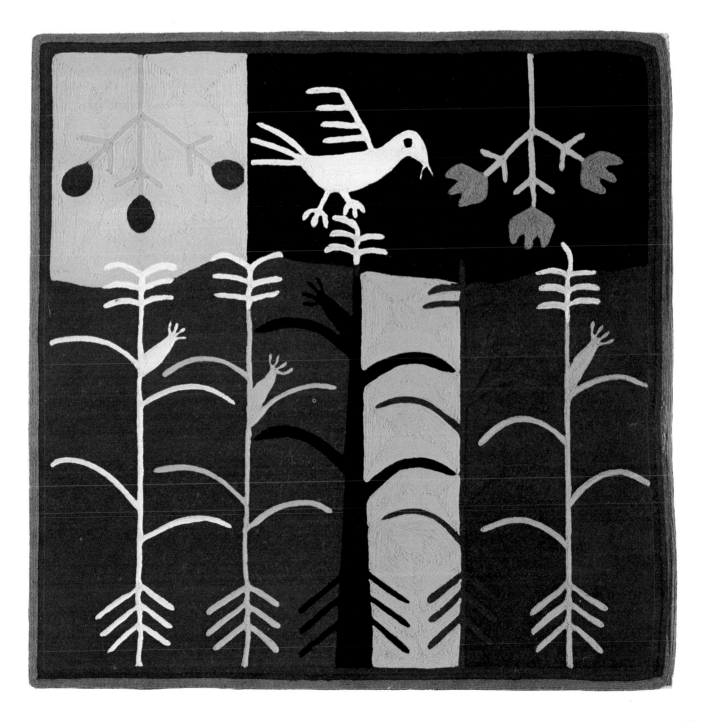

HUNTING THE DEER FOR THE SACRIFICE by Cresencio Pérez Robles.
15 x 21″ (38.1 x 53.3 cm.). Yarn on plywood, beeswax. #76.26.19. The Fine
Arts Museums of San Francisco. Gift of Peter F. Young

Deer—*the* most sacred beings in the animal world—are closely identified with
the divine peyote cactus. Before deer became relatively scarce in the Sierra
Madre Occidental, no ceremony or major agricultural act could commence
without a prior ceremonial deer hunt. The internal skeletal parts in the artist's
rendering of the deer relate to Huichol belief that life resides in the bones and
that the deer will be reborn from its skeletal parts.

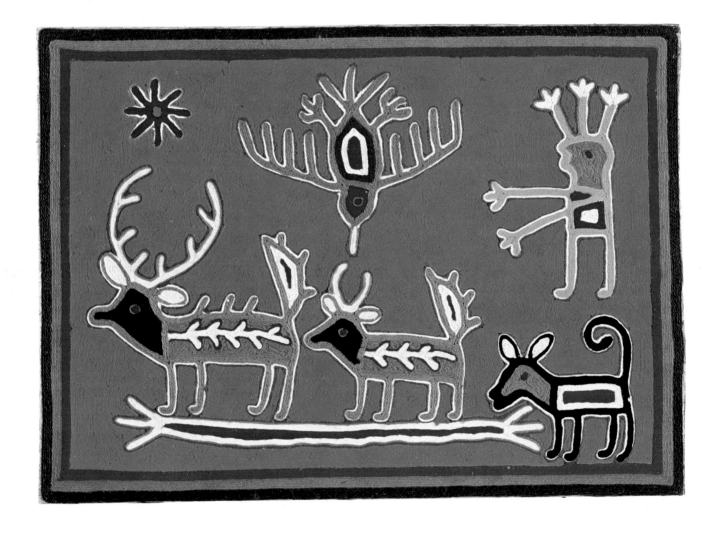

24

THE POWER OF THE TREE OF THE WIND (KIERI) by Hakatemi.
23⅝ x 23⅝″ (60 x 60 cm.). Yarn on plywood, beeswax. #74.21.2. The Fine
Arts Museums of San Francisco. Gift of Peter F. Young

The "Tree of the Wind" is a hallucinogenic but also dangerous plant. Although
Huichols do not employ the hallucinogenic properties of this "tree," they hold
it in awe as a dangerous sorcerer to whom offerings are made to ward off evil. In
ancient times, goes the Huichol myth, the Tree of the Wind, Kieri, was a great
sorcerer who deceived the people and who was eventually vanquished, with the
aid of peyote, by Kauyumarie.

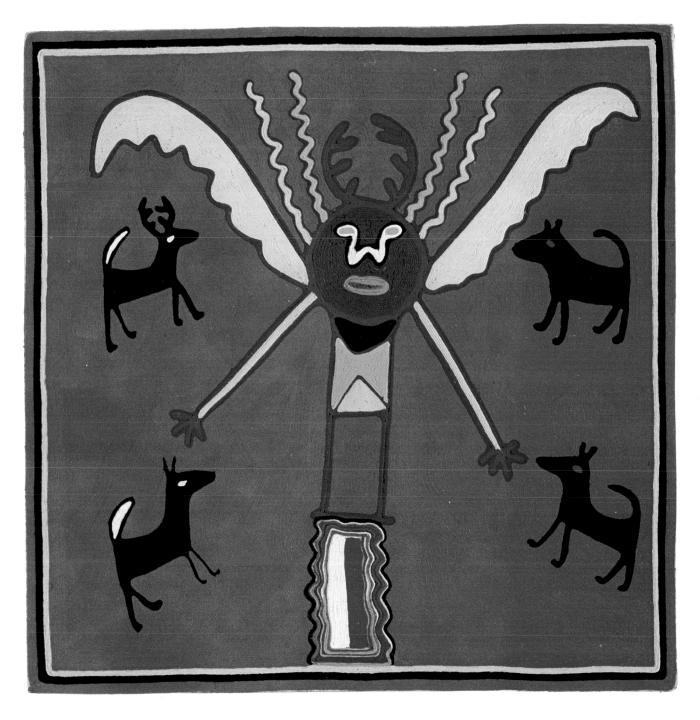

HOW THE HUSBAND ASSISTS IN THE BIRTH OF A CHILD by
Guadalupe, widow of Ramón Medina Silva, after yarn painting by Ramón.
23½ x 23½″ (59.7 x 59.7 cm.). Yarn on plywood, beeswax. #74.21.14. The
Fine Arts Museums of San Francisco. Gift of Peter F. Young

According to Huichol tradition, when a woman had her first child the husband
squatted in the rafters of the house, or in the branches of a tree, directly above
her, with ropes attached to his scrotum. As she went into labor pain, the wife
pulled vigorously on the ropes, so that her husband shared in the painful, but
ultimately joyous, experience of childbirth.

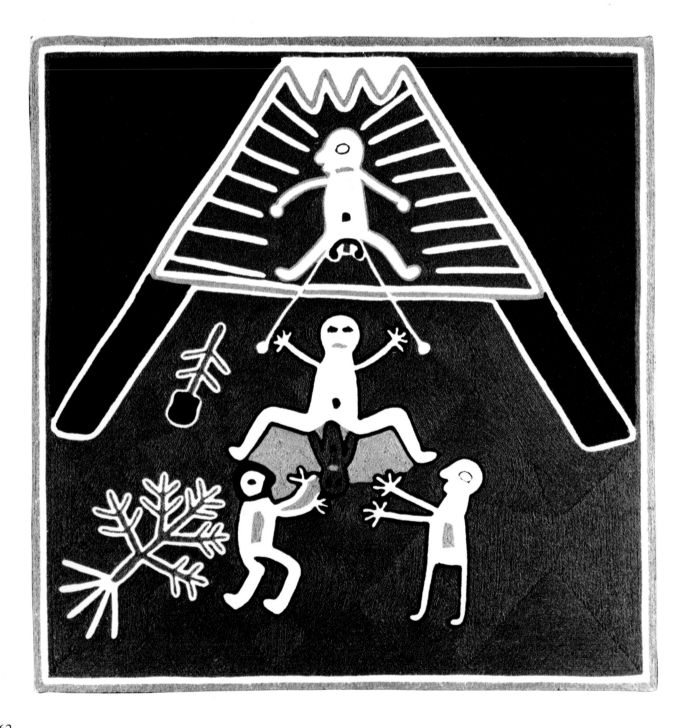

THE DEAD SOUL'S JOURNEY TO THE SPIRIT WORLD by Guadalupe, widow of Ramón Medina Silva, after yarn painting by Ramón.
23½ x 23½″ (59.7 x 59.7 cm.). Yarn on plywood, beeswax. Original by Ramón illustrated Furst 1968–69:20. #75.30.4. The Fine Arts Museums of San Francisco. Gift of Peter F. Young

Depicted here is the crucial point in the dead soul's journey to the spirit world where it may take either the left or the right fork. The right path is guarded by animals that test the soul—the dog that had not been fed, the crow chased from the maize field, and the opossum, whose flesh is taboo, looking for traces of its meat in the soul's mouth. The left, painful path leads to a corral of mules that trample the soul if its owner committed incest or had sexual relations with a "Spaniard" (i.e. non-Huichol). However, a joyous reception eventually awaits the soul in the *rancho* of the dead relatives, for the Huichol universe knows neither hell nor eternal punishment.

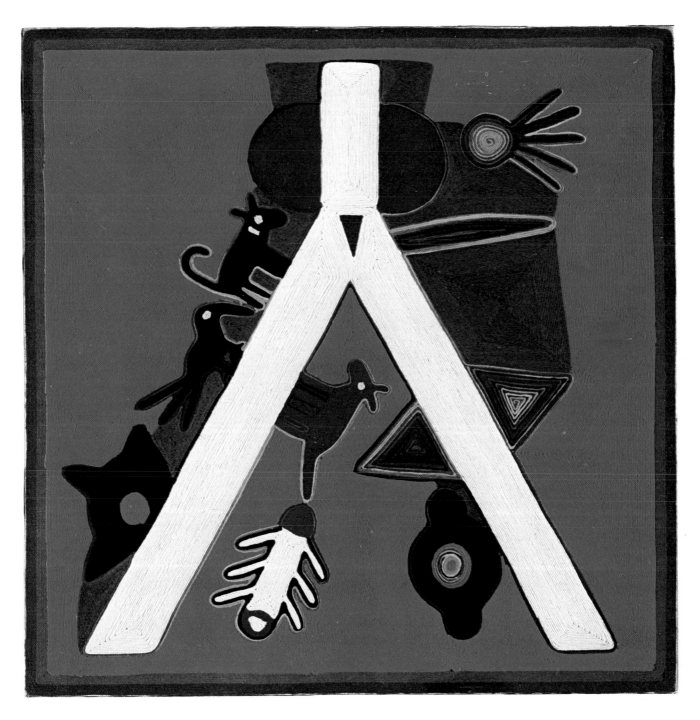

FRONT SHIELD (front view)

19½″ diameter (49.5 cm. diameter). Yarn, wood sticks, paper. Collected by Lumholtz (1890–98). Illustrated Lumholtz 1900:116. #65-427. From the anthropology collections, The American Museum of Natural History, New York City

A type of votive object Lumholtz found suspended by a cord from the roof of a god house. He identifies it as ''the Sun surrounded by his animals,'' which include jaguars, deer, birds, and serpents. The outer geometric designs are said to symbolize clouds and rain. The piece is worked in black, blue, red, yellow, green, and brown yarn on white.

FRONT SHIELD (back view of Plate 27)

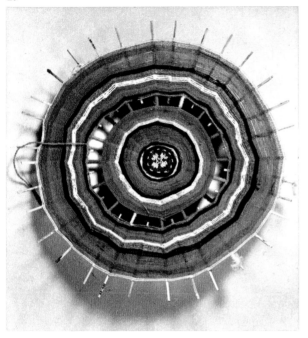

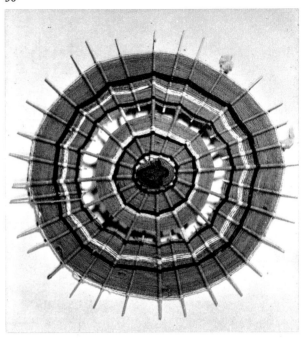

29

FRONT SHIELD (front view)

17½″ diameter (44.5 cm. diameter). Yarn, wood sticks, beeswax, beads. Collected by Lumholtz (1890–98). Illustrated Lumholtz 1900:124. #65-431. From the anthropology collections, The American Museum of Natural History, New York City

According to Lumholtz, this is an unusual type of sun shield because of its open section around the middle. Originally, bits of cotton were attached to the ends of the sticks (note two still attached). The beadwork cross in the center is supposed to represent a prayer for rain.

30

FRONT SHIELD (back view of Plate 29)

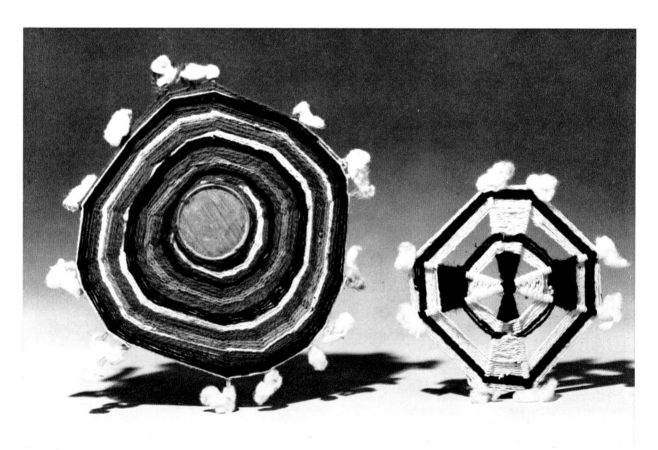

31

Left: VOTIVE OFFERING

9″ diameter (22.8 cm. diameter). Yarn, wood, cotton. Collected by Zingg (1934–35). #1508/12. Collections of the School of American Research in the Museum of New Mexico, Santa Fe

In red, white, black, and brown yarn.

Right: VOTIVE OFFERING

6½″ diameter (16.5 cm. diameter). Yarn, wood, cotton. Collected by Zingg (1934–35). #1480/12. Collections of the School of American Research in the Museum of New Mexico, Santa Fe

In brown and white yarn. According to informant, four openings in the center represent the four doors through which the sun was born. Object would have been attached to a prayer arrow.

32

Left: BACK SHIELD

8¼ x 4″ (21 x 10.2 cm.). Yarn and cane. Collected by Zingg (1934–35). Illustrated Dutton 1962:33. #14174/12. Collections of the School of American Research in the Museum of New Mexico, Santa Fe

Back shields are a type of votive offering frequently attached to prayer arrows (see Plate 36) which serve as specific prayers to a particular deity. This example is black, brown, red, and white yarn on cane. Eagle design appears on both sides.

Center: BACK SHIELD

9¾ x 2⅜″ (24.7 x 6 cm.). Yarn, cane, feathers. Collected by Zingg (1934–35). Illustrated Dutton 1962:33. #14170/12. Collections of the School of American Research in the Museum of New Mexico, Santa Fe

Yellow and pink yarn on split cane with abstract pattern. Reportedly used by old man to fan the "corn goddess" at a feast to prepare soil for seed.

Right: BACK SHIELD

6⅞ x 3″ (17.5 x 7.6 cm.). Yarn and cane. Collected by Zingg (1934–35). #1492/12. Collections of the School of American Research in the Museum of New Mexico, Santa Fe

Red, black, and white. According to informant, a representation of Tukakame (god of death).

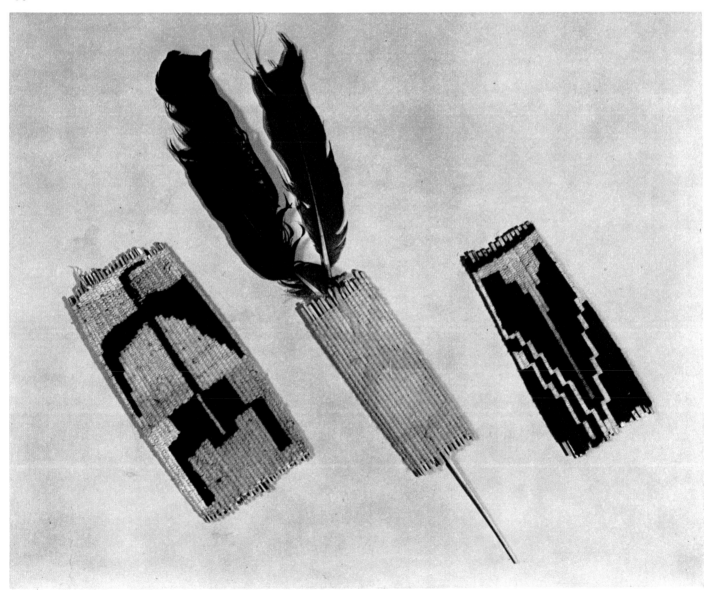

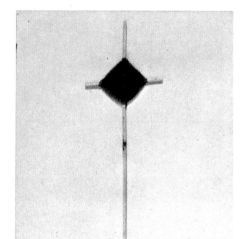

33

GOD'S EYE

12 x 4" (31 x 10 cm.). Wood and yarn. Collected by Lumholtz (1890–95). Illustrated Lumholtz 1900:157. #65-440. From the anthropology collections, The American Museum of Natural History, New York City

Lumholtz describes the god's eye as the symbol of the power of seeing and understanding unknown things. Prayers are expressed through this symbolic object, so that the ''eye of the god may rest on the supplicant.'' This particular god's eye is dedicated to Mother East Water. Red, brown, and blue.

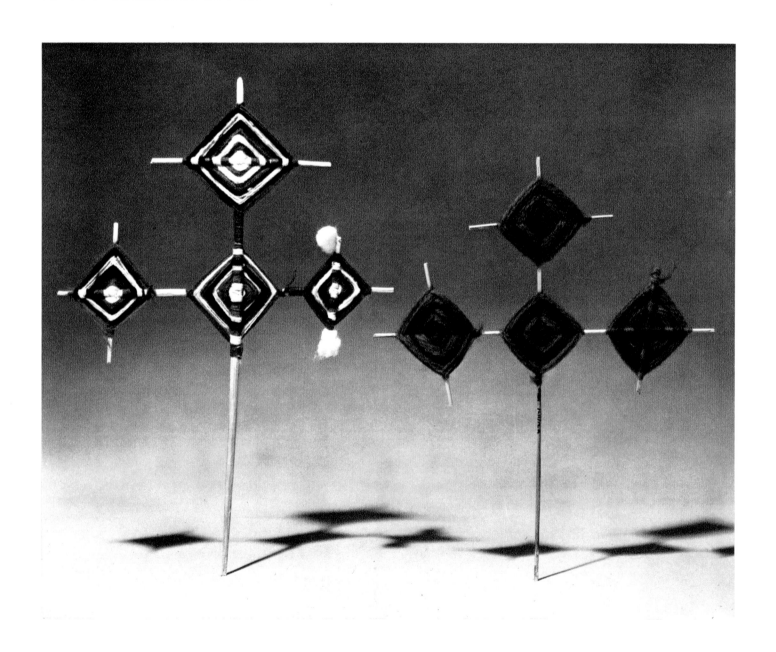

34

Left: GOD'S EYE

11⅞ x 8⅛" (30.2 x 20.5 cm.). Yarn, sticks, cotton. Collected by Zingg (1934–35). #14166/12. Collections of the School of American Research in the Museum of New Mexico, Santa Fe

Black, red, blue, and white yarn on split cane.

Right: GOD'S EYE

10 x 8¼" (25.4 x 21 cm.). Yarn, sticks, cotton. Collected by Zingg (1934–35). #1211/12a. Collections of the School of American Research in the Museum of New Mexico, Santa Fe

In red and blue yarn.

The god's eye is a traditional type of votive offering left at sacred places, but larger varieties are now made strictly for the tourist trade.

35

CEREMONIAL ARROW

20½ x 5" (52 x 12.7 cm.). Wood, fiber, cotton cloth, hawk feathers, paint. Collected by Lumholtz (1890–98). Illustrated Lumholtz 1900:104. #65-445. From the anthropology collections, The American Museum of Natural History, New York City

According to Lumholtz, this is the *koma* (deer hunter's arrow) of the Deer God in the South. The red and blue embroidery of two small deer being held by a man on the back of a large deer symbolizes the deer hunt. The fiber circle may consist of the grass that deer eat, and the large feather attached to the shaft is from the red-tailed hawk.

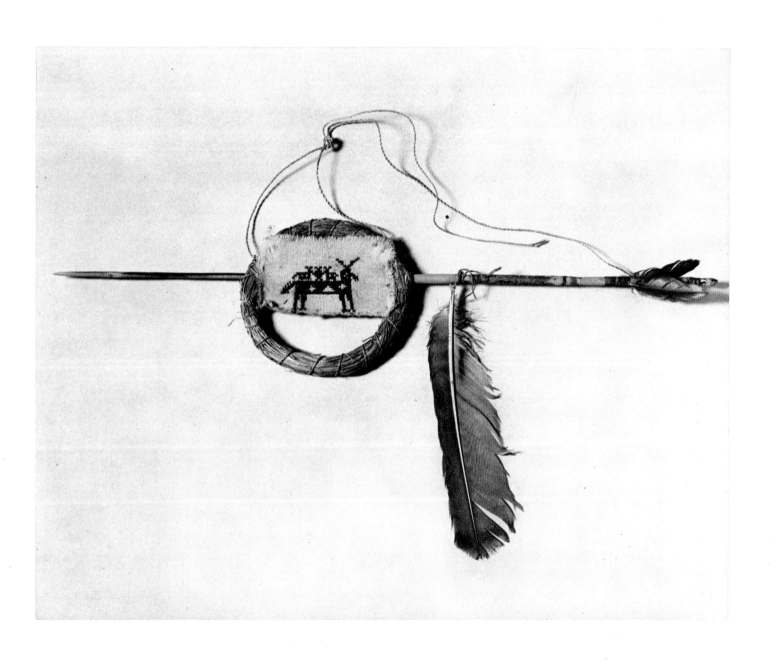

Top: CEREMONIAL ARROW

20 x 9½" (51 x 24 cm.). Wood, yarn, hawk feathers, paint. Collected by Lumholtz (1890–98). #65-451. From the anthropology collections, The American Museum of Natural History, New York City

Bottom: CEREMONIAL ARROW

22 x 6" (56 x 15 cm.). Wood, yarn, hawk feathers, paint. Collected by Lumholtz (1890–98). #65-600. From the anthropology collections, The American Museum of Natural History, New York City

According to Lumholtz, these votive arrows are used as prayer offerings, the many attachments being symbolic of the needs and wishes of an individual directed to a particular god. Both these arrows have back-shield attachments. One arrow (top) has a pair of miniature sandals which may have served to guide the feet to prevent them from stumbling on the trail.

Left to right:

WOVEN STRAW ANIMALS

Bundle 5⅝ x 5" (14.3 x 12.7 cm.). Straw and sticks. Collected by Zingg (1934–35). #14010/12. Collections of the School of American Research in the Museum of New Mexico, Santa Fe

Effigy rabbits, usually attached to votive or prayer arrows, are deposited at various sacred spots and shrines as offerings to specific deities.

VOTIVE OR PRAYER ARROW

17⅞ x 5⅞" (45.4 x 15 cm.). Wood, feathers, woven rabbits, yarn. Collected by Zingg (1934–35). #1632/12. Collections of the School of American Research in the Museum of New Mexico, Santa Fe

According to informant, made for sun as offering for health, life, or recovery from illness. Feathers of hawk and parrot indicate the sun,

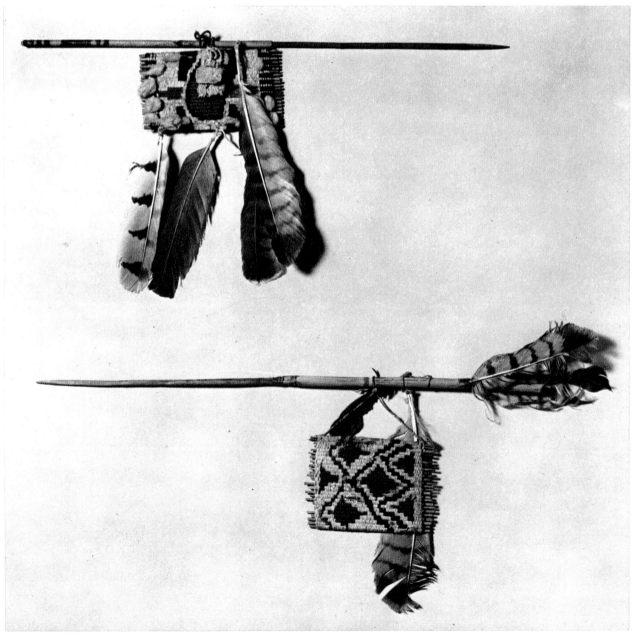

and woven rabbits enable the arrow to see or communicate with the sun.

VOTIVE OR PRAYER ARROW

23⅜ x 3″ (59.3 x 7.7 cm.). Wood, hawk feathers, red and black paint, red yarn. Collected by Zingg (1934–35). Illustrated Zingg 1938:607; Dutton 1962:19. #14159/12a. Collections of the School of American Research in the Museum of New Mexico, Santa Fe

Votive arrows such as this are stuck in miniature replicas of shaman's chairs (*uweni,* see Plate 44) which are placed on altars or in sacred caves. Attachments, a miniature bow and triangle, may be prayers for favors from the particular god to whom the chair belongs.

SHAMAN'S PLUME WITH WOVEN EYE OF GOD

13½ x 4⅛″ (34.2 x 10.5 cm.). Wood, feathers, yarn. Collected by Zingg (1934–35). #14160/12c. Collections of the School of American Research in the Museum of New Mexico, Santa Fe

According to Zingg (who quotes Lumholtz), this object would be connected with ceremonies performed by both the singing shaman and the prophesying and healing shamans and used for both curing and communicating with the gods. God's eye in red, white, blue, and black.

WOOD STICK WITH RED CORD

19⅞ x ½″ (50.5 x 1.3 cm.). Wood and red wool ribbon. Collected by Zingg (1934–35). #14162/12g. Collections of the School of American Research in the Museum of New Mexico, Santa Fe

According to Zingg, one of the eight brazilwood wands dedicated to Grandfather Fire. Called *itsu,* it is made of the heart of the sun.

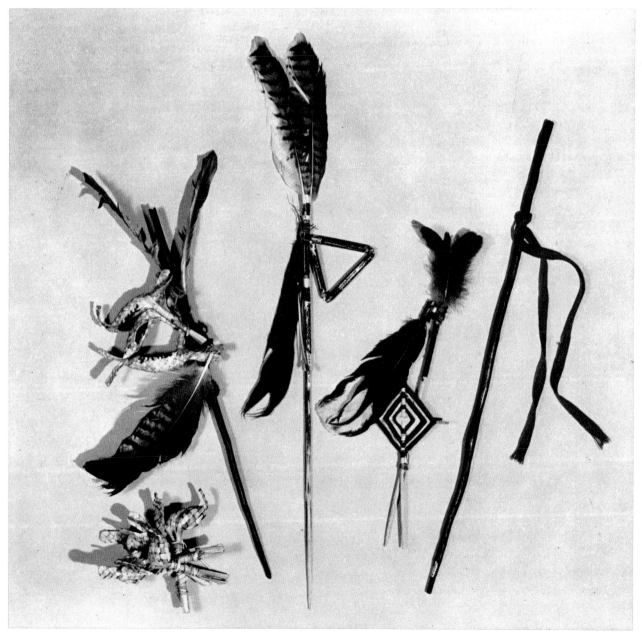

37

38

Left: SHAMAN'S PLUME

19¼ x 4½″ (48.8 x 11.4 cm.). Hawk feathers, bamboo, cotton, yarn. Collected by Peter T. Furst (1966). #X68-3126B. The Museum of Cultural History, University of California at Los Angeles

Right: SHAMAN'S PLUME

17¾ x 15″ (45.1 x 38.1 cm.). Hawk feathers, bamboo, cotton, yarn. Collected by Peter T. Furst (1966). #X66-293. The Museum of Cultural History, University of California at Los Angeles

Used on 1966 peyote pilgrimage by Ramón Medina Silva.

Shaman's plumes are used as prayer or votive arrows. Cotton puffs are said to signify clouds.

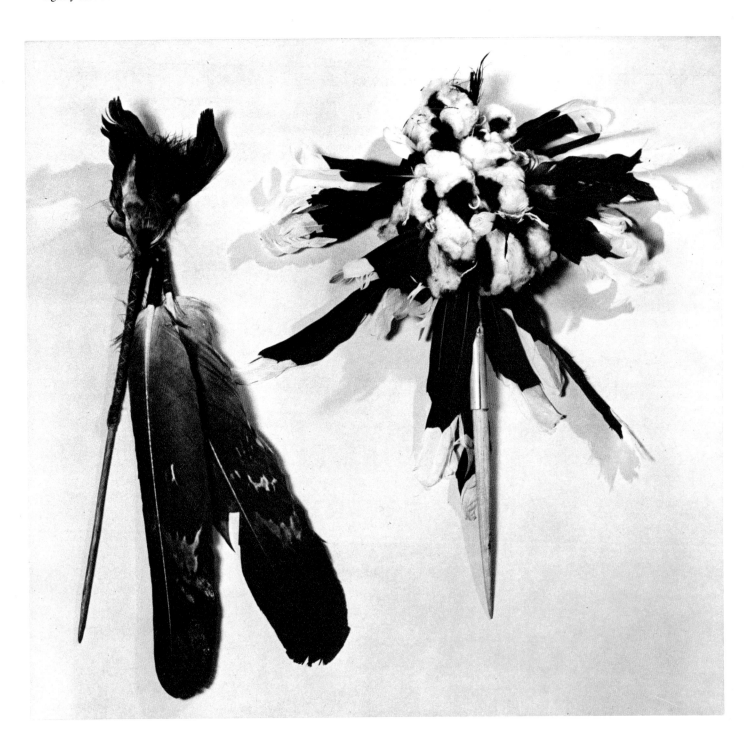

Left: HEAD PLUME

14½ x 4″ (37 x 10 cm.). Hawk feathers, wood, yarn. Collected by Lumholtz in San Andrés (1890–98). Illustrated Lumholtz 1900:177; Zingg 1938:586. #65-402. From the anthropology collections, The American Museum of Natural History, New York City

According to Lumholtz, such plumes were tied to men's heads with ribbons or fastened to their hats during ceremonies or feasts.

Right: PLUME

24½ x 1½″ (62 x 4 cm.). Blue-jay and parrot feathers, wood, yarn. Collected by Lumholtz in Santa Catarina (1890–98). Illustrated Lumholtz 1900:178; Zingg 1938:591. #65-1528. From the anthropology collections, The American Museum of Natural History, New York City

According to Lumholtz, this plume is dedicated to Elder Brother Deer and worn as a hair ornament by dancers at the feast of *hikuli* (peyote). He comments that the Huichols generally imported the blue plumes from the Cora.

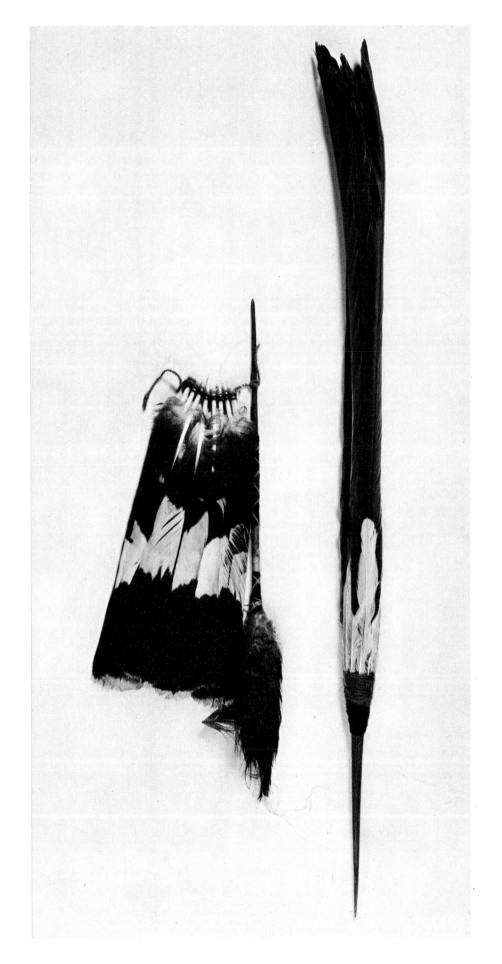

40

CERAMIC FIGURE
5½ x 1½″ (14 x 4 cm.). Clay. Collected by Lumholtz
(1890–98). #65-337. From the anthropology collections,
The American Museum of Natural History, New York City

This votive figure may represent a cow or a mule with a
bowl on its back.

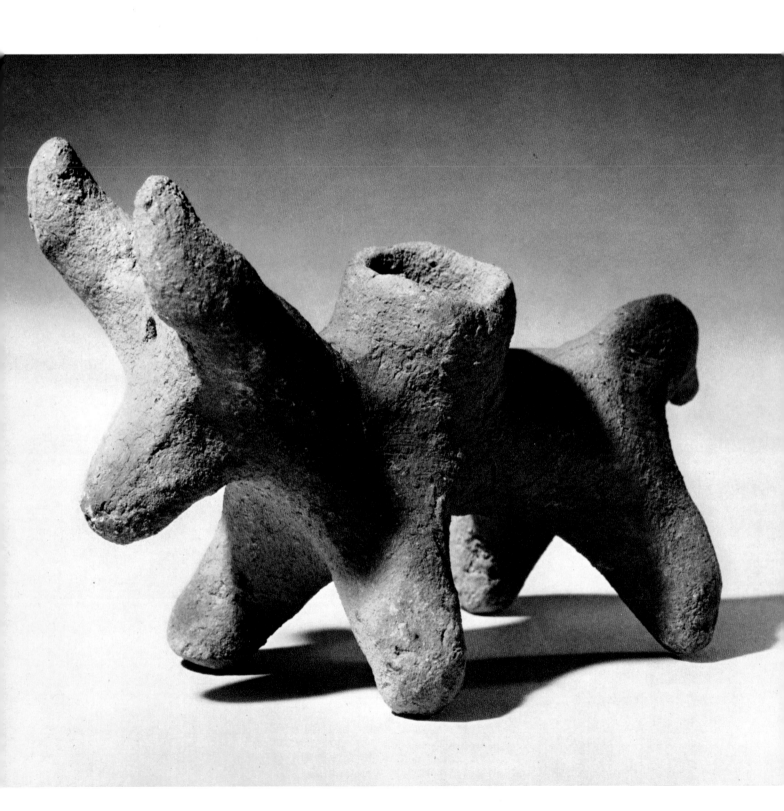

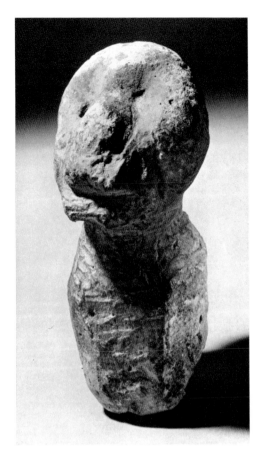

Left: CARVED HUMAN FIGURE
10¼ x 2½" (26 x 6.3 cm.). Wood. Collected by Zingg
(1934–35). #1227/12. Collections of the School of
American Research in the Museum of New Mexico, Santa
Fe

Right: CARVED HUMAN FIGURE
13⅛ x 2¾" (33.3 x 7 cm.). Wood. Collected by Zingg
(1934–35). #1226/12. Collections of the School of Amer-
ican Research in the Museum of New Mexico, Santa Fe

Zingg identifies both as toys or dolls.

41

FIGURAL CARVING
3⅝ x 1⅞" (9.2 x 4.7 cm.). Stone. Collected by
Zingg (1934–35). #1228/12. Collections of
the School of American Research in the
Museum of New Mexico, Santa Fe

According to Zingg, a toy or doll. It may have
served as a votive offering.

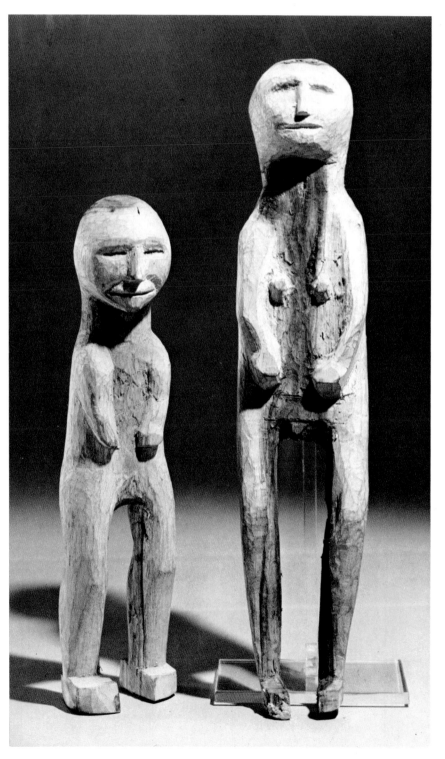

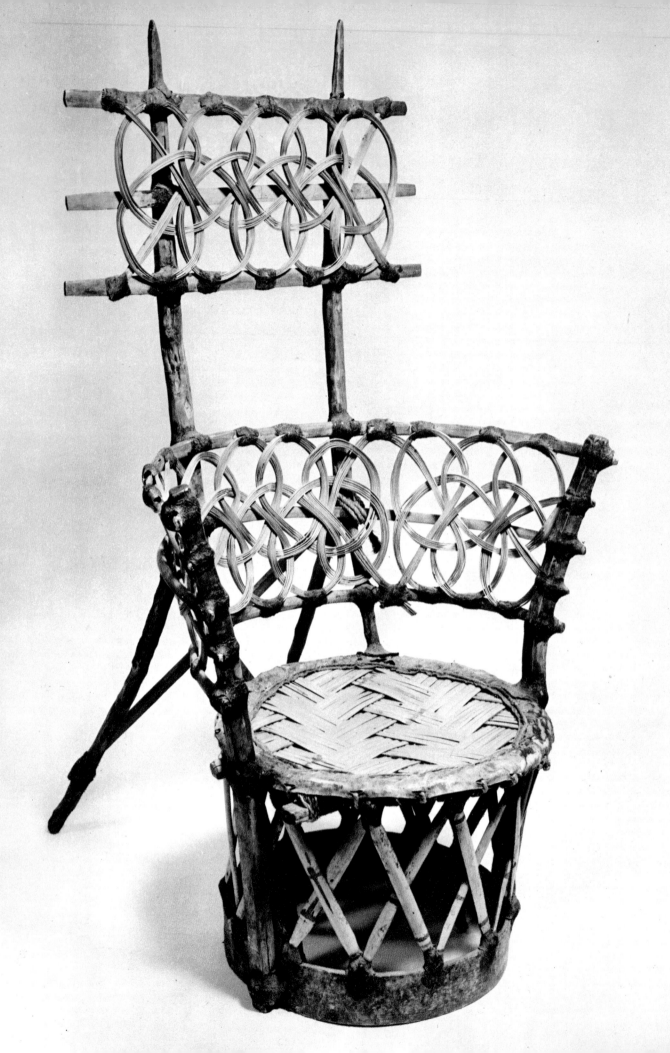

SHAMAN'S CHAIR

38¾ x 22″ (98.5 x 55.6 cm.). Bamboo, oak, deer skin, pitch, fiber. Collected by Zingg (1934–35). #6001/12. Collections of the School of American Research in the Museum of New Mexico, Santa Fe

Shaman's chair, characteristically made of a combination of hard and soft woods. May be similar to Aztec prototypes. This type of chair would actually be used by a shaman, while deities would be provided with similar chairs in miniature which, according to Zingg, would "facilitate communication" (see also Plate 44).

44

GOD'S CHAIR WITH FEATHERS

23¼ x 11½″ (59 x 29.2 cm.). Bamboo, hawk and parrot feathers, fur, yarn. Made by Ramón Medina Silva. Collected by Peter T. Furst (1966). #X67-2475. The Museum of Cultural History, University of California at Los Angeles

Votive chair *(uweni)* made in the image of a shaman's chair. Placed on altars or used as a destination in a ritual.

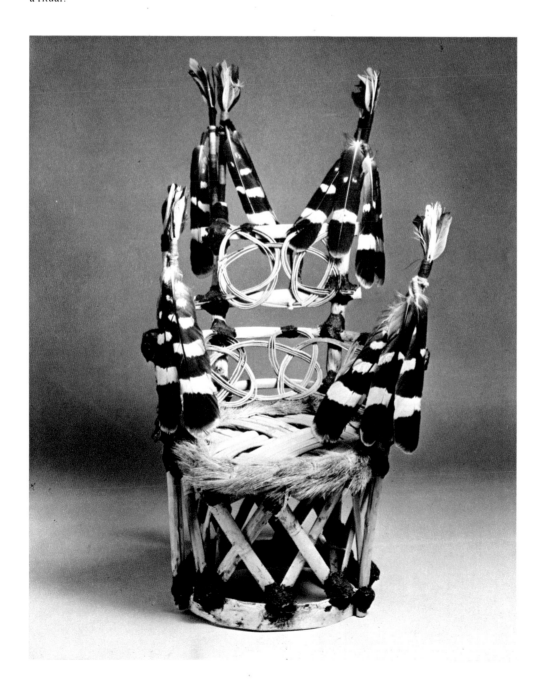

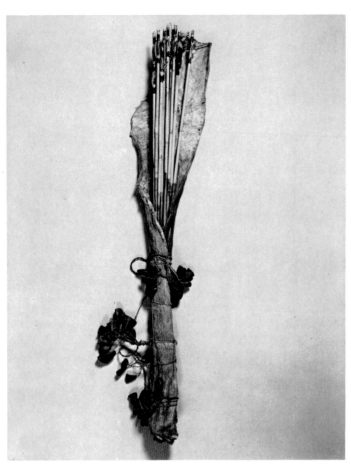

45

QUIVER AND ARROWS
39 x 6½″ (99 x 16.5 cm.). Deer hide and hoofs, wood, feathers, fiber. Collected by Lumholtz (1890–98). #65-1705. From the anthropology collections, The American Museum of Natural History, New York City

Lumholtz makes a distinction between ceremonial arrows and hunting arrows, such as these, which were used for killing deer. According to Lumholtz, the deer hoofs sound like rattles and possibly bring luck during the hunt.

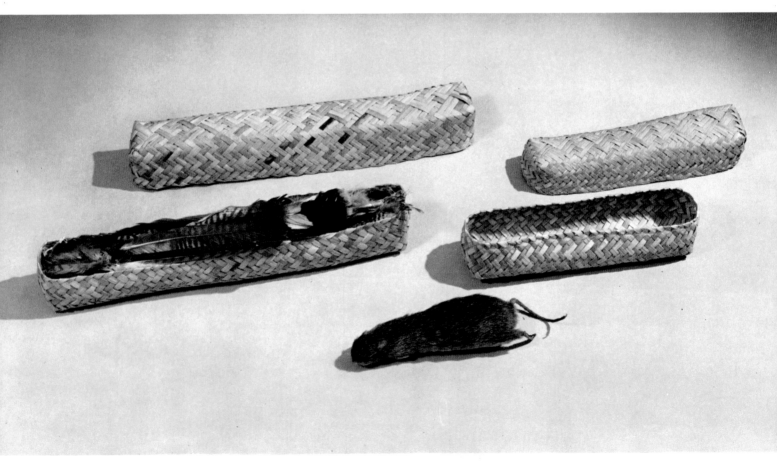

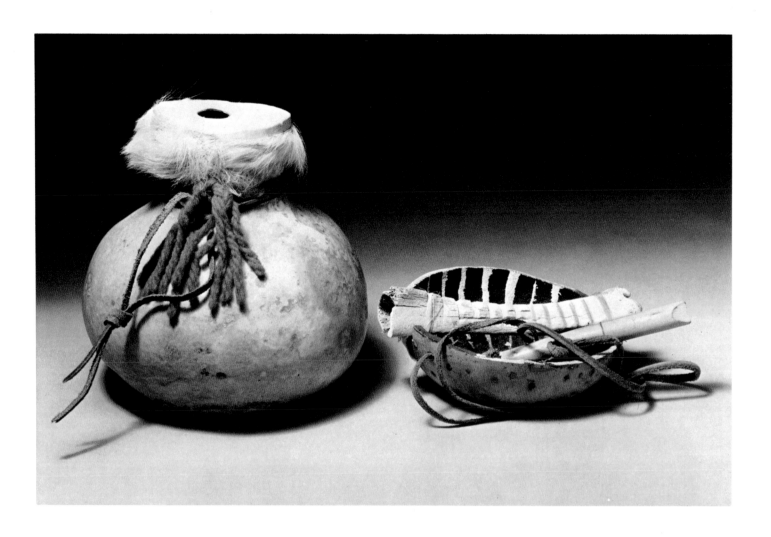

◀ 46

Left: SHAMAN'S KIT WITH FEATHERS

18 x 3 x 2⅜" (45.7 x 7.6 x 6 cm.). Fiber, feathers, string. Collected by Zingg (1934–35). #1526/12a. Collections of the School of American Research in the Museum of New Mexico, Santa Fe

Shaman's kit with feathers used for curing, and for communicating with the gods.

Right: SHAMAN'S KIT OR BASKET WITH STUFFED RAT

12 x 3 x 2⅜" (30.5 x 7.6 x 6 cm.). Fiber, rat, red cloth. Collected by Zingg (1934–35). #1476/12a,b,c. Collections of the School of American Research in the Museum of New Mexico, Santa Fe

According to Zingg, this shaman's kit with stuffed rat is part of the ceremonial equipment of the peyote hunter, prepared in commemoration of the rat that stole the fire in the peyote, a myth he recounts at length. The rat has red cloth inlay for eyes.

47

Left: SHAMAN'S GOURD DRUM

8⅞ x 9" (22.5 x 22.8 cm.). Gourd, hide, bone, yarn, fur. Collected by Peter T. Furst (1966). #X67-2482. The Museum of Cultural History, University of California at Los Angeles

Right: SHAMAN'S RASP

3⅞ x 8¾" (9.8 x 22.2 cm.). Gourd, hide, bone, paint. Collected by Peter T. Furst (1966). #X67-2479. The Museum of Cultural History, University of California at Los Angeles

Musical instruments.

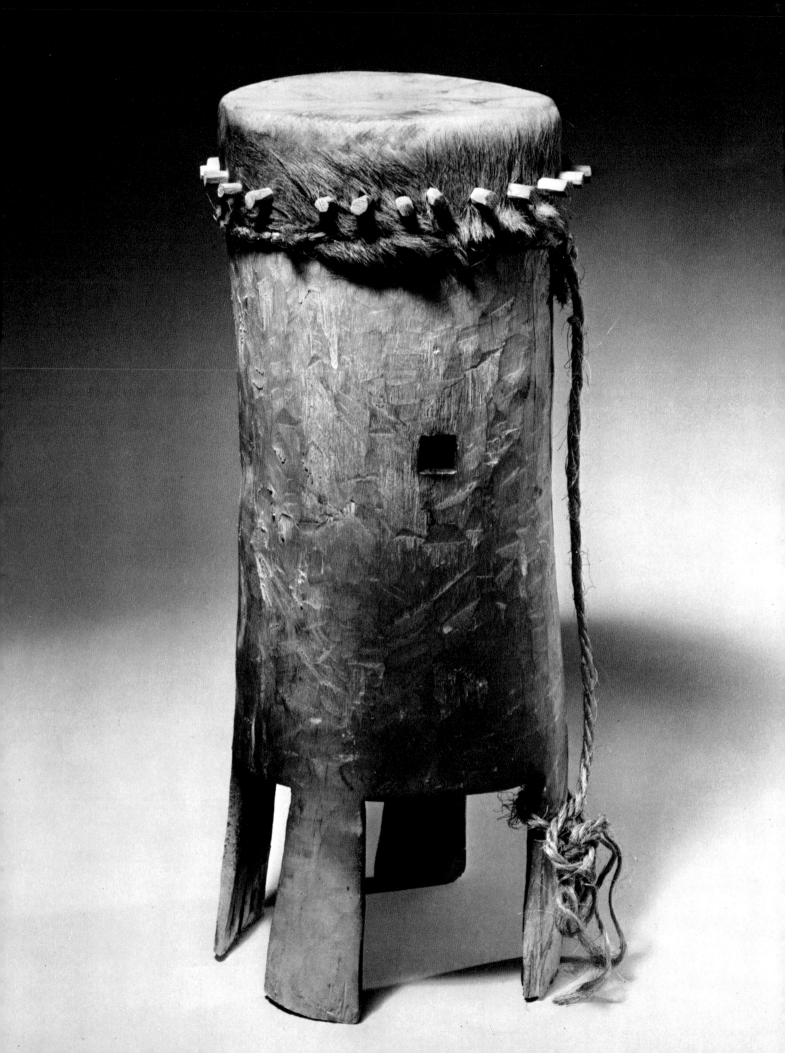

SHAMAN'S DRUM
24⅝ x 10⅛" (65.1 x 25.7 cm.). Wood, deer hide, fiber. Collected by Peter T. Furst in San Andrés (1966). #X66-324. The Museum of Cultural History, University of California at Los Angeles

Called *tepu,* it is used in rituals and curing. The mouth of the drum (the rectangular hole in the side) issues smoke during rituals when a fire with incense is burned underneath. The shaman takes soot from the rectangular area, considered the mouth of the god, and places it on the forehead, wrists, feet, or cheeks of individuals considered to be in a ritually imperiled state, to combat disease and other malevolent evil spirits.

49

Left: GUITAR
19⅞ x 6⅛" (50.5 x 15.3 cm.). Wood, steel strings. Collected by Zingg (1934–35). #1988/12. Collections of the School of American Researchh in the Museum of New Mexico, Santa Fe

Handmade five-string guitar.

Center: RATTLE
9⅝ x 2⅛" (24.5 x 5.4 cm.). Gourd, cane, glass beads, beans, pebbles, red yarn. Collected by Zingg (1934–35). #14140/12. Collections of the School of American Research in the Museum of New Mexico, Santa Fe

Gourd rattle, perforated with many small holes, used as a musical instrument. According to Zingg, a type similar to archaeological specimens from the Tarahumara area.

Right: VIOLIN AND BOW
18⅛ x 6¼" (bow 17½") (46.3 x 15.6 cm.; bow, 44.3 cm.). Wood, steel strings, fiber, horsehair (on bow). Collected by Zingg (1934–35). #1987/12a,b. Collections of the School of American Research in the Museum of New Mexico, Santa Fe

Handmade bow and string violin.

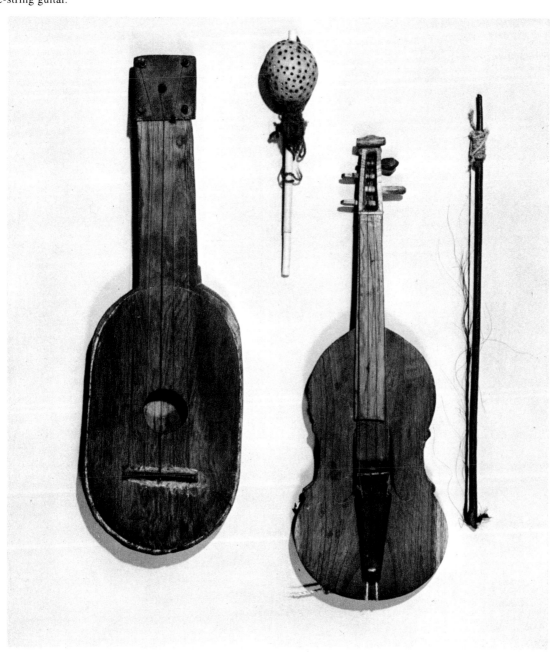

50

MAN'S HAT

17¾" diameter x 3" (44.5 cm. diameter x 7.6 cm.). Straw, squirrel tails, red flannel, beads, wool. Collected by Lumholtz (1890–98). Illustrated Lumholtz 1900:192; Zingg 1938:584. #65-684. From the anthropology collections, The American Museum of Natural History, New York City

Lumholtz identifies this as a *hikuli* seeker's hat. Typically adorned with squirrel tails and/or feathers, red crosses, and beads.

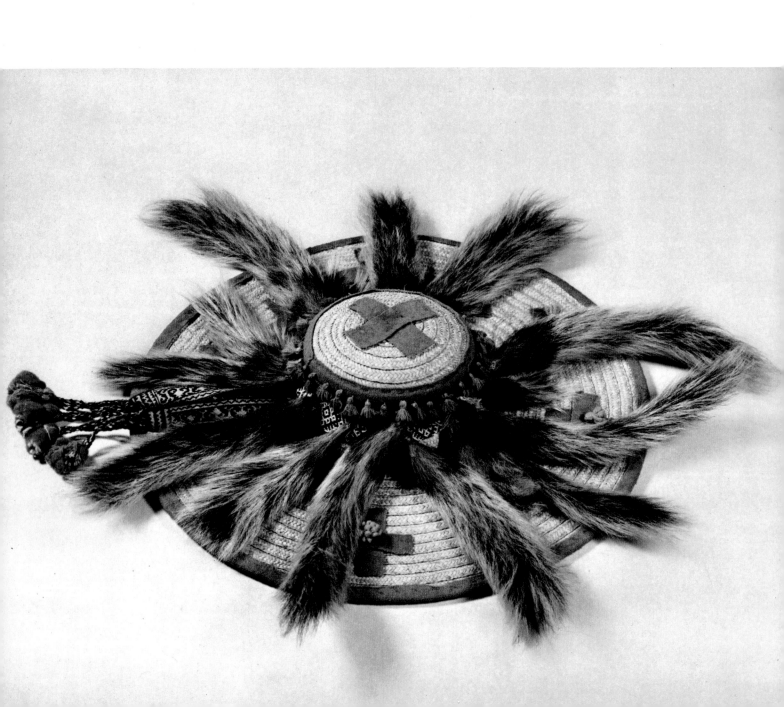

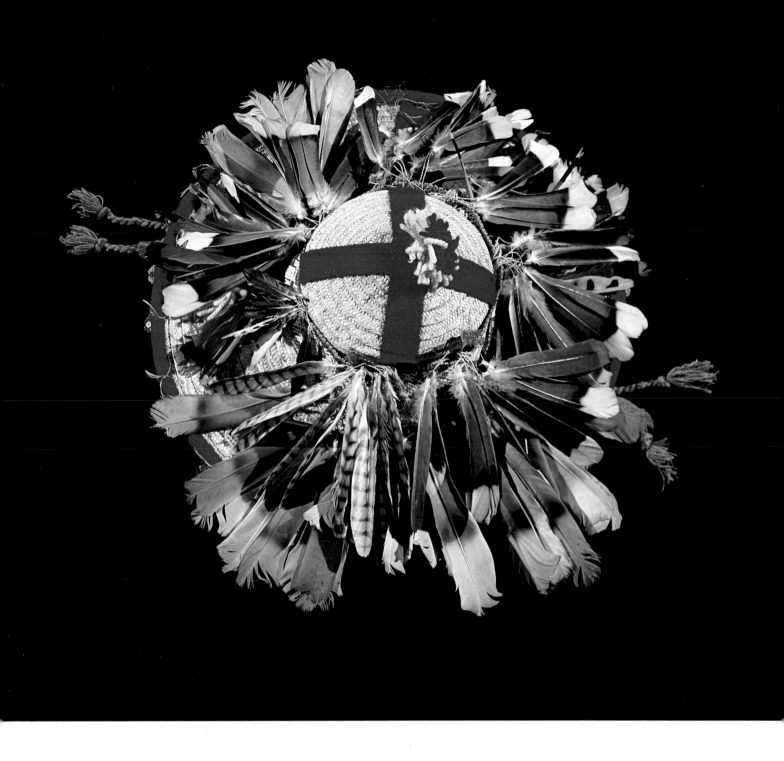

51

MAN'S HAT
16″ diameter x 3½″ (40.6 cm. diameter x 8.7 cm.). Straw, pigeon and hawk
feathers, wool, yarn, beads, fiber. Collected by Eger (1976–77). #L77.58.16.
Eger-Valadez Collection

Modern hat in traditional style with red crosses and trim, beaded band and
beaded tassels around edge.

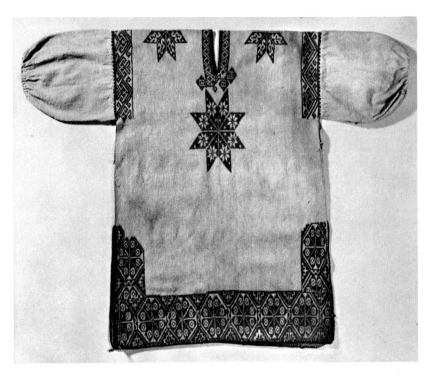

52

MAN'S SHIRT

35 x 45″ (89 x 114.5 cm.). Natural wood, red-and-black embroidery. Collected by Lumholtz. #65-757. From the anthropology collections, The American Museum of Natural History, New York City

Traditional type of man's wool shirt with central design motif of the *toto* (pronounced too-too) flower, a major Huichol design motif associated with peyote. Inside large design are smaller versions of the same flower. The shirt is partially joined on the sides and has separately joined sleeves.

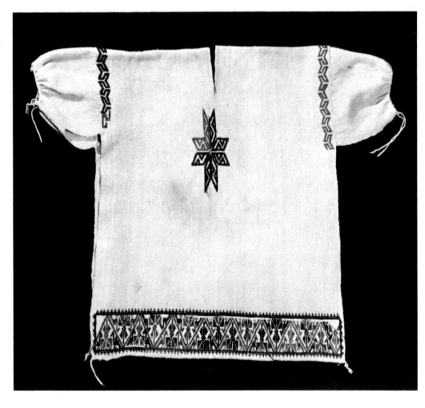

53

MAN'S SHIRT

33 x 41″ (83.8 x 104.1 cm.). Natural wool with red, black, and blue embroidery. Collected by Zingg (1934–35). #9610/12. Collections of the School of American Research in the Museum of New Mexico, Santa Fe

Completely slit sides with separately joined sleeves. Compare with shirt collected by Lumholtz (Plate 52) for similarities in style and motif.

54

MAN`S SHIRT
40 x 42″ (101.5 x 106.5 cm.). Natural wool and black embroidery. Collected by
Peter Collings in San Andrés (1968–77). #L77.65.1. Collection of Anne and
Peter Collings

Compare with Lumholtz and Zingg examples (Plates 52 and 53). Note fringe on
sleeves and reduced border embroidery. According to Collings, a very old shirt
style still worn today, but very rare. This example has slit sides and separately
joined sleeves. Made by a woman originally from Santa Catarina.

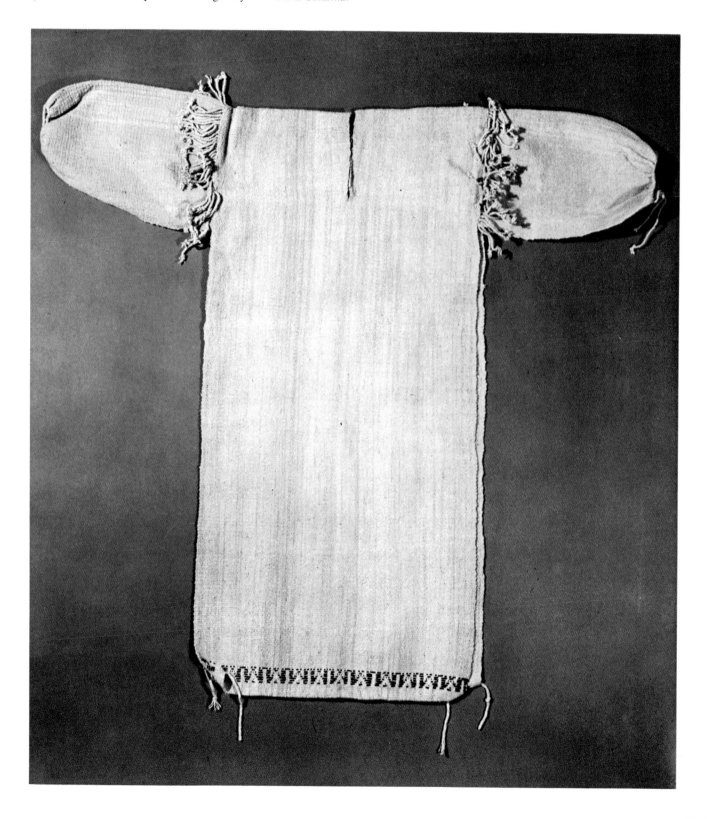

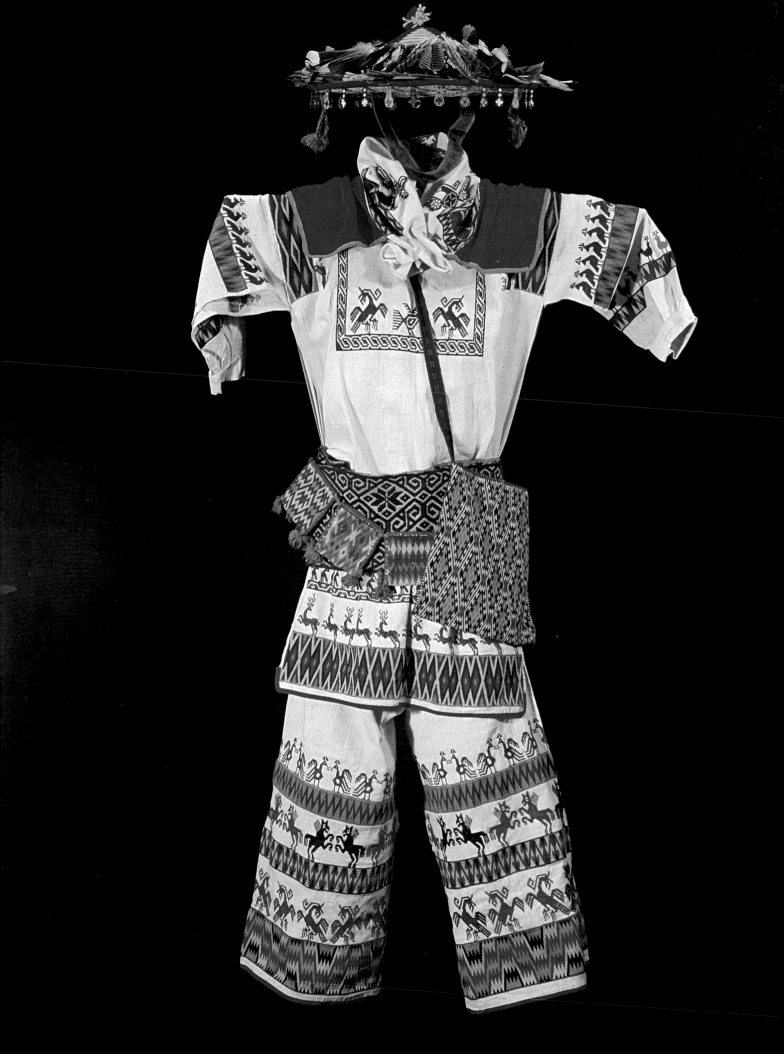

MAN'S OUTFIT

Cape: 44 x 38″ (112 x 96.5 cm.). Shirt: 36½ x 50¾″ (92 x 129 cm.). Pants: 36½ x 23″ (92 x 59.6 cm.). Pocket belt: 41 x 3¾″ (104 x 9.5 cm.). Wool belt: 9′4″ x 6½″ (284 x 16.5 cm.). Fine stitch bag. Cotton cloth and embroidery, wool belt. Collected by Eger (1976–77): cape, shirt, and pants in San José; pocket belt, wool belt, and bag in San Andrés. #L77.58. Eger-Valadez Collection.

Man's outfit in multicolored embroidery (cross-stitch and bargello). Note various bird and animal motifs, variations on the deer, horse, or eagle. Elaboration of embroidery varies but does not signify importance of person. The recently made brown wool belt is becoming increasingly rare in the Sierras as sheep become more scarce.

MANTLE OR CAPE

52½ x 44½″ (133.3 x 113 cm.). Cotton and wool with embroidery. Collected by Zingg (1934–35). #9656/12. Collections of the School of American Research in the Museum of New Mexico, Santa Fe

Collected by Zingg as a sample for yarn study. Man's embroidered cape on white muslin, unfinished. Elaborate design in red, green, and blue. Red wool-flannel border and red ties.

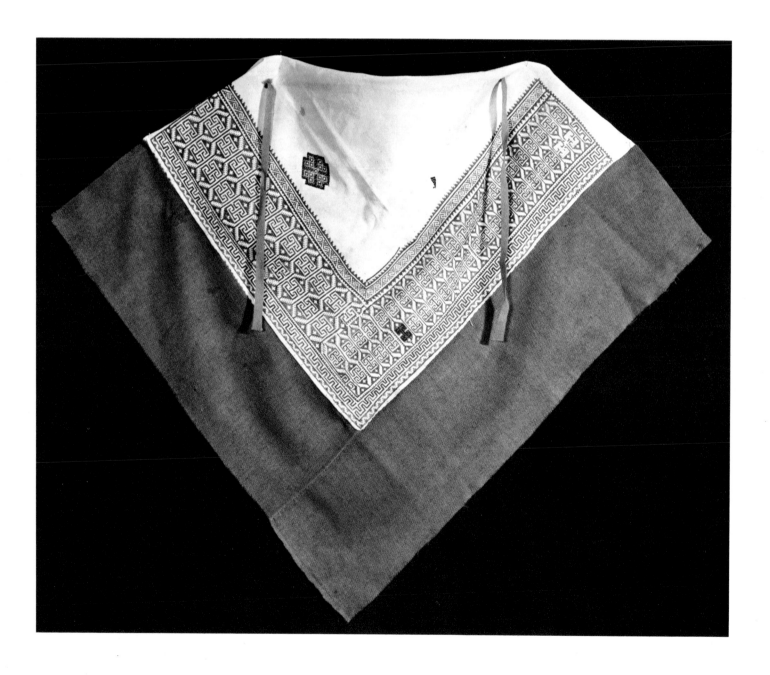

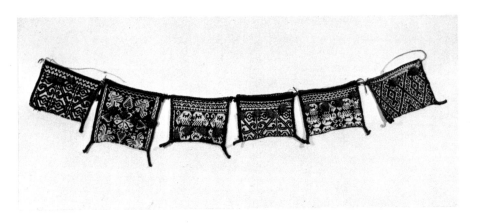

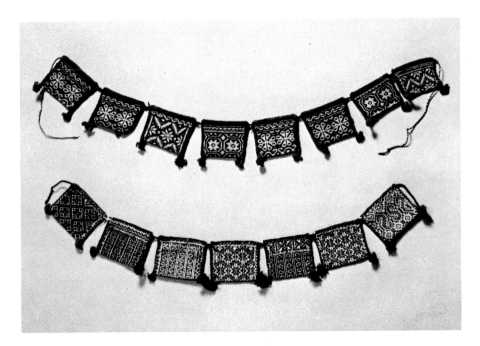

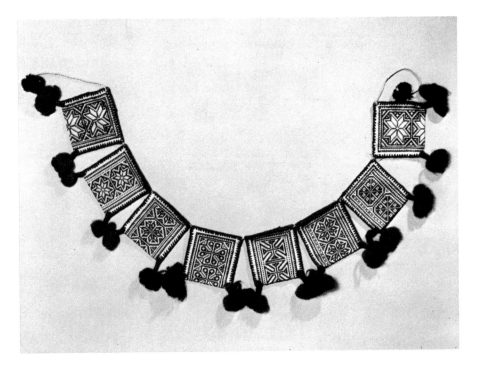

57

POUCH OR POCKET BELT

33 x 4½″ (84 x 11.5 cm.). Wool and string. Collected by Lumholtz in Santa Catarina (1890–98). #65-656a-f. From the anthropology collections, The American Museum of Natural History, New York City

Have been called peyote pouches, but may be used for all-purpose carrying or worn empty for ceremonial or decorative effect. Standard part of man's outfit, strung around the waist and grouped with other bags or belts. This example is woven in black and white with red tassels and edges.

58

Top: POUCH OR POCKET BELT

4 x 31⅞″ (10.2 x 81 cm.). Natural and dyed wool and string. Collected by Zingg (1934–35). #9573/12. Collections of the School of American Research in the Museum of New Mexico, Santa Fe

Wool, woven in black and white, with red tassels and edges.

Bottom: POUCH OR POCKET BELT

3½ x 27″ (8.8 x 68.5 cm.). Natural and dyed cotton and string. Collected by Zingg (1934–35). #9584/12. Collections of the School of American Research in the Museum of New Mexico, Santa Fe

Cotton, embroidered in green, red, black, and blue.

Pouch or pocket belts may consist of any number of pouches. It is interesting to compare these examples with the Lumholtz belt (Plate 57).

59

POUCH OR POCKET BELT

5⅛ x 30¾″ (13 x 78.1 cm.). Cotton, yarn, fiber. Collected by Peter T. Furst (1966). #X63.99. The Museum of Cultural History, University of California at Los Angeles

A modern example of a pocket belt which once belonged to Ramón Medina Silva. Red and white embroidery with red tassels on cotton cloth.

60

Left: TOBACCO GOURD
2¾ x 2½″ (7 x 6.3 cm.). Gourd, deer scrotum, braided fiber. Collected by Zingg (1934–35). Illustrated Dutton 1962:43. #14132/2. Collections of the School of American Research in the Museum of New Mexico, Santa Fe

Right: TOBACCO GOURD
4½ x 3¾″ (11.5 x 9.5 cm.). Gourd and braided fiber. Collected by Zingg (1934–35). Illustrated Dutton 1962:43. #14127/12. Collections of the School of American Research in the Museum of New Mexico, Santa Fe

Hollow gourds with stoppers, used for carrying tobacco.

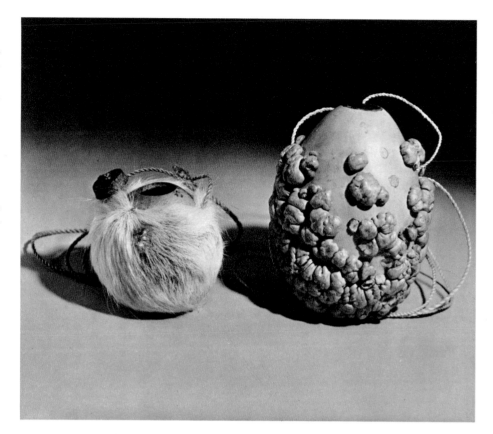

61

Top: PARTIALLY WOVEN BAND ON LOOM
58¾ x 1⅛″ (149.2 x 2.8 cm.). Bamboo, wool, cotton. Collected by Zingg (1934–35). #9569/12. Collections of the School of American Research in the Museum of New Mexico, Santa Fe

Example illustrating how bands were made. Simple form of a backstrap loom with heddle rod, batten, and sticks. Unfinished double-weave band in red and white with black border strip bearing deer design.

Bottom: WOVEN BAND
42 x 1½″ (106.7 x 3.8 cm.). Wool and cotton. Collected by Zingg (1934–35). #9396/12. Collections of the School of American Research in the Museum of New Mexico, Santa Fe

Finished band, black and white with red-orange tassels.

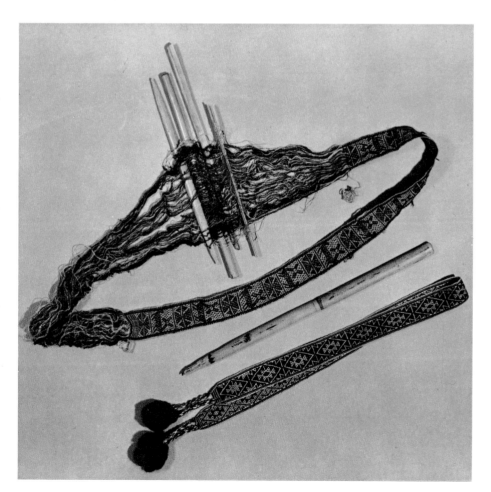

62

WOVEN BAND
47½ x 5½″ (120.5 x 14 cm.). Natural and dyed wool. Collected by Lumholtz in San Andrés de Cohamiata (1890–98). #65-213. From the anthropology collections, The American Museum of Natural History, New York City

Brown and white double weave with red edges. Worn as a belt or girdle.

63

WOVEN BAND
10′ x 4½″ (305 x 11 cm.). Natural and dyed wool. Collected by Lumholtz (1890–98). #65-1386. From the anthropology collections,

The American Museum of Natural History, New York City

Blue and white double weave, with animal designs resembling what Lumholtz called the "dog" motif. (See Plate 72 for matching bag.)

64

Top: WOVEN BAND
37 x 2⅞″ (94 x 7.8 cm.). Natural and dyed wool. Collected by Zingg (1934–35). #9369/12. Collections of the School of American Research in the Museum of New Mexico, Santa Fe

Design may signify the façade of the god house or the flower façade of the god house.

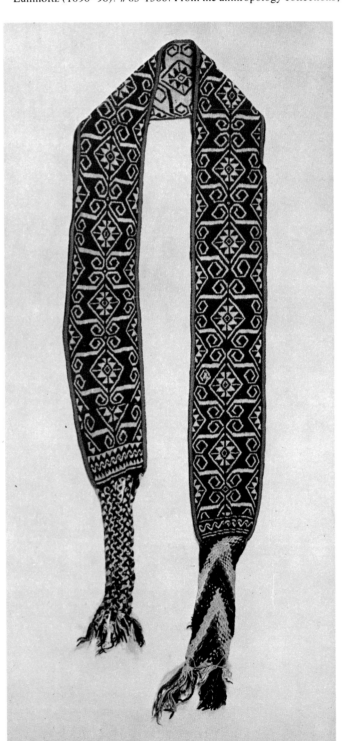

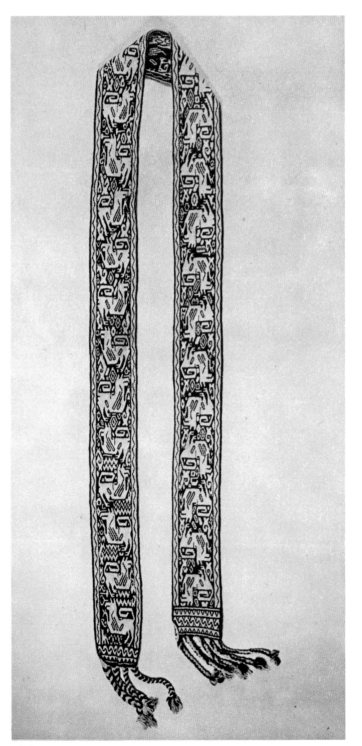

62

63

Bottom: WOVEN BAND

10′5½″ x 3⅞″ (318.7 x 9.8 cm.). Natural and dyed wool. Collected by Zingg (1934–35). #9364/12. Collections of the School of American Research in the Museum of New Mexico, Santa Fe

Both bands in brown and white double weave with red borders.

65

Top: WOVEN BELT

87 x 3¾″ (221 x 9.5 cm.). Natural and dyed wool. Collected by Collings in San Sebastian (1966–67). #L77.65.4. Collection of Anne and Peter Collings

Brown and white double weave with red edges.

Center: WOVEN BELT

9′4″ x 5″ (294 x 12.5 cm.). Natural and dyed wool. Collected by Collings in Santa Barbara (1966–67). #L77.65.2. Collection of Anne and Peter Collings

Brown and white double weave with red edges.

Bottom: WOVEN BELT

88 x 4⅓″ (224 x 11 cm.). Natural and dyed wool. Collected by Collings in San Sebastian (1966–67). #L77.65.3. Collection of Anne and Peter Collings

Blue and white with red edges.

Three contemporary examples of traditional type of woven belt. Some design motifs represent various flowers or versions of the *toto* flower.

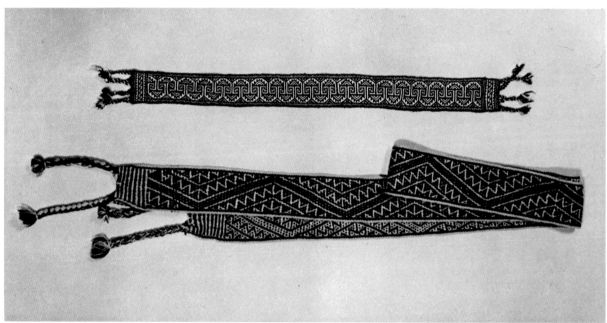

64

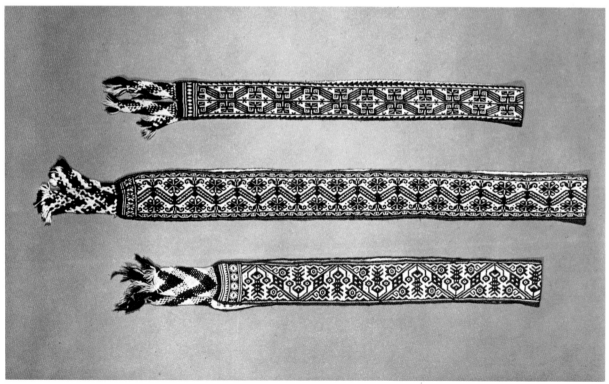

65

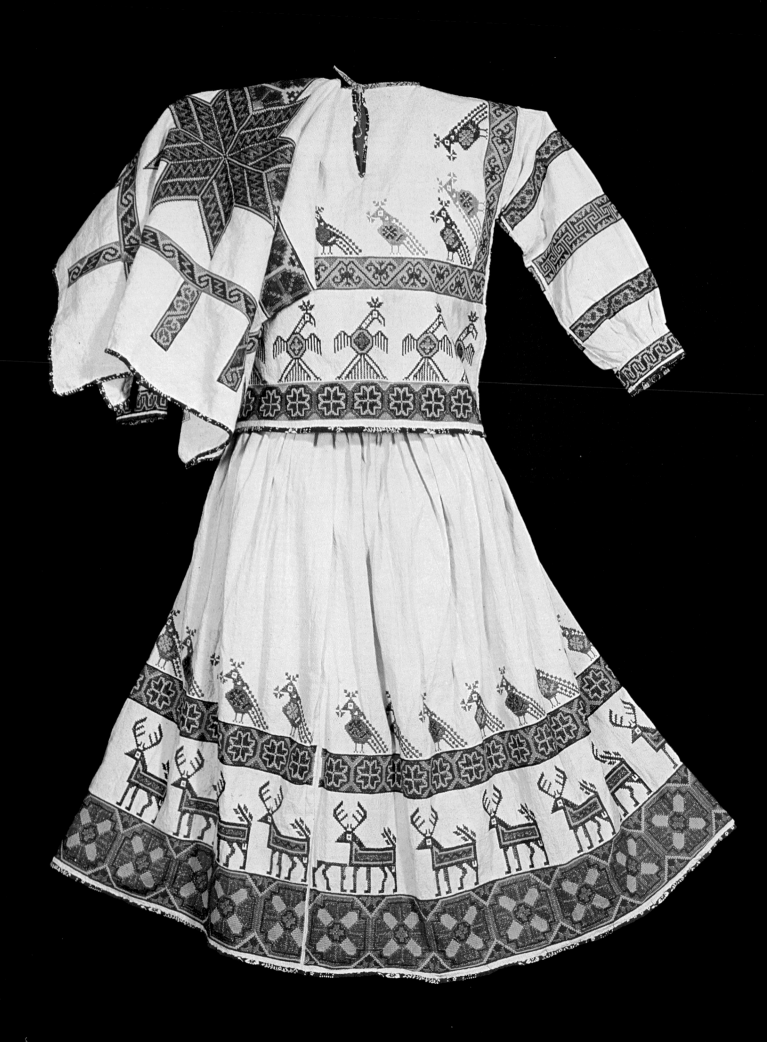

WOMAN'S OUTFIT

Shawl: 35 x 35″ (89 x 89 cm.). Blouse: 18½ x 48½″ (47 x 123 cm.). Skirt: 28½ x 41″ (72 x 104 cm.). Cotton cloth, embroidery, cotton thread. Collected by Eger in Cohamiata (1976–77). #L77.58. Eger-Valadez Collection

Woman's outfit with traditional embroidery motifs. Note the large *toto* flower on shawl and variations of same on blouse and skirt. Deer and eagle motifs throughout. Primarily worked in cross-stitch with bargello border.

67

SHAWL

53 x 25″ (134.5 x 63.5 cm.). Wool and embroidery. Collected by Lumholtz in San Andrés Cohamiata (1890–98). #65-321. From the anthropology collections, The American Museum of Natural History, New York City

Red, orange, gold, and yellow embroidery on black wool. Two separately woven pieces, joined, leaving slit for the head. Separately woven band sewn around all edges.

68

SMALL PONCHO

32 x 34½″ (81.2 x 87.6 cm.). Natural and dyed wool and embroidery. Collected by Zingg (1934–35). #9276/12. Collections of the School of American Research in the Museum of New Mexico, Santa Fe

Handspun natural brown wool with white, yellow, and red embroidery. Examples such as this and Plate 67 are no longer made, and are exceedingly rare. Two separately woven pieces joined at an angle, leaving slit for the head. Partly fringed.

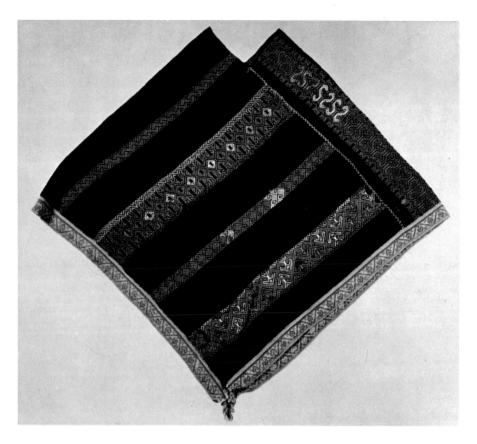

69

WOMAN'S SKIRT

33½ x 63½ (85 x 161 cm.). Cotton and wool with aniline dye. Collected by
Lumholtz (1890–98). #65-772. From the anthropology collections, The
American Museum of Natural History, New York City

Imported cotton cloth with embroidery in red, blue, and green. Gathered at top;
made in five pieces.

WOMAN`S SKIRT

31½ x 54½″ (80 x 138.4 cm.). Cotton and wool. Collected by Zingg (1934–35). #9629/12. From the anthropology collections, The American Museum of Natural History, New York City

Commercial cotton muslin with woven wool waistband. Unfinished border embroidered in red and black. Skirt made in one piece and pleated at top.

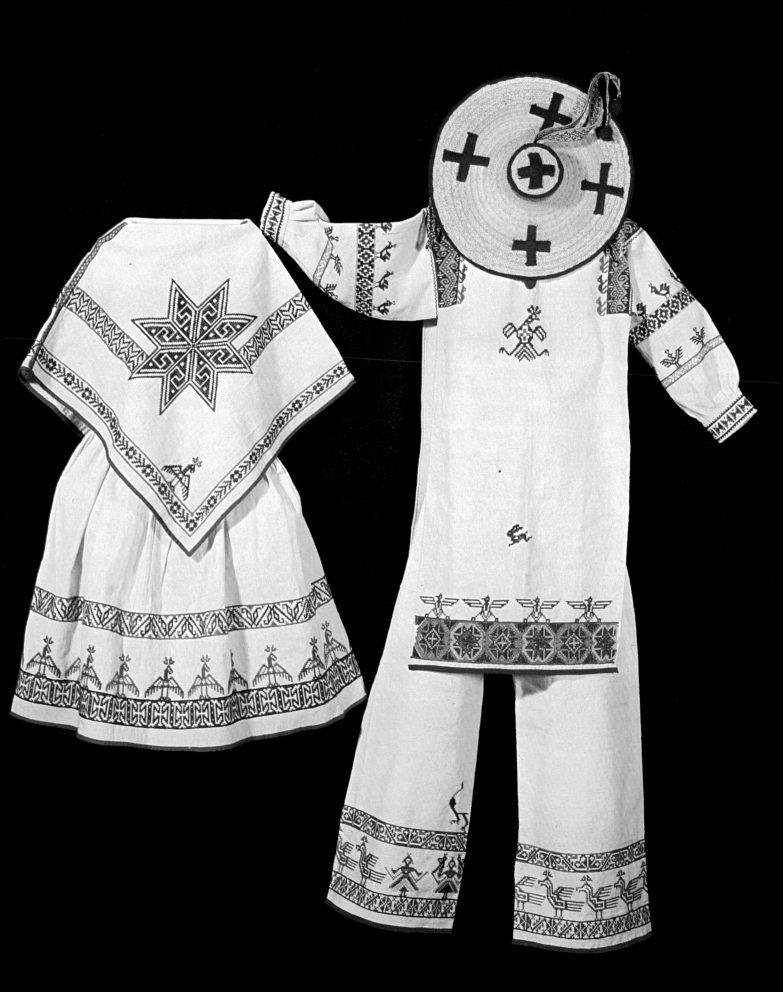

CHILDREN'S OUTFITS

Left: Girl's shawl. 23½ x 23¾″ (59.5 x 60.5 cm.); Girl's skirt. 19 x 27½″ (48 x 70 cm.).

Right: Boy's shirt. 28⅓ x 20″ (71.5 x 51 cm.); Boy's pants. 27½ x 38″ (70 x 96.5 cm.).

Cotton cloth, embroidery thread. Collected by Eger in Huastita (1976–77). #L77.58. Eger-Valadez Collection

Huichol clothing with traditional embroidered motifs. Note large *toto* flower motif on girl's shawl, and numerous eagle and bird motifs throughout, worked in cross-stitch and bargello. Both women and girls wear the shawl poncho-style. Shawls are sometimes fashioned from two print handkerchiefs sewn together.

Right (top): Boy's hat. 12½″ diameter x 3″ (37.7 cm. diameter x 7.6 cm.). Straw and wool. Collected by Zingg (1934–35). #1185/12. Collections of the School of American Research in the Museum of New Mexico, Santa Fe

Boy's hat with five red crosses and woven wool band in blue and red.

WOVEN BAG

34½ x 14″ (87.5 x 35.5 cm.). Natural and dyed wool. Collected by Lumholtz in Santa Catarina (1890–98). #65-650. From the anthropology collections, The American Museum of Natural History, New York City

All-purpose carrying pouch. Navy-blue and white double weave with geometric and animal motifs, the latter resembling what Lumholtz termed the "dog" motif. (See Plate 63 for matching belt.)

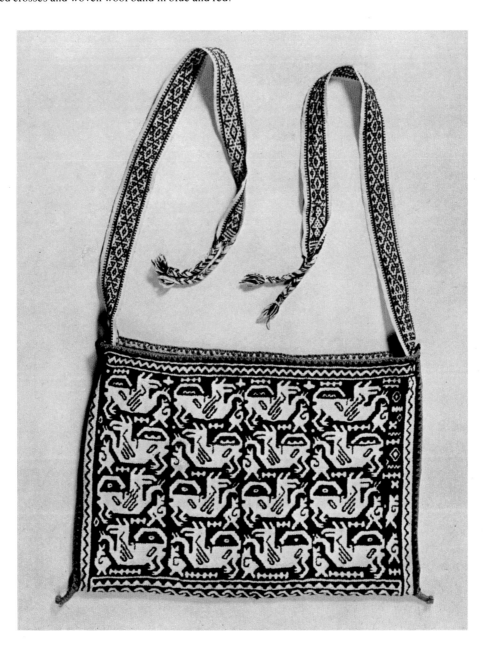

Top: WOVEN BAG

10 x 10⅝ (25.4 x 27 cm.) not including strap. Natural and dyed wool. Collected by Zingg (1934–35). #9628/12. Collections of the School of American Research in the Museum of New Mexico, Santa Fe

Bears a double image step-fret pattern on both sides.

Bottom (left): WOVEN BAG

8½ x 9″ (21.6 x 22.9 cm.) not including strap. Natural and dyed wool. Collected by Zingg (1934–35). Illustrated Dutton 1962:37. #9342/12. Collections of the School of American Research in the Museum of New Mexico, Santa Fe

Bears images of the royal eagle on both sides.

Bottom (right): WOVEN BAG

10¼ x 11½″ (26 x 29.2 cm.) not including strap. Natural and dyed wool. Collected by Zingg (1934–35). #9283/12. Collections of the School of American Research in the Museum of New Mexico, Santa Fe

Bears a motif Lumholtz called the god's eye.

All-purpose carrying pouches, in brown and white double weave.

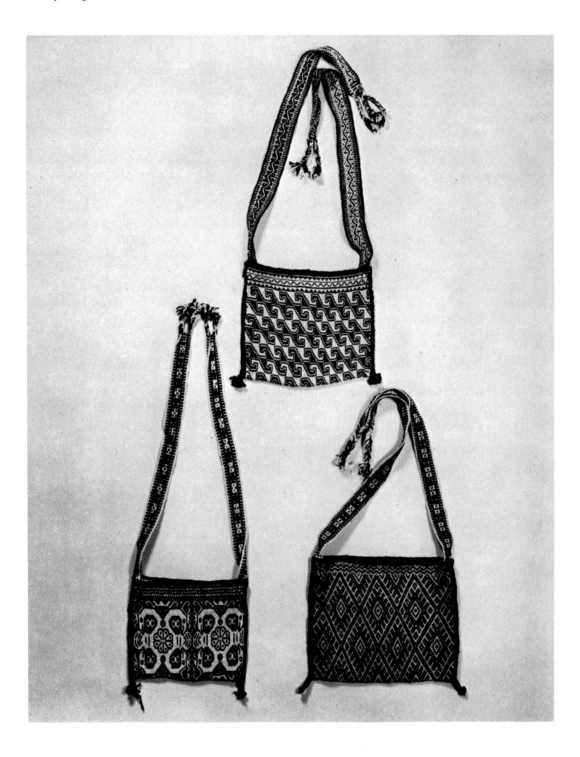

74

Top: WOVEN BAG

30½ x 8½ (77.5 x 21.5 cm.) not including strap. Natural and dyed wool. Collected by Collings in San Andrés (1966–77). #L77.65.8. Collection of Anne and Peter Collings

Collings identifies the motifs as double-headed eagle and *toto* flower.

Bottom (left): WOVEN BAG

27 x 11½″ (68.5 x 29 cm.) not including strap. Natural and dyed wool. Collected by Collings in San Andrés (1966–77). #L77.65.6. Collection of Anne and Peter Collings

Collings identifies the motifs as peyote or *toto* flower design and *islabon* (fire-striking device).

Bottom (right): WOVEN BAG

24½ x 10½″ (62 x 26.5 cm.) not including strap. Natural and dyed wool. Collected by Collings in San Andrés (1966–77). #L77.65.5. Collection of Anne and Peter Collings

Collings identifies the motif as a geometric pattern, one of the earliest design motifs.

All-purpose carrying pouches, in brown and white double weave.

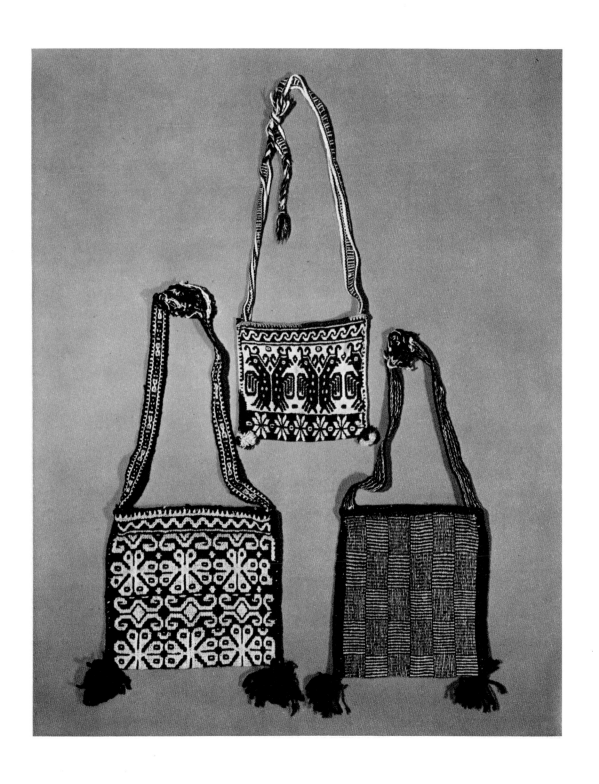

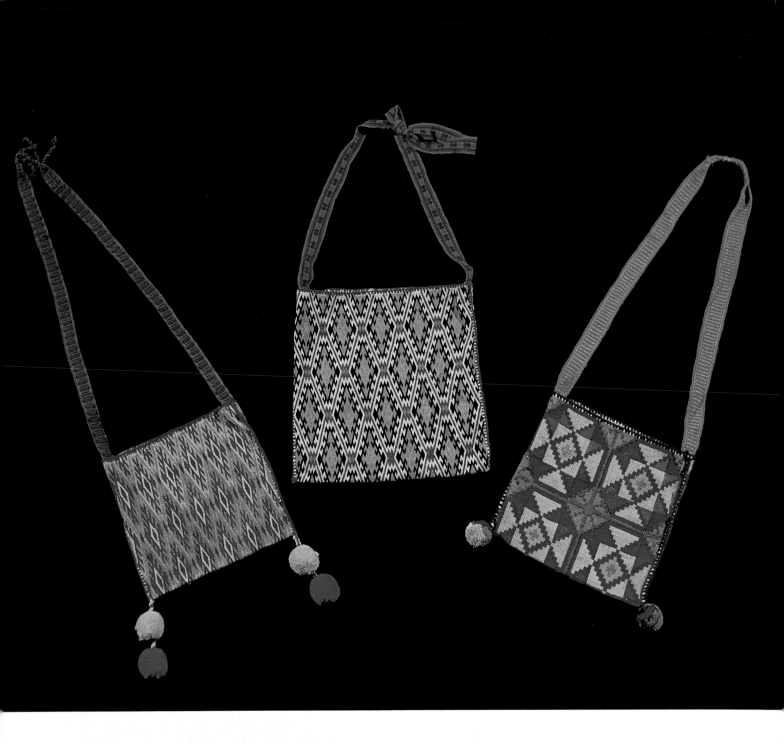

75

FINE STITCH BAGS

Left: 29 x 8½″ (73.5 x 21 cm.). *Center:* 27 x 10½″ (68.5 x 26 cm.). *Right:* 26 x 8½″ (66 x 21.5 cm.). Cotton cloth, wool, embroidery thread, yarn. Collected by Eger in San Andrés (1976–77). #L77.58. Eger-Valadez Collection

Fine stitch bags embroidered in bargello or the running stitch. Stitching technique adapted from the Cora but designs are uniquely Huichol. Colors and designs vary considerably. Woven wool handles on each.

76 ▶

EMBROIDERED BAGS

Top: (left) 30 x 12″ (76 x 30.5 cm.). Natural and dyed wool; *(right)* 30 x 13″ (76 x 33 cm.). Imported cotton cloth. *Bottom: (left)* 30 x 15½″ (76 x 39.5 cm.). Imported cotton cloth; *(right)* 35 x 15½″ (89 x 39.5 cm.). Natural and dyed wool. Collected by Collings (1966–77) in San Andrés and Huastita (bottom left). #L77.65. Collection of Anne and Peter Collings

A selection of multicolored embroidered bags with variations on the *toto* flower, crosses, and double-headed eagle motifs.

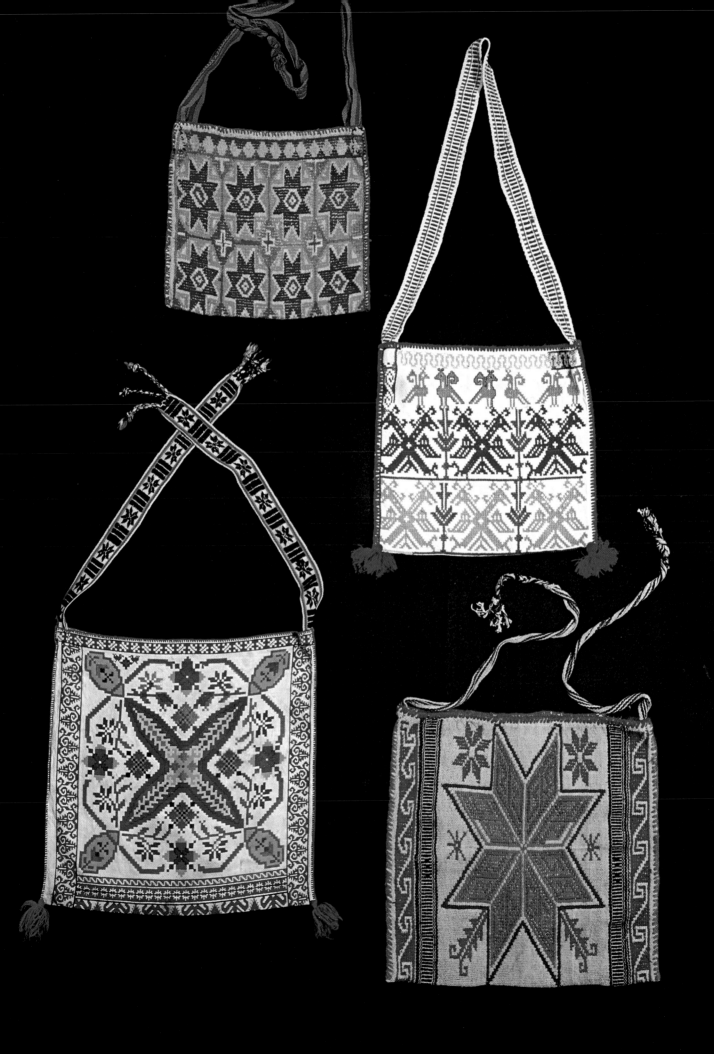

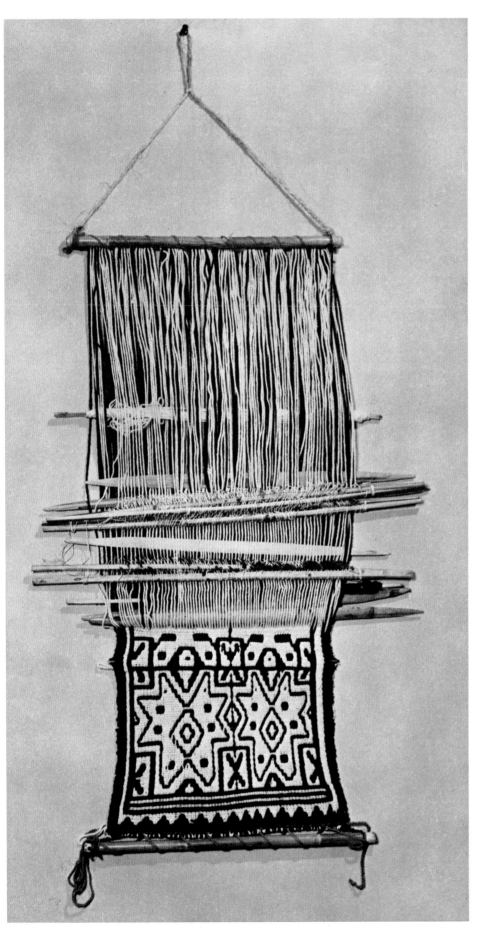

BACKSTRAP LOOM WITH UNFINISHED BAG
31⅛ x 21″ (79 x 53.3 cm.). Wood, bamboo, synthetic wool, cotton. Collected by Peter T. Furst (1966). #X66-2602. The Museum of Cultural History, University of California at Los Angeles

Backstrap loom with heddle rods, batten, and sticks. Double-weave black-and-white bag in process. Pattern represents a version of the *toto* flower motif.

78

BEAD EARRINGS

3⅛ x 2″ (7.9 x 5.1 cm.). Glass beads and string. Collected by Zingg (1934–35). #14105/12. Collections of the School of American Research in the Museum of New Mexico, Santa Fe

Blue and white glass-bead earrings with traditional motifs. Beads acquired in trade.

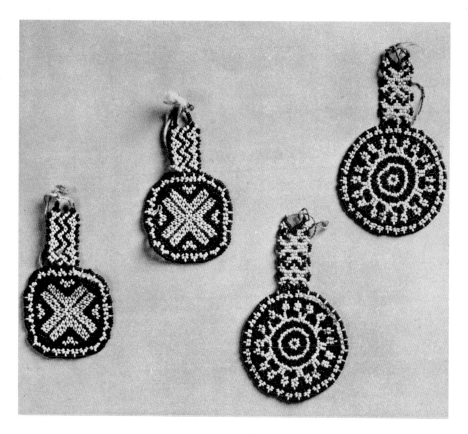

79

Top: SHELL NECKLACE

16 x 3¾″ (40.6 x 9.5 cm.). Shells, yarn, beads, fiber, bottle-gourd tips. Collected by Zingg (1934–35). #14107/12. Collections of the School of American Research in the Museum of New Mexico, Santa Fe

White beads, red bits of cotton, and zigzag-cut tips of bottle gourds.

Bottom: SHELL NECKLACE

15¾ x 4⅝″ (40 x 11.7 cm.). Shells, yarn, beads, fiber. Collected by Zingg (1934–35). #10437/12. Collections of the School of American Research in the Museum of New Mexico, Santa Fe

Blue beads and red bits of cotton.

Shell jewelry associated with deities of the sea. Zingg notes that the shells are called the "toe nails of Grandmother Growth."

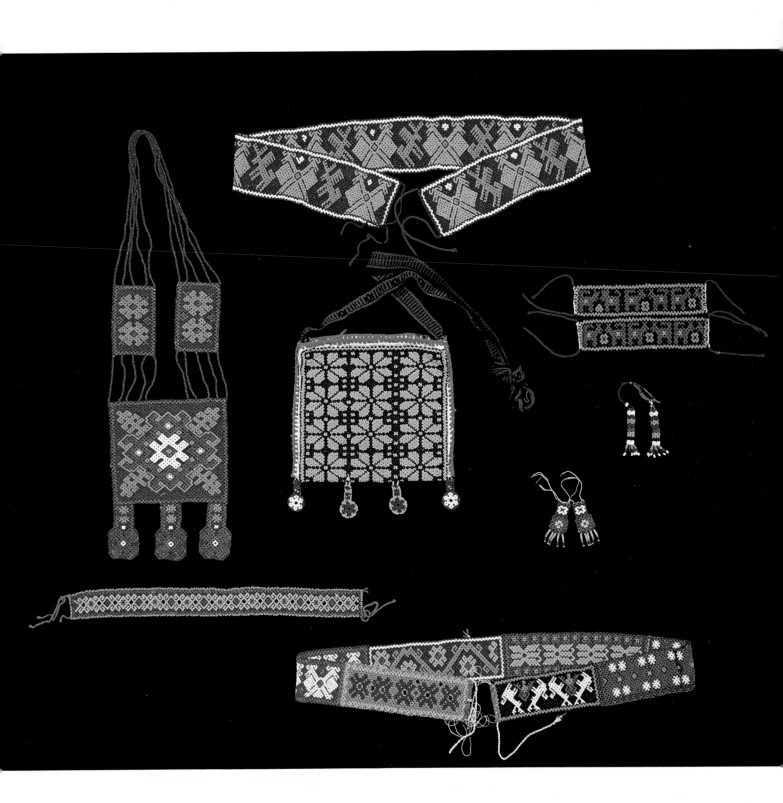

80

Top:

BEADED BELT

32½ x 2½" (81.5 x 6.5 cm.). Beads, nylon thread, yarn. Collected by Eger in Cohamiata (1976–77). #L77.58.24. The Foundation for the Indians of the Sierra

Red, blue, yellow, and white beads worked in double-headed eagle motif and deer pattern, both symbolic of shamanism.

Clockwise:

PAIR of BRACELETS

6 x 1½" (15 x 4 cm.). Beads, nylon thread, yarn. Collected by Eger in San Andrés (1976–77). #L77.58.21a,b. The Foundation for the Indians of the Sierra

Orange, blue, and black beads with deer and peyote motif.

BEADED EARRINGS

Flat: 2 x 1" (5 x 2.5 cm.). *Round:* 4 x ¾" (10 x 1 cm.). Beads, nylon thread, string. Collected by Eger in San Andrés (1976–77). #L77.58.19a,b; #L77.58.20a,b. The Foundation for the Indians of the Sierra

Multicolored earrings, worn primarily by women.

BEADED BELT WITH SIX SECTIONS

36½ x 2" (92.5 x 5 cm.). Collected by Eger in Cohamiata (1976–77). #L77.58.23. The Foundation for the Indians of the Sierra

Multicolored beads with motifs of deer, *toto* flower, butterfly and double-headed eagle.

BEADED CHOKER

18 x 1⅓" (46 x 3 cm.). Beads, nylon thread, yarn. Collected by Eger in Cohamiata (1976–77). #L77.58.18. The Foundation for the Indians of the Sierra

Necklace choker in blue, orange, yellow, and red. Same design often worked in bargello embroidery.

BEADED NECKLACE WITH PENDANT

19¾ x 5½" (50 x 14 cm.). Beads, nylon thread. Collected by Eger in San Andrés (1976–77). #L77.58.17. The Foundation for the Indians of the Sierra

Necklace with pendant in blue, orange, white, and green beads. Design represents cross with five directions and projections.

Center:

BEADED BAG

22 x 7½" (56 x 19 cm.). Cotton cloth, beads, nylon thread, multicolored yarn. Collected by Eger in San Andrés (1976–77). #L77.58.22. The Foundation for the Indians of the Sierra

Beaded bag worked primarily in yellow and black. Same motif of *toto* flower prevalent in embroidery.

Selected Bibliography

Aaronson, Bernard, and Osmond, Humphrey, eds. *Psychedelics: The Uses and Implications of Hallucinogenic Drugs*. Cambridge, Mass.: Schenkman, 1971.

Aguirre Beltrán, Gonzalo. *Regiones de Refugio*. México: Instituto Nacional Indigenista-S.E.P., No. 17, 1967.

Beals, Ralph. *The Comparative Ethnology of Northern Mexico Before 1750*. Berkeley: University of California Press, 1932.

Benítez, Fernando. *In the Magic Land of Peyote*. Translated by John Upton. Austin: University of Texas Press, 1975.

Buber, Martin. *Between Man and Man*. New York: Macmillan, 1965.

Castaneda, Carlos. *The Teachings of Don Juan: A Yaqui Way of Knowledge*. New York: Ballantine Books, 1969.

Collings, Peter. "The Huichol Indians: A Look at the Present-day Drug Culture." *The Master Key* 47(1973), No. 4; 48(1974), No. 1.

Dobkin de Rios, Marlene. "Man, Culture and Hallucinogens: An Overview." In *Cannabis and Culture*, edited by Vera Rubin. The Hague: Mouton, 1975.

Dutton, Bertha. *Happy People: The Huichol Indians*. Santa Fe: Museum of New Mexico Press, 1962.

Eliade, Mircea. *Shamanism: Archaic Techniques of Ecstasy*. Translated by Willard Trask. Bollingen Series No. 76. Princeton, N.J.: Princeton University Press, 1964.

————. *The Two and the One*. New York: Harper Torchbooks, 1962.

Ellis, Havelock. "Mescal: A New Artificial Paradise." *Contemporary Review* (London) 73(1898):130–41.

Ely, Evelyn. "Ojos de Dios." *El Palacio* (Quarterly Journal of The Museum of New Mexico) 3(1977):2–14.

Fabila, A. *Los Huicholes de Jalisco*. Mexico City: Instituto Nacional Indigeoista, 1959.

Furst, Peter T., ed. *Flesh of the Gods: The Ritual Uses of Hallucinogens*. New York: Praeger, 1972.

————. "Huichol Conceptions of the Soul." *Folklore Americas* 27(1967):39–106.

————. "The Roots and Continuities of Shamanism." In *Stones, Bones, and Skin: Ritual and Shamanic Art*, edited by Anne Trueblood Brodsky, Rose Danesewich, and Nick Johnson. Toronto: The Society for Art Publication, 1977.

————. "To Find Our Life: Peyote Among the Huichol Indians of Mexico." In Furst (ed.), *Flesh of the Gods*.

————, and Anguiano, Marina. "Myth and Ritual Among the Huichol Indians." In *Enculturation in Latin America: An Anthology*, edited by Johannes Wilbert. Los Angeles: UCLA Latin American Center Publications, 1976.

————, and Myerhoff, Barbara G. "Myth as History: The Jimson Weed Cycle of the Huichols of Mexico." *Anthropologica* 17(1966):3–39.

————. *Peyote Hunt: The Sacred Journey of the Huichol Indians*. Ithaca, N.Y.: Cornell University Press, 1974.

Fischer, Roland. "On Creative, Psychotic, and Ecstatic States." In *Art Interpretation and Art Therapy*, edited by I. Jakab. New York: S. Karger, 1969.

Garcia, Celia. "Contemporary Huichol Textiles: Patterns of Change." In *4th Annual Irene Emery Roundtable on Museum Textiles*. Washington, D.C.: The Textile Museum, 1976.

Geertz, Clifford. "Religion as a Cultural System." In *Anthropological Approaches in the Study of Religion*, edited by M. Burton. Association of Social Anthropologists Monographs 3. London: Tavistock, 1965.

Grimes, Joseph E. "Huichol Tone and Intonation." *International Journal of American Linguistics* 25(1959):221–32.

————. "Huichol Economics." *America Indígena* 21(1961), No. 4: 281–330.

————. *Huichol Syntax*. The Hague: Mouton, 1964.

————, and Grimes, Barbara F. "Semantic Distinctions in Huichol (Uto-Aztecan) Kinship." *American Anthropologist* 64(1962):104–12.

————, and Hinton, Thomas B. "The Huichol and Cora." In *Handbook of Middle American Indians*, vol. 8, edited by E. Z. Vogt and R. Wauchope. Austin: University of Texas Press, 1969.

Harner, Michael, ed. *Hallucinogens and Shamans*. London: Oxford University Press, 1973.

Hers, Marie-Areti. "Primeras Temporadas de la Misión Arqueológica Belga en la Sierra del Nayar." *Boletín* (México: Instituto Nacional de Antropologia e Historia) No. 16 (1976):41–44.

HUICOT. *Centro Coordinador para el Desarrollo de la Región HUICOT—Informe*, México, 1976.

James, William. *The Varieties of Religious Experience*. New York: Longmans, Green, 1935.

Jung, Carl G. *Collected Works*. Bollingen Series. Princeton, N.J.: Princeton University Press, 1946.

Kelley, J. Charles. "Archaeology of the Northern Frontier,

Zacatecas and Durango.'' In *Handbook of Middle American Indians*, vol. 11, edited by E. Z. Vogt and R. Wauchope. Austin: University of Texas Press, 1971.

Kuhn, Thomas. *The Structure of Scientific Revolutions*. Chicago: University of Chicago Press, 1962.

La Barre, Weston. ''Hallucinogens and the Shamanic Origins of Religion.'' In Furst (ed.), *Flesh of the Gods*.

Laski, Marghanita. *Ecstasy: A Study of Some Secular and Religious Experiences*. Bloomington: Indiana University Press, 1961.

Leary, T., Metzner, R., and Alpert, R. *The Psychedelic Experience: A Manual Based on the Tibetan Book of the Dead*. New York: University Books, 1964.

Lévi-Strauss, Claude. *The Savage Mind*. Chicago: University of Chicago Press, 1966.

Lewin, Louis. *Phantastica: Narcotic and Stimulating Drugs*. New York: Dutton, 1974.

Lommel, Andreas. *Shamanism: The Beginnings of Art*. Translated by Michael Bullock. New York: McGraw-Hill, 1967.

López-Portillo y Weber, José. *La Conquista de Nueva Galicia*. México: Secretaria de Educación Pública, 1939.

Lumholtz, Carl. *Decorative Art of the Huichol Indians*. Memoirs of the American Museum of Natural History 3. New York: American Museum of Natural History, 1904.

————. *Symbolism of the Huichol Indians*. Memoirs of the American Museum of Natural History 1. New York: American Museum of Natural History, 1900.

————. *Unknown Mexico*. New York: Charles Scribner's Sons, 1902.

McCarty, Kieran and Matson, Dan. ''Franciscan Report on the Indians of Nayarit, 1673.'' *Ethnohistory* 22(1975), No. 3: 193–221.

Mandell, Arnold J. *Coming of [Middle] Age: A Journey*. New York: Summit Books, 1978.

Marsh, R. P. ''Meaning and the Mind-Drugs.'' *ETC* 22(1965): 408–30.

Maslow, Abraham H. ''Religious Aspects of Peak Experiences.'' In *Personality and Religion: The Role of Religion and Personality Development*, edited by William Sadler. New York: Harper and Row, 1970.

Mitchell, S. Weir. ''The Effects of Anhelonium Lewini.'' *British Medical Journal*, December 5, 1896, pp. 1625–29.

Myerhoff, Barbara G. ''Balancing Between Worlds: The Shaman's Calling.'' *Parabola: Myth and the Quest for Meaning* 1(1976), No. 2:6–13.

————. ''The Deer-Maize-Peyote Symbol Complex Among the Huichol Indians of Mexico.'' *Anthropological Quarterly* 43(1970):64–78.

————. ''The Huichol and the Quest for Paradise.'' *Parabola: Myth and the Quest for Meaning* 1(1975), No. 1:22–39.

————. ''Organization and Ecstasy: Deliberate and Accidental Communitas Among Huichol Indians and American Youth.'' In *Symbol and Politics in Communal Ideology: Cases and Questions*, edited by Sally Moore and Barbara Myerhoff. Ithaca, N.Y.: Cornell University Press, 1975.

————. *Peyote Hunt: The Religious Pilgrimage of the Huichol Indians*. Ithaca, N.Y.: Cornell University Press, 1974.

————. ''Return to Wirikuta: Ritual Reversal and Symbolic Continuity on the Peyote Hunt of the Huichol Indians.'' In *The World Upside Down: Studies in Symbolic Inversion*, edited by Barbara Babcock. Ithaca, N.Y.: Cornell University Press, 1978.

————. ''Shamanic Equilibrium: Balance and Mediation in Known and Unknown Worlds.'' In *American Folk Medicine*, edited by Wayland D. Hand. Berkeley and Los Angeles: University of California Press, 1977.

Norman, J., and Guillermo, A. E. ''The Huichols: Mexico's People of Myth and Magic.'' *National Geographic* 151(1977): 832–53.

Negrin, Juan. *The Huichol Creation of the World*. Sacramento: E. B. Crocker Art Gallery, 1975.

Orr, Philip. *Prehistory of Santa Rosa Island*. Santa Barbara, Cal.: Santa Barbara Museum of Natural History, 1968.

Osmund, Humphrey. ''A Review of the Clinical Effects of Psychotemimetic Agents.'' *Annals of the New York Academy of Sciences* 66(1957):418–34.

Pahnke, Walter N. ''Drugs and Mysticism.'' *International Journal of Parapsychology* 8(1966):295–313.

Parsons, Elsie Clews. *Pueblo Indian Religion*. 2 vols. Chicago: University of Chicago Press, 1939.

Preuss, Konrad Theodor. *Die Nayarit-Expedition*, vol. 1: *Die Religion der Cora-Indianer*. Leipzig: B. G. Teubner, 1912.

Reed, Karen. *Los Huicholes*. México: Instituto Nacional Indigenista-S.E.P., No. 11, 1972.

Reynoso, Salvador. *Autos hechos por el Capitán don Juan Flores*

de San Pedro, sobre la Reducción, Conversión y Conquista de los Gentiles de la Provincia del Nayarit en 1722. Guadalajara: Librería Font, 1964.

Riley, Carroll and Winters, Howard. "The Prehistoric Tepehuan of Northern Mexico." *Southwest Journal of Anthropology* 19 (1963):177–85.

Schultes, Richard Evans. "An Overview of Hallucinogens in the Western Hemisphere." In Furst (ed.), *Flesh of the Gods.*

Shadow, Robert and Weigand, Phil C. "Archaeology of the Bolaños Highlands, Western Mexico." Paper presented to the Society for American Archaeology, New Orleans (1977).

Strong, William Duncan. *Aboriginal Society in Southern California.* Banning, Cal.: Malki Museum Press, 1972.

Turner, Victor. *The Forest of Symbols: Aspects of Ndembu Ritual.* Ithaca, N.Y.: Cornell University Press, 1967.

———. *The Drums of Affliction: A Study of Religious Processes Among the Ndembu of Zambia.* Oxford: Clarendon and the International African Institute, 1968.

———. *The Ritual Process: Structure and Anti-Structure.* Chicago: Aldine Publishing, 1969.

Velázquez, María del Carmen. *Colotlán. Doble Frontera contra los Bárbaros.* México: U.N.A.M. Cuadernos del Instituto de Historia, Serie Histórica No. 3, 1961.

Wasson, R. G. *Soma: Divine Mushroom of Immortality.* New York: Harcourt, Brace, Jovanovich, 1969.

Watts, Alan. *The Joyous Cosmology: Adventures in the Chemistry of Consciousness.* New York: Vintage Books, 1965.

———. "Psychedelics and Religious Experience." In Aaronson and Osmond (eds.), *Psychedelics.*

Weigand, Phil C. "Circular Ceremonial Structure Complexes in the Highlands of Western Mexico." In *Archaeological Frontiers: Papers on New World High Cultures in Honor of J.*

Charles Kelley, edited by Robert Pickering. University Museum Studies No. 4. Carbondale: Southern Illinois University Museum, 1976(a).

———. *Co-operative Labor Groups in Subsistence Activities Among the Huichol Indians.* Mesoamerican Studies No. 7. Carbondale: Southern Illinois University Museum, 1972.

———. "Differential Acculturation Among the Huichol Indians." In *Culture Change in Northern Mexico,* edited by Phil C. Weigand and Thomas B. Hinton. Tucson: University of Arizona Press, 1977(a).

———. "The Ethnoarchaeology of Highland Western Mexico." In *Ethnoarchaeology: A World-Wide Perspective,* edited by Michael Stanislawski. New York: Academic Press, 1977(b). (On press.)

———. *Modern Huichol Ceramics.* Mesoamerican Studies No. 3. Carbondale: Southern Illinois University Museum, 1969.

———. "The Role of the Huichol Indians in the Revolutions of Western Mexico." *Proceedings of the Pacific Coast on Latin American Studies.* Tempe: Arizona State University, Center for Latin American Studies, 1976(b). (In press.)

———. "The Role of an Indianized Mestizo in the 1950 Huichol Revolt." *Specialia No. 1–Interamericana No. 1.* Carbondale, Latin American Institute, Southern Illinois University, 1969.

Weiss, Gerald. "Shamanism and Priesthood in Light of the Campa Ayahuasco Ceremony." In Harner (ed.), *Hallucinogens and Shamanism.*

Wilbert, Johannes, ed. *Enculturation in Latin America: An Anthology.* Los Angeles: UCLA Latin American Center Publications, 1976.

Zingg, Robert M. *The Huichols: Primitive Artists.* New York: G. E. Stechert, 1938.

The Contributors

LOWELL JOHN BEAN, professor of anthropology at California State University, Hayward, received his Ph.D. in anthropology from the University of California at Los Angeles. His research interests are in cultural ecology, culture change, and shamanism, especially as applied to native Californians. He is the author of several books, including *Mukat's People* and, with Katherine Saubel, *Temelpakh*, as well as many articles. He has worked among several California Indian groups and with shamans from the Cahuilla, Luiseno, Pomo, and Hupa. He serves as co-editor of the Ballena Press Anthropological Papers and as associate editor of the *California Journal of Anthropology*. He is former chairman of the Department of Anthropology at California State University, Hayward, and former president of the Southwestern Anthropological Association.

SYLVIA BRAKKE VANE received her Master's degree in anthropology from California State University, Hayward, after many years of group work in her community and earlier undergraduate and graduate work in biomedical science at the University of Minnesota and Harvard Medical School, respectively. Although her work in anthropology has centered on problems of school desegregation, archival research, and field research among California Indians at the Morongo Indian Reservation and among northern California urban Indians, she has had a longtime interest in comparative religion, and has served as assistant to the director of the Smith-Andersen Gallery in Palo Alto. She is the author of "A Community and Its School as a System: Menlo-Atherton Desegregation, 1967-1970" (Master's thesis, CSUH) and of a number of papers and, with Dr. Bean, is the co-author of *California Indians: Primary Resources* and "What to Teach about California Indians" (*California Social Science Review*, 1973). She has served as consultant to the Far West Laboratories for Educational Research and Development and to the San Francisco School District, and is *Newsletter* Editor and Program Chairman for the Southwestern Anthropological Association.

Since 1975, SUSAN EGER has been a field director for The Foundation for the Indians of the Sierra, a nonprofit organization which was formed to help the Huichols and other indigenous populations deal with the effects of outside pressures upon their traditional cultures. Working in collaboration with The Indian Institute (INI) and PLAN HUICOT, she and her colleague Peter Collings have aided the Huichols by providing much needed agricultural assistance and medical services and supplies.

Susan Eger is currently a graduate student in Latin American Studies at UCLA, working under Johannes Wilbert and Ronald K. Siegel. Her special research interests include women in anthropology, shamanism, indigenous art in the new world, and the use of hallucinogenic plants as they relate to art production. She has lived in the Sierras since 1975; much of her research has focused on collecting and preserving traditional Huichol embroidery patterns for indigenous use. Many of her research methods adapt twentieth-century technology to help preserve traditional designs and modes of art production.

PETER T. FURST, Ph.D., is Professor of Anthropology at the State University of New York at Albany and Research Associate in Ethnobotany at the Botanical Museum of Harvard University. He has done extensive fieldwork among the Indians of Mexico, Guatemala, and Venezuela and is the author of numerous articles and monographs on pre-Columbian art and iconography, and on religion, ritual, curing systems, and ethnohistory among Mesoamerican Indians, particularly the Huichols. His two most recent books are *Flesh of the Gods: The Ritual Use of Hallucinogens* and *Hallucinogens and Culture*. In 1966, Dr. Furst and Dr. Barbara G. Myerhoff became the first anthropologists to participate in a Huichol peyote pilgrimage, an experience Dr. Furst repeated in 1968. The 1968 pilgrimage resulted in an hour-long 16-mm. documentary film, *To Find Our Life: The Peyote Hunt of the Huichols of Mexico*.

ARNOLD J. MANDELL (psychiatrist, neurochemist, writer, teacher, jazz pianist, and long-distance runner) is an expert of international repute on the relationships between brain states and behavior. A graduate of Stanford University and Tulane Medical School, Dr. Mandell took psychiatric training and served on the faculty of the University of California at Los Angeles and Irvine before moving to La Jolla in 1969 as founding chairman of the Department of Psychiatry at the new University of California medical school in San Diego. His professional activities range through patient care, teaching, and laboratory research on mammalian brain chemistry and behavior. He has served on numerous governmental and editorial committees and boards, and authored or co-authored more than two hundred publications. Immediate past president of the Society of Biological Psychiatry, he was recently named Johananoff International Fellow in Advanced Biomedical Studies by the Mario Negri Institute for Pharmacological Research in Milan, Italy. His essay on Castaneda's *Don Juan* in *Ontario Review* won a Pushcart Prize in 1976. That year also saw the publication of his controversial account of his experience as consultant to the San Diego Charger football team, *The Nightmare Season*. His most recent book, *Coming of [Middle] Age: A Journey*, was published in 1978.

KAL MULLER, who received his Ph.D. in French literature from the University of Arizona, has worked as an administrator for the United Nations and as an interpreter for the U.S. Department of State. An experienced traveler and professional photo-journalist, he has contributed articles to *National Geographic, Natural History, Journal de la Société des Océanistes*, among others. He spent three years researching, filming, and photographing in the New Hebrides, and two years living in the Huichol district of San Andrés de Cohamiata. He has worked in collaboration with a number of educational institutions and continues to lecture, photograph, and write.

BARBARA G. MYERHOFF received her Ph.D. in anthropology from the University of California at Los Angeles in 1968. Her dissertation, "Deer-Maize-Peyote Symbol Complex Among the Huichol Indians of Mexico," formed the basis of her book *Peyote Hunt: The Sacred Journey of the Huichol Indians*, which was nominated for a National Book Award. She was, with Peter Furst, one of the first anthropologists to participate in a peyote pilgrimage. Presently she is head of the Department of Anthropology at the University of Southern California, where she is a professor. Her current work among elderly Eastern European Jews in Los Angeles is concerned particularly with their ritual and symbolic life. Her recent film on them—*Number Our Days*—won the 1977 Academy Award for Best Short Subject Documentary, and she is currently working on a soon-to-be-published book on these people by the same title.

PREM DAS (Paul C. Adams) has been actively exploring altered states of consciousness for the past ten years. His first instruction in the techniques of raja yoga was from Baba Ram Dass, who then sent him to India to study with Baba Hari Das. From this teacher he received his name and further instruction in raja and kundalini yoga. Upon his return to this country, he went to Mexico seeking quiet and a simple life style in which to practice the yoga techniques learned in India. A Huichol shaman with whom he became friends took him to his village high in the mountains of west-central Mexico where he met the elder shaman don José, who has since led him to the completion of a Huichol shaman's five-year apprenticeship. Presently Prem Das is writing a book entitled *The Singing Earth* and teaching seminars on Huichol shamanism at growth centers and universities throughout the United States.

PHIL C. WEIGAND received his Ph.D. in anthropology at Southern Illinois University in 1970. He began field research in western Mexico in 1960 and has spent two years living among the *comunidades* of the Huichols and Tepecanos.

A former chairman of the Department of Anthropology at the State University of New York at Stony Brook, he currently holds an Associate Professorship at that institution. He has been a Research Collaborator at Brookhaven National Laboratory in Art and Archaeology since 1972. His special interests include the archaeology and history of western Mexico and Huichol social, political, and economic organization, and he is the author of numerous articles on these subjects.